WESKER'S POLITICAL PLAYS

T0347508

Arnold Wesker's

POLITICAL PLAYS

CHIPS WITH EVERYTHING

THEIR VERY OWN AND GOLDEN CITY

THE JOURNALISTS

BADENHEIM 1939

PHOENIX, PHOENIX BURNING BRIGHT

OBERON BOOKS
LONDON

WWW.OBERONBOOKS.COM

First published in this collection in 2010 by Oberon Books Ltd
521 Caledonian Road, London N7 9RH
Tel: +44 (0) 20 7607 3637 / Fax: +44 (0) 20 7607 3629
e-mail: info@oberonbooks.com
www.oberonbooks.com

Cover photograph by Nobby Clark

PB ISBN 9781840029543
E ISBN: 9781849438988

Contents

INTRODUCTION *by Michael Billington* 7,

CHIPS WITH EVERYTHING 11,

THEIR VERY OWN AND GOLDEN CITY 79,

THE JOURNALISTS 177,

BADENHEIM 1939 279,

PHOENIX, PHOENIX BURNING BRIGHT 341

Introduction

Arnold Wesker is a remarkably diverse dramatist. As previous volumes in this series have shown, he has written social plays, lyrical plays and monologues that are a gift for aspiring actors. But politics has always been central to Wesker's work. His famous 1950s trilogy – *Chicken Soup With Barley*, *Roots* and *I'm Talking About Jerusalem* – was a memorable statement of intent that offered nothing less than an intepretation of history: it used the experience of the Kahn family to chart, over a quarter of a century, a growing disillusionment with the prospect of radical change. "Like many Jewish writers," Kenneth Tynan wrote in 1960, "Mr Wesker thinks internationally yet feels domestically; and it is this combination of attributes that enables him to bring gigantic events and ordinary people into the same sharp focus."

That remains true today. But the special virtue of the five plays collected in this volume is that they enable us to trace the development of Wesker's ideas and the changes in his dramatic technique. The first play in the volume, *Chips With Everything*, dates from 1962: the last, *Phoenix, Phoenix Burning Bright*, from 2006. Taken together, the five plays range widely both geographically and historically. Examining people as both groups and individuals, they also explain how Wesker, while remaining an affirmative humanist, has reached a position where he distrusts all fixed ideologies. We may not always agree with him; but, by reading these five plays, we understand how he has arrived at these conclusions.

One of Wesker's great strengths has always been his ability to extract general truths from his personal experience; and you see that vividly in *Chips With Everything*. In 1950 Wesker was called up to do his mandatory two year's National Service in the Royal Air Force. Out of the first eight weeks of basic training came a play that offers one of the best descriptions you'll find in British drama of the insidious nature of the class system. The action stems from a calculated act of rebellion by Pip Thompson, a general's son who rejects officer training to lead his fellow-recruits into acts of defiance against authority. But the officer class is playing a waiting-game. Knowing that Thompson will ultimately be won over, the Pilot Officer suavely tells him: "It goes right through us,

Thompson. Nothing you can do will change that. We listen but we do not hear, we befriend but do not touch you, we applaud but do not act- to tolerate is to ignore."

This is Wesker at his most political. What he presents, through dramatic action, is a particular example of something the German-American social philosopher, Herbert Marcuse, later turned into a universal principle: that a ruling elite retains its power through a "repressive tolerance." But Wesker is writing a play rather than a pamphlet; and the work's brilliance lies in its emotional ambivalence. Pip's power over his colleagues may be questionable but the scene where he leads them in a raid on a coke-store is always theatrically thrilling. And the final passing-out parade is a masterpiece of theatrical irony. There is something deeply moving about the way a bunch of raw conscripts has been transformed into a cohesive unit; yet we also realise that the price you pay for corporate discipline is a perpetuation of institutional hierarchy. In its way the ending is as powerful, precisely because it is as contradictory, as that of Brecht's *Mother Courage.*

In the same year that *Chips With Everything* opened, 1962, Wesker announced he was temporarily forsaking playwriting to set up Centre Fortytwo: an organisation devoted to creating, in alliance with the trades union movement, a national network of arts festivals. Although much mocked at the time, it was a brave gesture. It was also one that produced endless frustration which fed into the writing of *Their Very Own and Golden City*, given its first British production at the Royal Court in 1966. Even that experience was not entirely happy: Wesker records how he foolishly endorsed the director's decision to have one set of actors play the protagonists in youth and age. Yet reading the play today, I'm struck by Wesker's ability once again to turn his own personal experience into a resonant political metaphor: one showing how the optimistic idealism of youth is bruised by the compromises of experience.

Wesker certainly operates on a vast canvas. Moving back and forth in time, he shows how the young Andrew Cobham dreams of becoming a famous architect and building six ideal new cities on a human scale and with popular support: confronted by realpolitik, however, he struggles to achieve one. What is impressive is how much information Wesker manages to pack in: everything from a potted history of the Ramsay Macdonald government to a demonstration of the internecine power-battles

within the trades union movement. The play also seems even more topical today than when it was written. It is bitterly ironic that Andrew and his fellow visionaries dream of a re-invigorated movement to be called "New Labour"; for what the play shows is how, in Britain, the most that socialist governments can ever hope to achieve is minor modifications to the existing capitalist system. As Cobham says at the end of his life, "the Labour movement provides prefects to guard other men's principles for living." Written at the time of the Harold Wilson government, that seems an even more apt epitaph for the Blair and Brown years.

Politically, Wesker is a realist who never loses his sense of human potential. What he can't abide is anything that diminishes life's infinite richness; and judging by his play, *The Journalists*, which I first saw in an amateur production in Coventry 1971, he sees the British press as a supreme example of a belittling negativism. Based partly on Wesker's own fly-on-the-wall experience of watching The Sunday Times put together, this is a work-play in the tradition of *The Kitchen*. What it says is also unequivocal: that journalism reflects our Lilliputian society's self-wounding desire to cut everyone down to size. At a time when print journalism is itself in retreat in the face of the internet, the play inevitably now has a period feel: investigative journalism has declined, screens have banished the collegiate banter of newspaper offices and printed opinion is subject to instant rebuttal by the vast army of bloggers. Yet the emergence of the blog-culture only serves to reinforce Wesker's basic political point: that human dignity is damaged, and democracy imperiled, when journalism turns from a necessary watchdog into an agent of destruction.

Technically, *The Journalists* is impressive in its use of the technique of kaleidoscopic collage. And Wesker takes the process a stage further in *Badenheim 1939*: an adaptation of Aharon Appelfeld's remarkable 1981 novel about the breakdown of identity amongst the population of an Austrian spa town awaiting the journey to the camps. Wesker has never been anything other than a Jewish writer; but what he here confronts, very movingly, is the tragic delusion that a traditional belief in art, culture and civilisation can act as a protection against the impending Holocaust. Music is a crucial feature of the play; and what Wesker shows, in a manner reminiscent of Max Frisch's *The Fire Raisers*, is how the inhabitants of the eponymous festival town go about their daily business, initially oblivious to the sanitation inspectors

who become symbols of insidious tyranny. While offering an elegy to a dying society, the play also captures the diversity of Jewish experience through a series of Daumier-like vignettes; and, although the play would test the resources and the budget of any company, one could imagine its theatrical potency.

As a political writer, Wesker is capable of operating on a dual scale. In plays like *The Kitchen*, *The Journalists* and *Badenheim 1939* he puts vast social groups on stage. But he is equally at home in chamber pieces in which the nuclear family or gatherings of friends echo the concerns of the wider world. And in his most recent play, *Phoenix, Phoenix Burning Bright*, he comes closer than ever before to laying out his personal philosophy: that, for all the bankrupt materialism, inflexible dogma and potential anarchy of the modern world, life is still infinitely precious. Wesker explores his ideas through a weekend in the Cambridgeshire countryside: a Jewish art history professor and his wife come to visit a pair of old Danish friends whose marriage is visibly rocky. On the surface, there is little external action: meals are eaten, music is played, ideas are exchanged. But, underneath the bland routine of affluence, relationships shift and fears about the precariousness of existence expressed. And when Raphael, the art history professor, cups his hands and shouts to the wide-open Cambridgeshire spaces, "all ideology is anti-social" you feel he is speaking for Wesker as well as himself.

It is a potent reminder of the journey Wesker himself has undergone as a political dramatist. In *Chicken Soup With Barley* there is a residual sympathy with the unrepentantly socialist matriarch, Sarah Kahn, who announces "If you don't care, you'll die." Having spent much of his theatrical life dissecting failed Utopian dreams, Wesker now seems wary of imprisoning doctrines and emerges as a passionate and eloquent standard-bearer for liberal humanism. And, given the history he has lived through, who is to say he is wrong?

Michael Billington

CHIPS WITH EVERYTHING

TO JOHN DEXTER
who has helped me to understand the theatre of my plays and
directed them when most others said they would fail

Characters

Conscripts

ARCHIE CANNIBAL 239

WINGATE (CHAS) 252

THOMPSON (PIP) 276

SEAFORD (WILFE) 247

ANDREW McCLURE 284

RICHARDSON (GINGER) 272

COHEN (DODGER) 277

SMITH (DICKEY) 266

WASHINGTON (SMILER) 279

Officers

CORPORAL HILL

WING COMMANDER

SQUADRON LEADER

PILOT OFFICER

P.T. INSTRUCTOR, FLT SGT GUARD

NIGHT CORPORAL

FIRST CORPORAL

SECOND CORPORAL

AIRMAN

First performed at the Royal Court Theatre 27 April 1962, directed by John Dexter, designed by Jocelyn Herbert, with the following cast:

CORPORAL HILL Frank Finlay

239 CANNIBAL George Innes

252 WINGATE Colin Campbell

276 THOMPSON John Kelland

247 SEAFORD Laurie Asprey

284 McCLURE Alexander Balfour

272 RICHARDSON Colin Farrell

277 COHEN Hugh Futcher

266 SMITH John Bull

279 WASHINGTON Ronald Lacey

WING COMMANDER Martin Boddey

SQUADRON LEADER Robert Bruce

PILOT OFFICER Corin Redgrave

P.T. INSTRUCTOR FLT SGT Michael Goldie

RECRUIT Peter Kelly

NIGHT GUARD Bruce Heighley

FIRST CORPORAL Roger Heathcott

SECOND CORPORAL Michael Blackham

FIRST AIRMAN Michael Craze

SECOND AIRMAN Alan Stevens

(This production contained more cast than was scripted for.)

Act One

An R.A.F. hut.

Nine new conscripts enter. They are subdued, uncertain, mumbling. CORPORAL HILL appears at door, stocky, northern, collarless man. He waits till they notice him, which they gradually do till mumbling ceases, utterly – they rise to attention. After a long pause.

HILL: That's better. In future, whenever an N.C.O. comes into the hut, no matter who he is, the first person to see him will call out 'N.C.O.! N.C.O.!' like that. And whatever you're doing, even if you're stark bollock naked, you'll all spring to attention as fast as the wind from a duck's arse, and by Christ that's fast. Is that understood? (*No reply.*) Well is it? (*A few murmurs.*) When I ask a question I expect an answer. (*Emphatically.*) Is that understood!

ALL: (*Shouting.*) Yes, Corporal!

HILL: Anyone been in the Air Cadets? Any of the cadets? Anyone twenty-one or more then? Nineteen? (*Two boys, ANDREW and DICKEY, raise their hands. To one.*) Month you were born?

ANDREW: July, Corporal.

DICKEY: May, Corporal.

HILL: (*To DICKEY.*) You're senior man. (*To ANDREW.*) You're assistant. Shift your kit to top of hut. Not now – later.

> *HILL scrutinizes the rest. He lays his hand on the two smallest – DODGER and GINGER.*

These small boys, these two, they're my boys. They'll do the jobs I ask them when I ask them; not much, my fires each day, perhaps my bunk – my boys. But they won't do my polishing – I do that myself. No one is to start on them, no one is to bully

them, if they do, then they answer to me. (*Pause.*)
You can sit now.

> *Reads out list of names, each recruit rises and sits as
> called. Boys sit on their beds, waiting; HILL paces up
> and down, waiting his time. Then.*

Right, you're in the R.A.F. now, you're not at home.
This hut, this place here, this is going to be your
home for the next eight scorching weeks. This billet
here, you see it? This? It's in a state now, no one's
been in it for the last four days so it's in a state now.
(*Pause.*) But usually it's like a scorching palace!
(*Pause.*) That's the way I want it to be cos that's the
way it's always been. Now you've got to get to know
me. My name is Corporal Hill. I'm not a very happy
man, I don't know why. I never smile and I never
joke – you'll soon see that. Perhaps it's my nature,
perhaps it's the way I've been brought up – I don't
know. The R.A.F. brought me up. You're going to go
through hell while you're here, through scorching
hell. Some of you will take it and some of you will
break down. I'm warning you – some of you shall
end up crying. And when that happens I don't want
to see anyone laughing at him. Leave him alone,
don't touch him.

But I'll play fair. You do me proud and I'll play fair.
The last lot we 'ad 'ere 'ad a good time, a right time,
a right good scorching time. We 'ad bags o' fun,
bags o' it. But I will tear and mercilessly scratch the
scorching daylights out of anyone who smarts the
alec with me – and we've got some 'ere. I can see
them, you can tell them. I count three already, you
can tell them, by their faces, who know it all, the
boys who think they're GOOD. (*Whispered.*) It'll be
unmerciful and scorching murder for them – all.
Now, you see this wireless here, this thing with
knobs and a pretty light that goes on and off? Well
that's ours, our wireless for this hut, and for this hut
only because this hut has always been the best hut.
No other hut has a wireless. I want to keep that. I

like music and I want to keep that wireless. Some people, when they get up in the morning, first thing all they want to do is smoke, or drink tea – not me, I've got to have music, the noise of instruments.

Everyone's got a fad, that's mine, music, and I want to be spoilt, you see to it that I'm spoilt. Right, if there's anyone here who wants to leave my hut and go into another because he doesn't like this 'un, then do it now, please. Go on, pick up your kit and move. I'll let 'im. (*No movement.*) You can go to the Naafi now. But be back by ten thirty, cos that's bleedin' lights out. (*Moves to door, pauses.*) Anyone object to swearing? (*No reply. Exit.*)

 Stunned. A boy rushes in from another hut.

BOY: What's your'n say?

SMILER: (*Imitating.*) My name is Corporal Hill, I'm not a happy man.

BOY: (*Imitating a Scotsman.*) My name is Corporal Bridle – and I'm a bastard!

SCENE TWO

The Naafi.

One boy strumming a guitar.

WILFE: Dear mother come and fetch me
Dear mother take me home
I'm drunk and unhappy
And my virginity's gone.

My feet are sore and I'm weary
The sergeant looks like dad
Oh, a two bob bit would buy me a nip
And a Naafi girl in my bed.
Now Eskimo Nell has gone back to the land
Where they know how to – Eight weeks!
EIGHT STUPID WEEKS, MOTHER!

CHAS: I've left two girls at home, two of them, and I've declared passionate love to them both – both. Poor

girls, promised I'd marry them when it was all over. They'll miss me.

WILFE: Wouldn't be so bad if my mother could hear me, but she's as deaf as a bat.

PIP: Bats are blind.

WILFE: Oh dear me, bats are blind, deary, deary me fellows.

PIP: Look old son, you're going to have me for eight painful weeks in the same hut, so spend the next five minutes taking the mickey out of my accent, get it off your chest and then put your working-class halo away because no one's going to care – O.K.?

CHAS: Where are you from then?

PIP: My father is a banker, we idolize each other. I was born in a large country house and I'm scorching rich.

CHAS: You're going to do officer training then?

PIP: No! My father was also a general!

WILFE: Oh my father was a general
 And I'm a general's son
 But I got wise to the old. man's lies
 And kicked him up his you know, you
 know, you know, you know what I mean.
 Now Eskimo Nell has gone back to the land –
 EIGHT STUPID WEEKS, MOTHER!

SMILER: Give over, Wilfe, give over.

GINGER: Well roll on Christmas, roll on I say.

DODGER: So what then? You'll be back after four days, and then four more weeks of this –

GINGER: But I'll be married.

DODGER: You'll be what?

GINGER: I'm getting married two weeks from tomorrow –

CHAS: Bleedin' daft to get married. I got two girls back home, one's blonde and one's dark – it's the Jekyll and Hyde in me. Married? Bleedin' daft!

PIP: You mean you can actually think of better things to do than produce babies?

CHAS: You shut your classical mouth you, go away, 'oppit! 'Oppit or I'll lay you down. I haven't liked you from the start.

PIP: Oh sit down, there's a good boy, I wouldn't dream of fighting you.

SMILER: You don't mind being a snob, do you?

PIP: One day, when I was driving to my father's office, the car broke down. I could have got a taxi I suppose, but I didn't. I walked. The office was in the City, so I had to walk through the East End, strange – I don't know why I should have been surprised. I'd seen photographs of this Mecca before – I even used to glance at the *Daily Mirror* now and then, so God knows why I should have been surprised. Strange. I went into a cafe and drank a cup of tea from a thick, white, cracked cup and I ate a piece of tasteless currant cake. On the walls I remember they had photographs of boxers, autographed, and they were curling at the edges from the heat. Every so often a woman used to come to the table and wipe it with a rag that left dark streaks behind which dried up into weird patterns. Then a man came and sat next to me – WHY should I have been surprised? I'd seen his face before, a hundred times on the front pages of papers reporting a strike. A market man, a porter, or a docker. No, he was too old to be a docker. His eyes kept watering, and each time they did that he'd take out a neatly folded handkerchief, unfold it and, with one corner, he'd wipe away the moisture, and then he'd neatly fold it up again and replace it in his pocket. Four times he did that, and each time he did it he looked at me and smiled. I could see grains of dirt in the lines of his face, and he wore an old waistcoat with pearl buttons. He wasn't untidy, the cloth even seemed a good cloth, and though his hair was thick with oil it was clean. I can even remember the colour of the walls, a pastel pink on the top half and turquoise blue on the bottom, peeling. Peeling in fifteen different places; actually, I counted them. But

what I couldn't understand was why I should have been so surprised. It wasn't as though I had been cradled in my childhood. And then I saw the menu, stained with tea and beautifully written by a foreign hand, and on top it said – God I hated that old man – it said 'Chips with everything'. Chips with every damn thing. You breed babies and you eat chips with everything.

Enter HILL.

HILL: I said ten thirty lights out, didn't I? Ten thirty I said. I want to see you move to that hut like wind from a duck's behind –

WILFE: And O Jesus mother, that's fast mother, that's eight weeks and that's fast!

HILL: That's fast, that's fast, into the hut and move that fast. Into the hut, into the hut, in, in, into the hut. (*Looks at watch. Pause.*) Out! I'll give you…

SCENE THREE

Parade Ground: morning.

HILL: Out! I'll give you sixty seconds or you'll be on a charge, one, two, three, four – come on out of that hut, twenty-five, twenty-six, twenty-seven, twenty-eight. AT THE DOUBLE! Now get into a line and stop that talking, get into a line. A straight line you heaving nig-nogs, a straight line.

This is the square. We call it a square bashing square. I want to see you bash that square. Right, now the first thing you've got to know, you've got to know how to come to attention, how to stand at ease and easy, how to make a right turn and how to step off.

Now to come to attention you move smartly, very smartly, to this position: heels together. STOP THAT! When I was born. I was very fortunate, I was born with eyes in the back of my neck and don't be cheeky. Legs apart and wait till I give the command SHUN. When I give the command SHUN, you will

move sharply, very sharply, to this position. Heels
together and in a line, feet turned out to angle of
thirty degrees, knees braced, body erect and with the
weight balanced evenly between the balls of the feet
and the heels.

Shoulders down and back level and square to the
front.

Arms hanging straight from the shoulders. Elbows
close to the sides.

Wrists straight.

Hands closed – not clenched.

Back of the fingers close to the thighs.

Thumbs straight and to the front, close to the
forefinger and just behind the seam of the trousers.
Head up, chin in, eyes open, steady and looking
just above their own height. Come on now, heels
together, body erect and evenly balanced between
the balls of the feet and the heels – you didn't know
you had balls on your feet did you – well you have,
use them.

Stand up straight there – keep your mouth shut and
your eyes open and to the front. Right, well, you are
now standing – somewhat vaguely – in the position
of the attention.

To stand at ease you keep the right foot still and
carry the left foot to the left so that the feet are
about – do it with me – so that the feet are about
twelve inches apart. At the same time force the
arms behind the back, keeping them straight, and
place the back of the right hand in the palm of the
left, thumbs crossed, fingers and hands straight
and pointing towards the ground. At the same fine
transfer the weight of the body slightly to the left so
as to be evenly balanced. Keep your arms straight
and don't bend at the waist. (*Inspects them.*) Right
hand inside your left, *your* left not his. Try to make
your elbows meet.

When you hear me give the command SQUAD, I want you to jump to that position, smarten up, as if you were going somewhere. We'll try it – stand easy, relax, just relax, but keep your hands behind your back, don't slouch, don't move your feet and don't talk – just relax, let your head look down, RELAX! IF YOU DON'T RELAX I'LL PUT YOU ON A CHARGE!

Squad, squad – SHUN! As you were, I want you to do it together.

Squad – SHUN! As you were. Squad – SHUN! STAND AT BASE!

To make a Right Turn: keeping both knees straight, turn through ninety degrees to the right swivelling on the heel of the right foot and the toe of the left raising the toe of the right and the heel of the left in doing so. Keeping the weight of the body on the right foot, on completion of this movement the right foot is flat on the ground, the left leg to the rear and the heel raised – both knees braced back and the body in the position of attention. Bring the left foot into the right, good and hard, and for the time being I want that left knee good and high, slam your foot in good and hard and keep still.

Squad, squad – SHUN.

Turning to the right – RIGHT TURN.

All right you creepy-crawly nig-nogs, moon men that's what you are, moon men. I want it done together. As you were. Squad, turning to the right – RIGHT TURN.

Now, to Step off. When I say by the front – quick march, I don't want your pretty left foot forward anyways, like this, no, it's got to be scorching smart, like a flash of greased lightning. ONE! Like this (*Petrified stance of a man about to step off.*) ONE! Like that, and I want that left hand up as high as you can get it and your right level with your breast pocket.

Now, on the word – MARCH – I want you only to
take a step forward, *not* to march. I want you only
to take a step forward, just pretend, got that? Some
dimwitted piece of merchandise is sure to carry on.
Now then, watch it. SQUAD – by the front – quick
MARCH!

> *Sure enough two boys march off and collide with
> those standing still, and one in the front marches off
> out of sight.*

Stop that laughing. I'll charge the next man I see
smile.

> *Stands, watching the other one disappear.*

All right, Horace, come back home. (*AIRMAN returns,
sheepishly.*)

You nit, you nit, you creepy-crawly nit. Don't you
hear, don't you listen, can't you follow simple orders,
CAN'T YOU? Shut up! Don't answer back! A young
man like you, first thing in the morning, don't be
rude, don't be rude. No one's being rude to you.

Stop that laughing. I'll charge the next man I see
smile. (*To SMILER.*) You, I said wipe off that smile. I
said wipe it off.

SMILER: I'm not smiling, Corporal, it's natural, I was born
with it.

HILL: Right then, don't ever let me see that face frown
or I'll haul you over the highest wall we've got.
(*Approaching one of the two marching ones.*) You. If
you'd been paying attention you might 'ave done it
correctly, eh? But you weren't, you were watching
the little aeroplanes, weren't you? You want to fly?
Do you want to reach the thundering heavens, my
little lad, at an earlier age than you imagined, with
Technicolor wings? KEEP YOUR EYES ON ME.
(*To all.*) You better know from the start, you can
have it the hard way or you can have it the easy
way, I don't mind which way it is. Perhaps you like
it the hard way, suits me. Just let me know. At ease
everyone. Now, we'll try and make it easier for you.

We'll count our way along. We'll count together, and
then maybe we'll all act together. I want everything
to be done together. We're going to be the happiest
family in Christendom and we're going to move
together, as one, as one solitary man. So, when I say
'attention' you'll slam your feet down hard and cry
'one'. Like this. And when I say 'right turn' you'll
move and bang your foot down and cry 'one-pause-
two'. Like this. Is that clear? Is that beyond the
intellectual comprehensibilities of any of you? Good!
SQUAD – wait for it – atten-SHUN!

SQUAD: ONE!

HILL: As you were, at ease. Did I say slam? Didn't I say
slam? Don't worry about the noise, it's a large
square, no one will mind. Squad – atten-SHUN.

SQUAD: ONE!

HILL: As you were. Let's hear that 'One'. Let's have some
energy from you. I want GOD to hear you crying
'ONE, ONE, ONE – pause TWO!' Squad – atten-
SHUN!

SQUAD: ONE!

HILL: Right TURN!

SQUAD: ONE – pause – TWO!

HILL: By the left – quick. – MARCH!

*The boys march off round the stage, sound of marching
and the chanting of 'One, One, One – pause – Two!
One, One, One – pause – Two!'*

SCENE FOUR

Sound of marching feet. Marching stops. The lecture hall.

*Boys enter and sit on seats. Enter – the WING COMMANDER,
boys rise.*

WING COMMANDER: Sit down, please. I'm your Wing Commander.
You think we are at peace. Not true. We are never at
peace. The human being is in a constant state of war
and we must be prepared, each against the other.

History has taught us this and we must learn. The
reasons why and wherefore are not our concern. We
are simply the men who must be prepared. You, why
do you look at me like that?

PIP: I'm paying attention, sir.

WING COMMANDER: There's insolence in those eyes, lad – I
recognice insolence in a man; take that glint out of
your eyes, your posh tones don't fool me. We are
simply the men who must be prepared. Already the
aggressors have a force far superior to ours. Our
efforts must be intensified. We need a fighting force
and it is for this reason you are being trained here,
according to the best traditions of the R.A.F. We
want you to be proud of your part, unashamed of
the uniform you wear. But you must not grumble
too much if you find that government facilities for
you, personally, are not up to standard. We haven't
the money to spare. A Meteor, fully armed, is more
important than a library. The C.O. of this camp is
called Group Captain Watson. His task is to check
any tendency in his officers to practical jokes, to
discountenance any disposition in his officers to
gamble or to indulge in extravagant expenditure; to
endeavour, by example and timely intervention, to
promote a good understanding and prevent disputes.
Group Captain Watson is a busy man, you will
rarely see him. You, why are you smiling?

SMILER: I'm not, sir, it's natural. I was born like it.

WING COMMANDER: Because I want this taken seriously, you know,
from all of you. Any questions?

WILFE: Sir, if the aggressors are better off than us, what are
they waiting for?

WING COMMANDER: What's your name?

WILFE: 247 Seaford, sir.

WING COMMANDER: Any other questions?

Exit. Enter SQUADRON LEADER. The boys rise.

SQUADRON LEADER: Sit down, please. I'm your squadron leader. My task is not only to ensure respect for authority, but also to foster the feelings of self-respect and personal honour which are essential to efficiency. It is also my task to bring to notice those who, from incapacity or apathy, are deficient in knowledge of their duties, or who do not afford an officer that support which he has a right to expect- or who conduct themselves in a manner injurious to the efficiency or credit of the R.A.F. You are here to learn discipline. Discipline is necessary if we are to train you to the maximum state of efficiency, discipline and obedience. You will obey your instructors because they are well trained, you will obey them because they can train you efficiently, you will obey them because it's necessary for you to be trained efficiently. That is what you are here to learn: obedience and discipline. Any questions? Thank you.

Exit. Enter PILOT OFFICER. The boys rise.

PILOT OFFICER: Sit down please. I'm your pilot officer. You'll find that I'm amenable and that I do not stick rigidly to authority. All I shall require is cleanliness. It's not that I want rigid men, I want clean men. It so happens, however, that you cannot have clean men without rigid men, and cleanliness requires smartness and ceremony. Ceremony means your webbing must be blancoed, and smartness means that your brass – all of it – must shine like silver paper, and your huts must be spick and span without a trace of dust, because dust carries germs, and germs are unclean. I want a man clean from toe nail to hair root. I want him so clean that he looks unreal. In fact I don't want real men, real men are dirty and nasty, they pick their noses – and scratch their skin. I want unreal, superreal men. Those men win wars, the others die of disease before they reach the battlefields. Any questions? You, what are you smiling at?

SMILER: I'm not, sir, it's natural. I was born like that.

PILOT OFFICER: In between the lines of that grin are formed battalions of microbes. Get rid of it.

SMILER: I can't, sir.

PILOT OFFICER: Then never let me hear of you going sick.

Exit. Enter P.T. INSTRUCTOR, FLIGHT SERGEANT.

P.T.I: As you were. I'm in charge of physical training on this camp. It's my duty to see that every minute muscle in your body is awake. Awake and ringing. Do you hear that? That's poetry! I want your body awake and ringing. I want you so light on your feet that the smoke from a cigarette could blow you away, and yet so strong that you stand firm before hurricanes. I hate thin men and detest fat ones. I want you like Greek gods. You heard of the Greeks? You ignorant troupe of anaemics, you were brought up on tinned beans and television sets, weren't you? You haven't had any exercise since you played knock-a-down-ginger, have you? Greek gods, you hear me? Till the sweat pours out of you like Niagara Falls. Did you hear that poetry? Sweat like Niagara Falls! I don't want your stupid questions!

Exit.

PIP: You have babies, you eat chips and you take orders.

CHAS: Well, look at you then, I don't see you doing different.

They march off. Sound of marching feet.

SCENE FIVE

Sound of marching feet and the men counting. The hut. Billet inspection. ANDREW, the hut orderly, tidying up. Enter the PILOT OFFICER.

ANDREW: (*Saluting.*) Good Morning, sir.

PILOT OFFICER: Haven't you been told the proper way to address an officer?

ANDREW: Sorry sir, no sir, not yet sir.

PILOT OFFICER walks around. ANDREW follows awkwardly.

PILOT OFFICER: There's dust under that bed

ANDREW: Is there, sir?

PILOT OFFICER: I said so.

ANDREW: Yes, you did, sir.

PILOT OFFICER: Then why ask me again?

ANDREW: Again, Sir?

PILOT OFFICER: Didn't you?

ANDREW: Didn't I what, sir?

PILOT OFFICER: Ask me to repeat what I'd already said. Are you playing me up, Airman? Are you taking the mickey out of me? I can charge you, man. I can see your game and I can charge you.

ANDREW: Yes, you can, sir.

PILOT OFFICER: Don't tell me what I already know.

ANDREW: Oh, I wouldn't, sir – you know what you already know. I know that, sir.

PILOT OFFICER: I think you're a fool, Airman. God knows why the Air-Ministry sends us fools. They never select, select is the answer, select and pick those out from the others.

ANDREW: What others, sir?

PILOT OFFICER: Don't question me!

ANDREW: But I was only thinking of –

PILOT OFFICER: You aren't paid to think, Airman, don't you know that? You aren't paid to think. (*Long pause.*) No, it's no good trying that line. (*Sits.*) Why pretend? I don't really frighten you, do I? I don't really frighten you, but you obey my orders, nevertheless.

It's a funny thing. We have always ruled, but I suspect we've never frightened you. I know that as soon as I turn my back you'll' merely give me a V sign and make a joke of me to the others, won't you? And they'll laugh. Especially Thompson. He knows you're not frightened, that's why he's in the ranks.

But I'll break him. Slumming, that's all he's doing, slumming. What's your name?

ANDREW: Andrew McClure, sir.

PILOT OFFICER: I don't suppose Thompson's really slumming. There *is* something about you boys, confidence, I suppose, or cockiness, something trustworthy anyway. I can remember enjoying the Naafi more than I do the Officers' Mess. What was your job?

ANDREW: Electrician, sir.

PILOT OFFICER: My father was an electrician. He used to play the piano. He really played beautifully. Tragic – my God – it was tragic.

ANDREW: Had an accident, sir?

PILOT OFFICER: That would be your idea of tragedy, wouldn't it? My father never had that sort of accident; he couldn't, he owned the factory he worked for. It's the other things that happen to people like him. The intangible accidents. No, his fingers remained subtle till he died, and he touched the keys with love whenever he could, but no one heard him. That was the tragedy, Andrew. No one heard him except four uncaring children and a stupid wife who saw no sense in it. God, Andrew, how I envied that man. I could have bought so much love with that talent. People don't give love away that easily, only if we have magic in our hands or in our words or in our brush then they pay attention, then they love us. You can forget your own troubles in an artist's love, Andrew; you can melt away from what you were and grow into a new man. Haven't you ever wanted to be a new man? (*Places hand on MCCLURE's knee in a friendly gesture.*)

ANDREW: Don't do that, please, sir.

PILOT OFFICER: (*Contemptuous that his friendly gesture was misread.*) Don't ever rely on this conversation, don't ever trust me to be your friend. I shall not merely frighten you, there are other ways – and you will need all your

pity for yourself. I warn you not to be fooled by good nature, we slum for our own convenience.

Enter a FLIGHT SERGEANT.

FLIGHT SERGEANT: When is – I beg your pardon, sir.

PILOT OFFICER: You can take over now, Flight. (*Exit.*)

FLIGHT SERGEANT: When is this place going to be straight?

ANDREW: Pardon, Sergeant?

FLIGHT SERGEANT: *Flight* Sergeant!

ANDREW: Sorry, FLIGHT Sergeant.

FLIGHT SERGEANT: When is this place going to be straight, I asked?

ANDREW: I've just straightened it, Serg – er Flight – er Flight Sergeant.

FLIGHT SERGEANT: You what? If I come in here tomorrow and I can't eat my dinner off that floor I'll have you all outside on fatigues till midnight. Have you got that?

ANDREW: Yes, Flight Sergeant.

FLIGHT SERGEANT: Well, keep it. Tight! Tight! Tight, tight –

> *'Tight, tight, tight', mixes to sounds of marching feet, men counting.*

SCENE SIX

The billet at night. The boys are tired. Beds are being made, brasses, shoes, webbing attended to.

ANDREW: And then he says: 'I shall not merely frighten you, there are other ways, and you will need all your pity for yourself.' Man, I tell you it was him was frightened. A tall meek thing he is, trying to impress me.

HILL: It's not him you want to be frightened of, it's royalty. Royalty! I hate royalty more than anything else in the world. Parasites! What do they do, eh? I'm not in this outfit for them, no bloody fear, it's the people back 'ome I'm here for, like you lot. Royalty –

PIP: Good old Corporal Hill, they've made you chase red-herrings, haven't they?

ANDREW: And he had something to say about you too, Pip Thompson. He said you were slumming, laddie, slumming; he said: 'Thompson knows you're not frightened, that's why he's in the ranks – but he's slumming'.

PIP: So he thinks you're not frightened? He's right – you're not, are you? But there *are* other ways – he's right about that too.

DODGER: You know, I've been looking at this hut, sizing it up. Make a good warehouse.

GINGER: A good what?

DODGER: Warehouse. It's my mania. My family owns a pram shop, see, and our one big problem is storage. Prams take up room, you – know. Always on the look-out for storage space. Every place I look at I work out the cubic feet, and I say it will make a good warehouse or it won't. Can't help myself. One of the best warehouses I ever see was the Vatican in Rome. What you laughing at? You take a carpenter – what does he do when he enters – what does he do when he enters a room, eh? Ever thought about that? He feels how the door swings open, looks straight across to the window to see if the frame is sitting straight and then sits in the chair to see if it's made good – then he can settle down to enjoy the evening. With me it's pregnant women. Every time I see pregnant women I get all maternal. You can have your women's breasts all you want and her legs. *Me,* only one spot interests me – one big belly and we've made a sale. Can't help it – warehouses and pregnant women.

DICKEY: Hey, Cannibal my dear associate, what are you so engrossed in?

CANNIBAL: It's a book about ideal marriage, now leave me be.

DICKEY: Why you dirty-minded adolescent you – put it away.

DODGER: Here, let's have a read.

He and some others crowd round to read on.

PIP: 252 WINGATE! – give me a hand with this bed, will you, please.

CHAS: Why I bloody help you I don't know, not at all I don't.

PIP: Because you like me, that's why.

CHAS: *Like* you*?* Like *you?* You're the lousiest rotten snob I know.

PIP: And you like snobs.

CHAS: Boy, I hate you so much it hurts. You can't even make a bed properly.

PIP: It was always made for me.

CHAS: There you go. See what I mean. Boasting of your bleedin' wealth and comfort. Well, I don't want to know about your stinking comforts, don't tell .me, I don't want to hear.

PIP: Oh, yes you do. You love to hear me talk about my home. We have a beautiful home, Charles, twenty-four rooms, and they're all large and thick with carpets.

CHAS: Modern?

PIP: No, built in the time of George III.

CHAS: I don't want to know.

PIP: They started to build it in 1776 when George Washington was made commander-in-chief of the American colonists and the greatgrandfathers of the Yanks were issuing the Declaration of Independence. A jubilant period, Charles – exciting. Did you know that while my great-great-grandfather was trading with the East India Company in the land of the strange chocolate people, bringing home the oriental spoils, the American grandfathers were still struggling to control a vast land at a time when there was no communication? But they didn't struggle long. Each time my greatgrandfather came home he. heard more bad news about those traitorous Americans. Returning from India in 1830, with a cargoof indigo, he heard, twenty-three years

after everyone else, that the steamboat had been invented. Terrible news. Returning in 1835 with a cargo of teak they told him about the strange iron horse that ran on wheels. Terrible, terrible, news. Returning in 1840 with a cargo of coriander he was so enraged that he refused to believe it possible to send messages through the air, and so he died without ever believing in the magic of telegraph. What do you think of that, Charles boy? Still, my favourite relative was his father, a beautiful boy, the kind of boy that every aunt wanted to mother and every cousin wanted to marry. The only thing was he was incredibly stupid, much more than you, Charles, and strangely enough he was called Charles also. My family talk about him to this very day. You see, the fact was that very few people ever realised he was so stupid because he was such a handsome boy and very rarely spoke. And because of his silence everyone thought he was very wise, and this was so effective that he increased our family fortune by double. (*Nearly everyone is listening to him by now.*) You want to know how? Well it was like this. Shortly after the shock of losing America, the English were disturbed by another event – another shock that rocked the whole of Europe and set my family and all their friends shaking. One day, the French kings and princes found themselves bankrupt – the royalty and the clergy never used to pay any taxes, you see they left that on the shoulders of the middle class and the commoners, and yet they still managed to become bankrupt. So what did they do? They called a meeting of all the representatives of all the classes to see what could be done – there hadn't been such a meeting for over a century, what a party! What a mistake! because, for the first time in a long while, the commoners not only found a means of voicing their discontent over the paying of taxes, but they suddenly looked at themselves and realised that there were more of them than they ever imagined – and they weren't fools. Now, they

voiced themselves well, and so loudly that they won a victory, and not simply over the tax problem, but over a dozen and one other injustices as well. Big excitement, jubilation, victory! In fact, they found themselves so victorious and so powerful that they were able to cut off the heads of poor Louis XVI and Marie Antoinette and start what we all know as the French Revolution.

CHAS: What about Charlie, the silly one?

PIP: Patience, my handsome boy, don't hurry me. Now, my family had a lot of interest in France and its royalty, so they decided to send this beautiful boy out to see what was happening to their estates and fortunes. And do you think he did? Poor soul, he couldn't understand what the hell was happening. The royalty of all Europe was trembling because of what the French did to Louis and Marie, and he just thought he was being sent on a holiday. To this day we none of us know how he escaped with his life – but, not only did he escape with his life, he also came back with somebody else's life. A French princess! And would you believe it, she was also a simpleton, a sort of prototype deb with a dimple on her left cheek. Her family had given her all their jewels, thinking that no one would touch her, since she was so helpless, and indeed no one did. No one, that is, except our Charles. He met her on his way to Paris in a Franciscan monastery and asked her to teach him French. There were her relatives being beheaded one by one and there was she, chanting out the past tense of the verb 'to be'. You can guess the rest, within four weeks he was back in England with a lovely bride and four hundred thousand pounds' worth of jewellery. They built a new wing to the house and had seven children. The rooms glitter with her chandeliers, Charlie boy – and – well, just look at the way your mouth is gaping – you'll get lockjaw.

HILL: Don't you tell stories, eh? Don't you just. I bet you made that one up as you went along.

PIP: That's right, Corporal, the French Revolution was a myth.

CHAS: Tell us more, Pip, tell us more stories.

PIP: They're not stories, Charlie boy, they're history.

CHAS: Well, tell us more then.

PIP: What's the use?

CHAS: I'm asking you, that's what's the use. *I'm* asking *you*.

> *PIP picks up his webbing to blanco. The others withdraw and pick up what they were doing. CHARLIE is left annoyed and frustrated. HILL takes a seat next to the fire and plays a mouth-organ. In between sounds he talks.*

HILL: I was pleased with you lads today. You're coming on. When you did those last about turns I felt proud. You might even be better than the last lot we had. Know that? And by Christ that last lot were good. But there's one of you needs to buck up his ideas, shan't mention names.

SMILER: I try, Corporal.

HILL: Well, you want to try harder, my son. Look at you.

SMILER: I look at myself every day, Corporal.

HILL: That stupid smile of yours, if only you didn't smile so much. Can't you have an operation or something? I'll go bleedin' mad looking at that for another five weeks.

DODGER: Oh, my gawd, listen to this! Listen what it says here. 'Between two hundred and three hundred million spermatozoa are released at one time of which only one succeeds. in fertilizing the female ovum.' Jesus! All them prams!

GINGER: Give us a good tune, Corp, go on.

HILL: You're my treasure, aren't you, eh, Ginger lad? Don't know what I'd do without you. What shall I play for you, you name it, I'll play it.

GINGER: Play us the 'Rose of Tralee'.

HILL: You want the 'Rose of Tralee', my beauty? You shall
have it then.

> *CORPORAL HILL plays, the boys rest, work, write*
> *letters, and listen.*

GINGER: When's the Christmas Eve party?

DODGER: Tomorrow a week, isn't it?

HILL: Uh-huh.

> *Continue sound of mouth-organ – change to.*

SCENE SEVEN

The Naafi. Christmas Eve Party.

The rock-'n'-roll group play vigorously. The boys jiving,
drinking, and singing. Officers are present.

WING COMMANDER: Look at them. Conscripts! They bring nothing
and they take nothing. Look at them. Their wild
dancing and their silly words – I could order them
at this moment to stand up and be shot and they'd
do it.

SQUADRON LEADER: You're drinking too much, Sid.

WING COMMANDER: Civilians! How I hate civilians. They don't
know – what do they know? How to make money,
how to chase girls and kill old women. No order, no
purpose. Conscripts! They bring their muddled lives
and they poison us, Jack; they poison me with their
indifference, and all we do is guard their fat bellies.
I'd sacrifice a million of them for the grace of a
javelin Fighter, you know that?

SQUADRON LEADER: Don't let them see you scowl. Smile, man,
smile. It's a Christmas Eve party. We're guests here.

SMILER: (*To WILFE.*) Go and offer the Wing Commander a
drink, then, go on.

WILFE: Leave off, will you, man? All evening you have been
pestering me. What do I want to go giving officers
drinks for?

SMILER: Go up to him and say 'with the compliments of our hut, sir', go on.

WILFE: I'll pour a bottle on you soon if you don't leave off.

SMILER: Your fly button's undone.

WILFE: Where? Smiler, I'll bash you – you tantalize me any more this evening and I'll bash that grin right down to your arse, so help me, I will.

SMILER: Listen to him. Wilfe the warrior. Do you talk like this at home? Does your mummy let you?

WILFE: Now why do you talk to me like that? Why do you go on and on and on? Do I start on you like that? Take him away, will you boys, take him away and drown him.

SMILER: Go after one of them Naafi girls, go on, Wilfe. Go and find out if they're willing.

CANNIBAL: Naafi girls! Camp bloody whores, that's all they are.

DICKEY: Well, he's woken up. Cannibal has spoken, come on, me ole cocker, say more.

CANNIBAL: Who's for more drinks?

DICKEY: Good old Cannibal! He uttered a syllable of many dimensions. The circumlocircle of his mouth has moved. Direct yourself to the bar, old son, and purchase for us some brown liquid. We shall make merry with your generosity.

CANNIBAL: I don't know where he gets the words from. He lies in his bed next to me and he talks and he talks and he sounds like an adding-machine.

DICKEY: You're under-educated, my old son – you're devoid of knowledgeable grey matter. You should've gone to a technical school like me; we sat in study there and ate up books for our diluted pleasure. We developed voluble minds in that technical college and we came away equipped with data. Data! That's the ticket – the sum total of everything. Direct your attention to the bar I say, and deliver us of that inebriating liquid, my hearty.

CANNIBAL: Ask him what he means. Go on, someone! I don't know. He lies on his bed next to me and he talks and he mumbles and talks and he mumbles. One night he woke up and he shouted: 'Kiss me, Mother, kiss your dying son.'

DICKEY: You lie in your teeth, O dumb one. Buy the drinks.

CANNIBAL: And another night he crept up to me and he was crying. 'Let me in your bed,' he moaned, 'let me get near you, you're big and warm.'

DICKEY: You're lying, Cannibal. Don't let me hear more of your lies.

CANNIBAL: Shall I tell them how you pray at night?

> *DICKEY throws his beer over CANNIBAL and they fight.*

WING COMMANDER: Separate those men! Hold them! Stop that, you two, you hear me, an order, stop that! (*They are separated.*) Undisciplined hooligans! I won't have fighting in my camp. Is this the only way you can behave with drink in you? Is it? Show your upbringing in your own home where it grew but not here, you hear me? Not here! This is Christmas Eve. A party, a celebration for the birth of our Lord, a time of joy and good will. Show me good will then. I will not, will not, will not tolerate your slum methods here. This is a clean force, a clean blue force. Go to your huts, stay there, stay there for the rest of the evening and don't wander beyond ten feet of your door. Disobey that order and I shall let out the hell of my temper so hard that you'll do jankers the rest of your National Service.

> *DICKEY and CANNIBAL leave. On the way, DICKEY trips over, and CANNIBAL helps him to his feet.*

WING COMMANDER: They don't even fight seriously – a few loud words, and then they kiss each other's wounds. God give us automation soon.

SQUADRON LEADER: You suffer too much, Sid.

WING COMMANDER: Nonsense! And forget your theories about my unhappy childhood. Mine is a healthy and natural hatred.

SQUADRON LEADER: I haven't time to hate – it takes me all my time to organise them.

WING COMMANDER: Look at them. What are they? The good old working class of England. Am I supposed to bless them all the time for being the salt of the earth?

SQUADRON LEADER: They provide your food, they make your clothes, dig coal, mend roads for you.

WING COMMANDER: Given half the chance you think they would? For me? Look at them, touching the heights of ecstasy.

PIP: They're talking about us – the officers.

CHAS: What are they saying?

PIP: They're saying we're despicable, mean, and useless. That fight disturbed the Wing Commander – we upset him.

ANDREW: Don't say 'we' and imagine that makes you one of us, Pip.

PIP: Don't start on me, Andy, there's a good man.

ANDREW: Don't do us any favours.

PIP: I don't have to drop my aitches in order to prove friendship, do I?

ANDREW: No. No, you don't. Only I've known a lot of people like you, Pip. They come drinking in the pub and talk to us as though we were the salt of the earth, and then, one day, for no reason any of us can see, they go off, drop us as though that was another game they was tired of. I'd give a pension to know why we attract you.

WING COMMANDER: What do you know about that one, Jack, the one with the smart-alec eyes and the posh tones?

SQUADRON LEADER: Thompson? Remember General Thompson, Tobruk, a banker now?

WING COMMANDER: So that's the son. Thompson! Come here,
Airman.

PIP: Sir?

WING COMMANDER: Enjoying yourself?

PIP: Thank you, sir.

WING COMMANDER: Gay crowd, eh?

PIP: I imagined you would dislike conscripts, sir.

WING COMMANDER: I haven't met you before, Thompson; your
father impressed me but you don't.

PIP: Is that all, sir?

WING COMMANDER: I can have you, boy. I can really have
you – remember that.

CHAS: What'd he want, Pip, what'd he say?

PIP: He wouldn't dare. Yes, he would. He's going to test
you all. The old fool is really going to play the old
game. I wonder what method he'll choose.

WILFE: What d'you mean, old game, what old game?

PIP: How he hates you; he's going to make an
announcement. Listen how patronising he'll be.
Whatever happens, do as I tell you-don't question
me, just do as I tell you.

ANDREW: If you have a war with that man, Pip, don't use me
as fodder, I'm warning you.

PIP: Help, Andy, I'm helping, or do you want to be made
fools of?

WING COMMANDER: Silence everybody, your attention please,
gentlemen – Thank you. As you all know we
hoped, when we organised this gay gathering for
you, that we'd have a spot in the evening when
everyone would get up and do a turn himself. A
dirty recitation, or a pop song. I'm sure that there's
a wealth of native talent among you, and now is the
chance for you to display it in all its glory, while the
rest of us sit back and watch and listen. My officers
are always complaining of the dull crowds we get
in this camp, but I've always said no, it's not true,

they're not dull, just a little inhibited – you – er know what inhibited means, of course? So now's the time to prove them wrong and me right. You won't let me down, will you, lads? Who's to be first? Eh? Who'll start?

PIP: Very subtle, eh, Andy?

WILFE: Will someone tell me what's going on here? What's so sinister about a talent show?

WING COMMANDER: The first, now.

PIP: Bums, Andrew –

ANDREW: Bums?

PIP: Your bloody saint, the poet –

ANDREW: I know he's a poet but –

PIP: Recite him, man, go on, get up there and recite.

ANDREW: Recite what? I –

PIP: In your best Scottish accent now.

ANDREW: Hell, man (*Once there.*) I – er – Burns. A poem.

> *Recites it all, at first hesitantly, amid jeers, then with growing confidence, amid silence.*

> This ae nighte, this ae nighte,
> *Every nighte and alle,*
> Fire and fleet and candle-lighte,
> *And Christe receive thy saule.*

> When thou from hence away art past,
> *Every nighte and alle,*
> To Whinny-muir thou com'st at last;
> *And Christe receive thy saule.*

> If ever thou gavest hosen and shoon,
> *Every nighte and alle.*
> Sit thee down and put them on;
> *And Christe receive thy saule.*

> If hosen and shoon thou ne'er gav'st nane
> *Every nighte and alle,*
> The whinnes sall prick thee to the bare bane;
> *And Christe receive thy saule.*

> From Whinny-muir when thou art past,

> *Every nighte and alle,*
> To Purgatory fire thou com'st at last;
> *And Christe receive thy saule.*
>
> If ever thou gavest meat or drink,
> *Every nighte and alle,*
> The fire sail never make thee shrink;
> *And Christe receive thy saule.*
>
> If meat and drink you ne'er gav'st nane,
> *Every nighte and alle,*
> The fire will burn thee to the bare bane
> *And Christe receive thy saule.*
>
> This ae nighte, this ae nighte,
> *Every nighte and alle,*
> Fire and fleet and candlelight,
> *And Christe receive thy saule.*
>
> *Ovation.*

WING COMMANDER: Come now, something more cheerful than that. How about a song – something from Elvis Presley.

> *Band and boys begin pop, song.*

PIP: Not that, not now.

WING COMMANDER: Lovely, yes, that's it, let's see you enjoying yourselves.

PIP: Don't join in, boys – believe me and don't join in.

WILFE: What *is* this – what's going on here?

WING COMMANDER: Look at them – that's them in their element.

PIP: Can't you see what's happening, what he's thinking?

WING COMMANDER: The beer is high, they're having a good time.

PIP: Look at that smug smile.

WING COMMANDER: Aren't they living it up, just, eh? Aren't they in their glory?

PIP: He could lead you into a swamp and you'd go.

WING COMMANDER: Bravo! Bravo! That's the spirit! Make merry it's a festive occasion and I want to see you laughing. I want my men laughing.

> *Loud pop song. PIP moves to guitarist and whispers in his ear. Boy protests, finally agrees to sing 'The*

*Cutty Wren', an old peasant revolt song. Boys join in
gradually, menacing the officers.*

ALL: 'Where am you going?' said Milder to Malder,
 'We may not tell you,' said Festle to Fose
 'We're off to the woods,' said John the Red Nose,
 'We're off' to the woods: said John the – Red
 Nose

 'What will you do there?' said Milder to Malder.
 'We may not tell you,' said Festle to Fose.
 'We'll shoot the cutty wren,' said John the Red
 Nose,
 'We'll shoot the cutty wren,' said John the Red
 Nose,

 'How will you shoot him?' said Milder to
 Malder.
 'We may not tell you,' said Festle to Fose.
 'We've guns and we've cannons,' said John the
 Red Nose,
 'We've guns and we've cannons,' said John the
 Red Nose.

 'How will you cut her up?' said Milder to
 Malder.
 'We may not tell you,' said Festle to Fose.
 'Big hatchets and cleavers,' said John the Red
 Nose,
 'Big hatchets and cleavers,' said John the Red
 Nose.

 'How will you cook her?' said Milder to Malder.
 'We may not tell you,' said Festle to Fose.
 'Bloody great brass cauldrons,' said John the
 Red Nose,
 'Bloody great brass cauldrons,' said John the
 Red Nose.

 'Who'll get the spare ribs?' said Milder to
 Malder.
 'We may not tell you,' said Festle to Fose.
 'Give them all to the poor,' said John the Red
 Nose,

'Give them all to the poor,' said John the Red Nose.

WING COMMANDER: Quite the little leader, aren't you, Thompson? Come over here, I want a word with you in private. Stand to attention, do your button up, raise your chin – at ease. Why are you fighting me, Thompson? We come from the same side, don't we? I don't understand your reasons, boy – and what's more you're insolent. I have every intention of writing to your father.

PIP: Please do.

WING COMMANDER: Oh, come now. Listen, lad, perhaps you've got a fight on with your father or something, well that's all right by me, we all fight our fathers, and when we fight them we also fight what they stand for. Am I right? Of course I'm right. I understand you, boy, and you mustn't think I'm unsympathetic. But it's not often we get your mettle among conscripts – we need you. Let your time here be a truce, eh? Answer me, boy, my guns are lowered and I'm waiting for an answer.

PIP: Lowered, sir?

WING COMMANDER: You know.very well what I mean.

WING COMMANDER and OFFICERS leave.

HILL: Well, a right mess you made of that interview. If there's any repercussions in our Flight, if we get victimized cos of you, boy, I'll see you -

PIP: Don't worry, Corp, there won't be any repercussions.

CHAS: Well, what in hell's name happened – what was it all about?

SMILER: This party's lost its flavour – let's go back to the hut, eh? I've got a pack of cards – let's go back and play cards.

CHAS: (*Of PIP.*) Talk to him is like talking to a brick wall. PIP!

SCENE EIGHT

The Naafi.

PIP: You've got enemies, Charles boy. Learn to know them.

The others have gone.

CHAS: Enemies? I know about enemies. People you like is enemies.

PIP: What do *you* mean when you say that, Charles?

CHAS: Oh, nothing as clever as you could mean, I'm sure.

PIP: Come on, dear boy, we're not fighting all the time, are we? You mustn't take too much notice of the way I talk.

CHAS: You talk sometimes, Pip, and I don't think you know that you hurt people.

PIP: Do I? I don't mean to.

CHAS: And sometimes there's something about your voice, the way you talk – that – well, it makes me want to tell you things.

PIP: You were telling me about enemies you like.

CHAS: You're embarrassed.

PIP: You were telling me –

CHAS: Now why should I embarrass you?

PIP: – enemies you like.

CHAS: No, about people you liked who were enemies. There's a difference. I'm surprised you didn't see the difference.

PIP: Go on.

CHAS: Go on what?

PIP: What do you mean?

CHAS: Mean?

PIP: What you just said.

CHAS: Well, I said it. That's what it means.

PIP: Oh, I see.

CHAS: I do embarrass you, don't I?

PIP: A bit. Are you an only child, Charles?

CHAS: I got six brothers. You?

PIP: Four brothers.

CHAS: What I meant was people say things meaning to help but it works out all wrong.

PIP: You could have meant a number of things, I suppose.

CHAS: Words do mean a number of things.

PIP: Yes, Charles.

CHAS: Well, they do.

PIP: Mm. I'm not sure why we started this.

CHAS: Well, you said we got enemies, and I was saying –

PIP: Oh, yes.

CHAS: There, now you've lost interest. Just as we were getting into conversation you go all bored.

PIP: Don't nag at me, Charles.

CHAS: Charlie.

PIP: Oh, I can't call you Charlie – it's a stupid name.

CHAS: Now why did you have to say that? Making a rudeness about my name. Why couldn't you leave it alone. I want to be called Charlie. Why couldn't you just call me Charlie? No, you had to criticise.

PIP: All right, Charlie then! Charlie! If you don't mind being called Charlie you won't ever mind anything much.

CHAS: You're such a prig – I don't know how you can be such a barefaced prig and not mind.

PIP: I'm not a prig, Charles, that's so suburban – a snob perhaps but nothing as common as prig, please. Tell you what, I'm a liar.

CHAS: A liar?

PIP: Yes – I haven't got four brothers – I'm an only son.

CHAS: So am I.

PIP: You? Yes – I might've guessed. Poor old Charlie. Terrible, isn't it? Do you always try to hide it?

CHAS: Yes.

PIP: Not possible though, is it?

CHAS: No. Funny that – how we both lied. What you gonna do when they let us out of camp?

PIP: When is it?

CHAS: Next Friday.

PIP: Oh, go into the town, the pictures perhaps.

CHAS: Can I come?

PIP: Yes, I suppose so.

CHAS: Suppose so! You'd grudge your grandmother a coffin.

PIP: But I've just said you could come.

CHAS: Yes, dead keen you sounded.

PIP: Well, what do you want?

CHAS: Don't you know?

PIP: Oh, go to hell!

CHAS: I'm sorry, I take it back, don't shout. I'll come – thanks. (*Pause.*) If I was more educated you think it'd be easier, wouldn't it, between us?

PIP: What do you mean 'us'?

CHAS: Let me finish –

PIP: For God's sake don't start wedding me to you –

CHAS: Just let me –

PIP: And don't whine –

CHAS: You won't let me –

PIP: You are what you are – don't whine.

CHAS: Let me bloody finish what I was going to say, will you! You don't listen. You don't bloody listen.

PIP: I'm sorry –

CHAS: Yes, I know.

PIP: I'm listening.

CHAS: Oh, go to hell – you

PIP: I'm sorry, I take it back, don't shout, I'm listening.

CHAS: I didn't say *I* thought it'd be easier if I was more educated – I said *you'd* think it'd be easier, I thought *you'd* think, it. And I was just going to say I disagreed – then you jumped.

PIP: Yes, well, I thought – yes, well, you're right Charles, quite right. It's no good wanting to go to university –

CHAS: Facts, that's all it is..

PIP: Like me and work – manual labour. The number of intellectuals and artists who are fascinated by manual labour. Not me though, Charles. I haven't the slightest desire to use my brawn, prove myself a man, dirty my nails.

CHAS: And facts don't mean much to me either.

PIP: It's dull, repetitive, degrading.

CHAS: Intelligence counts, not facts. Stick your education, your university- Who cares why Rome was built.

PIP: Van Gogh with the miners; Hemingway, hunting.

CHAS: Even if I knew all about that it wouldn't make it any easier.

PIP: God, how I despise this yearning to be one of the toilers.

CHAS: I knew someone who used to wear a bowler cos he thought it made him look educated.

PIP: The dignity of labour!

CHAS: But it wouldn't make it any easier –

PIP: The beauty of movement!

CHAS: Not between us -

 They smile.

SCENE NINE

The hut.

SMILER: What shall it be – poker, pontoon?

WILFE: I'm for bed.

SMILER: 'I'm for bed', little boy is tired.

WILFE: You can go on man – nothing seems to affect you.

CANNIBAL: What happened? They kick you out too?

SMILER: We got sick – you game for poker?

DICKEY: The squalor overcame you, eh? Ah, well, welcome back to the delinquents.

Enter HILL.

HILL: Well, I've got a right bunch, haven't I, a real good crowd, that's a fact.

GINGER: Come off it, Corp – you know we're O.K. on the square.

DODGER: That's all that counts, isn't it, Corp?

HILL: My boys – even them, my own little boys let me down.

SMILER: It's poker, Corp, you playing?

HILL: I shan't say anything now because you're away home in two days – but when you come back it's rifle drill and bayonet practice – and that's tough, and if you slack – I'm warning you – no more easy life, it'll be back to normal for you all.

DODGER: Play us a tune, Corp.

HILL: You don't deserve no tunes – a kick up the arse you deserve, the lot, where it hurts, waken you up.

CHARLES, SMILER, PIP, arid DICKEY sit down to play. The others lie in their beds, and HILL plays the mouth-organ.

GINGER: There's a bloody great moon outside. Dodge, you seen it? With a whopping great halo.

DODGER: Nippy, too. Who wants some chocolate? My uncle has a sweet shop. (*Produces dozens of bars.*)

DODGER: Ginge, what trade you going to apply for?

GINGER: Driver – I'm going to get something our of this mob – it's going to cost them something keeping me from civvy street. Driving! I've always wanted to drive

– since I don't know how long. A six BHP engine, behind the wheel controlling it – nyaaaaaaarr. I dream about it. I dream I'm always in a car and I'm driving it, but I got no licence. I always know I've never driven a car, but somehow it comes easy to me and I've never got a ruddy licence. I'm always being chased by cops – and I keep dreaming it, the same dream. I got no licence, but I'm driving a car and the police are after me. What'll I dream about when I can drive a car, I wonder.

DODGER: You won't. Stands to reason you won't need to; when you got the real thing you don't pretend. How about some tea? Ginger, my cock, make some tea on the stove and we'll eat up these biscuits also.

CANNIBAL: Dreams is real you know, they may be pretending in your sleep, but they're real. I dreamt my girl was a prostitute once and when I see her next day she looked like one and I give her up.

DODGER: What's wrong with prostitutes? We need them, let's keep them I say. Nationalize them. Stuck in clubs like poor bleedin' ferrets.

WILFE: Don't it make you sick, eh? Don't it make you sick just – these eight weeks, these two years, the factory – all of it? Don't it make you just bleedin' sick? I SAID SICK, MOTHER, SICK! Poor dear, she can't hear a word.

Pause. Mouth-organ. Warm hut.

CANNIBAL: I'm going to get in that Radar Plotting lark. All them buttons, them screens and knobs. You have to learn about the stars and space for that.

DICKEY: That's astronomy, my fine fellow. The code of the heavens. Radar! Radar is the mystic digits of sound waves; you have to have an enlightened degree of knowledge for that. Cannibal, my son, you're not arrogant enough, not standard enough for that. But I could – oh yes, I could rise to the heights of radar. I've put in for that.

SMILER: I think I'll go into Ops. Bring the planes in. Operations calling D 17, are you receiving me, are you receiving me – over! D 17 calling flight-control, I'm receiving you – left jet gone, I said gone, think I'll have to make a forced landing, stand by for emergency. Nyaaaaaaah passssssssss, brrrrrrrrrr – we'll all learn a trade and then 'oppit – nyaaaaaaaaaa.

> *Pause.*

ANDREW: I like us. All of us, here now. I like us all being together here. In a way you know I don't mind it, anything. Old Corp and his mouth-organ – all of us, just as we are, I like us.

> *Pause. Mouth-organ. Warm hut.*

GINGER: We've run out of coke you know – water won't ever boil.

PIP: Then we'll pinch some.

DICKEY: What?

PIP: That's all right with you isn't it, Corp? You don't mind a little raiding expedition?

HILL: You think you'll get in the coke yard? You won't, you know, mate; there's a wire netting and a patrol on that.

PIP: We'll work out a plan.

CHAS: Oh, knock it off, Pip, we're all in bed soon.

PIP: Think we can't outwit them?

DODGER: You won't outwit them, mate, they've got it all tied up neat, not them, me old *lobus*. –

PIP: If you can't outwit them for a lump of coke, then they deserve to have you in here for a couple of years.

HILL: I know what you are, Thompson – you're an agent provocative.

WILFE: I'm game, how do we do it?

GINGER: We could snip the wire and crawl through.

PIP: No. We want to raid and leave no sign.

ANDREW: What do we put it in?

DICKEY: Buckets.

DODGER: Too noisy.

PIP: Buckets with sacking at the bottom. How high is the netting?

HILL: About six feet. You'll need a ladder.

WILFE: Take it from the fire hut near by.

CANNIBAL: What if there's a fire?

WILFE: Let it burn.

PIP: No, no risks. Efficient, precise, but humane. They happen to be the only qualities for absolute power. That's what we want – absolute success but without a price. Coke in ten minutes, with no one caught and no one but us the wiser. Trust me?

SCENE TEN

A large square of wire netting.

A GUARD walks round it. Boys are in the shadows.

PIP: Now watch him – he walks round slowly – we can make three moves for each round except the last one and that requires speed. I want the first three stages started and finished between the time he disappears round the first corner and before he turns the third. If he changes his course or hurries his step or does anything that means one of us is caught, then we all, all of us make an appearance. He can't cop the lot. Right? (*All exert.*)

> *GINGER dashes to wire, and places chair – dashes to other side of stage. PIP runs to chair, jumps up and over. DODGER runs to take chair away and joins GINGER. The GUARD appears and carries on round. DODGER runs back places chair. WILFE runs to chair with another, jumps on it, and drops chair into PIP's hands, runs off. DODGER runs on, and withdraws chair. The GUARD appears, and continues. DODGER runs on with chair again. ANDREW runs With*

buckets to chair, jumps up and passes them to PIP.
GINGER runs to take chair away. GUARD appears,
and continues. In like process, two buckets are returned
'full' of coke. In the last stage, PIP jumps back over
netting, leaving chair. GINGER and DODGER appear
with two stools. DICKEY dashes on to top of two stools,
leans over wire and reaches down for chair, which he
throws to ANDREW. DODGER and GINGER run off
with the two stools. GUARD appears and continues.
This scene can be, and has to be, silent, precise,
breathtaking, and finally very funny.

SCENE ELEVEN

The hut again.

Mouth-organ. DODGER pouring out tea, drinking, eating.
Silence.

DICKEY: Yes. Yes – very satisfactory. Very pleasing. I
wouldn't've thought we could do it.

CHAS: No more you wouldn't have done it without Pip.

DICKEY: Do I detect in young Charles the ineffable signs of
hero worship?

CHAS: You'll detect black and blue marks, that's what you'll
detect.

DICKEY: I think we've got a love affair in our midst.

CHAS: Just because I respect a man for his nerve? You gone
daft?

DICKEY: No, I think my mental balance is equilibralized,
it's you I fear for my Charlie boy. First you start off
baiting young Thompson here and now you can't
take your eyes off him.

PIP: Don't act the goat, Dickey.

DICKEY: I'm correct in my observations though aren't I, Lord
Thompson?

PIP: No observation you make is correct, Dickey, you just
remember other people's.

DICKEY: But you have a marvellous mind, don't you?

CHAS: He has.

DICKEY: Now there's a question. Would we have pinched the coke without Pip's mind?

HILL: You always need leaders.

PIP: (*Ironically.*) Always!

HILL: Well, don't you always need leaders?

PIP: Always, always!

HILL: Yes, always, always?

PIP: Always, always, always! Your great-great-grandfather said there'll always be horses, your great-grandfather said there'll always be slaves, your grandfather said there'll always be poverty and your father said there'll always be wars. Each time you say 'always' the world takes two steps backwards and stops bothering. And so it should, my God, so it should –

WILFE: Easy, Airman, easy.

GINGER: Hey, Dodge – come and look outside now. Have you ever seen a halo as big as that! – look at it.

DODGER: Means frost.

ANDREW: *This* ae nighte, this ae nighte,
 Every nighte and alle,
 Fire and fleet and candle-lighte,
 And Christe receive thy saule.

SLOW CURTAIN

Act Two

SCENE ONE

The hut, dark early morning. Enter night GUARD.

GUARD: Hands off your cocks and pull up your socks, it's wake to the sun and a glorious day. (*Pulls off blankets of one near by.*) Rise, rise, rise and shine – Christmas is over. CHRISTMAS IS OVER.

> *Exit.*

> *There have been moans and movements. Return to silence. Enter HILL. Pause.*

HILL: CHRISTMAS IS OVER, he said.

> *Moans and movements.*

It's over, done, finished. You're 'ome. You're 'ome again and it's rifles today. Rifles and a stricter routine. You've been slacking. I've warned you and told you and today is judgement day, especially for you, Smiler – today is especially judgement day for you. You too, Airmen Wilfe Seaford, and Archie Cannibal, you shan't be passed. I intend making you the smartest squad in the glorious history of flying – and I will. But you – A/C2 Thompson – you're too good for me, too smart. The Wing Commander and all the officers in charge of this camp have got their guns on you and they're aiming to throw the book at you – the whole, heavy scorching book, so you beware and guard your mouth. I've heard, I know – so guard your mouth. CHRISTMAS IS OVER.

> *Exits.*

WILFE: Christmas is over and don't we know it. Rouse, yourself, Smiler, or you'll get us all in the cart.

SMILER: Leave off.

WILFE: Rouse yourself, I say – I aren't suffering cos of you. Get up or I'll turn you under your bed.

No reply. WILFE does so. SMILER rises from under the rubble and angrily fights with WILFE till separated by others.

ANDREW: Cut it out or I'll lay you both.

DICKEY: It's the basic animal rising to undiluted heights in them. A nasty morning, my boys, a nasty morning, nasty tempers, and a nasty undiluted life.

CANNIBAL: And you can shut your undiluted mouth for a start, too. I'm not stomaching you the rest of the time.

DICKEY: What side of the bed did you rise from?

CANNIBAL: I'm fit for you, so don't worry.

Enter HILL with rifles.

HILL: Come and get them. Don't grab them, don't drop them, and don't lose them. We start with them first thing after breakfast and I intend to train you so hard that you'll not be happy unless they're in bed with you.

Exit. Immediately, half the boys start playing cowboys and Indians, dropping behind beds and crawling on the floor, firing them at each Other, 'BANG. BANG.' Enter HILL.

The next man to pull that trigger, his feet won't touch the ground.

SMILER clicks one unintentionally.

You – I've wanted to pounce on you, Smiler.

SMILER: It slipped, Corp – an accident.

HILL: You say accident, I say luck. I'm charging you, Smiler, just a little charge, a few days' jankers to start with – that's all.

PIP: Why don't you charge us all, Corporal?

HILL: YOU SHUT UP. You, I've warned. All of you, I've warned. The joke's over, the laughing's done. Now get ready. (*Exit.*)

DODGER: We used to have a master who'd crack a joke, and then look at his watch to see we didn't laugh too long.

HILL: All right, get fell in, the lot of you.

SCENE TWO

The parade ground.
The men in threes.

HILL: The first thing is – not to be afraid of it. It won't
hurt you and if you handle it correctly you can't
hurt it. (*Only one boy laughs.*) I know you think they're
nice toys. With one of them in your hand you feel
different, don't you, you feel a man, a conquering
bloody hero? You want to run home and show your
girl, don't you? Well, they're not toys – you can kill a
man wi' one o' them. Kill 'im! Your napkins are still
wet – you don't really understand that word 'kill', do
you? Well, *you* can be killed. There! Does that bring
it home to you? A bullet can whip through your
flesh and knock breath out of *you*. Imagine yourself
dying, knowing you're dying, you can feel the hole
in your body, you can feel yourself going dizzy, you
can feel the hot blood, and you can't breathe. You
want to breathe but you can't, the body you've relied
on all these years doesn't do what you want it to do,
and you can't understand it. You're surprised, you're
helpless, like those dreams where you're filling –
only dying isn't a dream because you know, you
know, you know that you're looking at everything
for the last time and you can't do a bloody thing
about it, that's dying. And that's a rifle. So don't let
me catch anybody aiming it at anybody – loaded
or not. Now, you hold it here, just below the barrel,
pushing it out slightly to the right and forward,
with the butt tucked well in at the side of your feet
– so – well in firm, straight, at ease – and at the
command to 'shun' I want that rifle brought smartly
in at the precisely same moment. So. Attenshun!
Together, and your hand holding firmly on to that
rifle. I don't want that rifle dropped – drop that rifle

and I want to see you follow it to the ground. Right. Squad – atten-shun!

SQUAD: One!

> *SMILER drops gun.*

HILL: Leave it! Smiler, you nasty squirming imbecile! Can't you hear me? Can't you hear anything? Don't anything go through your thick skull? Look at you. Slob! Your buttons, your blanco, your shoes – look at them. They're dull. You're dull! You're like putty. What keeps you together, man? You're like an old Jew – you know what happens to Jews? They go to gas chambers. Now pick it up. Squad – atten-shun!

SQUAD: One!

HILL: Now to slope and shoulder arms, you make three movements. Watch me, follow me and you won't make a mess of it. I'll do it slowly and I'll exaggerate the movements. Shoulder ARMS! One pause, two pause, three. Slope ARMS! One pause, two pause, three. Again (*Repeats.*) Now – you do it. Squad! Shoulder ARMS!

SQUAD: One pause, two pause, three.

HILL: Slope ARMS!

SQUAD: One pause, two pause, three.

> *Repeats order.*

HILL: You're no good, Smiler, you're no good. Shoulder ARMS! Smiler, one pace forward march. The rest, about turn. By the left, quick march.

> *The squad march off, all except SMILER. The wall of the guardroom drops into place as scene changes to.*

SCENE THREE

The guardroom.

SMILER at the slope. Enter HILL and two other corporals.

FIRST CORPORAL: This him?

HILL: That's him.

SECOND CORPORAL: What's your name, lad?

SMILER: Smiler.

SECOND CORPORAL: I said your name, lad.

SMILER: 279 A/C2 Washington, Corporal.

FIRST CORPORAL: Washington, is it? You mustn't lie then, ha-ha! If you mustn't lie, then tell us, is your mother pretty? Is she? Answer me, lad. Do you know it's dumb insolence not to answer an N.C.O.? We'll make that six day's jankers, I think. Answer me, lad.

SMILER: Yes. She was.

FIRST CORPORAL: Have you ever seen her undressed? Eh? Have you, lad? Have you seen her naked?

SECOND CORPORAL: Wipe that smile off your face, lad.

SMILER: I'm not smiling, Corporal, it's natural, I was born like it.

FIRST CORPORAL: Arguing with an N.C.O. We'll make that nine days' jankers.

HILL: All right Smiler, order arms, slope arms, order arms, slope arms, slope arms, slope arms.

The two CORPORALS walk round him.

FIRST CORPORAL: You're a slob, Smiler.

SECOND CORPORAL: A nasty piece of work.

FIRST CORPORAL: You're no good, lad.

SECOND CORPORAL: No good at all. You're an insult.

FIRST CORPORAL: Your mother wasted her labour.

SECOND CORPORAL: Your father made a mistake.

FIRST CORPORAL: You're a mistake, Smiler.

SECOND CORPORAL: A stupid mistake.

FIRST CORPORAL: The Queen doesn't like mistakes in her Air Force.

SECOND CORPORAL: She wants good men, Smiler, men she can trust.

FIRST CORPORAL: Stand still, boy. Don't move. Silent, boy. Still and silent, boy.

HILL: That'll do for a taster, Smiler. That'll do for the first
lesson. Tomorrow we'll have some more. We'll break
you, Smiler, we'll break you, because that's our job.
Remember that, just remember now – remember
– About TURN! By the left – quick march, eft – ite,
eft – ite. Remember, Smiler, remember.

 Exit.

SCENE FOUR

WING COMMANDER's office.

*With him at a table are SQUADRON LEADER and PILOT
OFFICER.*

WING COMMANDER: Just remember who we're dealing with –
remember that. I don't want a legal foot put wrong
– I just want him broken in.

PILOT OFFICER: Not broken in, sir, but loved – he's only lost
temporarily, for a short, natural time, that's all.

WING COMMANDER: Bloody little fool – sowing seeds of discontent
to semi-educated louts; what do they understand of
what he tells them?

SQUADRON LEADER: Gently, Sid, anger'll only make it easier for
him to be stubborn.

PILOT OFFICER: Leave it to me, sir, I think I know how to do it, I
think I know the boy very well.

WING COMMANDER: I know the boy, by Christ I know him, I've
known them all and I've broken them all.

 HILL marches PIP into the room and goes.

PIP: You called me to see you, sir.

WING COMMANDER: Take your hat off blast you, Thompson, take it
off, lad, in front of an officer.

SQUADRON LEADER: Please sit down, won't you, Thompson, sit
down and be at ease for a little while; we'd simply
like a chat with you.

WING COMMANDER: Your square bashing is coming to an end. We're concerned about you. We have to find you something to do. It has to be decided now.

SQUADRON LEADER: I think, Wing Commander, if you'll excuse me, it would be more correct to say that Personnel must decide that in London, but we can recommend from here, isn't that the case? We are on the spot, so we can recommend.

PILOT OFFICER: We See, Thompson, that you've put down administration orderly as your first and only choice. A very strange choice.

WING COMMANDER: A damn fool choice, boy, your brains, your carriage and background, damn perversity!

SQUADRON LEADER: You know what administration orderly implies, don't you, son?

WING COMMANDER: Anything and everything – waste, absolute waste.

SQUADRON LEADER: Anything from dishwashing to salvage, from spud-bashing to coal-heaving.

 Pause.

PILOT OFFICER: Listen Pip, excuse me, sir?

WING COMMANDER: Yes, yes, carry on.

PILOT OFFICER: Let's drop the pretence. We're the same age and class, let's drop this formal nonsense. The Air Force is no place to carry on a family war, Pip. This is not a public school, it's a place where old boys grow into young men, believe me. Don't force me to start listing all your virtues and attributes. We're not flatterers, but don't let's be falsely modest either – that's understood between us, I'm sure. God, when I think of what I did to try and get out of coming into this outfit – two years wasted I thought. But waste is what you yourself do with time – come on man, if people like us aren't officers, then imagine the bastards they'll get. This is a silly game, Pip – why look, you're even sulking. Adman orderly! Can you see yourself washing dishes?

PIP: It might be a pretence to avoid responsibility.

PILOT OFFICER: You, Pip? Come now! It may be that you want to prove something to yourself. I don't know, why don't you tell us?

PIP: Your tactics are obvious, please don't insult my intelligence. I do not feel obliged to explain my reasons to you.

WING COMMANDER: You'll do what you're told.

PILOT OFFICER: It's not a question of obligation, no one's forcing –

PIP: I have no wish to –

PILOT OFFICER: But there's no one forcing you –

PIP: I said I have no wish to –

PILOT OFFICER: But-no-one-is-forcing-you –

PIP: I have no wish to explain anything to you I say.

Pause.

WING COMMANDER: Corporal Hill!

Enter HILL.

HILL: Sir?

WING COMMANDER: The men in your squad are slobs. Their standard is low and I'm not satisfied. No man passes out of my camp unless he's perfect – you know that. Pull them together, Corporal Hill, fatigues, Corporal Hill. They're a wretched bunch, wretched, not good enough.

HILL: Yes, Sir (*Exit from room.*)

All right, fall in, the lot of you.

Boys enter.

You're slobs, all of you. Your standard is low and I'm not satisfied. No man passes out of my hut unless he's perfect, I've told you that before. You're a wretched bunch – a miserable, wretched bunch, and since you're not good enough, it's fatigues for you all. Squad will double mark time.

They do so for one minute. Exeunt at the double. The inquisition resumes.

WING COMMANDER: Carry on, P.O.

PILOT OFFICER: Right, Thompson, I have some questions to ask you. I don't want clever answers. You wish to be an administration orderly?

PIP: That is correct, sir.

PILOT OFFICER: Doesn't it occur to you that that very act, considering who you are, is a little – revealing? It's a rather ostentatious choice, isn't it?

PIP: It could be viewed like that.

PILOT OFFICER: You enjoy mixing with men from another class. Why is this? Do you find them stimulating, a new experience, a novelty, do you enjoy your slumming?

PIP: It's not *I* who slum, sir.

PILOT OFFICER: I suppose you feel guilty in some way for your comfortable and easy upbringing; you feel you must do a sort of penance for it.

PIP: A rather outdated cause to be a martyr for, don't you think, sir?

PILOT OFFICER: Possibly, Thompson, possibly. You enjoy their company, though, don't you?

PIP: I enjoy most people's company.

PILOT OFFICER: Not ours, though.

PIP: Certain standards are necessary, sir.

PILOT OFFICER: A very offensive reply, Thompson – it's almost a hysterical reply – a little too desperately spoken, I would say. But look, we haven't stiffened, we aren't offended, no one is going to charge you or strike you. In fact we haven't really taken any notice. We listen to you, we let other people listen to you but we show no offence. Rather – we applaud you, flatter you for your courage and idealism but – it goes right through us. We listen but we do not hear, we befriend but do not touch you, we applaud but we do not act. To tolerate is to ignore, Thompson. You will not really become an administration orderly, will you?

PIP: What I have written, stays.

PILOT OFFICER: You will not be a foolish, stiff, Empire-thumping officer – no one believes in those any more. You will be more subtle and you will learn how to deal with all the Pip Thompsons who follow you. I even think you would like that.

PIP: What I have written stays. You may recommend as you please.

PILOT OFFICER: Yes, we shall put you up for officer training.

OFFICERS exeunt. Scene changes to

SCENE FIVE

The Square. A dummy is hanging. It is bayonet practice for the squad.

HILL: Even officers must go through this. Everyone, but everyone must know how to stick a man with a bayonet. The occasion may not arise to use the scorching thing but no man passes through this outfit till he's had practice. It's a horrible thing, this. A nasty weapon and a nasty way to kill a man. But it is you or him. A nasty choice, but you must choose. We had a bloke called Hamlet with us once and he had awful trouble in deciding. He got stuck! I don't want that to be your fate. So! Again, hold the butt and drop the muzzle – so. Lean forward, crouch, and let me see the horriblest leer your face can make. Then, when I call 'attack' I want to see you rush towards that old straw dummy, pause, lunge, and twist your knife with all the hate you can. And one last thing – the scream. I want to hear you shout your lungs out, cos it helps. A horde of screaming men put terror in the enemy and courage in themselves. It helps. Get fell in, two ranks. Front rank will assume the on-guard position – ON GUARD! Run, scream, lunge.

HILL demonstrates it himself. One by one, the men rush forward at the dummy, until it comes to PIP. He stands still.

I said attack. Thompson, you, that's you. Are you gone daft? I've given you an order – run, scream, you. Are you refusing to obey? A/C Thompson I have ordered you to use your bayonet. You scorching, trouble-making, long-haired, posh-tongued, lump of aristocracy – I'll high jump you, court-martial you. I'll see you rot in every dungeon in the force. Oh, thank your lucky stars this ain't the war, my lad; I'd take the greatest pleasure in shooting you. You still refuse? Right – you men, form up a line behind this man; I'll need you all for witnesses. A/C2 Thompson, I am about to issue you with a legitimate order according to Her Majesty's rules and regulations, Section ten paragraph five, and I must warn you that failing to carry out this order will result in you being charged under Section ten paragraph sixteen of the same book. Now, when I say attack, I want to see you lower your gun in the attack position and race forward to lunge at that dummy which now faces you. Is that order understood?

PIP: Yes, Corporal.

HILL: Good. I am now about to give the command. Wait for it and think carefully – this is only practice and no one can be hurt. Within ten seconds it will all be over, that's advice. Attack.

Silence. No movement.

Squad – slope ARMS! A/C Thompson – I'm charging you with failure to obey a legitimate order issued by an N.C.O. in command under Her Majesty's Air Force, and may God help you, lad.

All march off except THOMPSON.

SCENE SIX

Enter ANDREW.

ANDREW: Idiot.

PIP: You?

ANDREW: Who the hell is going to be impressed?

PIP: You, Andrew?

ANDREW: Yes, Andrew! I'm asking you – who the hell do you think, is going to be impressed? Not me. The boys? Not them either. I've been watching you, Pip – I'm not impressed and neither are they.

PIP: You don't really think I'm interested in the public spectacle, Andy, you can't? No, no I can see you don't. Go off now. Leave me with it – I've got problems.

ANDREW: No one's asking you to make gestures on our behalf.

PIP: Go off now.

ANDREW: Don't go making heroic gestures and then expect gratitude.

PIP: Don't lean on me, Andy – I've got problems.

ANDREW: I don't think I can bear your martyrdom – that's what it is; I don't think I can bear your look of suffering.

PIP: I'm not suffering.

ANDREW: I don't know why but your always-acting-right drives me round the bend.

PIP: I'm not a martyr.

ANDREW: It's your confident cockiness – I can't stand your confident cockiness. How do you know you're right? How can you act all the time as though you know all right from wrong, for God's sake.

PIP: Don't be a bastard jock.

ANDREW: I'm trying to help you, idiot. The boys will hate any heroic gesture you make.

PIP: Andy, you're a good, well-meaning, intelligent person. I will die of good; well-meaning, and

intelligent people who have never made a decision
in their life. Now go off and leave me and stop
crippling me with your own guilt. If you're
ineffectual in this world that's your look-out – just
stay calm and no one will know, but stop tampering
with my decisions. Let *them* do the sabotaging, they
don't need help from you as well. Now get the hell
out – they wouldn't want you to see the way they
work.

> *Exit ANDREW.*

SCENE SEVEN

PILOT OFFICER: It goes right through us, Thompson. Nothing you
can do will change that. We listen but we do not
hear, we befriend but do not touch you, we applaud
but do not act – to tolerate is to ignore. What did
you expect, praise from the boys? Devotion from
your mates? Your mates are morons, Thompson,
morons. At the slightest hint from us they will
disown you. Or perhaps you wanted a court martial?
Too expensive, boy. Jankers? That's for the yobs.
You, we shall make an officer, as we promised. I
have studied politics as well, you know, and let me
just remind you of a. tactic the best of revolutionaries
have employed. That is to penetrate the enemy and
spread rebellion there. You can't fight us from the
outside. Relent boy, at least we understand long
sentences.

PIP: You won't impress me with cynicism, you know.

PILOT OFFICER: Not cynicism – just honesty. I might say we are being
unusually honest – most of the time it is unnecessary
to admit all this, and you of all people should have
known it.

PIP: I WILL NOT BE AN OFFICER.

PILOT OFFICER: Ah. A touch of anger, what do you reveal now,
Thompson? We know, you and I, don't we?
Comradeship? Not that, not because of the affinity of

one human being to another, not that. Guilt? Shame because of your fellow beings' suffering? You don't feel that either. Not guilt. An inferiority complex, a feeling of modesty? My God. Not that either. There's nothing humble about you, is there? Thompson, you wanted to do more than simply share the joy of imparting knowledge to your friends; no, not modesty. Not that. What then? What if not those things, my lad? Shall I say it? Shall I? Power. Power, isn't it? Among your own people there were too many who were powerful, 'the competition was too great, but here, among lesser men – here among the yobs, among the good-natured yobs, you could be. KING. Supreme and all powerful, eh? Well? Not true? Deny it – deny it, then. We know – you and I – we know, Thompson.

PIP: Oh, God –

PILOT OFFICER:God? God? Why do you call upon God? Are you his son? Better still, then. You are found out even more, illusions of grandeur, Thompson. We know that also, that's what we know, that's what we have, the picture you have of yourself, and now that we know that, you're really finished, destroyed. You're destroyed, Thompson. No man survives whose motive is discovered, no man. Messiah to the masses! Corporal Hill! (*Exit.*)

HILL: (*Off stage.*) Sir?

SCENE EIGHT

Enter HILL.

HILL: I have instructions to repeat the order, Thompson. The powers have decided to give you another chance. I don't know why, but they know what they're doing, I suppose. When I give the order 'attack' I want you to lean forward, run, thrust, and twist that blade in the dummy. Have you understood?

PIP: Yes, Corporal.

HILL: Run, thrust and twist that blade – good. ATTACK.

PIP pauses for a long while, then with a terrifying scream he rushes at the dummy, sticking it three times, with three screams.

SCENE NINE

The hut.

CHARLES and PIP.

CHAS: What they say, Pip? What they want you for, what did they say? Hell, look at your face, did they beat you? Did they make you use the bayonet? They did, didn't they? I can tell it from your face. You're crying – are you crying? Want a cigarette? Here, have a cigarette. The others have all gone to the Naafi, it's New Year's Eve, gone for a big 'booze-up. Bloody fools – all they do is drink. I think I'll give it up, me. Well, what did they say, man – talk to me? You know why I didn't go to the Naafi – I was waiting for you. It seemed fishy them calling you in the evening, so I waited to see. Pip? I'm telling you I waited for you. I wanted to tell you something, I want to ask you a favour; I've been meaning all these last days to ask you this favour. You see – you know me, don't you, you know the sort of bloke… I'm – I'm not dumb, I'm not a fool, I'm not a real fool, not a bloody moron and I thought, well, I thought maybe you could, could teach me – something, anything. Eh? Well, not anything but something proper, real.

PIP: Ask someone else – books, read books.

CHAS: Not books! I can't read books, but I can listen to you. Maybe we'll get posted to the same place, and then every evening, or every other evening, or once a week, even, you could talk to me a bit, for half an hour say. Remember how you talked that night about your grandfathers, about all those inventions and things. Well, I liked that, I listened to that, I

could listen all night to that. Only I want to know about something else, I want to know about – I don't even know how to put it, about – you know, you know the word, about business and raw materials and people working and selling things – you know, there's a word for it –

PIP: Economics.

CHAS: Enocomics – that's it.

PIP: Economics not enocomics.

CHAS: Ee-mon-omics.

PIP: No, Ee –

CHAS: Ee

PIP: Con

CHAS: Con

PIP: Om

CHAS: OM

PIP: ICs

CHAS: ICS.

PIP: Economics.

CHAS: Economics. There, about that, could you? I'd listen, you could draw diagrams and graphs; I wasn't bad at maths.

PIP: Someone else, Charles, not me, someone else.

CHAS: There you go. You're a hypocrite – a hypocrite you are. You take people to the edge. Don't you know what I'm asking you, don't you know what I'm really asking you?

PIP: Ask someone else.

CHAS: But I want to be with you – I want to. Ah, you give me a pain in the neck, you do, you're a coward. You lead and then you run away. I could grow with you, don't you understand that? We could do things together. You've got to be with someone, there's got to be someone you can trust, everyone finds someone and I found you – I've never asked anyone before, Jesus, never –

PIP: Ask someone else.

CHAS: Someone else. Someone else. It's always someone else, you half-bake you, you lousy word-user you. Your bleedin' stuffed grandfathers kept us stupid all this time, and now you come along with your pretty words and tell us to fend for ourselves. You clever useless leftover you. Oh, you're cocky, aren't you – Ask someone else. The truth is – you're scared, aren't you? You call us mate, but you're a scared old schoolboy. The pilot officer was right, you're slumming. You're a bleedin' slummer –

PIP: And he also said 'we will listen to you-but we will not hear you, we will befriend you but not touch you, we will tolerate and ignore you'.

CHAS: Well, what did that mean?

PIP: We'll do anything they want just because they know how to smile at us.

CHAS: You mean *I'll* do what they want, not you, boy. You're one of them – you're just playing games with 'em, and us mugs is in the middle – I've cottoned on now. (*Long pause.*) I'll do what *you* want, Pip.

PIP: Swop masters? You're a fool, Charles, the kind of fool my parents fed on, you're a fool, a fool –

> *Fade in the sound of marching feet and the Corporals repeating the insults they heaped upon SMILER and change to*

SCENE TEN

A roadway.

SMILER has run away from camp. He is desperate, haggard and tired. Mix: 'You're a fool, Charles' to 'You're a slob, Smiler' A nasty piece of work' You're no good lad', etc., rising to crescendo –

SMILER: LEAVE ME ALONE! Damn your mouths and hell on your stripes – leave me alone. Mad they are, they're mad they are, they're raving lunatics

they are. CUT IT! STUFF IT! Shoot your load on
someone else, take it out on someone else, why do
you want to pick on me, you lunatics, you bloody
apes, you're nothing more than bloody apes, so
damn your mouths and hell on-your stripes! Ahhhhh
– they'd kill me if they had the chance. They think
they own you, think that anyone who's dressed
in blue is theirs to muck about, degrade. YOU
BLOODY APES, YOU WON'T DEGRADE ME!
Oh my legs – I'm going home. I'll get a lift and
scarper home. I'll go to France, I'll get away. I'LL
GET AWAY FROM YOU, YOU APES! They think
they own you – Oh my back. I don't give tuppence
what you say, you don't mean anything to me, your
bloody orders nor your stripes not your jankers
nor your wars. Stick your jankers on the wall, stuff
yourselves, go away and stuff yourselves, stuff your
rotten stupid selves – Ohh – Ohhh, Look-at the sky,
look at the moon, Jesus look at that moon and the
frost in the air. I'll wait. I'll get a lift in a second or
two, it's quiet now, their noise is gone. I'll stand and
wait and look at that moon. What are you made
of, tell me? I don't know what you're made of, you
go on and on. What grouses you? What makes you
scream? You're blood and wind like all of us, what
grouses you? You poor duff bastards, where are
your mothers? Where were you born – I don't know
what grouses you, your voices sound like dying hens
– I don't know. That bloody lovely moon is cold, I
can't stay here. I'll freeze to death. That's a laugh,
now that'd fool them. Listen! A bike, a motor-bike,
a roaring bloody motor-bike. (*Starts thumbing.*)
London, London, London, London, LONDON!
(*The roar comes and dies.*) You stupid ghet, I want a lift,
can't you see I want a lift, an airman wants a lift back
home. Home, you bastard, take me ho'ooooome.
(*Long pause.*) *Now* they'll catch me, now they'll come,
not much point in going on – Smiler boy, they'll
surely come, they're bound to miss you back at
camp – eyes like hawks they've got – God! Who

cares. 'Stop your silly smiling, Airman' – 'It's not a smile, Corp, it's natural, honest, Corp. I'm born that way. Honest Corp, it's not a smile…'

Enters hut.

SCENE ELEVEN

The hut.

CHARLES and PIP as we left them. SMILER is now with them.

SMILER: The bastards won't believe it's natural. Look at me, me!

> *A very broken SMILER stands there. SMILER turns to PIP for help. PIP approaches him and takes him gently in his arms. They sway a moment.*

Wash my feet for me.

> *SMILER collapses. PIP lays him on the ground. He is about to remove his shoes.*

CHAS: Leave him. I'll do it.

> *CHARLES doesn't know what to do to begin with. Surveys SMILER. Then – picks him up and lays him on his bed, looks at him; thinks; takes off his shoes and socks.*

His feet are bleeding.

> *Takes a towel and pours water from pot on it; washes SMILER's feet; a long unconscious moan from SMILER; clock strikes midnight; sound of boys singing 'Auld Lang Syne'. CORPORAL HILL's voice, loud.*

HILL: (*To stage.*) You pass out with the band tomorrow – rifles, buttons, belts, shining, and I want you as one man, you hear me? You'll have the band and it'll be marvellous; only you Smiler, you won't be in it, you'll stay behind a little longer, my lad – HAPPY NEW YEAR.

> *Silence. One by one the rest of the men come in, returning from the Naafi. They make no sound, but their movements are wild and drunk. No sound at*

all – like a TV with sound turned off, till they see
SMILER.

DODGER: Look at his feet. The rotten bastards, look at his feet.

ANDREW: What'd he do?

CHAS: Tried to hop it.

ANDREW: Couldn't make it?

CHAS: Walked for miles and then came back.

CANNIBAL: They had it in for him, you've got no chance when
they got it in for you.

GINGER: He's staying behind, you know? I reckon they'll
make him do another two weeks of this.

DICKEY: Give me the chance just give me one chance and I'd
have them. Five minutes in civvy street and I'd have
them chasing their own tails.

WILFE: Ah, you wouldn't, man – you talk like this now but
you wouldn't, and you know why? Cos you'd be just
as helpless there, you'd be just as much wind and
nothing there, man. 'Just gimme the boss,' you'd say,
'just gimme him for one hour in uniform and I'd
teach him what a man is.' That's all you'd say, civvy
street, the forces it's the same, don't give me that.

GINGER: What about Smile's stuff?

CANNIBAL: I'll do it.

CHAS: No, you won't, I'm doing it.

CANNIBAL: All right, all right, then. Blimey, what's gotten into
you? Jumping at me like that – I don't much want to
do my own buggers, let alone his. Takes all the guts
out of you, don't it. Look at him, lying there like a
bloody corpse. His feet-are cold.

DODGER: He's like a baby. Sweet as a sleeping baby. Have you
ever watched a baby sleep? It always looks as though
it's waiting for something to happen, a grown-up
seems to be hiding away but a nipper seems to trust
you, anyone. He's done it, ain'tee, eh? He's really
had it –

CHAS: For Christ's sake, give over – you talk like he was dead or something. Come on, help cover him.

As many as possible manoeuvre SMILER so that his jacket and trousers come off, with the least disturbance. This action is done lovingly and with a sort of ritual. DODGER takes a comb to SMILE's hair and CHARLES gently wipes a towel over his face. Then they tuck him in bed and stand looking at him. Unknown to them the PILOT OFFICER has been watching them.

PILOT OFFICER: Beautiful. Tender and beautiful. But I'm sorry, gentlemen, this man is needed in the guardroom.

Enter HILL.

HILL: Squad – shun!

The men slowly come to attention, except CHARLES, who, after a pause, moves to his bed and sits on it. One by one the other boys, except PIP, also sit on their beds in defiance.

PILOT OFFICER: Corporal – take that smiling airman to the guard-room.

CHAS: YOU'LL LEAVE HIM BE!

PILOT OFFICER: And take that man, too.

GINGER: You won't, Corporal Hill, will you?

PILOT OFFICER: And that man, take the lot of them, I'll see them all in the guardroom.

PIP: You won't touch any of them, Corporal Hill, you won't touch a single one of them.

PILOT OFFICER: Do you hear me, Corporal, this whole hut is under arrest.

PIP: I suggest, sir, that you don't touch one of them. (*PIP and the PILOT OFFICER smile at each other, knowingly, and PIP now begins to change his uniform, from an airman's to an officer's.*) We won't let him will we Charles – because you're right. Smiler has been badly treated and you are right to protect him. It's a good virtue that, loyalty. You are to be commended, Charles, all of you; it was a brave thing to do, protect a friend. We lack this virtue all too often, don't you

agree, sir? These are good men, sometimes we are
a little hasty in judging them – don't you agree, sir,
a little too hasty? These are the salt of the earth, the
men who make the country, really. Don't worry,
Charles, nor you, Ginger, nor you, Andrew – none
of you, don't worry, you shan't be harmed – it was
a good act. We like you for it, we're proud of you,
happy with you – you do agree, don't you, sir?
These are men we need and these are the men we
must keep. We are not hard men, Charles – don't
think ill of us, the stories you read, the tales you hear.
We are good, honest, hard-working like yourselves
and understanding; above all we are understanding,
aren't we, sir? There, that's a good fit, I think. (*The
PILOT OFFICER hands a list over to PIP. PIP reads out
the list.*)

PIP: 239 A/C2 Cannibal – (*CANNIBAL rises to attention.*)
administration orderly, posted to Hull. (*Stands at ease.
Same procedure for others.*)
252 A/C2 Wingate – administration orderly, posted
to Oxford.
247 A/C2 Seaford – administration orderly, Cyprus.
284 A/C2 McClure – typing pool, Malta.
272 A/C2 Richardson – administration orderly,
Aden.
277 A/C2 Cohen – administration orderly, Halton.
266 A/C2 Smith – administration orderly, Lincoln.
279 A/C2 Washington – put back three weeks to
flight 212 – decision of employ will be made at a
later date. Squad – Squad, SHUN.

 *Sudden loud sound of brass band playing the R.A.F.
 March Past.*

SCENE TWELVE

*Music of March Past. The Parade Ground. Passout Parade.
The men march into position. A flagpole is moved in.*

HILL: Squad atten-shun! Shoulder arms! Right turn! By
the left quick march! Lift your heads, raise them,

raise them high, raise them bravely, my boys. Eft
ite, eft ite, eft ite, eft. Slope that rifle, stiffen that
arm – I want to see them all pointing one way,
together – unity, unity. Slam those feet, slam, slam,
you're men of the Queen, her own darlings. SLAM,
SLAM! SLAM! Let her be proud. Lovely, that's
lovely, that's poetry. No one'll be shot today my
boys. Forget the sweat, forget the cold, together in
time. I want you to look beautiful, I want you to
move as one man, as one ship, as one solid gliding
ship. Proud! Proud! Parade, by centre, quick march,
saluting to the front.

> *Men salute to audience, return back to face WING
> COMMANDER. Music stops. WING COMMANDER on
> a rostrum. officers around him.*

WING COMMANDER: (*A long, broad, embracing smile.*) I am satisfied.
Good. Good men. One of the best bunch I've had
through my gates. Smart, alert, keen. Two years of
service in Her Majesty's Air Force lie ahead of you,
I am confident of the service you will give, you have
turned out well, as we expected, nothing else would
have done, just as we expected. God speed you.

> *GINGER comes to attention. Lays rifle on ground. Steps
> forward to flagpole and takes ropes in his hands.*

HILL: Parade about turn.

> *Men now facing audience again.*

SQUADRON LEADER: Parade, for colour hoisting. PRESENT ARMS!

> *GINGER very very slowly hoists the R.A.F. colours.
> Let it be a tall pole. 'The Queen' is played, and there
> is a slow curtain.*

THEIR VERY OWN AND GOLDEN CITY
A play in two acts and many scenes

TO MY DEAR FRIEND TOM MASCHLER

PREFACE TO REVISED EDITION

To Henryk Bering Liisberg[1], the director of the municipal theatre of the Danish city of Aarhus, and to his company of actors and technicians I owe an enormous debt of gratitude for giving me the facilities to direct this difficult play almost entirely as I wanted. No expense was spared.

In doing so I fell in love with the work again. Of course it's too ambitious, the theme belongs to the cinema, it stretches across more time and action than the theatre should properly handle. Yet I promise the reader it is worth struggling to read through the involved stage directions, for lumber though it does yet it lumbers with a daring we all found exhilarating.

After the London productions in which the director made the mistaken and crippling decision (with which I foolishly agreed.) to have one set of actors play both the old and young protagonists, I thought the play was irretrievably flawed. But with the help of the Danish actors and through the brilliant set of Hayden Griffen I came to understand the play better and to discover that, though it attempts too much, it is not *irretrievably* flawed. It *does* work.

I owe my discovery of this to the faith of

HENRYK BERING LIISBERG

to whom this new edition is dedicated.

London, 12 December 1980

1 Now Director General of the Royal Theatre, Copenhagen.

…and accordingly the Trade Unionists and their leaders who were once the butt of the most virulent abuse from the whole of the Upper and Middle classes are now praised and petted by them because they do tacitly or openly acknowledge the necessity for the master's existence; it is felt that they are no longer the enemy; the class struggle in England is entering into a new phase, which may even make the once dreaded Trade Unions allies of capital, since they in their turn form a kind of privileged group among the workmen; in fact they now no longer represent the whole class of workers as working *men* but rather as charged with the office of keeping the human part of the capitalists' machinery in good working order and freeing it from any grit of discontent…

Now that's the blind alley which the Trade Unions have now got into; I say again if they are determined to have masters to manage their affairs, they must expect in turn to pay for that luxury…remembering that the price they pay for their so-called captains of industry is no mere money payment – no mere tribute which once paid leaves them free to do as they please, but an authoritative ordering of the whole tenor of their lives, what they shall eat, drink, wear, what houses they shall have, books, or newspapers rather, they shall read, down to the very days on which they shall take their holidays – like a drove of cattle driven from the stable to grass.

WILLIAM MORRIS: *from a lecture*
on 'Socialism' given at the
Victoria Hall, Norwich, on
8 March 1886

The world premiere of Their Very Own and Golden City *was at the Belgian National Theatre in 1965. The first London presentation of the play opened on 19 May 1966 and was directed at the Royal Court Theatre by William Gaskill, sets by Christopher Morley, with the following cast:*

ANDREW COBHAM Ian MCKellen

JESSIE SUTHERLAND Gillian Martell

JOHN CASPER George Howe

JAKE LATHAM Sebastian Shaw

SMITHY Bernard Gallagher

KATE RAMSAY Ann Firbank

PRIEST Roger Booth

STONEY JACKSON William Stewart

PAUL Dobson John Shepherd

CHAIRMAN OF LOCAL TOWN
PLANNING COMMITTEE Richard Butler

REGINALD MAITLAND Sebastian Shaw

TED WORTHINGTON Bernard Gallagher

BILL MATHESON Richard Butler

BRIAN CAMBRIDGE Joseph Greig

TOASTMASTER Roger Booth

MAISY Jannette Legge

GUESTS, ETC.

David Leland

Jaqueline Harrison

Janet Chappell

Jannette Legge

Kenneth Cranham

LIST OF CHARACTERS

ACT I

ANDREW COBHAM,
JESSIE SUTHERLAND,
PAUL DOBSON,
STONEY JACKSON
} *as youngsters*

ANDREW COBHAM *an architect*

JESSIE SUTHERLAND *his Wife*

PAUL DOBSON *a Journalist*

STONEY JACKSON *a minister*

JAKE LATHAM *an old trade union organizer*

SMITHY *a local Labour Party chairman*

KATE RAMSAY *– a daughter of local aristocracy, Jake's friend*

JOHN CASPER *an architect*, Andrew's *employer*

ACT II

CHAIRMAN OF LOCAL TOWN PLANNING COMMITTEE

OFFICER OF MINISTRY OF TOWN AND COUNTRY PLANNING

ALFIE HARRINGTON *an industrialist*

REGINALD MAITLAND *Minister of Town and Country Planning*

TED WORTHINGTON
BILL MATHESON
BRIAN CAMBRIDGE
TOASTMASTER
} *trade union leaders*

Couples for crowd scenes from whom can be taken three walk-ons.

NOTE

Because of the construction of this play– which is in the form of a 'flash-forward' (as opposed to 'flash-back'.) – two sets of actors are needed to play ANDREW COBHAM, JESSICA SUTHERLAND, PAUL DOBSON, STONEY JACKSON: one set of young actors to whom we constantly return in the setting of the Cathedral, and another set who will act out the play from being young men and women to old ones. In the London production one set of actors played both parts and this established a particular style to the production.

But in May 1974 the author directed the play in Aarhus, Denmark, where he not only reverted to two sets of actors but also made changes to the play.

This edition incorporates those changes plus directions based on the set designed by HAYDEN GRIFFEN.

The following characters can be played by the same actor:

JAKE LATHAM *and* REGINALD MAITLAND

WORTHINGTON *and* SMITHY

JOHN CASPER *and* ALFIE HARRINGTON

CHAIRMAN *and* MATHESON

THE SET

The basic principle of the set is simple: the 'future' is talked about in the cathedral and therefore must be played-out inside it.

The cathedral setting which is constantly present is composed of a pillar on either side of the stage, a stained-glass window to the rear, a catafalque to the front of the stage (protruding out into the audience?), and two mock-gothic ecclesiastical screens cutting across the centre of the stage which should contain a revolve. Each scene is set up behind the screens which part to allow the setting to be revolved on.

It is in the nature of the play that the sets can begin to move into position while the previous scene is ending, thus ensuring a completely fluid style of production.

SCENES

ACT I:

1 Interior of Durham Cathedral	–1926
2 Casper's architect's office	– 1933
3 A riverside	– some hours later
4 A public house	– some months later
5 Jake's study	– some weeks later
6 Andy's bed-sitter	– some days later
7 Durham Cathedral	– 1926
8 A riverside	– 1935
9 Andy's study	– 1936
10 Andy's study	– some days later
11 A public meeting hall	– some months later
12 Durham Cathedral	– 1926
13 A Town Hall chamber	– 1947

ACT II:

I The riverside	– some days later
2 Andy's study	– some weeks later
3 Durham Cathedral	– 1926
4 Platform of the T.U.C.	– 1948
5 The continuous scene	– 1948-85 or thereabouts – moving through these settings:

Part 1 Golden City offices

Part 2 Andy's study

Part 3 Golden City offices

Part 4 Corridor of Ministry of Town and Country Planning

Part 5 Harrington's cocktail party

Part 6 Maitland's cocktail party

Part 7 Golden City offices/Durham Cathedral

Part 8 Office in Trades Union Congress House

Part 9 Golden City offices

Part 10 Andy's study

Part 11 Building site in the Golden City

Part 12 Banquet scene

Part 13 Andy's lounge

Part 14 The card table

Part 15 Durham Cathedral

N.B. If the cathedral scenes in either Act are heavily played this entire play will fail. Innocence, gaiety and a touch of lunacy is their atmosphere.

The author is aware that certain instances in the play do not conform to actual Trade Union or Labour Party procedure, and hopes that the poetic licence he has taken will be understood.

Act One

SCENE ONE

Interior Durham Cathedral.

Music of Thomas Tallis's 40-part motet, Spem in alium.[1]
Empty stage.

*A young man enters, ANDREW COBHAM. He carries a
drawing-board and knapsack. It is the year 1926.*

*What he is looking at he is seeing for the first time.
Discovery.*

He could weep for the beauty of the moment.

Instead, exhilarated, he tosses his knapsack into the air.

YOUNG ANDY: (*With surprise.*) I – am as big as – it. They built
cathedrals for one man – it's just big enough. (*He
closes his eyes.*) Show me love and I'll hate no one.
(*JESSICA SUTHERLAND wanders in.*) Give me wings
and I'll build you a city. Teach me to fly and I'll do
beautiful deeds. (*He opens his eyes and looks up at the
roof.*) Hey God, do you hear that? Beautiful deeds, I
said.

YOUNG JESSIE: Andy?

YOUNG ANDY: For one man, Jessie, a cathedral is built for one
man.

YOUNG JESSIE: Do you talk to yourself?

YOUNG ANDY: Every man should have a cathedral in his back
garden.

YOUNG JESSIE: I've never heard you talk to yourself.

YOUNG ANDY: Look at the way that roof soars.

YOUNG JESSIE: Talk to yourself and you'll go mad.

YOUNG ANDY: Doesn't it make you love yourself?

YOUNG JESSIE: 'Those whom the gods wish to destroy they first
turn mad.'

1 (Argo label ZRG 5436.)

YOUNG ANDY: When a man loves himself he loves the world. Listen. (*Music swells.*)

I reckon the gods touch composers with a fever every night. I bet Bach got to heaven before Shakespeare. Look.

Sunlight strikes through the coloured glass.

Jessie, if you'll marry me I'll build you a house that soars – like this cathedral. and you, you'll give me six beautiful children, and they'll soar, mad, like that roof there. How's that?

YOUNG JESSIE: The gods'll destroy you, that's for sure.

YOUNG ANDY: Today, Jessie, I know, I know. I know everything I want to do with my life.

Wanders around in a trance.

The Youngsters PAUL DOBSON, STONEY JACKSON wander in.

They too have been affected by the cathedral's interior.

YOUNG JESSIE: I found him talking to himself.

YOUNG STONEY: And God no doubt.

YOUNG PAUL: It's that roof. The audacity, the cheek, to build like this.

YOUNG STONEY: Blessed. They were blessed.

YOUNG PAUL: Blessed? The men who built this? Never! Blasphemous, more like. To try to reach your God with pillars like these – blasphemous. Bless 'em

YOUNG ANDY: Supposing you had the chance to build a city, a new one, all the money in the world, supposing that; this new city – what would you do with it?

YOUNG STONEY: He's Off.

YOUNG ANDY: What would you chuck out, have done with?

YOUNG PAUL: Just look at it, man. Don't question, look.

YOUNG ANDY: The chance to change the pattern of living for all time? There it is, all virgin, new land, lovely, green, rich, what would we do with it? Supposing that? What would us do?

YOUNG STONEY: I wouldn't. I wouldn't even bother to answer 'cos I'd know the money would never be there.

YOUNG JESSIE: But if it were?

YOUNG STONEY: Trust you to encourage him.

YOUNG PAUL: Why not? Supposing. All these people, pooling their money, for a city, just supposing.

YOUNG STONEY: You Suppose, I can't.

YOUNG JESSIE: Well, what would us do?

YOUNG STONEY: You don't expect answers, do you?

YOUNG ANDY: Did you know people thought the invention of the printing press was just a new technique for producing books?

YOUNG STONEY: He's off again.

YOUNG JESSIE: Wasn't it?

YOUNG ANDY: Was it, hell! 'Is that you up there, God?' we yelled. And presto! A thousand books came out. 'No,' they said.

YOUNG STONEY: Andy!

YOUNG ANDY: 'No.' Presto like that.

YOUNG JESSIE: But everyone knows it.

YOUNG ANDY: They don't, they don't. Aye, they know they can read a book on any subject under the sun, that they know. But it's more, the printing press meant more. It meant something could be done which a long time ago couldn't be done, change! That's what the printing press meant – change.

YOUNG STONEY: Change! Change! You always want to be changing things.

YOUNG ANDY: No! I just want to know, all the time, that change is possible. Then, when it's needed, I'll do it. STAND CLEAR. (*ANDY stands on his head.*)

YOUNG JESSIE: Get up, you idiot, someone'll see you.

YOUNG ANDY: (*Still on his head.*) Stoney, you're sulkin'. (*Returns to crouching position.*) Don't sulk, Stoney. A thousand books said 'no', honest they did.

YOUNG STONEY: And another thousand said 'yes'.

YOUNG ANDY: Stoney, I love you, I don't have to love God also, do I? Kiss me. (*No response.*) I'll kiss you then. (*Gives STONEY a long kiss then immediately stands on his head again.*) You know, it's almost as impressive this end up.

YOUNG JESSIE: You ragged-arsed apprentice, this cathedral's done things to you.

YOUNG ANDY: Perhaps they should build them upside down.

YOUNG JESSIE: Get back, I tell you, they'll throw us out. Paul, Stoney – do something, tell him.

YOUNG STONEY: Leave him, he looks prettier.

> *STONEY wanders off to start his sketching.*

YOUNG ANDY: (*Descending to crouching position again.*) And when I'm older I'll meet someone who's educated, and he'll look at me 'cos I've got an interesting face and we'll talk together and he'll think – 'this lad's not like the others, I think I can do something with him' – and we'll have long discussions – STAND CLEAR.

> *Returns to standing on his head.*

YOUNG JESSIE: Get off your head, Andy, stand on your feet.

YOUNG PAUL: You won't control him

> *PAUL wanders off to start his sketching.*

YOUNG JESSIE: ANDREW COBHAM!

YOUNG ANDY: I'll meet all sorts of people, learn all sorts of things – I'll have good friends, Jessie Sutherland, good people, all of them. (*Returns to his feet.*)

YOUNG JESSIE: That's better. I wonder you've any blood left in your feet. Now what are you doing? Why are you limping?

> *ANDY moves to unwrap his board and pencils.*

YOUNG ANDY: Broke me leg down a mine.

YOUNG JESSIE: You've never been down a mine.

YOUNG ANDY: Look at that mad roof, Jessie – that's the height a man is, a house should be built that high. (*He sits, leans against wall, begins to draw.*)

YOUNG JESSIE: Does Mr Casper know that you're studying architecture out of office hours?

YOUNG ANDY: He knows.

YOUNG JESSIE: Isn't he impressed?

YOUNG ANDY: Why should he be, he doesn't believe I'll succeed.

YOUNG JESSIE: Will you though?

YOUNG ANDY: I should be in college, studying, full time.

YOUNG JESSIE: Succeed – will you?

YOUNG ANDY: But what's a poor lad to do without cash?

YOUNG JESSIE: I'm asking you, will you though?

YOUNG ANDY: Instead, I am suffering.

YOUNG JESSIE: Thee? Suffer? Tha'll never suffer, tha's too cheeky.

YOUNG ANDY: Aye, I'll succeed. I'll end up architecting. You know it in a place like this.

YOUNG JESSIE: (*Sitting beside him to begin her own sketching.*) How sure you sound.

> *Now the next scene slowly revolves into position With CASPER echoing what YOUNG ANDREW forecasts he will say: 'You're a draughtsman', etc.*

YOUNG ANDY: Old Casper will totter around mumbling to himself, 'You're a draughtsman, a good draughtsman, good draughtsmen can't be found every day, be satisfied, the good Lord made you a draughtsman don't argue with him.' And then the news will come through that I've passed and he'll go on mumbling, 'brilliant, clever boy, the good Lord's made you an architect, praise Him then, mumble, mumble, mumble.' And he'll offer me a partnership, you'll see – dear God, look how that ceiling soars. (*The youngsters remain.*)

SCENE TWO

It is the year 1933. Architect's Office JOHN CASPER, head of the firm, is in his office with ANDY.

CASPER is unfolding over a blackboard some of his favourite designs.

CASPER: Soar! Soar! Every building doesn't have to soar, Mr Cobham. Williamson was a great architect. The good Lord made him a great architect to build modest churches not edifices of megalomania. I sometimes think you must suffer from megalomania.

ANDY: Don't stop, Mr Casper. Jessie promised to ring the examination results through soon.

CASPER: I must be quite mad doing this for you, Cobham. It's most irresponsible of me to encourage you in this wish to be an architect. You're a draughtsman, a good draughtsman, be satisfied that the good Lord – with my help – made you a draughtsman. Besides, I'm sure the normal routine of this office would have taken your mind off your results just as well.

ANDY: Jessie promised, Mr Casper, and I've never asked you to show me your favourites before – it'll be soon.

CASPER: And surely you've gathered my tastes after five years working with me?

ANDY: Just occupy me a little longer.

CASPER: This is perhaps my favourite – John Martin's alms houses for the old people in Cirencester. Lovely houses, beautiful square – look at those gardens –

ANDY: Was it the good Lord made those or John Martin?

CASPER: Now you mock me, Cobham.

ANDY: Nay, I'm jesting, tha's a gentle man, I'd never mock thee. (*The phone rings.*)

CASPER: Thank God, now perhaps I can get my work done.

ANDY: (*Lifts phone, listens, is stunned.*) Thank you. (*Pause.*) Yes – I can hear you. (*Replaces receiver. Silence.*)

CASPER: You haven't passed. You *have* passed? They've accepted your designs? Andy lad? Look at him,

has. the good Lord struck you dumb? You've passed?

ANDY can only smile.

You have passed then. Well then, well I never then. The good Lord *has* made you an architect – well then: It says a lot about me, doesn't it, lad? I must see those designs again, where are they, those 'testimonies of study'? (*Looks.*) These them? (*Unfolds plans.*) Soar? Soar? Is this what you mean by soar? Yes, well it says a lot about me then.

CASPER lays down plans, walks once round the still silent ANDREW, then faces him, stretches out his arms and embraces him.

You must register with the Council of Architects, you must qualify, straight away you must do it, now to begin with, at once and then, Andrew, I'll make an offer – listen to me, talking of offers so soon, it's indecent – never mind, I'm delighted, delighted. Chief Assistant, share of the profits and promise of a partnership in two years if all goes well. What do you say? I'll ring up, my solicitors now, this minute, draw up a contract, are you listening? Do you hear me? Cobham! Andrew! What are you doing? The blood'll run to your head, Andrew –

ANDY stands on his head and the scene has changed to –

SCENE THREE

A riverside, some hours later.

ANDY still on his head.[1]

JESSIE packing away a picnic spread out on a groundsheet.

ANDY: I'll ring up my solicitors, now, this minute,' he said, 'draw up a contract, share of the profits, a partnership'

YOUNG JESSIE: Andy Cobham, stand on your feet, you're a big lad now.

JESSIE: What did you say?

ANDY: (*Returning to his feet.*) Casper's a good man, a gentle man, but he's a dull architect. I'll not stay with him.

JESSIE: Whose practice will you join then?

ANDY: I shan't join a practice. I'll join the local Council, gain more experience.

JESSIE: What do they pay?

ANDY: Pay?

JESSIE: Are we to live on nothing when we marry?

ANDY: Oh aye – marry.

JESSIE: Look how your moods change. What is it now, Andy? (*Silence.*) Andy, I'm asking you. Sometimes I have to squeeze words from you – Andy!

ANDY: Can you feel the sun on you, Jessie? Take off your blouse.

JESSIE: Don't be mad – on a common field – to take off – undress – don't be mad

ANDY: It's all happened with too much ease, Jessie, not much struggle.

JESSIE: Not much struggle? You! You lap up action like a kitten with milk – you wouldn't know you'd struggled till you died.

1 *Note: *YOUNG ANDY* also stands on his head so that both *YOUNG* and *OLD JESSIE* say together, 'Andy Cobham, stand on your feet'. Similar links can be found throughout the play.

ANDY: The year of depression for everyone else but the world's going right for me.

JESSIE: Depression! Hitler! All my father does is talk of depressions and wars near by and round corners and on horizons.

ANDY: Your father's not a fool, then, he's heard the news. Terrible news, all over Europe, Jessie. Hard to believe with the sun on your back.

JESSIE: Will there be bombs, then, and killing, and destruction?

ANDY: Destruction? Aye, the cities will fall.

JESSIE: You frighten me, Andy.

ANDY: (*Snatching her up and hugging her.*) I want six children from you, Jessie. One after another, six of them.

JESSIE: Mind me, Andy, you're hurting. me – Andy!

ANDY: (*Rocking her in his arms.*) Andy, Andy, chocolate pandy, that's what my kids will say, with buttons and beans and cabbage greens and rainbows every day. Jessie, it's very cold being young, isn't it, lass?

(*Suddenly ANDY hoists her over his shoulder.*) Give me twelve children, twenty children –

JESSIE: Put me, down, you bullying oaf, put me down, I'm feeling sick. Put me down or there'll be no children, you're pushing my belly in –

ANDY: (*Jumping.*) – and in and in and in and in. (*Changes her position into his arms.*) Who wants a girl more complicated than you? You're simple like a cottage loaf and pure-smelling like a rose.

JESSIE: (*Pushing him away.*) Simple! Simple! Cottage loaves and apple dumplings! You don't think me foolish by any chance? I mean I'd not be happy knowing we were married just 'cos we've been together these years. You wouldn't marry anyone you thought a fool you wouldn't, would you, would you, Andy?

Shrouding her in a groundsheet. Now a game they play.

ANDY: Do you love me?

JESSIE: I love you.

ANDY: How do you know?

JESSIE: Because I love myself.

ANDY: That's a terrible conceit.

JESSIE: Conceit? But you taught me. Love yourself and you love the world. Well, I'm full of myself. I feel beautiful. Every bit of me. Look. (*Her arms stretched out wide.*) Isn't every bit of me the most beautiful thing you've ever seen? Cottage loaves, dumplings, roses and all?

> *She closes her eyes to bask in the warmth of the sun and his gaze. But her innocence and hope remind him all the more of other fears. He moves away.*

Now look, you've changed again. You see, you change from mood to mood at such a speed.

ANDY: It's just – I'm thinking that near by it sounds like such a dreadful war that all I want to do is eat the cottage loaf and smell the rose. You've a lovely face, Jessie, lovely, lovely, lovely.

JESSIE: Catch me then.

> *JESSIE picks up picnic satchel and runs.*

(*Off.*) Catch me, catch me. (*Silence.*) I've found another spot – the ground is softer – Andeeeeeee catch meeeeee.

> *ANDY remains. As the scene is changing YOUNG ANDY and JESSIE, arms round each other's waist, are moving off to another part of the cathedral.*

YOUNG ANDY: And when I'm older I'll meet someone who's educated, and he'll look at me 'cos I've got an interesting face and we'll talk together and he'll think 'this lad's not like the others, I think I can do something with him' and we'll have long discussions, about all sorts of things, and I'll meet all sorts of people and learn from them. Good friends! I'll have good friends, Jessie Sutherland,

good people, all of them. (*By which time the next scene is in position.*)

SCENE FOUR

Some months later.

A public house.

A group of seven people, JAKE LATHAM, SMITHY, ANDREW COBHAM, three union members and a BARMAN have gathered after a trade union branch meeting.

SMITHY: To our retiring chairman, a toast. Jake Latham. (*All raise glasses.*)

JAKE: My last term as chairman of the Durham Tanners' Union and only six members turned up. Even my resolution was defeated. Pathetic, isn't it? Three officials, three members and one of them is new – and our books show a membership of 259.

SMITHY: Bloody trade union branch meeting? Funeral parlour more like – where no one liked the dead 'un.

JAKE: Nineteen thirty-three will go down as one of the blackest years – I'll never understand.

SMITHY: Well you was daft to try passing a resolution on education with only a few of us here. And besides, you can't ask us to support the spending of money on education when there's no houses.

JAKE: I'm too old for your slogans about empty stomachs, Smithy, what about empty heads? Look at us. We might just as well have had the whole branch meeting in the pub.

SMITHY: Give us a farewell speech, Jake. Say something.

JAKE: Goodbye.

SMITHY: Don't be mean.

JAKE: You mean I've got to return something for this dreary old medal of service? (*Holding up watch on chain.*) I'd have done better to have stayed making saddles for the gentry! All right, I'll ask a question

then. I know it's answers the young always want
but I'm afraid this old 'un's going to be different
– that's my reputation anyway, being different, a
stale sort of reputation- I'm feeling now. I haven't
got answers so let's bequeath them a question
eh, young Cobham? What holds a movement
together? Any movement, not even a movement,
a group of people, say, or a family, or a nation or
a civilization? Something must. Do you know? Or
you? Or you? Whatever it is *we* didn't find it, God
help us, *we* didn't find it.

It's a lousy year, 1933, I don't like it at all, a
miserable year in which to end office. Gentlemen,
here's to you.

(*JAKE breaks away to join ANDY.*) If you want
apologies for my morbidity you won't get it.

ANDY: I'm not afraid of a challenge.

JAKE: Challenge, is it? An optimist, are you?

ANDY: An optimist? Yes brother, I suppose I am.

JAKE: Brother! Well, I mayn't ever have the opportunity
to temper your optimism but I can advise you to
drop the jargon. 'Brother!' A useless title, full of
empty love.

ANDY: A traditional greeting, Mr Latham; it's got a good
history.

JAKE: Use history, don't imitate it. 'Brother' 'let's face
facts!' 'Let us stand together!' 'It's only with strong
determination that we can go forward!' Jargon!

ANDY: If the old words are failing us then perhaps they'd
better be rescued, not abandoned.

JAKE: Nonsense! You can't rescue jargon. It's the
language of the dead. Don't damn new thoughts
with dead words.

ANDY: You prefer homely maxims to jargon, is it?

JAKE: That was not a homely maxim and don't be
cheeky.

ANDY: Don't be –?

JAKE: – cheeky. I'm a clever man, Mr Cobham, but I'm
 an old and vain one. I could teach you a lot but I
 can't bear a young 'un who doesn't know his place.

ANDY: Know his –?

JAKE: – place. Stop gawping – you'll get lockjaw. I've
 no time for rebels, they hate the past for what
 it didn't give them. The Labour Movement is
 choked with bad-mannered, arrogant little rebels
 who enjoy kicking stubborn parents in the teeth.
 Revolutionaries is what we want – they spend less
 time rebelling against what's past and give their
 energy to the vision ahead.

ANDY: 'The vision ahead?' I thought that was the jargon
 we should drop, Mr Latham.

JAKE: Oh ye gods! Good night, Mr Cobham. (*Makes to go.*)

ANDY: Jake Latham!

 JAKE Stops.

 What could you teach me?

 *JAKE pauses to assess this young man as the scene
 revolves to.*

SCENE FIVE

*JAKE's study, some weeks later. ANDY is helping JAKE
rearrange his bookcase.*

JAKE: When you come to me and say 'teach me' what do
 you mean? No, first – why me?

ANDY: I've always had a picture in my mind of an old,
 sorry –

JAKE: Yes, yes, old, I'm old, don't fumble, I'm old.

ANDY: A man, somebody, who'd talk to me. Don't
 misunderstand me, I don't want to be told what to
 think. I've read, I've always read, but I've never
 been, well, guided. Waste, I can't bear waste, I may
 die young, you see.

JAKE: Huh! romantic as well. An optimistic romantic! I'd say you were doomed, Cobham. Go home.

ANDY: I'm not impressed with cynicism, Mr Latham, it's a bit dull is cynicism. You say I'm damned and it sounds clever I know, but I'm not impressed. Neither were you, were you?

JAKE: Are you patronizing me, young lad, are you?

ANDY: Mr Latham, I –

JAKE: I've been chairman of my branch, Cobham, on and off for the last twenty years, chairman of a local trade union branch in a dreadful and dreary industrial town. Does it occur to you to ask why someone like me is a chairman only of a local branch – does it?

ANDY: Perhaps you'll tell me in good time but just now –

JAKE: Right! Learn? You want -to learn? Answer me this then. Ramsay MacDonald handed in his resignation as Labour Prime Minister two years ago and assumed the Leadership of a National Coalition Government What led up to that 1931 crisis?

ANDY: I work in an architect's office, Mr Latham, I want to build cities, I'm not a student of economics.

JAKE: How interesting. You want to build cities but you don't want to know about economics.

ANDY: Do I have to know about economics before I'm permitted to build my cities?

JAKE: Your cities, eh?

ANDY: Why laugh at me? Is it every day someone comes to you and says 'teach me'?

JAKE: No. Never, actually. No one's ever given me such a responsibility. Laugh, do I? Daft old man, me. I'm a bit overwhelmed perhaps. I don't know what to teach you, lad. It must have been ' the vanity of an old man made me invite you here. I'm not a teacher. I've got a pocket full of principles, that's all really. If you'd tried to answer my question I'd

have tried to apply those principles, but… There
was a principle involved in that crisis you know.
It wasn't very widely argued but it was there. Do
you know what the Bank of England did – poor
bloody Ramsay MacDonald – they frightened the
pants off him. All our gold was going, you see,
flowing out of the window it was, people drawing
left, right and centre. So the directors of the Bank
demanded to see the Prime Minister and give him
their view of the situation. And what was their
view? They said to him: 'MacDonald, old son, this
isn't a financial problem, it's a political one. No one
abroad will lend us any money because they are
worried about your government,' they said. 'The
Labour Government is squandering,' they said, 'too
much money on silly things, frivolous things, social
services and education,' they said. 'Foreigners
don't trust your government, Mr MacDonald, they
don't think you can handle the affairs of the British
nation.' Huh! You wouldn't think that a Labour
Prime Minister would fall for anything as simple
as that, would you? But he did, old MacDonald.
'You're right,' he said to the Bank of England.
'We *have* been silly, I'll make cuts.' So he tried,
but he didn't have all the Cabinet with him, and
he resigned, formed a coalition government and
then made the cuts. It's almost unbelievable, isn't
it? Where does the principle come in? I'll tell
you. (*Beginning to get excited.*) Would it have been
unreasonable to expect a socialist government
to apply socialist economic principles instead
of the usual patchwork? It wouldn't, would it?
But did they? (*Mocking.*) 'The time isn't ripe! The
government'll be defeated!' The sort of answer
we all give when we don't do the things we feel
are right. So here's the question: is it better to risk
defeat in defence of a principle or hang on with
compromises?

ANDY: (*Eagerly, infected by JAKE's excitement.*) Do you want me to answer?

JAKE: Of course not, just listen. Now, er, where was I?

ANDY: Compromise!

JAKE: Ah! Now, people always need to know that someone was around who acted. Defeat doesn't matter; in the long run all defeat is temporary. It doesn't matter about present generations but future ones always want to look back and know that someone was around acting on principle. That government, I tell you, should've screamed out to the opposition 'REVOLUTION' – like that. 'Control imports! Clamp down on speculators! Revolution!' Like that, at the top of its voice; and then, taken hold of British industry by the scruff of its neck and made it develop, themselves, full employment! And perhaps they'd have crashed – it was a doomed government anyway – and perhaps we'd have shuddered. But after the crash, after the shuddering and the self-pitying and the recriminations, we'd have been stunned with admiration and the sounds of the crash would've echoed like bloody great hallelujahs, bloody great hallelujahs – What the hell you standing on your head for? You silly or something? Apoplectic?

ANDY: It's relaxing, I'm happy.

JAKE: You're a vegetarian also, I suppose?

ANDY: Here, you try it.

JAKE: Me?

ANDY: I'll make it easy for you (*Lies on his back and raises his knees.*) Put your hands on my knees.

JAKE: Certainly not.

ANDY: You're so dull, you politicians. I'll catch you.

KATHERINE RAMSAY enters.

KATE: How amusing, Jake.

JAKE: Andrew Cobham, this is Katherine Ramsay; Kate – Andrew Cobham

ANDY: (*Jumping up.*) I didn't know you were expecting a
visitor. (*To KATE.*) Evening.

JAKE: Sit down, boy, I've invited her so that you two
could meet. Kate is the daughter of Lord and Lady
Ramsay – the local landlords. Her mother and I
were once er – well, as a young man I worked for
her father, as a saddler, and she and I – once, er,
well, we were in love.

KATE: You can almost see him stiffen, Jake.

JAKE: No, she's not my daughter.

KATE: I thought you said he was different.

JAKE: Beautiful woman – Kate's mum – rare, strong.
Great scandal! And my puritanical colleagues
never let me forget it. Thank God I'm also a good
organizer.

KATE: You're a draughtsman, Mr –

ANDY: Cobham's the name.

 ANDY attempts to leave.

JAKE: What you rushing for?

ANDY: My fiancée – I'm meeting her.

KATE: Why do you limp, Mr –?

ANDY: Cobham's the name.

JAKE: Why does he what?

ANDY: I used to be a miner, Miss, and one day the props
gave way and I used my leg instead – for five hours
till help came. I've not been able to use it since.

KATE: But you –

ANDY: Good night, then, glad to have met you, Miss – er
– Kate

KATE: Kate!

ANDY: Thank you, Jake.

 *ANDY goes, limping badly and bravely into his bedsitter
which is revolving into view[1].*

JAKE: Mine? He's never been near a mine.

 1 Note: At the same time *JAKE* and his study are being revolved

JAKE: Of course not, Jake, he's never been near a mine.

SCENE SIX

ANDY's bedsitter, some days later. KATE enters.

ANDY is at work on his drawing board. KATE nonchalantly sorts through his books.

KATE: Why did you run away from Jake's that night?

ANDY: You're a forward lass, coming upon me like this.

JAKE: Were you afraid?

ANDY: How did you know I'd be in?

KATE: It's my nature to take chances. Were you afraid?

ANDY: I bet you smoke pipes.

KATE: No, cigars. Were you afraid?

ANDY: I try not to be feared of anything.

KATE: Why did you go so quickly then?

ANDY: How you do persist.

KATE: Persistence is a family trait. You turned on your heel because my mother is Lady Ramsay, didn't you? I want you to know, Mr Cobham, I'm a classless woman.

ANDY: Aye, I can see it.

KATE: I can't bear people who wear their class on their hearts like an emblem.

ANDY: Seems to me you're more intent in denying it than I am in looking for it.

KATE: I want us to be friends.

ANDY: You sound desperate.

KATE: Passionate, not desperate. You must know certain things about me, Mr Cobham.

ANDY: I don't see as I must know anything. I was brought up to earn friendship.

off stage. *KATE* has to walk forward into the new set/scene.
It will be obvious by now how these changes are effected, and
from here on such stage directions will be omitted.

KATE: That's our difference then, I don't have to earn anything, I was born with rights.

ANDY: Aye, of course, you're a classless woman.

KATE: (*Attempting to fold his pile of unpressed clothes.*) You're a fool if you think I'm talking about class rights. (*He snatches shirt from her hands. She gently retrieves it and continues folding.*) Human rights, Mr Cobham, from any class. There are certain people who are born with natures that naturally deserve love and respect. Yours, like mine, is one of them.

ANDY: I think you're seeing me as you want.

KATE: Oh? You really see yourself as a humble man? You shame yourself with false modesty?

ANDY: I don't see as how modesty is always false, and I don't see as how being capable and ambitious should make me immodest. I am what I am, I don't feel the need to boast loudly or deny loudly. What I *do* is my boast, not what I say or don't say.

KATE: Charming, Andy, it becomes you.

ANDY: And I'm not needing your comments.

KATE: Don't be ungracious.

ANDY: I'm annoyed.

KATE: Don't be annoyed either, it's my nature to be direct.

ANDY: It's your nature to be a lot of things, it seems. Do you always talk about yourself?

KATE: I want us to be friends.

ANDY: You want, you want! You'll have to earn, young lady. (*He returns to try and work. She takes out a long, thin cigar.*)

KATE: How long have you lived here?

ANDY: Eighteen months.

KATE: (*Referring to a chair.*) Did you buy that monstrosity or does it belong here?

ANDY: It belongs here.

KATE: Why don't you get rid of it?

ANDY: It belongs here

KATE: My dear, the landlady should be given to understand that you are doing her a kindness by getting rid of it.

ANDY: It's not my habit to interfere with other people's property.

KATE: And you're the socialist, are you? (*He protests. She ploughs on.*) Look at this room. You want to be an architect? You want to build beautiful homes? Then how can you surround yourself with ugliness? Look how you dress, look what you hang on your walls How can you dare plan other people's houses when you live with such mediocrity?

ANDY: I –

KATE: How can you dare?

ANDY: I -

KATE: How?

ANDY: I – blast you, woman, I'll not have anyone talk at me like this.

KATE: Honesty hurts you, then?

ANDY: It's your tone of voice, it gets in the way.

KATE: Do you deny that I'm right?

ANDY: I'll not be dragged –

KATE: You deny I'm right?

ANDY: I'll not –

KATE: Do you?

ANDY: I'm attached to my surroundings. Personal things count for me. That's a truth also – attachments count.

KATE: Even attachments to the third-rate?

 Pause.

ANDY: You know, I'd agree with you if only your voice didn't sneer at your words. I don't like people who sneer. (*She offers him a lovely smile.*)

KATE: Tell me, have you ever really worked down a
 mine?

ANDY: No.

KATE: Why did you limp, then?

ANDY: It's a joke I have.

KATE: Why look, you're blushing.

ANDY: Ye gods, has ever a person so twisted me all ways
 in so short a time?

KATE: What is the joke?

ANDY: It's a silly joke.

KATE: Tell it me.

 Music. Tallis.

 *As they are moved off she is smiling at his confusion and
 embarrassment through which his own smile breaks.
 They will be friends for life.*

SCENE SEVEN

The Cathedral.

*Music continuing. The young ones are all sitting eating
sandwiches.*

YOUNG STONEY: How will we really all end, I wonder? Will we stay
 the friends we are?

YOUNG ANDY: I remember at school we used to ask, 'Where shall
 us be in five years from now – just five years?'

YOUNG PAUL: (*Croaking.*) Five years older.

YOUNG STONEY: I've tomato sandwiches – who likes tomato
 sandwiches?

YOUNG JESSIE: I'll swop half a pork pie for two of them

YOUNG STONEY: Don't like pork pies – they're all fat.

YOUNG JESSIE: I made it myself.

 PAUL starts coughing.

YOUNG ANDY: Shut up coughing, Paul, and read us one of your
 poems.

YOUNG STONEY: Why do all poets die of consumption?

YOUNG JESSIE: Give over, Stoney – the air here is none too good for a cough like that.

YOUNG STONEY: She doesn't speak-much but when she does – what wisdom.

YOUNG JESSIE: The gift for gabbing belongs to you, it's you who's taking up religion.

YOUNG ANDY: Stoney Jackson will be the most irreverent priest I know.

YOUNG PAUL: (*Looking at one scrap of paper.*)
'My lids lay heavily with guilt,'

No, not that one. (*Searching through other scraps.*)

You love me now but wait until
Upon my lips you feed no more
And in my arms you lie and scatter
Lovely dreams you struggled for.
Upon my heart you'll lay your head
And know of things that matter more.

So hard is love and soft its sighs
And soft the contours of our lives,
Not all your woman's winter tears
Shall take you back among sweet sighs.
You love me now but wait until
You've crossed my love between your thighs.

There is a long silence. Music, the poem, youthful friendship have drawn them together. YOUNG ANDY, moved, leaps up hugging himself with pleasure.

YOUNG JESSIE: You were a gang when I first met you all.

YOUNG ANDY: (*Sauntering around in his own world.*) – There's something about people. getting together and doing things.

YOUNG JESSIE: You were all in Woolworth's together.

YOUNG ANDY: I don't see the point of insisting you're an individual – you're born one anyway:

YOUNG JESSIE: I was fascinated.

YOUNG ANDY: But a group together, depending on each other, knowing what they want, knowing how to get it –

YOUNG JESSIE: Stoney used to pretend he was blind, and I
remember Paul could walk from one. end of the
city to the other without looking up from his book.

YOUNG ANDY: But a group together –

YOUNG JESSIE: I watched you all –

YOUNG ANDY: Now that's something.

YOUNG JESSIE: You were pinching sweets.

YOUNG STONEY: Ssh!

YOUNG PAUL: What is it – ?

YOUNG STONEY: They've started a service. (*Music grows. ANDREW
mounts the catafalque.*)

YOUNG ANDY: I'll give a sermon.

PAUL and STONEY start applauding.

YOUNG JESSIE: Now they'll chuck us out, now sure as sure they'll
chuck us out.

YOUNG ANDY: Shut up, you ignorant proles you, don't you know
you mustn't applaud in churches? Now, dearly
beloved apprentices, my ragged-arsed brothers, my
sermon today comes from the Bible.

YOUNG STONEY: All sermons come from the Bible.

YOUNG ANDY: Well, my Bible then. And the prophet Blake said,
'Bring me my bow of burning gold, bring me my
arrows of desire.'

*YOUNG JESSIE begins to hum the song in a softly mock
heroic manner. Against her humming ANDY delivers
his 'sermon'.*

YOUNG STONEY: Since when did you read Blake in the Bible?

YOUNG ANDY: I didn't, I read the Bible in Blake – now hush!
'Bring me my spear, O clouds unfold, bring me my
chariot of fire! I will not cease from mental strife,
nor shall my sword sleep in my hand, till we have
built Jerusalem in England's green and pleasant
land.' Till we have built Jerusalem, dearly beloved
apprentices, in England's green and pleasant land.
Now, how can we build Jerusalem in England's
green and pleasant land?

ALL: Get rid of the rotten houses!

YOUNG ANDY: Right. Who built the rotten houses?

ALL: The property owners!

YOUNG ANDY: Right. Who's going to kick the property owners out?

ALL: Labour!

YOUNG ANDY: Right. Who's going to control the next government?

ALL: Labour!

YOUNG ANDY: Right. And –

YOUNG JESSIE: Quick, there's someone coming.

> *ANDY scampers down and everyone innocently turns to his sketching board. A FROCKED PRIEST walks through, smiling encouragingly at them. ANDY resumes his sermon, but not from the tomb.*

YOUNG ANDY: And when the new Labour comes, who will they turn to to build their homes?

ALL: US!

YOUNG ANDY: 'Boys', they'll say, no, 'Sons' – 'Sons', that's what they'll call us. 'Our sons,' they'll say. 'We've done it, we won, now – to work, you ragged-arsed brothers: Build us homes.' That's what they'll say – 'Build us homes' – am I right, boys?

> *They all get ready to go back to their drawing.*

YOUNG PAUL: You're right –

YOUNG STONEY: Of course he's right –

YOUNG ANDY: Of course I'm right!

YOUNG PAUL: (*Going off.*) He's always right!

YOUNG STONEY: (*Much too loudly.*) He's always right!

YOUNG JESSIE AND ANDY: (*Together.*) Ssssh!

YOUNG STONEY: (*Wandering off in another direction, clumsily, thinking – as always – that he's forgotten something.*) Ssssh!

> *YOUNG ANDY and JESSIE skip off hand in hand jubilantly chanting 'New Labour! New Labour! New Labour!'.*

SCENE EIGHT

*The riverside. It is the year 1935 KATE and ANDY
approaching.*

ANDY: New Labour! New Labour! We never learn, never!

KATE: I take it you're having housing problems with the
local council.

ANDY: (*Laying out raincoat for her.*) Patchwork, patchwork.
It's like Jake says – they do nothing but patchwork.

KATE: (*Lying down.*) What do you expect from clerks and
butchers?

ANDY: Beware, beware, my brethren, of the woman who
claims to be classless.

KATE: There's not even a dignified pause and 'bang'
– look at your emancipated working class, leaping
to adopt the values of simpering shopkeepers.

ANDY: She sneers, my God, how she sneers.

KATE: (*Sitting up.*) Stop fighting me, Andrew Cobham,
my attacks are reserved for the half-hearted and
insensitive. I don't attack a class, only certain kinds
of human beings. Just because the bloody town
council sits on your designs. You don't like the
town council? Change them! Or join them –

Pause.

Ah! Join them! Now that's an idea. Tick tick tick
tick. Look at that brain turning over and over (*Lying
back again.*)

ANDY: When a person talks, I think.

KATE: Tick tick tick tick. When Jake first introduced us I
said, 'Keep an eye on that young man.'

ANDY: She's talking about herself again.

KATE: Tick tick tick tick. He will play his life like a game
of chess, Jake, I said. Working ten moves ahead
– a politician's way, really. But I suppose one will
admire him, I said, for being a gambler – because if

the first move is wrong he's gambled away the next nine.

ANDY: How clever the young Ramsay girl is, so observant about people, so witty and naughty.

KATE: Tick tick tick tick. How's your wife?

ANDY: We used to court here, by this river – the 'smelly'.

KATE: A clever girl that, her head screwed on.

ANDY: (*Taking off socks and shoes.*) *Our* womenfolk aren't social plotters, you know – not calculating, like your lot.

KATE: Nonsense! A woman will calculate no matter which class she comes from – or would you like to sell me the myth of the workingclass mother tending her brood of hard-working sons and plainspeaking daughters?

ANDY: How cool the grass is.

KATE: Still, I suppose it's good for the biography. Andrew Cobham, a man of simple tastes – great though he was he constantly returned to the bosom of the common people and his simple wife.

ANDY: My house is in order, my food is cooked, and my children are loved and cared for.

KATE: Yes, well, it sounds as though you have a good housekeeper. Only she sent you out with a button missing from your shirt. Our housekeeper wouldn't put anything back in the drawer without looking for tears and lost buttons.

ANDY: I'm sure that when the costume you're wearing loses its buttons you'll just buy a new one.

KATE: I didn't buy this one, I made it.

ANDY: You have hobbies then – how clever.

KATE: Not clever at all – I hate making things. If I had my way I'd have everything made for me, I can't bear manual labour, but it relieves my boredom and softens my temper.

ANDY: Are you in love with me?

KATE: Yes.

ANDY: God knows why I asked. (*Pause.*) Now look at that city down there. What gangrenous vision excited the men who built that, I wonder?

KATE: There's a war coming, soon.

ANDY: Soon?

KATE: Two or three years.

ANDY: That soon?

KATE: Unless I've drawn the wrong conclusions from what I saw.

ANDY: You really went in cold blood, parading as a Nazi sympathizer, admiring the work of concentration camps?

KATE: What matter how cold my blood was? I needed to know. I told them I was a journalist and went to find out.

ANDY: You're a ruthless woman, Kate Ramsay.

KATE: Oh you're such a bore with your half-hearted humanity. Ruthless! My so-called ruthlessness has now equipped me to save thousands. (*Pause. Unable to resist pricking him.*) Besides, can I help it if I look like the master race?

ANDY: I don't know why we fought for sex equality, so help me I don't.

KATE: Rest on no laurels, my dear, it hasn't happened yet. Do you know I once asked Jake to take me to his union branch meeting and he spent all evening with his tail between his legs – I embarrassed him.

ANDY: Dressed with your sort of ostentatiously simple elegance, I don't wonder.

KATE: (*Rising.*) Simple elegance is not ostentatious – unless you're not used to it Or would you have me go to his branch meeting dressed in tweeds or those nasty cotton frocks from the stores? I don't believe in wearing cloth caps to earn love from the masses.

(*Pause.*) Andy – would you consider standing for councillor?

ANDY: If only you didn't make politics sound like a dirty job.

KATE: How touchy he is.

ANDY: What the hell do I know of local politics?

KATE: You could get in – you're trusted.

ANDY: (*Moving off.*) God help me, Kate, I don't want to go into local politics – I'm an architect; they should be screaming for me to build their houses, down on their bloody knees for me.

KATE: (*Following.*) Singing hallelujahs for you.

ANDY: Aye, well, aye! Singing hallelujahs for me.

> *They've gone.*

SCENE NINE

ANDY's study. It is the year 1936.

Empty.

STONEY staggers in pretending to be blind. JESSIE follows him with a tea tray.

STONEY: Where is he, where's the man? Take me to him, let me feel him (*Feels a chair.*) Andy? Ah master, safe and sound, still with us. God be praised.

JESSIE: Stoney Jackson! You're the most irreverent priest I know. God'll have stern things to tell thee, lad.

STONEY: He's still got his wooden leg.

JESSIE: Get off your knees, fool – your childhood's passed.

> *PAUL enters.*

PAUL: Is the reverend bloody father still playing games?

> *PAUL and STONEY help themselves to tea, they are 'at home'.*

STONEY: Is Andy still with the council?

PAUL: How long does a council meeting go on for, for God's sake?

JESSIE: You should know, Paul, you've covered them often enough.

PAUL: Is he going to stand for council again?

JESSIE: No, he's not. He'll finish this term of office and then go into practice on his own. Two minor building projects is all he's pushed through and he says it's not worth it.

PAUL: I see they're writing about his schemes in the *Architects' Journal*.

JESSIE: That's what you're here to talk about.

STONEY: Aye, Andy and his cities; we've been summoned.

JESSIE: That's right, boys, you've been summoned. He has his answers.

The men surprise JESSIE by hoisting her on their shoulders, as though back to their youth. But she accepts her place as 'Queen', folding her arms regally.)

STONEY: (*Quoting ANDY.*) 'What would you chuck out, have done with? What new things would you put there?'

PAUL: 'There it is, all virgin, a new piece of land, lovely, green, rich, what would us do with it?'

STONEY: 'Private industry? Have done with it. Let. the unions – and the co-ops take over – think what we could do with the profits.'

PAUL: 'Politicians are men we hire to mend roads and tend to the sewers.'

STONEY: 'The Prime Minister is an, accountant. Give the city to its teachers and artists.'

JESSIE: He has his answers.

With great laughter they lower her.

STONEY: Aye, we know them.

Sounds of ANDY approaching and arguing with someone else. It is SMITHY, chairman of the local Labour Party.

SMITHY: And you must debate it. Andy, you, in public, and you know it.

PAUL: What is it, Andy?

ANDY: Jake – the bloody fool

PAUL: What is it?

SMITHY: I'm chairman of this city's Labour Party –

PAUL: Aye –

SMITHY: Thirty years in the movement.

PAUL: Aye, aye.

SMITHY: I've seen it before

PAUL: Will you give over rambling and –

SMITHY: If I ramble, Paul, then that's my pace, let me make my own pace. It may be slow and maybe I'm not as brilliant as some of you, but my political experience tells me no one'll follow a divided party.

PAUL: What's agitating him, Andy?

SMITHY: Local elections, that's what's agitating me. Next week we've got local elections and in a year's time general elections and Jake Latham's splitting the party.

PAUL: Smithy –

SMITHY: At my own pace, Paul, please, at my own pace. Labour Party Conference last year voted to re-arm and give more power to the League of Nations so's the Nazis could be prevented from growing – right? And now there's a split in the party and Jake is among those who've turned against the party's decision to support economic sanctions and re-armament

PAUL: Against?

SMITHY: Alright, we all know it might lead to war, but the party's decision was a responsible one.

PAUL: Against? On the eve of elections?

SMITHY: Who'll vote for us now? Thirty years in the movement – split after split – a party of individuals and eccentrics. Everyone shooting their mouths off in different directions. Bloody intellectuals!

STONEY: Well, Andy?

SMITHY: No discipline, that's what I can't understand, no discipline.

STONEY: Politics is your game now – here's your first big dilemma: eve of poll and your closest friend has decided to take a stand on his own.

SMITHY: He can take whatever stand he likes but not after he's allowed policy to be made, not after he's continued to stand as Area Chairman on that policy. (*Pause.*) Andy, you – you must argue it out, at the next meeting, with Jake, before the elections, I'll get every delegate to pack the hall.

PAUL: Don't be a fool, Smithy – you can't ask Andy to attack Jake in public, not old friends you can't.

SMITHY: Old friends, old friends! We're all old friends, sloppy bloody old friends. The movement can burn and you wouldn't care so long as we was old friends together.

ANDY: I'll talk to him.

SMITHY: No Andy. I want it debated. I'm in the chair and I'll see –

ANDY: I'll talk to him, I tell you.

STONEY: And your plans, Andy? For the new cities? Your answers?

ANDY: Aye, the new cities, well they'll have to wait. There's another bloody war coming up. They'll have to wait

ANDY and a commiserating JESSIE go off. YOUNG ANDY, arm round YOUNG JESSIE, strolls through to take up position by catafalque. Like a reprise he tells her again:

YOUNG ANDY: And when I'm older I'll meet someone who's educated, and he'll look at me 'cos I've got an interesting face and we'll talk together and he'll think 'this lad's not like the others. I think I can do something with him' and we'll have long discussions, about all sorts of things and I'll meet all sorts of people and learn from them. Good friends!

I'll have good friends, Jessie Sutherland, good people, all of them.

They sit back to back, as the future continues to be played out around them.

SCENE TEN

ANDY's study some days later. JAKE and ANDY.

JAKE: Perhaps I should have told you. Of all people I should have told you.

ANDY: Fool.

JAKE: Old, Andy, I'm an old man. I don't always feel inclined to discuss every thought.

ANDY: Then stand down, old men should stand down.

JAKE: Old men should, should they?

ANDY: Don't play with me now, Jake. Stand down.

JAKE: Old men. So we fight, do we?

ANDY: I shall state what I feel to be right.

JAKE: Oh, Andy lad, how you do sound pompous at times. You don't have to be evasive with me. I ask you, we fight – do we?

ANDY: Hasn't Kate told you? Haven't you understood what Kate has told you? The Nazis have burnt the books of their poets – their poets, Jake.

JAKE: You know Kate is returning to Europe?

ANDY: I know it.

JAKE: 'I look like the master race,' she said, 'and I can speak fluent German. No better qualifications for a secret agent, you know.'

ANDY: It'll satisfy her need for drama, she'll love it.

JAKE: What'll you do when the war is over?

ANDY: Damn the war – damn you and the war.

Enter JESSIE with clean shirt at the ready.

JAKE: Perhaps the war will clear a path for you – you and your cities.

ANDY: Jake, don't oppose me at the meeting.

JAKE: Don't?

ANDY: I don't want to fight my friends.

JAKE: (*Idly picking up a sheet of ANDY's notes.*) You shouldn't saddle yourself with friends whose opinions you don't share.

ANDY: Don't oppose me, Jake, I'm weary of battling.

JAKE: Weary already?

ANDY: You don't think I enjoyed those council battles?

JAKE: It's you who should stand down perhaps.

> *ANDY is silent.*

Aye, then we'll fight. It'll be a good lesson for thee. I'll not stay to tea, lass. Look after him.

> *JAKE leaves.*

JESSIE: You can't, Andy – not Jake. That's a long friendship.

ANDY: Why do you always remind me of the things I know?

JESSIE: (*Helping him into shirt.*) Here, it's pressed. I hope it's not still damp.

ANDY: Pressed? This collar? Pressed?

JESSIE: Collars are difficult, they never press straight.

ANDY: And there's a button missing. Time and again I've asked you – never put anything back without checking for tears and loose buttons. Now I shall be late.

JESSIE: There's others.

ANDY: No, I'll make do.

JESSIE: (*Buttoning him up while he knots his tie.*) You're snapping, Andy.

ANDY: Snap? Do I? I didn't ever think I'd be a grumpy old man.

JESSIE: Thirty – old?

ANDY: It's a bad age, thirty. At twenty-nine you're still a
 young man; – at thirty, well, it's a halfway point
 between then and never.

JESSIE: I suppose everyone will be there.

ANDY: Yes.

JESSIE: Will you come back afterwards – the two of you?

ANDY: Probably.

JESSIE: Shall I make food?

ANDY: Food we'll have had. Just tea, your cake and some
 strong tea.

JESSIE: It won't be a vicious argument, will it, Andy?

ANDY: I shall state what I feel to be right.

JESSIE: Of course.

ANDY: You don't think that's pompous, do you; you never
 think anything I say is pompous – but it is. Jake's
 right. I never thought I'd be pompous.

JESSIE: Grumpy and pompous – all at thirty, my!

ANDY: (*Embracing her.*) Oh God, Jessie, Shall us ever build
 cities? Shall us ever stop wasting energy and build
 those cities?

JESSIE: No time is waste, Andy.

ANDY: Yes, waste.

 *He moves to take up his position on the new set
 revolving in.*

JESSIE: It's all a time of growing, lad.

ANDY: Waste.

JESSIE: Growing, growing, it's a time of growing,
 believe me.

ANDY: Waste! Waste! Waste!

SCENE ELEVEN

*It's a large meeting, some months later. The debate is in
progress. Centre is chairman, SMITHY. Left standing forward
is JAKE, right is ANDY.*

Note: The platform must not face the audience but should face downstage, off, from where come the intermittent sounds, growls or applause of the unseen public.

JAKE: (*Emotionally.*) ...God knows how it was done. I don't know how it was done. The degree to which we can be fooled sometimes leads me to despair and despise the class from which I come. And now again, in 1936, the same humbugging machinery is in operation, the same appeal to our patriotism is being made. Do we sharpen our knives again? Is that our answer? Every time, is that going to be our answer? Don't you know what we've created in these last hundred years? An international movement capable of raising a finger and saying yes or no to every important issue confronting the world today.

Why did we create it? To raise our wages from one shilling to one and a penny an hour? Is that all?

(*Gentler.*) I am aware that if we do not fight this war then our civilization will enter into terrible times. Terrible times. I know this – I've not loaded the argument on my side, if anything I've done the opposite. But what can an old man do except say the things he passionately believes? Old men have no need to lie, it's all over for them – the days of tactic, of political manoeuvre, of patchwork. What should an old man say but the thoughts which all his life he's felt were perhaps too irresponsible to utter? Irresponsible? It is said that people like me are irresponsible. I don't know, my friends, I do not know. I feel I will never know the answer – your vote for my resolution calling a halt to this useless rush to re-arm must be my answer; what you decide will decide me.

But, (*Urgently.*) I want to say this. Defeat doesn't matter. In the long run all defeat is temporary. It doesn't matter about present generations, but future ones always want to look back and know is that someone was around acting on their beliefs. I can

only tell you that I believe we were intended to live
on this earth at peace with one another – if some
people do not allow us to do this then I am ready
to stand as the early Christians did and say – this is
my faith, this is where I stand and if necessary, this
is where I will die.

Tumultuous applause.

ANDY: (*Very coolly.*) Andrew Cobham, secretary Number
7 Branch. I want you to know that the man I
shall be attacking is the one to whom I owe most
of my intellectual development; in this way you
will know how deeply I feel about the issue. This
meeting must not be influenced either by sentiment
or personal attachment. Let me remind you that
when Jake Latham says what he has said today
it is rather late to say it and I hope you will carry
no resolution of an emergency character simply
to help a man with a conscience like Jake's decide
what he ought to do. How he should act is a matter
for his own conscience. For Jake Latham to hawk
his conscience around for other people to absolve
is not only confusing the issue but is basically
dishonest. (*Roar of disagreement. ANDY must fight all
the way.*) Because, if in the end Jake Latham is going
to act on the basis of individual conscience, then
he had no right at any time to assume a position of
leadership.

JAKE: I've always declared my position.

ANDY: (*To JAKE, warm though chastising.*) But you remained
in office knowing you were leading hundreds of
people who in the end you would have to abandon
on grounds of private conscience.

VOICES: We asked him to stay! Thank God he did! etc.

ANDY: (*Back to public, contemptuously.*) You asked him
to stay! You asked him to stay! For love? For
affection? There was a time when you prevented
this man from going to the top of his movement
because of some private affair that offended your

puritanical morals and now you declare love for
him? Why? Because he's shaking with the pain
of his own conscience? When your father has an
accident do you sit and croon about your love for
him or do you ignore your love and face the fact
there are hospitals that can cure him? Love or
facts? There is a time for love when facts are faced.
This is no moment to be seated at the feet of self-
styled saints.

VOICES: Shame!

Withdraw!

He's more of a saint than you'll ever be.

ANDY: (*Raising his voice above the cries.*) I tell you, I tell you
– if you want Jake Latham to become a saint then
let me make it easier for you by lighting the faggots
for his martyrdom.

Stunned silence. ANDY begins at low temperature,
rising to crescendo.

Facts. Facts. It's too late for sentiment and, just as
you, I'm sick at heart that this is so.

Now,

let us begin. The argument is that this will be
another war which in the end will serve the
interests of those who rule.

Facts:

In every fascist state it is the Labour Movement
that has been attacked; who fondly thinks that in
defeat it will not happen here? The argument is
for unity of Labour's International Movement to
prevent this war.

Facts:

Jake Latham is the man who calls for unity,
but look – he takes a stand that cracks the very
solidarity he wants. How dare he argue then for
unity?

The argument is that in a war we should reply by
paralysing every nation with a strike.

Facts:

Who will strike? The unions are destroyed in most of Europe. Who's left? Confronted with these facts do we continue speaking glibly about what could be achieved by strike in the event of war? There only ever was one answer – the international control of the seas and an economic pact throughout the world which would control the source of our raw materials. That was an answer, at the time, the right time. Now, it's too late. I'm sorry, Jake Latham, saint, or no saint, it's too late. (*Out of disgust with what he's had to do he throws this last sentence away and returns to table.*) Those who can't accept the movement's policy must take a course that is their own – but not, I tell you, not inside this movement.

Applause, starting slowly, hesitantly mounts to huge ovation. ANDY, JAKE and SMITHY step down. SMITHY attempts to shake ANDY's hand. ANDY turns his back. SMITHY leaves.

ANDY: Damn you, Jake Latham, you've made me do damage to myself again.

JAKE: Did you imagine it was facts that swayed that gathering to your side, Andy? When you stand up and say you're sick at heart, you win a sentimental point and all your pleas to them to take no heed of sentiment are waste. And when you say you owe a debt to someone you attack, then you have made another sentimental point which all your pleading to ignore will not cut out. And was it fair to say I 'hawked' my conscience all around? Was that the action of a friend.

ANDY: You're saying I betrayed a friend?

JAKE: Be careful of your cities, that's what I'm saying. One day you're old and you say right things – but it's all too late; that's what I'm saying.

ANDY: Will you come back with me now? Jessie has cake and tea ready.

JAKE: Cake and strong tea, is it? Aye, let's go. I'll go with you home.

Arm on ANDY's shoulder, they leave. The stage. slowly comes to dark. The sound of an air-raid siren is heard; planes approach, bombs fall, flames crackle – the war has come and must be over in these few seconds until –

SCENE TWELVE

The Cathedral.

YOUNG JESSIE heaves YOUNG ANDY to his feet. She is in a state of high excitement.

YOUNG JESSIE: What kind of cities shall we build, Andy?

YOUNG ANDY: Cities of light and shade, Jessie, with secret corners.

YOUNG PAUL and STONEY have just rushed in, in a larking mood.

YOUNG JESSIE: Paul, what kind of cities?

YOUNG PAUL: (*Getting to his knees, hands on heart.*) Cities for lovers, Jessie, and crowds and lone wolves.

YOUNG JESSIE: Stoney?

YOUNG STONEY: (*Croaking to his knees.*) Cities for old men and crawling children, Jessie.

From their kneeling position both boys can hoist a surprised JESSIE on to their shoulders where she then sits as 'queen' folding her arms regally. They parade her around the stage as though showing her their cities, YOUNG ANDY leading.

YOUNG ANDY: Cosy cities, Jessie, family cities.

YOUNG PAUL: With wide streets and twisting lanes.

YOUNG STONEY: And warm houses, low arches, long alleys.

YOUNG ANDY: Cities full of sound for the blind and colour for the deaf.

YOUNG PAUL: Cities that cradle the people who live there.

YOUNG ANDY: That frighten no one.

YOUNG STONEY: That sing the praises of all men, Jessie.

*They pause in their marching. She rises to the mood
of prophecy and catechism.*

YOUNG JESSIE: Who will help you, my ragged-arsed brothers?

YOUNG ANDY: The new Labour!

YOUNG JESSIE: The same as asked you to build the new houses?

YOUNG ANDY: Aye. After we've built the houses we'll go to the Council Chambers and we'll say, 'We've come again, we've built the houses and now your ragged-arsed sons have come to build you your cities.'

YOUNG STONEY: With their ragged arses!

YOUNG JESSIE: And shall us be proud?

YOUNG ANDY: (*As they now move off in triumph.*) Aye, us'll be proud, they'll be proud. 'Build us cities,' they'll say, they'll command. 'Build us cities of light.'

SCENE THIRTEEN

A Town Hall chamber.

It is the year 1947.

ANDY and CHAIRMAN of local town planning.

CHAIRMAN: We're not interested, we can't be interested. You must be mad to imagine my committee would ever have given it a thought. New cities? New ones? When we've made promises about post-war slum clearances?

ANDY: Slum clearances? Patchwork! All over the country bits and pieces of patchwork. I've done it.

CHAIRMAN: Rooms, give 'em that – to eat and sleep, give 'em that. Four walls, to keep out wind and rain – that's what we promised and that's what we'll give 'em.

ANDY: Patchwork, patchwork.

CHAIRMAN: People owning all their own houses? Workers owning their own factories? This Labour Council wouldn't last five minutes if we proposed a lunatic scheme like that.

ANDY: You sold us different dreams while we were at war, mister.

CHAIRMAN: Yes, yes, dreams – I know all about the spirit of 1945. Some intellectual loud-mouth does a bit of dreaming during war time and we're left to give it shape and practice in peacetime.

ANDY: And what a botch you make of it.

CHAIRMAN: Don't be cheeky wi' me, Cobham. You're a respected man now, a famous architect, a war hero and all that, but don't battle me with your insults. I've been in the game too long –

ANDY: Aye, and don't you talk like it, too.

CHAIRMAN: I'm twice your age and I've been a bloody founder of this local Labour Party, a founder –

ANDY: – and you act like you're the only ones can inherit the good bloody earth! You think you've got the prerogative on suffering, don't you? I can see you all, spending your time boasting who was out of work longest in the good old days. Your lot wear your past so bloody smugly, my God –

CHAIRMAN: Right now, lad, be easy. You mustn't think because I'm firm that I don't see –

ANDY: I mean, what's the difference? What's the bloody difference? The opposition used to give the same sort of answer – only they offered round the drinks meanwhile.

CHAIRMAN: Oh, lad, I'm sorry, here, I'm sorry, of course, what'll you have?

ANDY: My! Look how you rush to copy them.

CHAIRMAN: Now listen to me, Mr Cobham –

ANDY: Why not offer me tea, a good cup of strong working-class tea.

CHAIRMAN: Well tea then, tea, lad – MAISY! Two teas, luv!

ANDY: Now why should you offer me tea? That's why you and your puritanical colleagues will never do this city proud, you're such cheapskates. Give me

a whisky, Mr Comrade Chairman Jackson, I'm worth it. You get used to the idea that it's worth paying for what it's worth paying for! MAISY, we don't want any teas! A good whisky, a double one, 'cos you'll go a long way to find an architect like me in this city.

CHAIRMAN: Not in all my years have I been so –

ANDY: Socialist? Socialist Council, you call yourself?

CHAIRMAN: MR COBHAM

ANDY: Don't stop me, I'm in full flight. Socialist! 'Four walls, Mr Cobham, to keep out wind and rain, just somewhere to eat and sleep, Mr Cobham.' Practical men? I spit 'em! Facts, Mr Jackson: when I told this council years ago that Floral Houses should come down or they'd fall down, the reply was 'Nonsense! We've got schools to build, can't afford it.' Well, they fell and the new school was missing ten children. Facts: the last Labour Housing Chairman approved designs. for houses that now let in so much water half the inhabitants are in sanatoriums suffering from TB. And you, even you built a block of flats on top of an underground river. You practical boys are so mean-spirited that in half a century you'll turn us into one great sprawling slum. Even your whisky's cheap.

CHAIRMAN: You're asking us to change our whole society for God's sake.

ANDY: Hallelujah!

Pause.

CHAIRMAN: You're married, aren't you, Cobham?

ANDY: Aye.

CHAIRMAN: How many children?

ANDY: Three.

CHAIRMAN: Insured?

ANDY: Eh?

CHAIRMAN: Is everyone insured?

ANDY: Insured? What are you on about, insured? I'm talking about a new kind of city and all he can talk about is insurance.

CHAIRMAN: I'm not a fool, Cobham, and you listen, you listen, you listen to me. Patchwork? Slum clearance – patchwork? Right. I agree. And what's more I agree for your reasons: the intrusion of a little bit of order in the midst of chaos. Useless. I agree. Patchwork. I agree. Because one day the chaos will overwhelm the tiny bit of order, won't it? Very clever. You know it, you're not a fool. A bit romantic, maybe, but so what, a good quality, a fault on the right side as they say.

But think, think, Cobham, your cities, those beginnings of the good life. Think. You've not let us fool you, so you won't fool yourself, surely? *You* know why the cities won't work – them's also patchwork. Them's also a little bit of order in the midst of chaos. Bits of oasis in the desert that the sun dries up, that's all. Do you like my poetry? I can spin the right phrase out when I try, you know. I can toss a metaphor or two when I want. You lads don't have the prerogative on passion, Cobham, no more than we've the prerogative on suffering.

Now them's thoughts for you, them's real thoughts for you, you think on 'em.

Pause.

ANDY: Whether you stonewall, whether you legislate, whether you lobby, argue, deceive or apply your lovely reasonable sanity, the end is the same. A cheapskate dreariness, a dull caution that kills the spirit of all movements and betrays us all – from plumber to poet. Not even the gods forgive that.

Curtain.

Act Two

As curtain rises we hear the words of ANDY from previous scene 'Whether you stonewall... Not even the Gods forgive that.' The riverside some days later.

ANDY and KATE. She is sewing hem of old coat.

KATE: And when you told him that not even the gods will forgive him what did he say?

ANDY: He'd take the risk.

KATE: And so?

ANDY: And so – nothing!

KATE: Nothing?

ANDY: (*Angrily picking up stones to throw skimming over water.*) Slum clearances, that's what I'll do. Patch it up. Crutches, give 'em crutches.

KATE: How easily you've inherited the language of your critics.

ANDY: Well what do you expect? *'They'll* command us,' we used to say. *'They'll* command *us!* Look at us, what-betrayed ragged-arses we are; weaned on passion. Poor old passion! Poor, bloody; old passion! And for what?

Pause. KATE stops sewing.

KATE: Andy, you want to do it alone don't you?

ANDY: Are you mad?

KATE: Andy, why don't you do it alone?

ANDY: The odds are too great.

KATE: That's no reason.

ANDY: I'm too old.

KATE: That's no reason.

ANDY: Too tired, too wise.

KATE: No reason, no reason at all. Now, let's begin again.
 Andy, why don't you do it alone?

 He refuses to answer. She starts sewing again.

 Yes, well perhaps you're right. The idea of a
 Golden City is dreary anyway.

ANDY: I must have been mad.

KATE: Who ever believes a call to arms?

ANDY: Don't tempt me. It's just too easy to tempt me.

KATE: Who ever heard of enthusiasm commanding
 attention?

ANDY: I tempt myself all the time.

KATE: There's something so much more significant about
 despair, isn't there?

ANDY: I'm just the sort of fool to be tempted.

KATE: You could always say you tried, very honourable;
 all the glory of good intentions without the actual
 struggle.

ANDY: You're becoming a nagger and that's what I'd
 become if I did it alone, a righteous old nagger.

KATE: All right, Andy, I'm going home.

ANDY: Going? Don't I amuse you?

KATE: Perhaps you'd like to stand on your head for me?

ANDY: Aye, that if you like.

KATE: (*Exploding.*) Andy, I'm tired of timid lads who laugh
 at themselves: I'm tired of little men and vain
 gestures. I have a need, O God how I have a need
 to see someone who's not intimidated. Who's not
 afraid to be heroic again.

ANDY: Kate, the hero is a bore.

KATE: As you wish. (*Makes to leave.*)

ANDY: The hero is a sign, you old nag you – a sign of
 failure.

KATE: Ah! Failure, that's what you're afraid of?

ANDY: Yes, of course I'm afraid of failure – petrified.
 A golden city is doomed to failure, don't you

understand? One city, six cities, a dozen – what difference? It's all patchwork – like the chairman said. There'd be plenty wanting to help me patch up – oh, yes – and then when it was done they'd heave a sigh of relief that they'd managed to stave off the real revolution for yet another century: Why shouldn't I be afraid?

KATE: Then I ask you, since the bloody revolution you would like cannot be achieved; what is there left worth doing?

Pause.

ANDY: Who would build the city with me?

KATE: Your friends – where are they?

ANDY: Stoney, Paul? The war lost us. It would be like digging up the dead.

KATE: Then do that, wake the dead.

ANDY: I haven't the language of heroism, Kate.

KATE: Then forge it.

ANDY: From what? The words of politicians?

KATE: Forge it.

ANDY: From the old poets?

KATE: Forge it.

ANDY: From the pages of dead pamphlets?

KATE: Forge it, forge it.

ANDY: The language of heroism is a dead language, Kate. You need to be desperate to forge it.

KATE: A desperate language? Forge it.

ANDY: A desperate language breeds desperate deeds for God's sake.

KATE: Then I ask you again – what else is there left worth doing?

Long pause. The revolve slowly brings on next scene. They 'walk'.

ANDY: You know, recently I attended a May Day demonstration – a dreary march, from one street

corner to another. *There* were the usual half-hearted banners and *there* were the isolated hand-claps from the handful of people on the pavements; and in front of the march, sure enough, there was our foremost political leader of the left, giving his uncertain smiles and nods to empty streets and embarrassed children. And when the marchers arrived at their destination this foremost political leader of the left stood up and made a speech about pensions and housing and the balance of trade. And suddenly, out of the crowd, a young lad shouted, 'Inspire us!' Now, think of him, Kate. My God, inspire us.

SCENE TWO

ANDY's study, some weeks later.

PAUL, STONEY sit in uneasy silence. KATE sits, watching their reactions.

PAUL: Well, inspire us then.

ANDY: I see, you're going to make it difficult, are you?

PAUL: Why not? You've dragged us from the peace of our homes, now pay for it.

STONEY: You've become aggressive, Paul. It doesn't suit you.

PAUL: And you've become senile. I've no patience with people who still think they can advance human progress.

KATE: That's a dreary piece of cynicism. Is that the level of your disillusionment?

STONEY: I don't suppose Andy expected the joy of an old comrades' reunion – did you, Andy?

ANDY: Now that you're here I'm not sure what I expected.

PAUL: Well, you'd better. hurry up and find out, hadn't you?

STONEY: We're not being gracious, I'm feeling.

Awkward silence.

ANDY: Look at you both! You'd love to help me build these cities but you're too mean to show it. Look at you! Shrinking your poor little souls behind those comfortable disenchantments. How you wail and you whimper and you whine. (*Mocking.*) 'I've no patience with people who still think they can advance human progress.'

Pause.

PAUL: (*Reluctantly.*) How much will it cost?

ANDY: (*Jumping to it. He's got them.*) Good! A city for a hundred thousand inhabitants would take fifteen years to complete and cost £156,000,000.

STONEY: £156,000,000?

ANDY: That means every man must find £1,560 for everyone in his family – to pay not merely for their houses but for all the public buildings as well

STONEY: You've been working hard.

ANDY: I've got a questionnaire here, I've worked one out, we'll ask each person what kind of city he wants. Participation! We'll involve them, a real community project, a real one!

STONEY: And *our* roles? (*KATE impatiently rises to pour drinks.*) Each of us here? The part we play, tell us those. We're a bit of a battered lot, us. Look at us.

PAUL: What must we do now? Search our souls for some sort of credentials?

STONEY: Aye, in a way, credentials – a sort of worthiness

KATE: The reverend Dean wants to know if we're good people, don't you, dear?

STONEY: Yes, I do – is that wrong?

KATE: So look at us, Andy. What do you see? (*Giving PAUL his drink.*) A good journalist who might have made a good poet but didn't. Partner number one – frustrated! Terrible credentials. Go home, Paul Dobson. A minister, a religious administrator, a lover of love who can't bring himself to admit how dulled he is by his experience of it – partner

number two. Terrible, terrible credentials – back to your desk, Reverend Jackson. And finally myself, daughter of impoverished aristocracy, a woman with a constant. sneer in her voice, unloved and with no respect for the will of the people. Why don't we all go home, Reverend Jackson?

Silence.

STONEY: Where is Jessie, Andy?

KATE: Oh, my God!

STONEY: Why isn't she with us? She was part of us, once. Why does she stay in the kitchen?

KATE: (*Impatiently.*) Yes, where is your housekeeper? Why isn't your housekeeper asked to contribute to the discussions?

STONEY: See what I mean, Andy? She could never build such a city as you want, never! If I were Andy I'd have slapped the arse off you for that, but good and hard.

ANDY: Ignore it, Stoney. We don't have to be saints to have dreams.

STONEY: I cannot build your city with the sneers of a dying aristocracy ringing in my ears.

KATE: I'm not a dying aristocracy – I'm classless.

STONEY: Classless? The common man would smell you decaying a mile off.

KATE: The common man! What a fraudulent myth – the glorious age of the common man! My God, this is an age of flabbiness, isn't it? You know, Stoney, it's not really the age of the common man, it's the age of the man who is common, and if it's unforgivable that my class has produced the myth, then you should weep, yes weep, that your class has accepted it.

Haven't you noticed how we pat you on the head at the mere sign of intelligence? 'He reads,' we say; 'how quaint, give him newspapers with large print', but we keep the leather-bound volumes of poets on

our shelves. Haven't you noticed the patronizing way we say, 'He's artistic, how touching – give him pottery classes and amateur theatricals' – but the masters continue to hang on our walls and the big theatres are our habitat, not yours.

ANDY: (*Mocking.*) 'Our homes are made of brick with crisp square lines and fully equipped kitchens.'

KATE: – but ours are the Georgian mansions out in the fields and we have rooms for our guests while you, you have just enough for your family.

PAUL: (*Catching on.*) 'We're well fed and there's ample roast beef at home.'

KATE: – yes, Paul. But we know the taste of caviare, don't we? And there are vintage wines on our tables.

STONEY: (*Also catching on.*) 'And in this day of the man who is common and drives his Austin and Ford we think we're equal to any man.'

KATE: – but we have the Bentley and the Rolls and keep quiet.

Pause.

STONEY: So?

KATE: So, because we need to perpetuate the myth that class differences are past, we pat his head and consult the man who is common in the name of the common man. Questionnaires, Andy? (*Holding one up.*) Is this what *you* imagine makes it the age of the common man? This? (*Reading.*) 'For the people who plan to inhabit the new cities so that we may know better how to build them.' Fancy! Architects asking laymen how to build a city. Why should the man who buys his city know how to build it? Why shouldn't we turn to you for our homes, to the poet for his words, to the Church for its guidance? Participation? It's a sop, dear, to ease your conscience. Tear them up – be brave, you know well enough how you want those cities built – shall we tear them up?

ANDY pauses, uncertain. Then he takes questionnaire and tears it up.

PAUL: But Andy's not even convinced himself. It's all patchwork, he says. How can he persuade others of a glory he doesn't believe in himself?

ANDY: If I decide to build those cities, then I'll forget they could ever have been regarded as patchwork, I'll ignore history.

PAUL: And what makes you think we'd ever agree to this massive piece of self-deception?

ANDY: Paul, if I'd come to you with brave declarations and the cry of an easy Utopia would you have believed that?

Pause.

PAUL: No, I'd not have believed that.

ANDY: Then what else is there left worth doing? The alternative is that complete revolution we all used to talk about, but today? Here? Now? – there's no situation that's revolutionary, is there? Face it, all of you. There – is – no – revolutionary – situation.

ANDY challenges them all but there is only silence.

Then let's begin.

In the way you build a city you build the habits of a way of life in that city – that's a fact. Six Golden Cities could lay the foundations of a new way of life for all society – that's a half-truth, one that we're going to perpetrate, with our fingers crossed.

STONEY: And the method?

ANDY: (*With fresh energy. Now he's really captured their interests.*) Simple. There are architects and town planners throughout the country who I know would form six working committees to find sites and draw up plans.

PAUL: And the initial cost?

ANDY: Each committee would need £5,000 to open up offices for the first year. A year of planning,

building models, battling authorities and finding
the first 16,000 inhabitants. I've already set aside
£5,000 for our first offices.

STONEY: And the inhabitants? How do you begin to look for
them?

ANDY: When the whole scheme is announced in the press
there'll be thousands of applications – I know it.
We'll invite the applicants to attend a Monday
Meeting which we'll conduct weekly for perhaps
the first five years – maybe more. And at these
meetings the plans will be explained in detail and
we can select the right age groups and create the
correct balance of professions.

PAUL: And the money? How will the first money
come in?

ANDY: Instalments. Before the work can begin, each
family will have to start paying instalments on
their house – no, their city! It'll take three years to
accumulate sufficient capital to start building.

STONEY: And how long will it take before they can move in?

ANDY: Five years, five years for the first phase of building.

STONEY: Five years? Three years to start and five years of
building?

Eight years, Andy. You're asking people to wait
eight years to move into a house.

PAUL: Don't be so dull-witted, Stoney. They'll be waiting
eight years for their own city, more than their own
house.

STONEY: It's paralysing.

PAUL: One last question – industry. The money for
industry – who'll provide that?

ANDY: Industry. Aye, well, there lies the major battle.

*The YOUNGSTERS wander in. They mill group
themselves around the catafalque to listen to a story
from YOUNG ANDY. Firstly, though, OLD ANDY begins
telling it. Then YOUNG ANDY echoes him.*

Now, be patient, and I'll tell thee a story. There was
a man called Joseph Arch, once…

SCENE THREE

The Cathedral.

*PAUL and STONEY are lying around in resting positions,
listening to the Story ANDY is telling JESSIE.*

ANDY: There was a man called Joseph Arch once, a farm
labourer from Warwickshire, born about 1850. And
one day three men called on him, in his house, and
asked him to be their leader. They wanted him to
come that night into a town called Wellingbourne;
there was to be a meeting. They wanted, they told
him, to get the local farm labourers together and
start a union directly. 'Oh,' he said, 'a union, is it?
You'll have to fight hard for it and suffer for it,' he
said, 'you and your families,' he said. They told
him they knew that and they and their families
were ready.

JESSIE: Did it succeed?

ANDY: No, it was smashed – but they'd begun, and once
the Combination Laws were repealed they stopped
going underground and started in earnest.

Now, consider, it's only about sixty years later,
just that, a lifetime only, and look – there's all
those people, all that organization, all those
improvements. Now that strikes me as an exciting
story but no one seems to have seen what
happened. They know wages have gone up, they
can see improved housing and better working
conditions, but no one seems to have seen much
else. It's like, it's like – how should I tell you? – it's
like some people who are stranded on an island
and a hundred miles away is the mainland, so they
must build a boat. Now they only want the boat to
carry them for a little way, for a short time; but as
they build it they sink holds and erect decks, they

build cabins and kitchens, they give it a polish and lots of sails and all they do is travel a hundred miles from one piece of land to another. But that's daft, isn't it? I mean, why don't they seem to realize they could live on it, trade in it, travel right across the world in it? 'No,' they say, 'we only wanted it to go from the island to the mainland – that was its only job.' So there it is, in the harbour, and they keep it polished, waiting for another emergency – but that's all. And I don't know – but it seems to me that someone has to tell them that that ship can span every ocean there is, every ocean, look, and reach all corners of the . world. It seems to me – someone has to tell them that...

Now OLD ANDY is being revolved on. The YOUNGSTERS remain. YOUNG ANDY continues with his story. OLD ANDY echoes him.

SCENE FOUR

The Trades Union Congress. It is the year 1948.

A back projection of the General Council who are listening to ANDY addressing Congress.

ANDY is alone on a rostrum.

A long cloth banner stretches behind him with the words ANNUAL TRADES UNION CONGRESS.

At the base of the platform of the General Council is a decoration of flowers.

Note: He must not address the next speech to the audience.

YOUNG ANDY: (*Echoed by ANDY.*) Someone has to say, 'Look, look at that ship, it's more than a raft, it has sails. The wind can catch those sails and the ship can span every ocean there is. It can span every ocean and reach all corners of the earth.'

ANDY: (*Continuing alone.*) Why did we build such a ship, with eight million people aboard? To raise our wages every year by pennies? To ensure that our offices are guarded by first-aid kits and our factories

have posh flush lavatories? Is that all? When
with the lovely voice of all our energies we could
command the building of the most beautiful cities
in the world. More – the most beautiful world itself,
I tell you.

Years ago, many years ago, when I first came into
the movement, at a time of scant employment,
falling membership and apathy – a man asked a
question. Some of you will remember that man
– Jake Latham, chairman then, -dead now. The
movement had been alive for half a century, half a
hundred years of argument, and achievement, look;
yet – the 1933 crisis came and apathy confronted
him. 'What,' he asked, he was an old bewildered
man, 'what, since we have failed, is there that
holds men in a movement through all time? Any
movement, not even a movement – groups, a
family, a community, a civilization?' He had no
answer. Tired – he was a tired, old man.

But is this us? Old men? Tired old men? The most
terrible war in history is won – by us – we should
be jubilant, we should be singing. We should have
answers and not be doubled up by despair. Old
men have no answers and when old age is ours,
then, then we can cry in bewilderment. But now,
our blood is young, we should cry – we know! Old
age laments, leave lamentations till the grave – *we*
know! *We* know what holds men in a movement
through all time – their visions. Visions, visions,
visions! What else? To fight for a penny more an
hour for standing at the lathe, our energies for only
this? A movement built for only this? The battle for
our daily needs?

But men have minds which some good God has
given so we can tackle problems bigger than our
daily needs, so we can dream. Who dares to tell us
we've no right to dream? The dull and dreary men?
Then tell the dull and dreary men to crawl away.

I tell you,

this resolution now before you builds a dream. In the way you shape a city you shape the habit of a way of life. I tell you, we have a city we can build, we *have* a city. We have a city we can build out of whose contours comes the breath of such a brave new world.

ANDY is revolved off. The first Monday Meeting revolved on. Now it is STONEY who is echoing ANDY.

ANDY: (*Echoed by STONEY.*) I tell you,

the dull and dreary men preach caution, caution is a kind of fear. The dull and dreary men breed apathy, apathy is a kind of cancer. But look, *we* have a city. The dull and dreary men, beware – beware the dull and dreary men.

I tell you, look –

we have a city, we can have a city!

The speech ends to coincide with next set in position, and the applause of the Monday Meeting public who are also in position. The – YOUNGSTERS move off to continue sketching.

SPECIAL NOTE

From here on begins the 'continuous' scene – divided into 15 parts – that is to say, a scene taking us right to the end of the play as one set dissolves rapidly into another. It will cover many years and many situations and the purpose of proposing this method of staging is to create a sense of purpose, bustle, activity and – most important – growth and decay. The long battle to build the city will begin and end in this 'continuous' scene_ Towards. the end of each situation (set), preparation will be going on for the next situation (set), so that characters will turn immediately from one phase of the development to another. Similar to the style up till now, only more so. It must appear as one continuous movement, slowly and inexorably unfolding – rather like watching the painting of Dorian Gray slowly

*change. from a young man into an old and evil man
– as in the film.*

[The screens will remain apart till the final part.]

SCENE FIVE

Covering the years 1948-85 or thereabouts.

Part One

The Golden City offices.

This is the first of the 'Monday Meetings'.

*'Monday Meetings' will continue as the years go by, and
though them we will build up a verbal image of the cities.*

A board hangs in the background:

'MONDAY MEETING – FIRST WEEK'

*STONEY has just addressed the audience. KATE and PAUL are
in attendance. KATE is obviously angry about something.*

STONEY: (*Acknowledging applause.*) Thank you. Now, we'll be
 happy to answer questions.

QUESTIONER: Right! You've shaped the city. Very good! There
 are the plans, we've seen them, very good! But you
 want questions. Here's one. What about its spirit?
 The city's spirit – how will you shape that?

PAUL: Good question. A city's spirit, what will be the
 city's spirit? Look, look more closely at these plans.
 What do you see?

STONEY: Variety – that's what you see. Roads that are wide
 and alleys that ramble.

PAUL: Bold squares and. intimate corners.

STONEY: There's colour in that city, and sound.

PAUL: And movement of line and patterns of mass.

STONEY: Not a frightening city, not intimidating.

PAUL: And its heart? What do you see as its heart?
 Industry may be a city's backbone but what should
 be a city's heart?

VOICE: A Town Hall? –

STONEY: Look again – look more closely at these plans again. You can't seriously place a Town Hall at the city's heart – not a place where functionaries meet to organize our tax affairs and drainage problems.

PAUL: No. Our city's heart is its gardens, concert halls, theatres, swimming pools.

STONEY: Dance halls, galleries and meeting rooms.

PAUL: Restaurants and libraries, look – a rearrangement of priorities.

STONEY: And you can build it, over many years it's true, but you can build it. It's not been done before. No one's ever challenged men to pool their money and build their own city –

PAUL: – but it can be done.

It's the end of the meeting. The audience rise to go, murmuring, impressed.

ANDY enters.

PAUL shakes hands goodbye with one of the audience.

I mean, we oughtn't to be afraid…

KATE: (*To ANDY.*) You didn't turn up.

ANDY: How many came?

KATE: You didn't turn up.

ANDY: How many came I asked.

STONEY: Twenty.

KATE: The first of the Monday Meetings and you didn't turn up.

ANDY: You couldn't have understood, Kate, Jessie was ill.

KATE: Are you going to neglect this project every time there's an upset in the family?

ANDY: You forget yourself, Kate.

KATE: Answer me. Is this project to grow depending on the ups and downs of the Cobham household? Is it?

ANDY: The woman had a miscarriage for God's sake.

KATE: So? There are doctors to guard the sick, you have other things to guard.

ANDY: Thank you but I'll make my own decisions of priority.

KATE: Your decisions, any decisions you make,-affect this project. I charge you again – your family is your family and your work is your work, and you have not the right, no right at all, to neglect a project involving so many for the sake of your own good life.

STONEY: And we were the ones just talking about the good life?

KATE: Don't! Don't confuse what we preach with what we must do.

ANDY: Kate!

KATE: Yes, cry 'Kate', but I warn you – those of us who build the Golden City can never live in it, never.

Silence. STONEY and PAUL, embarrassed, leave.

ANDY: We need more funds, the kitty is low.

KATE: Nurse that then. There's the illness, find funds.

KATE leaves.

Part Two

It is ANDY's Study.

ANDY opens a drawer, pulls out -some drawings and tears them up. JESSIE enters. Watches him a while.)

JESSIE: What are you tearing? (*No answer.*) Don't be a fool, Andrew Cobham, what are you tearing? (*But she knows.*) Have you taken to tearing every design that your customer turns down? I thought it was the habit of architects to hold on to every last sketch

ANDY: I can remember, when I first started on my own, I swore I would never erect a building I didn't approve of – I swore that.

JESSIE: Nor you haven't, have you?

ANDY: No, I haven't.

JESSIE: Well?

ANDY: Well, woman, you know what the cynics say
– every man has his price; they must be right.

JESSIE: I always thought that cynicism didn't impress you.

ANDY: And it doesn't, but facts do and the fact is we've
hardly any money left and my designs for the
technical college have been turned down. – too
expensive.

JESSIE: Can't the project start paying you a salary now?
You've been going a year –

ANDY: Now stop that. I've told you. The funds are low.
The project and this household must live off the
practice; that's why I built it.

JESSIE: Andrew Cobham, as the years go on it gets harder
and harder to live with you. I'll not have you
grunting and storming through this house because
you're building a building you don't want to build.
You, with a screaming and snapping head above
what you are, is more than I can bear. We'll –

ANDY: A screaming and snapping head above what I
am, eh?

JESSIE: It's not been a happy year that's gone, not a calm
one.

Pause.

ANDY: I'll build them anything they want, Jessie. And my
City is my price.

Part Three

*JESSIE leaves. We hear the sound of applause. ANDY has just
addressed a Monday Meeting. Two or three from the meeting
come to greet him. He chats with them as he prepares to go
to the Ministry of Town and Country Planning. A doting
STONEY helps him on with his coat.*

ANDY: Right! We have a site. At last, after a year of searching, the first site for the first city has been found. And why? Because the number of people who've started to buy their own city has grown and everyone's started to take us seriously. They've had to: the money's coming in and that's a fact, that money is, a fact! Now – permission. One small council has offered us a site and the Ministry of Town and Country Planning must give permission to build. They must! They can't refuse! There's too much enthusiasm! Look at us – our hundredth Monday Meeting and our audiences have risen from twenty to six hundred and that's not the largest audience of applicants we've. had, no! Not by a long road! Do you know this scheme has captured the imagination not only of this country but of countries throughout the world. Aye! Throughout the world! The Ministry will have to give its blessing, Tory though it is. And you know what we'll say to them? 'You'll have the finest planners in the land at work,' we'll say. 'We'll make such innovations that you'll find a dozen problems solved in one go.' They can't refuse. Look at the size this meeting was, consider the response, they can't refuse. Goodbye. Thank you.

They wish him luck as he moves off. We are now in a corridor in the Ministry of Town and Country Planning. An OFFICIAL talks to ANDY.

Part Four

OFFICAL: Mr Cobham, it really was kind of you to come but believe me, there arrive at these offices, every day, half a dozen plans and schemes by lunatics who think they can solve our housing problems in an hour Not that I dare imply you are a lunatic; we are all aware, even the Minister I'm sure, of your fine achievements as an architect – but Mr Cobham,

I. couldn't even begin to interest the – Minister in
such a scheme.

ANDY: But the land's no good to agriculture, it's not a
beauty spot, we're not even asking you for the
money. Permission – that's all, authority and a
signature, at no price. We'll raise the costs, we're
raising the costs –

OFFICAL: And I don't want you to think it's because of the
political implication – I know that's what you're
thinking – it's not. A Ministry like this, unlike other
ministries, has very little need to make political
decisions, you know.

ANDY: Ah, I see, you're a classless, ministry.

OFFICIAL: Yes, very aptly put, Mr Cobham, a classless
ministry, yes, I like that. Good day.

ANDY: 'Yes, Mr Cobham, very aptly put, a classless
ministry, I like that.'

KATE appears.

KATE: That will teach you to work through office boys.
Now will you listen to me? With your reputation
you're going to meet the Minister.

Part Five

*A cocktail party is being prepared. A wall with a brash-
coloured modern abstract 'flies in'.*

Couples are wandering on.

*ALFRED HARRINGTON, an industrialist, whose party this is,
steps up to ANDY and KATE. A waiter takes their coats.*

HARRINGTON: I can't understand why you bother with small
officials. A man with your reputation should have
demanded an interview with the Minister at once.
Kate, why did you let this man humiliate himself,
you of all people?

KATE: Give him time, Alfred – we inherited our
arrogance, manipulating people comes easy to us.

HARRINGTON: She's tough is our Kate. You have a good ally,
Mr Cobham. We train them well but they stray.
Look at him, you think we're cynical, don't you?
Not really. We recognize ability. I'd be ashamed
of myself if I allowed my politics to blind me to
ability. Ability coupled with guts is irresistible. I
don't like all the aspects of your Golden City, but
it's alive, dear boy, it's on fire. That's how I made
my fortune. I was on fire. To build dams across the
rivers and create the power for light seemed the
most marvellous thing in the world. I built forty of
them, forty of 'them. My own thin line of longitude,
right around the globe. I was on fire, like you.
You're on fire, I can see your eyes flash! And I can't
resist. You'll see the Minister, I'll take you there
myself. Yes! My own thin line of longitude, right
round the globe.

*HARRINGTON moves to other guests. A more ornately
moulded wall with a Constable-type painting is flown
in to cover the other wall.*

Part Six

*It is the more luxurious setting of the Minister's cocktail party.
The Minister of Town and Country Planning – REGINALD
MAITLAND – approaches ANDY and KATE.*

MAITLAND: My dear Mr Cobham, it's an honour to meet you.
Alfie Harrington has been speaking about your
plans for ages – it's taken so long for us to meet,
forgive me. Delighted, Miss Ramsay.

A waiter offers drinks.

ANDY: It's very kind of you, Minister. I'm happy our
project has gone so high as your good self.

*MAITLAND, since women are only appendages, ignores
KATE who moves away to listen from a scathing but
dignified distance.*

MAITLAND: I know you imagine the Conservative ministries to
be filled with hostile and reactionary diehards. It's

a convenient image for you people on the left to
hold, but the fact is we're all hardworking men, like
yourself, and in order to stay in power we just have
to have the country's interests at. heart.

KATE: You'll see us then?

MAITLAND: But of course I shall see you; I'd be foolish, not to
say rude, if I didn't make it my business to meet
and listen to the nation's most able minds.

HARRINGTON reappears with a new drink.

ANDY: I'm concerned to see this city built, Minister, and
since your permission is needed then I'll seek it and
be grateful to receive it.

HARRINGTON: I bet your colleagues on the left won't be so
grateful.

MAITLAND: The truth about the left, dear Cobham, is that it's
dreary – face it – it's dull, self-righteous, puritanical,
dreary. Always known what's wrong, of course;
poverty; bad housing, long working hours – basic,
simple criticisms. But it's taken: us on the right to
rectify those wrongs and a little more besides.

ANDY: Aye, under pressure, though.

MAITLAND: 'Aye,' he said: He still retains his dialect, charming,
Cobham, charming. I'm delighted to have met you.
Harrington?

*MAITLAND moves off calling HARRINGTON to follow
him.*

KATE: He's patronizing you. You don't feel it? Well learn
to feel it. Look at you, you want so much so badly
that you're leaping-at small favours. Raise your
head and stop smiling. or you'll begin to feel
you've won the moment they start confiding those
funny intimate stories about famous men of power.

HARRINGTON returns.

HARRINGTON: A shrewd man, that. Talks like a fool but acts with
unparalleled toughness.

KATE: Of course he's shrewd, he knows we've 'found our
first 25,000 inhabitants -

ANDY: – and deposited our first two million pounds.

KATE: There's a great deal of political gain in being benevolent to the left.

The party breaks up. All go off except ANDY.

The first of the 'building-site sounds' is heard: a pneumatic drill. It comes on loudly to establish itself then fades into the background where it will remain and be added to by other building-site-sounds as the play progresses. These sounds, each different and real, should pulsate: rhythmically, like a musical background.

Part Seven

Two scenes now happen together: the present interleaves with the future.

A Cathedral scene becomes a counterpoint to a Monday Meeting scene.

STONEY and PAUL join ANDY to address the 300th Monday Meeting.

THE YOUNGSTERS enter, playfully throwing a haversack from one to the other, chanting with each throw.

ANDY: The building has begun. Enough money has been deposited and, ladies and- gentlemen, the – building – has – begun.

YOUNG ANDY: Cities of light and shade.

ANDY: The land's drained.

YOUNG JESSIE: Secret corners and wide streets.

ANDY: The huts are up.

YOUNG PAUL: Cities for lovers, that frighten no one.

YOUNG JESSIE sits by catafalque, exhausted.

ANDY: Water supplies within easy reach, road and rail communications –

YOUNG STONEY: Cosy cities, family cities.

YOUNG STONEY sits by catafalque, exhausted.

PAUL: – and a countryside that's lovely, aye, lovely, lovely. Have you ever watched a city growing, ladies and gentlemen?

YOUNG PAUL: Cities for crowds and lone wolves.

YOUNG PAUL sits by catafalque, exhausted.

PAUL: Have you ever heard the hum of men building their own city?

The walls rise and the flowers blossom.

YOUNG ANDY: Cities with sound for the blind and colour for the deaf. Wheeee!

YOUNG ANDY, giggling, joins his exhausted and happy friends by the catafalque.

ANDY: No endless rows of dreary houses but a grand design, of steeples and spires and buildings at levels that soar and fall.

STONEY: The walls rise and the flowers blossom; the rubble turns to roads.

ANDY: Sixteen hundred homes a year;. ladies and gentlemen, that's our target.

PAUL: The rubble turns to roads and the dust from machinery settles…

ANDY: Sixteen hundred homes a year.

STONEY: …and the dust from machinery settles to reveal the slate and granite, the glass and cement and all the patterns men make for the pleasure of their living.

Part Eight

During these last seconds, three men take their places behind or near a desk. They are trade union leaders, members-of the General Purposes Committee of the T.U.C., TED WORTHINGTON, BILL MATHESON, BRIAN CAMBRIDGE. It is an office in the T. U.C. building.

PAUL and STONEY leave. ANDY remains.

MATHESON: (*Reading from a small notebook, jeeringly.*) and the dust from the machinery settles to reveal the...' what's this? Slate? 'the slate and granite', is it?

YOUNG ANDY: So there it is, in the harbour, and they keep it polished, waiting for an emergency, this vast organization of theirs, this 'BRITISH TRADE UNION MOVEMENT'! But that's all! And I don't know, but it seems to me that someone has to tell them: that ship can span every ocean there is, *every* ocean, look, and reach all corners of the world. It seems to me someone has to tell them that, and if we do – then they'll listen.

MATHESON: 'The glass and cement and – and – all the patterns men make for the pleasure of their living.' Yes, that's it, 'all the patterns men make for, the pleasure of their living.' Yes. Pretty words. That's what I heard. I made notes, pretty words. The 300th Meeting it was, I went to listen. Pretty words you and your artist friends make.

CAMBRIDGE: All right, Bill, don't let's start off with sarcasm, we've got business to attend to.

MATHESON: Oh, I'm not being sarcastic. Andy knows me, don't you, Andy? Our unions have worked together many a time, haven't they? He knows me.

ANDY: Aye, I know you, Bill Matheson, and I know you resent me.

MATHESON: Resent you? Resent you? You're sensitive lad – too sensitive. Why should I resent you?

CAMBRIDGE: We've got business, I said; now settle.

MATHESON: Resent you? Yes, I do bloody resent you. The old chimera, the good ole Utopian Chimera rearing its irritating little head again.

ANDY: Do I have to listen to him, Brian?

CAMBRIDGE: Settle, I said.

MATHESON: There's one turns up every five years, the good old Utopian.

CAMBRIDGE: So help me, Bill, I'll turn you right out of the bloody door if you don't come to heel.

WORTHINGTON: He's a bit sloshed, is our Bill Matheson tonight, a bit over the eight.

CAMBRIDGE: Andy, I don't suppose I have to tell you why we've called you, do I, lad? The General Purposes Committee have to try and make order of these thousand and one resolutions before they're placed in front of Congress and we want to discuss the resolution your Union's putting up this year.

MATHESON: For the fourth year, mark you – that's persistence, that is, you and your draughtsmen's union. You must have a good membership behind you – wish I could get my buggers to support everything I propose.

ANDY: Start proposing the right things.

CAMBRIDGE: Now cut it out, lads, for Christ's sake. You're like a couple of bitchy females. (*To ANDY.*) I don't suppose we could persuade you to drop the resolution for this year, could we?

ANDY: No, you couldn't.

CAMBRIDGE: I mean, the more times it gets voted down the more bored the delegates get. You know how the lads are at Congress time – all sorts of bloody moods.

WORTHINGTON: It's staggering what you've done, Andy, staggering; but what about the other five cities? How's them? How's their committees going?

ANDY: Not as advanced as us, they're held back, waiting to see what happens to us. But –

MATHESON: Six cities? We must be mad to even discuss it with him. Six cities and he's asking the trade unions to finance the industry in all of them. You'd bankrupt us in six months.

ANDY: Not true – and you know it. At the rate at which they'd grow, the profits of our city could finance the industry of another. We've worked that out to

the last detail – you've had the facts and figures for the last two years.

WORTHINGTON: Then why don't you build one city first and let the others follow?

MATHESON: Because one isn't enough. Because he wants the bloody glory of being a great revolutionary figure, don't you know? Haven't you--heard the name he's got? The silent revolutionary – that's what the papers call him, the silent revolutionary.

WORTHINGTON: Ignore it, Andy, pass it by, answer my question – why not one city first?

ANDY: Because the prospect of six cities is the prospect of a real change. One becomes an experiment and experiments are patchwork. Remember Owen?

MATHESON: Yes, we do. Owen, Robert bloody Owen. Responsible for shattering what little- trade unionism existed in those days – half a century wasted. We remember Owen all right.

WORTHINGTON: You're a fool, Bill Matheson, no education. You know your trouble, don't you? You really believe in profits.

MATHESON: Right! You're dead right. I've said it in public and I'd say it here. It's human, the desire for profit is basic to the human mentality and the sooner we acknowledge it the sooner we'll get industrial peace. Owenites, that's what this lot is, Owenites, and they're going to shatter us again, I'm warning you, with-their six Golden bloody Cities.

CAMBRIDGE: Don't be daft, Bill, he didn't ever seriously think he'd see six cities in his lifetime – did you, Andy? Not seriously. I mean that's a bit of bargaining power you've set up, isn't it? Give way on the other five and get your way on one? A bit of market bargaining, eh?

ANDY: Now watch it, Brian, you're patronizing me. I've had enough of being patronized. Just state your position and don't play politics. I'm a tough hand and I don't need softening up, just state your case.

CAMBRIDGE: You're right, Andy, you're right. You have to face so many nitwits on this committee that I use diplomacy when it's not needed. I should have known better, I'm sorry. I'll put it fair and square. For the last three years the General Council have advised Congress not to vote in favour of financing industry in the six cities. Now I'm not saying the General. Council would ever recommend Congress to finance even one city, but it's bloody certain they can't consider six. If you want the scheme to make sense at all, then drop the other five.

ANDY: Drop them?

WORTHINGTON: Drop them, Andy, drop them. Build one of your cities, and change the resolution accordingly. You don't stand a snowball's chance in hell of getting Congress to vote money for six.

ANDY: Drop them?

CAMBRIDGE: Drop them?

Pause.

ANDY: But for one?

CAMBRIDGE: But for one – I'll tell you frankly. Your project has focused attention on the constitutions of nearly every trade union in the country –

WORTHINGTON: – and nearly every constitution declares its fervent aim as being the final take-over of the means of production –

MATHESON: – which everyone has forgotten – thank God –

CAMBRIDGE: – until now.

ANDY: And now the General Council are embarrassed?

CAMBRIDGE: And now the General Council are embarrassed. The success you've been having has embarrassed them. They'll have to decide something.

Pause.

ANDY: Can you guarantee they'll decide to recommend the financing of industry in one city?

CAMBRIDGE: Andy lad, for Christ's sake. You know I can't guarantee a thing like that.

ANDY: I'm really being pushed to the wall, aren't I?

CAMBRIDGE: I'd say you were being given a way out. You've now got the possibility of making one city work; before, there was the possibility of nowt. Think on it.

ANDY: I'll think on it.

MATHESON: Ha! he'll think on it!

WORTHINGTON: Oh give it a rest Bill Matheson, will you? Andy, a resolution last year called for us to make an investigation into the type of housing estates that the Government and local councils are building. You're a personal friend of the Minister now, you'd be a great asset, would you sit on the committee?

MATHESON: That's it, give him another job, he's got broad shoulders, he's a bloody hero; a silent revolutionary – don't you know.

WORTHINGTON: Take him home Brian, for Christ's sake.

CAMBRIDGE: Come on, Bill, you're like an old grandmother these days, have another drink, put you out of everybody's way.

MATHESON and CAMBRIDGE leave. WORTHINGTON is half may out as PAUL, KATE, STONEY loom in like presiding judges. It is the Golden city office.

Part Nine

WORTHINGTON: By the way, lad, have you ever stopped to consider what'll happen if industry couldn't be set up in the way you want it? You'd have six cities built and an army of unemployed smouldering in them. Think on it! (*Exits.*)

ANDY has his back to his three comrades.

KATE: So, they offered you the glory of another fact-finding committee, did they? Asked you to compromise with one voice and told you they

loved and needed you with another. Clever. Clever
boys. What was your answer? (*No reply.*) Andy,
what was your answer? (*No reply.*)

PAUL: What did you tell them, Andy?

STONEY: You didn't agree?

KATE: Leave him answer.

PAUL: Andy, you didn't agree, did you?

KATE: Leave him answer, I say.

STONEY: But he couldn't agree. There's five other
committees, they've got sites, all that work, those
architects, all that money invested –

PAUL: They didn't promise to finance even one city.

STONEY: Haven't we compromised enough, Andy?

PAUL: Or shall we compromise even on our self-
deception?

ANDY turns to them.

STONEY: My God, how old you look just now.

ANDY: How old we all look. We'll be very old soon, boys.

KATE: Andrew Cobham, when Brian Cambridge asked
you to drop the five Golden Cities, what did
you say?

Pause.

ANDY: (*Defiantly.*) I said – aye.

*The building-site sounds rise. The ominous thumping
of the petroldriven rammer is added to the drilling.
PAUL walks to a part of the office where there are six
rolled-up plans. He takes two and tears them in half
and leaves. STONEY does the same with three-others
and also goes. YOUNG PAUL and STONEY wander off,
wrapped in their own discussions. ANDY withdraws
the last plan from the basket and unfolds it. The sounds
fade low. Now YOUNG ANDY takes his YOUNG JESSIE
off in another direction. YOUNG PAUL's tone is happily
confident; OLD ANDY's is melancholic.*

YOUNG ANDY: (*Echoed, by ANDY.*) It'll be a beautiful city. They'll
own their houses, work in their factories and

there'll be time for all that lovely living. It'll be a
beautiful city.

*The youngsters have gone. ANDY hands the last roll to
KATE. He moves to kiss her face. She turns away. He
sadly leaves her. KATE glances dejectedly at the plan.
She sits. Utterly spent. Almost near tears.)*

KATE: It'll be a beautiful city.

Have you ever watched a city growing, ladies and
gentlemen? Have you ever heard the hum of men
building their golden city? The walls rise and the
flowers blossom; the rubble turns to roads and
the dust from machinery settles to reveal the slate
and the granite, the glass and cement, and all the
patterns men make for the pleasure of their living.

MAITLAND enters.

MAITLAND: …and all the patterns men make for the pleasure of
their living. You all make lovely sounds when you
talk about your city, lovely sounds. Why have you
called me, Kate?

KATE: You know why.

MAITLAND: Are you snapping at me, Kate Ramsay? I know it's
favours and help you want but I've been friend to
you all for long enough now not to be resented.

KATE: You must speak to Andy again. Offer to bring
industry to the city.

MAITLAND: Have the unions turned down the resolution?

KATE: The unions, the unions! The unions would have to
empty half their coffers for such an enterprise.

MAITLAND: He won't bless you for urging this compromise.

KATE: Compromise? What compromise? That the
workers won't own the factory they work in? As
if it makes much difference whether they own the
machine or not, they'll still hate it. Do you really
imagine I ever believed such things would make
a city golden? It'll be beautiful – enough! There'll
be no city like it in the world. They'll come from

the four corners – it'll be beautiful and that will be enough.

MAITLAND: When will they decide?

KATE: Congress will vote in four months' time. Andy still thinks they'll vote in favour after ten years – I know they won't. His 'life-long' boys! He's become so obstinate he can't find the strength to be honest.

MAITLAND: He won't listen to me, Kate; secretly he's always been suspicious of a right-wing Minister like me being around.

KATE: No, he's honest about you. He used to say, 'Old Maitland's earning a place in posterity, he wants to buy a piece of heaven and God's good will, and the Golden City will earn him a pass straight through the pearly gates.'

MAITLAND: Now he says?

KATE: 'Why shouldn't he buy his piece of heaven?' That's what he says now. 'Let him buy his pass, I've tried to buy mine.'

MAITLAND: I'll talk to him. After all, Kate, the city grows, the people in the city own their houses, the spirit of the place belongs to them and the co-ops have taken over most of the commerce. That's good, isn't it? He can't complain about that. But you're right. He needs heavy industry and only my 'lifelong' boys can provide that. He's got no alternative. Only you know, Kate, I can't do it alone; I can bring *some* money to the place but other people like Harrington will have to be involved.

KATE: Involve them.

She leaves, defiantly, MAITLAND following.

MAITLAND: I can't say I shall look forward to speaking to him. He'll snap. He snaps all the time. You all snap – been at it too long, Kate. All of you, a whole lifetime. He'll snap.

Building-site sounds rise. Add the shovelling of gravel.
JESSIE appears to polish some furniture. She is older
and weary – Everyone is older and weary.

Part Ten

We are in ANDY's study. Sounds fade low.

ANDY: (*Off.*) Nothing! I can find nothing in this house. A mess, it's all a great sprawling mess.

ANDY enters. He wears a dressing-gown and he coughs.

JESSIE: Screaming? Still screaming, Andrew Cobham. Do you want to stay in your sick-bed longer?

ANDY: I can't have Maitland come here and see me in a dressinggown – that jacket should have come back from the cleaners weeks ago, weeks.

JESSIE: Reggie Maitland is a Minister of Housing, he's a ruler, a manof power – he doesn't care. Now, sit in your chair, and I'll pour you a drink.

ANDY: You babble and fuss like an old washerwoman.

JESSIE: Do you want it neat or with soda?

ANDY: You *are* an old washerwoman.

JESSIE: I'll give you soda.

ANDY: And it's no good telling you. I tell you once, I tell you a dozen times, and still there's never a thing when I want it.

JESSIE: Heard from the office? How does the city grow?

ANDY: It grows.

JESSIE: What stage are you at?

ANDY: Stage? What would you know about a building stage?

JESSIE: You never talk, I have to squeeze words out of you. What stage are you at, I asked?

ANDY: Ten years have passed, it's two-thirds done – that stage.

JESSIE: Have all the people settled? They happy?

ANDY: Happy? Who knows? You can't leave misery behind, it comes with you. Ask their grandchildren.

JESSIE: And Paul and Stoney? Why do they stay away from here?

ANDY: They're tired. They work and they're tired. It's all routine now, they have private lives.

JESSIE: There was a time when your work kept you all together.

ANDY: You babble. You go on and on and you babble.

JESSIE: Friendship is a beautiful thing, you once said; people who share your – I'm sorry, I disturb you, don't I?

ANDY: Yes, you do.

JESSIE: I'm not much of a help to you, am I?

ANDY: Help? Help? You've mothered my children, you've kept my house, you cook, you mend – what other help can you give?

JESSIE: We don't even share walks to the smelly these days -

ANDY: Share, share! Everybody wants to share, everyone wants a bit of your peace or your love. Share? You share my bed.

JESSIE: (*Exploding.*) You've no right, Andy, you've no right. I can't add to your work, all right, I can see this, you point these things out, you keep on and on and pointing these things out, but you've no right to torment me.

I'm a good mother, you say, I cook, I mend, I even iron your shirts to your satisfaction, but – words, I can never find words. I'm not a fool; I've been made to feel it often enough, but I'm not a fool, even though I think you're right all the time, and – oh, if only I had the powers to argue and work it out – there's a wrong somewhere.

You said find your rightful place, I've found it. You said accept your limitations, I've accepted them – people should be happy with their limitations,

you said. Happy! Me, happy! My only reward is to be treated like a hired housekeeper instead of your wife.

ANDY: (*Softer.*) You babble, you babble, Jessie.

JESSIE: Don't you know what I'm saying? Don't you hear what I'm telling? I don't mind being inferior but I can't bear being made to feel inferior. I know I'm only a housekeeper but I can't bear being treated like one.

Wasn't it you wanted to treat everyone like an aristocrat? Well, what about me? I don't claim it as a wife, forget I'm your wife, but a human being. I claim it, as a human being. (*Pause.*) Claim? I'm too old to stake claims, aren't I? Like wanting to be beautiful, or enthusiastic or in love with yourself.

A pained, pained silence.

The city grows, you say?

ANDY: It grows.

JESSIE: And you're satisfied?

ANDY: Satisfied?

JESSIE: I shouldn't disturb you – rest.

JESSIE leaves.

Sounds rise slightly.

ANDY sits alone a while. MAITLAND enters. Sounds fade low.

MAITLAND: Andy, Andy – you're better then, good man, splendid. But you look morbid. You morbid?

ANDY: Morbid? I don't know. I just clench my teeth more, that's all.

MAITLAND: Holiday, take a holiday. I'll send you to a lovely spot I have in Greece. Go there, you don't know what pleasure it'd give me to offer you hospitality. Go there, Andy, go.

ANDY: I might, Reggie. I might at that.

MAITLAND: Excellent, excellent. Now then, I must be brief – I hate being brief, stupid life, never pausing for

friendship; not even for a sickbed, stupid life. Still, let me explain. Kate's told me, the unions won't play, will they?

ANDY: There's not been a decision.

MAITLAND: I know, Andy, I know, but expectations, you must think ahead; what if they don't? They've turned it down nine times, what if they don't?

ANDY: There's not been a decision. Kate had no right. They're my boys, they're my lifelong boys and they won't let me down.

MAITLAND: Andy, Andy. I want to see that city finished, you know I've helped it along and I want to see that city complete.

ANDY: They-won't-let-me-down!

MAITLAND: I've got a proposition – I've come to offer help Harrington can find one half of the industry you need – I can find the other. Don't scowl, man, I –

ANDY: Slow they are, slow and cautious – but sound. I've waited ten years and I can wait more –

MAITLAND: Oh, no, you can't, dear boy. Another year and you'll have unemployment on your hands, you know it, Andy, why be stubborn? We'll wait for Congress this year, of course we will. Do you think I wouldn't like to see the complete experiment work? I'm not a diehard, you know this; but that city is beautiful, beautiful, we've nothing like it in the country – do you think I want to see it abandoned to ruin?

ANDY: (*Maudlin.*) You see, Reggie, we've been at it for so long. I'd rather see it in ruins than make that compromise. Ruins don't matter, you can build on ruins, but future generations always want to look back and know that someone was around acting on principle. I want them to look back and know about me. I know you want it finished, you're a good man, but you mustn't ask me to make that compromise, not that one.

MAITLAND: But the architecture – future generations will want to look back at that too. That's a lifetime's work, that's a poet's work.

ANDY: I couldn't face myself, you see.

MAITLAND: Go to Greece. Go to the sun. You need the sun. Go to the sun and think about it.

ANDY: There's been no decision.

MAITLAND: We'll wait for it.

ANDY: When there's been a decision, I'll. think about it.

MAITLAND: We'll wait for it, we'll wait.

Part Eleven

MAITLAND leaves. Building-site sounds rise to crescendo. Add chugging of a tractor-engine. ANDY removes his dressing-gown to reveal a long white working-coat. The light grows and the scene becomes a magnificent abstract set of a building site.

ANDY stands and watches the scene change, listening to the howl of drilling, the whine of machines and the knock of hammers. Till now, we've built an image of the Golden City through words – now, visually, for the first time we must see and feel the magic and excitement of a city growing.

Two men in building helmets turn the pillars behind which is scaffolding – Others in helmets remove the sets of the study, and Monday Meeting office and position, to the rear, a card table, four chairs and a deep, plush chair.

Meanwhile, two others wait to receive a huge 'concrete' slab from above. The slab is positioned. It is now a banquet table. A waiter and liveried attendant 'begin' to lay the 'banquet' – glasses of champagne, bowls of fruit. But in to the earlier part of the scene, which is the building site, come BRIAN CAMBRIDGE and TED WORTHINGTON. All three stand, watch and listen. The sounds fade somewhat, but they still have to shout over them.

CAMBRIDGE: It grows, lad, it grows.

ANDY: Aye, it grows

WORTHINGTON: It's staggering what you've done, Andy, staggering –

ANDY: What's been decided?

WORTHINGTON: Not all you hoped for, Andy.

ANDY: What's been decided?

CAMBRIDGE: You didn't really expect them to vote in industry, you didn't really, did you? Private enterprise, let them do it, it's their job, not ours, Andy lad. Believe me, our own fights are enough. He didn't really hope for it, Ted

ANDY: I hoped and I didn't hope – but?

CAMBRIDGE: But something happened.

WORTHINGTON: A last-minute amendment that suddenly ran like wildfire round all Congress:

CAMBRIDGE: True, like wildfire, great enthusiasm, round all the lads.

ANDY: It was?

CAMBRIDGE: To sponsor the last ten thousand inhabitants on your books.

WORTHINGTON: And more.

ANDY: More?

CAMBRIDGE: To erect a second trade union centre in the Golden City.

WORTHINGTON: You've got another building to design, Andy.

CAMBRIDGE: You'd better get working again, hadn't you, lad?

WORTHINGTON: We want a fine building, the best of them all.

CAMBRIDGE: We'll fill it with paintings.

WORTHINGTON: And sculpture.

ANDY: And flowers.

CAMBRIDGE: Aye, and flowers.

Long pause. Then, limping up stage.

ANDY: Paul! Kate! Stoney!

CAMBRIDGE: What are you limping for, Andy?

WORTHINGTON: You hurt?

ANDY: My leg, didn't you know? I worked in the mines and one day the prop gave way and I used my leg instead, for five hours – till help came.

CAMBRIDGE and WORTHINGTON leave, used to this eccentric. ANDY strides downstage taking off his white coat to reveal an evening suit beneath.)

Paul! Kate! Stoney!

Two helmeted men come in to turn back- the pillars. One takes away ANDY's white coat. Eight GUESTS enter, four from each side, to the table, bringing their chairs behind which they stand. The WAITER brings on another, the liveried TOASTMASTER another. WAITER leaves. TOASTMASTER remains. ANDY calls again, like a man abandoned.

Kate! Stoney! Paul!

KATE and MAITLAND enter to take their place behind their chairs. TOASTMASTER strikes ground three times, with his staff. On third strike the building-site sounds switch off immediately. Lights change.

Part Twelve

It is the banqueting chamber of the Guildhall.

TOASTMASTER: My lords, ladies and gentlemen, prepare to receive your guest of honour.

ANDY walks slowly, with bows, to his place. at the head of the table. Applause.

He sits.

The guests sit.

The TOASTMASTER again knocks three times.)

My lords, ladies and gentlemen, pray silence for the Right Honourable Reginald Maitland, Her Majesty's Minister for Town and Country Planning.

Applause.

MAITLAND: My lords, ladies and gentlemen.

For those whose minds are mean, whose sense of
national pride is bankrupt, it will be considered
strange that a Minister of the right should stand
to pay tribute to a leader of the left. But a strong
nation is not made by mean and bankrupt men; for
this reason I have no hesitation in taking my place
here tonight to extend, across the political barrier,
a hand of sincere congratulations to one of our
country's most brilliant architects. We all know his
most famous and greatest achievement: for fifteen
years. I have watched and been proud to help,
where I could, the building of the – Golden City.
The Labour Movement can be proud of its son and
those of us in the opposition who have had to work
with him know – tough and resolute though he
was – that he was a man who could keep his word,
abide by agreements and not allow party politics
to interfere with what we all knew to be right for
the nation. And this nation, this proud little nation,
knows, has always known how to honour and pay
tribute to such men.

My lords, ladies and gentlemen, I give you – Sir
Andrew Cobham.

ALL: Sir Andrew Cobham!

SIR ANDREW rises.

Applause.

ANDY: My lords, ladies and gentlemen. I am too old now
to begin explaining and excusing the indulgences
I allow myself. If the country where I was born
and to whom I have given my best, sees fit to
honour me, then I must allow it to honour me in
the only way it knows how. Having spent a lifetime
bullying traditionalists in order to bring into being
a revolutionary project, it seems right to stop
bullying for a moment and share at least one of the
traditions of my opponents.

I suppose I will soon accustom myself to answering
to the name, Sir Andrew – we accustom ourself

to anything in old age. No, I mustn't be flippant,
I'm honoured; and I'd be churlish and ungracious
not to be – yes, churlish and ungracious not to
be. After all, the Golden City is built; there were
compromises but it's built, a hint, if nothing
else, of what might be. It would be churlish and
ungracious, (*He coughs.*) very churlish and foolishly
ungracious –

ANDY begins to cough violently.

*KATE takes him by the arm away from the table. The
set revolves slowly, the guests having risen to watch,
anxiously.*

*The card table, chairs and armchair come to rest. The
guests go, the banquet table is removed.*

*JESSIE appears. She and KATE remove ANDY's jacket
and help him on with his dressing-gown.*

*In walking from the banqueting table to the armchair,
ANDY stoops and becomes older. It is many years later.
It is ANDY's study.*

Part Thirteen

*Once he is seated in the chair, JESSIE and KATE face each other
from either side of it; KATE is holding his coat. JESSIE's gaze
challenges her right; finally KATE hands her the coat.*

JESSIE: (*To KATE.*) You shouldn't have treated me like a
hired housekeeper. You've damaged yourselves
now, haven't you? Both of you, for all time.

> *JESSIE and KATE leave. ANDY sits a long time alone.
> Finally –*

ANDY: I must stop clenching my teeth, I really must
try and prevent my teeth from clenching. Howl,
that's what I'd do if I opened my mouth – howl.
Unclench your teeth, you old fool you. But why
is it that I don't want to talk? Because I don't, you
know, not a word. One day – I know it – one day I
shan't even see people and then what'll happen. I
shall stay just still like, petrified, because I won't be

able to find a single reason why I should make one word follow another, one thought follow another. There, look, my teeth were clenched again. Do you know what depresses me? Men need leaders, that's what depresses me. They'll wait another twenty years and then another leader will come along and they'll build another city. That's all. Patchwork! Bits and pieces of patchwork. Six cities, twelve cities, what difference. Oases in the desert, that the sun dries up. Jake Latham, Jake Latham – ah, Jake Latham: My lifelong boys! *My* lifelong boys? Prefects! That's all; the Labour movement provides prefects to guard other men's principles for living. Oh we negotiate for their better application, shorter working week and all that but – prefects! They need them, we supply them.

Still, nothing wrong in that I suppose; a bargain! A gentlemen's agreement, understood by everybody. They let us build the odd Golden City or two, even help us and in the end – look at me!

I don't suppose there's such a thing as democracy, really, only a democratic way of manipulating power. And equality? None of that either, only a gracious way of accepting inequality.

JESSIE enters. She has some 'petitpoint' in her hand.

KATE, HARRINGTON and MAITLAND also appear and take their places at the bridge table.

Part Fourteen

Look again, they were clenched again. Unclench them. Silly old fool, you. Unclench them.

You shouldn't force people to dirty themselves. A man loves the world only when he loves himself, and what love do you have left for yourself, Andrew Cobham?

JESSIE: Talking to yourself again, Andrew Cobham. Yes, well, you always did, didn't you, old darling?

HARRINGTON: Has he been like this all evening, Jessie?

JESSIE: All evening and many evenings.

ANDY: (*Rising to join them at the bridge table, and whispering.*) They're good people, Jessie, all of them, you listen to me, good, good people.

He sits to play cards.

JESSIE Sews.

ANDY deals.

ANDY: You know, Kate, a girl came up to me after a lecture one day and she said, 'Sir Andrew' – she spat out the 'Sir' – 'Sir Andrew,' she said, 'I don't believe you. You said all the things I believe in but I don't believe *you.*'

MAITLAND: Concentrate on 'the game, Andy, you're my partner now you know.

ANDY: We don't really like people, do we? We just like the. idea of ourselves liking people.

KATE: (*Irritably.*) Play, Andy.

The set revolves slowly.

ANDY: One heart.

HARRINGTON: Double.

MAITLAND: Re-double.

KATE: No bid.

ANDY: Three hearts.

HARRINGTON: No bid.

MAITLAND: Four hearts.

KATE: No bid.

HARRINGTON plays a card.

MAITLAND now lays down his cards.

ANDY: Thank you.

Music. Tallis.

The screens have closed.

ANDY returns to armchair.

Part Fifteen

YOUNG ANDY and YOUNG JESSIE rush into the open space and from different directions. They look at each other, shrug, and rush off again in new directions. Within seconds, STONEY rushes in from another direction, and off again.

After another few secdnds, ANDY slowly returns.

YOUNG ANDY: I am as big as it. They build cathedrals for one man. It's just big enough (*Closes eyes.*) Show me love and I'll hate no one. Give me wings and I'll build you a city. Teach me to fly and I'll do beautiful deeds. Hey God! do you hear that? Beautiful deeds.

JESSIE and STONEY rush in.

YOUNG JESSIE: They've locked us in.

YOUNG STONEY: Whose idea was it to explore. the vaults? I knew we'd stayed there too long.

YOUNG JESSIE: They've locked us in.

YOUNG ANDY: I can't believe there's not one door open in this place.

YOUNG JESSIE: You and your stories about golden cities – they've locked us in.

YOUNG ANDY: I know there's a door open, I tell you.

PAUL wanders in, pretending he's nonchalantly inspecting the ceiling.

YOUNG STONEY: Have you found one?

YOUNG JESSIE: Is there – ?

PAUL keeps them in suspense.

YOUNG PAUL: I've found one.

YOUNG JESSIE: He's found one, he's found one – Paul's found an open door.

YOUNG ANDY: Right, my ragged-arsed brothers – mount your horses. (*PAUL and STONEY, one arm round each other's waist, bend forward and hold on to ANDY, who reaches one hand back to steady JESSIE who has mounted on the backs of the other two. They have a chariot.*)

We knew the door was open.

YOUNG JESSIE: How did you know, my ragged-arsed brothers?

YOUNG ANDY: Because we're on the side of the angels, lass

YOUNG JESSIE: – and are people good?

YOUNG ANDY: Aye – and people are good

YOUNG JESSIE: (*Whipping them.*) Giddy up, stallions. Forward, you ragged-arsed brothers – forward!

The heroic 'chariot' gallops off, leaving ANDY in armchair

Moonlight strikes through the coloured glass. Curtain.

END

THE JOURNALISTS

This is the eighth version of the. play, resulting from rehearsals for world premiere in Wilhelmshaven 10 October 1981.

QUOTATIONS

A journalist is stimulated by a deadline. He writes worse when he has time...

It is the mission of the press to disseminate intellect and at the same time destroy the receptivity to it...

The making of a journalist: no ideas and the ability to express them...

Truth is a clumsy servant that breaks the dishes while cleaning them...

KARL KRAUS, German satirist (1874-1936)

PUBLISHER'S NOTE

To obtain background material for this play, Arnold Wesker got permission to sit in on all the departments of *The Sunday Times*. An unplanned offshoot of his two-month research was a long essay called 'Journey into journalism', written in December 1971. Jonathan Cape's offer to publish the essay lead to confrontation. Certain journalists on *The Sunday Times* objected strongly to its appearance, and after an embattled, acrimonious correspondence which added some 10,000 words to the original slim document, Wesker felt honour-bound to withdraw his essay from publication until five years later he was given the go-ahead. It was published by *Writers and Readers* under the title 'Journey Into Journalism'; and later, together with the play and his diary of writing the play by Jonathan Cape under the general title of *The Journalists*.

About this misadventure, Wesker stated at the time, 'My journey into journalism was an unhappy one – an affectionate excursion which went sour… It's sad since I'd been very impressed with what I'd encountered in my eight weeks with them and thought I'd written a fair, serious and, though critical, yet affectionate piece. They didn't agree and so, since I'd obtained their co-operation for a play, I couldn't abuse it by publishing something they felt unfairly represented them.'

The Journalists is of course based on personal observation; but it is not a *pièce-à-clef* or simple documentary of *The Sunday Times* – nor is it the author's purpose that the play be misread as such.

Its scale of social and work relations and its elements of stage rhythm are in the best Wesker tradition already familiar to playgoers who applauded *The Kitchen* and the epic *Their Very Own and Golden City*.

INTRODUCTION

All drama is open to many interpretations. And they are made!

It is true that the writer doesn't perceive all the implications of his work, but equally true that the experience he's assembled in the order he's assembled it is intended to be evidence of one or a set of specific statements.

They may not be the only statements his work makes – it's in the nature of any assembled evidence that it will suggest the proof of different things to different men, but of all the possible statements a work makes – whether poetically or with a greater degree of prose – one will sound the loudest simply because the author has directed all the selection of his material into making it. One pattern will emerge the strongest because the author has delineated its shape with greater emphasis. What he has taken out in his various drafts he has taken out because he's said: that detracts from my theme, blurs my meaning.

When directors and actors interpret a play they are engaged in the act of discovering that one sound which is louder than the others, that one pattern which is stronger than the others.

Whatever sounds or patterns my audience will find in this work there is only one main one which I intended; may not have achieved but had hoped to.

The Kitchen is not about cooking, it's about man and his relationship to work. *The Journalists* is not about journalism, it is about the poisonous human need to cut better men down to our size, from which need we all suffer in varying degrees. To identify and isolate this need is important because it corrupts such necessary or serious human activities as government, love, revolution or journalism.

Swift wrote a novel which gave this cancerous need a name – Lilliputianism. The lilliputian lover competes with his (or her) loved one instead of complementing her. The lilliputian journalist resents the interviewee's fame, influence or achievement rather than wishing to honour it or caution it or seriously question it. The lilliputian bureaucrat (involved in the same process, but in reverse) seeks to maintain his own size by not acknowledging the possibility of growth in those over whom

he officiates; he doesn't cut down to size, he *keeps* down to size. The lilliputian revolutionary is more concerned to indulge resentments or pay off private scores than to arrive at real justice.

Thus government, love, revolution or journalism are time and time again betrayed. It is this with which my play is concerned.

ARNOLD WESKER
London, 24 January 1975

NOTES

THE SET

An impressionistic layout of the main offices of *The Sunday Paper*. There is a 'cut away' called The Centre Space where the action outside the offices is played.

In order that action and dialogue are evenly distributed over the stage area, the designer must pay careful attention as to which office is near which.

But however the rest is laid out, The News Room must occupy a large space, for most of the final activity goes on there.

To the rear is a screen upon which are projected the huge printing presses. At a point near the end of the play the projection is taken over by a film of the presses beginning to roll.

PRODUCTION

Activity must be continuous in all sections throughout the play while the plot weaves its way stopping here and there – sometimes for a lengthy exchange, sometimes for a few lines. Occasionally conversations will take place on the telephone between individuals from different offices.

While the audience focuses on one 'frame' (section) at a time, the orchestration of what happens *at the same time* in each remaining office is a director's problem. The following may help:

The rhythm of a Sunday newspaper office is one of a slow beginning at the start of the week (Tuesday) working up to an agitated flurry, which culminates at about six in the evening on the Saturday when the button is pushed to start the printing presses rolling for the first editions.

It is important, however, to remember this: it is a Sunday paper, not a daily one; therefore a lot of the pages will be laid out early on in the week. Many articles, indeed, have been set up weeks in advance. This means that not every department is hectic on the Saturday. For example the Arts Pages are well advanced, but Sport – which is waiting for stories of the Saturday matches – is frantic. The two real centres of Saturday's activity are The Stone – where the printers and journalists lay out the pages and make the last minute changes (this area is not shown); and

The News Room – where the editor and his closest advisers shape up, on blank sheets, the final product (this area is shown).

I have not indicated every action, but certain routine movements are continuous throughout – growing in intensity towards the end of the play, and the following actions can be drawn from to help the director in his orchestration:

Messengers taking copy from 'The Stone' or from one department to another.

Reporters writing or subs correcting copy at their desks. Journalists reading newspapers – endlessly! – or official documents.

Journalists in conversation in each other's departments.

Journalists shaving themselves with electric razors, women making up (could toilets be shown? they are constantly washing print off their hands).

A woman pushing a tea trolley is ever present; reporters flow to and from it for tea and sandwiches.

Reporters, secretaries at typewriters.

The constant making or receiving of telephone calls.

Individuals with special information being interviewed.

Clatter is continuous but, of course; volume of noise must be regulated or projection of dialogue will be a constant fight for the actors. Could it all be on tape? then actions could be mimed. I'm thinking particularly of typewriting.

Journalists are alert, fast-thinking and fast-talking individuals. The clue to achieving the right rhythm is to maintain a quick delivery of lines – but in the beginning to have long pauses *between departments* which become shorter as the play continues thus giving the impression of increasing activity.

When action takes place in The Centre Space the rest of the action and noise freezes.

TIME

This may be a problem since there are many assignments which are concertina-ed. It must be imagined that we are covering a week of five days *but* this week is also five weeks. That is to say we've taken our Tuesday from the first week, our Wednesday from the second week and so on. Time is therefore taking place on two planes, and some stories belong to the week, others to the five weeks.

The first professional presentation of The Journalists *took place on 15 June 1978 on French radio under the auspices of Lucien Attoun's France-Culture. Jugoslav TV presented a television version of the play, setting it in a T V house instead of a Sunday newspaper. The first production in the UK was an amateur one, given by the Criterion Theatre, Coventry, on 27 March 1977.*

The world premiere for the professional stage took place in Wilhelmshaven, West Germany, 10 October 1981, directed by Klaus Hoser.

The only professional performance in the UK, has been a reading by professional actors to raise funds for the Jacksons Lane Community Centre in Highgate which took place in the Centre's theatre once in the afternoon and again in the evening of 13 July 1975. The following was the cast:

MARY MORTIMER Sheila Allen

HARVEY WINTERS Ian McKellen

CHRIS MACKINTOSH Sebastian Graham Jones

JULIAN GALLAGHER William Hoyland

PAUL MANNERING Michael Mellinger

HARRY LAURISTON Dave Hill

MARTIN CRUIKSHANK David Bradley

ANTHONY SHARPLES Gawn Grainger

MORTY COHEN Oliver Cotton

DOMINIC FLETCHER John Hug

JANE MERRYWEATHER Katherine Fahy

ANGELA GOURNEY Janet Key

SEBASTIAN HERBERT Bernard Gallagher

JOHN PROSSER Hugh Thomas

ERNST GUEST Brian Badcoe

RONNIE SHAPIRO Harry Landis

MARVIN MCKEVIN Jim Norton

GORDON FAIRCHILD John Bennet

TAMARA DRAZIN Lisa Harrow

NORMAN HARDCASTLE Brian Cox

CYNTHIA TREVELYAN Gillian Barge

SECRETARY Liz Hughes

PAT STERLING Jennie Stoller

SIR ROLAND SHAWCROSS Robert Eddison
RT HON. GEORGE CARRON Mark Dignam
SIR REGINALD MACINTYRE Peter Jeffrey
OLIVER MASSINGHAM John Gill
A FINK Jonathan Pryce
AGNES Cheryl Campbell
JONATHAN David Yelland
DESMOND Andrew Byatt
MAC SMITH Fulton Mackay
MESSENGERS, SUBS, ETC.
Lindsay Joe Wesker
Arnold Wesker

Director Michael Kustow
Designed by Hayden Griffin
Lighting by Rory Dempster

Characters

MARY MORTIMER *a 'columnist'*
HARVEY WINTERS *the editor*
CHRIS MACKINTOSH }
JULIAN GALLAGHER } *journalists on In Depth*
PAUL MANNERING *News editor*
MARTIN CRUIKSHANK *News reporter*
ANTHONY SHARPLES *Business News editor*
MORTY COHEN *Business News journalists*
DOMINIC FLETCHER }
JANE MERRYWEATHER } *Women's Pages journalist*
SEBASTIAN HERBERT *Arts Pages editor*
ANGELA GOURNEY *Assistant Arts Pages editor*
RONNIE SHAPIRO *Sports editor*
MARVIN MCKEVIN *Assistant Sports editor*
GORDON FAIRCHILD *Foreign editor*
TAMARA DRAZIN *a foreign correspondent*
NORMAN HARDCASTLE } *journalists working in*
CYNTHIA TREVELYAN } *Political and Features*
SECRETARY *to the Editor*
SECRETARY *in the News Room*
PAT STERLING *a freelance journalist*
SIR ROLAND SHAWCROSS *Minister for Social Services*
RT HON. GEORGE CARRON *Minister for Science and Technology*
SIR REGINALD MACINTYRE *Chancellor of the Exchequer*
OLIVER MASSINGHAM *Under Secretary of State – Foreign Affairs*
A FINK *a man with 'secret' information*
AGNES }
JONATHAN } *sons and daughter of Mary Mortimer*
DESMOND }
MAC SMITH *a trade union official – Municipal and General* MESSENGERS, SUBS, REPORTERS

Act One

Part One

THE CENTRE SPACE

MARY MORTIMER is interviewing SIR ROLAND SHAWCROSS, MINISTER for Social Services, in his office. There's a tape recorder on the desk.

SHAWCROSS: And that, Miss Mortimer, is precisely what democracy is: a risky balancing act. The delicate arrangement of laws in a way that enables the state to conduct its affairs freely without impinging upon the reasonable freedom of the individual. Tilt it too much one way or the other and either side, state or individual, seizes up, unable to act to its fullest capacity.

MARY: But surely, Minister, with respect, you must agree that the *quality* of democracy doesn't only depend on the balance of freedom which our laws create between the individual and society, does it?

SHAWCROSS: By which you mean?

MARY: By which I mean that you may give the letter to the law but ordinary men are forced, daily, to confront the depressing petty officials who interpret those laws.

SHAWCROSS: Go on.

MARY: I could go on endlessly, Sir Roland.

SHAWCROSS: Go on endlessly. I don't see your question yet.

MARY: Well, I'm rather intimidated about going on, you've said these things much better than ever I could.

SHAWCROSS: Be brave.

MARY: All right. Great wisdom and learning may be required to *conceive* statutes but who expects great

wisdom and learning in officials? And the ordinary
man meets *them* not *you*. He faces the policeman, the
factory superintendent, the tax-collector, the traffic
warden – in fact the whole gamut of middle men
whose officious behaviour affects the temper and
pleasure of everyday life.

SHAWCROSS: And your question is?

MARY: What concern do you have for that?

SHAWCROSS: For the gap between the law maker and the law
receiver?

MARY: No, with respect, I'd put it another way. For the
change in the *quality* of the law which takes place
when mediocre men, are left to interpret it.

SHAWCROSS: That sounds like a very arrogant view of your fellow
creatures, Miss Mortimer.

MARY: Sir Roland, forgive me, I must say it, but that's
evasive.

Intercom buzzer rings.

VOICE: Your car in fifteen minutes, Minister.

SHAWCROSS: Thank you. (*Pause.*) Miss Mortimer, our first hour
is nearly up. Tomorrow you're dining with us at
home – it is tomorrow, I think? We can continue
then. But for the moment I'd like to speak off the
record. You've created a very unique reputation in
journalism. Rightly and properly you're investigating
the minds and personalities of men who shape
policy. And you're doing it in depth, in our offices,
our homes and on social occasions. I'm surprised
so many of us have agreed and perhaps it will
prove a mistake. We'll see. But there are aspects
of government which it's obviously foolish of us to
discuss in public no matter how eager we are to be
seen being open and frank. I'm not evasive but, to
be blunt, some of my thoughts are so harsh they
could be demoralizing. Ha! you will say, that is the
part of the man I'm after. But I often wonder, how
helpful *is* the truth? You're right, the ordinary man
must face the numb and bureaucratic mind. Our

best intentions are distorted by such petty minds.
But that can't really be my area of concern, can it? I
might then be forced to observe that the petty mind
is a product of a petty education. Should I then go
to complain to the Minister of Education? He might
then say education is only *part* of the, influence on a
growing person – there's family environment to be
considered. Should he then interfere in everyman's
home? No, no, no! Only God knows where wisdom
comes from, you can't legislate for it. Government
can only legislate for the *common* good; the *individual*
good is, I'm afraid, what men must iron out among
themselves. But I don't *act* on those thoughts. My
attempts at legislation are not less excellent because
I doubt the excellence of men to interpret them. So,
which truth will you tell? That I aspire to perfection
of the law? That I mistrust the middle men who must
exercise that law? Or will you combine the two?
The first is pompous, the second abusive, the third
confusing.

MARY: And you don't think people would respond to such
honesty?

SHAWCROSS: No! Frankly. Most people can't cope with honesty.

MARY: With respect, Minister, but that sounds like a very
arrogant view of your fellow creatures.

SHAWCROSS: Ha! (*Pause.*) We'll continue, we'll continue. I must
leave.

Both go to door which he holds open.

And it's not necessary to keep saying 'with respect',
Miss Mortimer. Do you enjoy saying it? Funny thing,
but people enjoy saying things like 'your honour'
'your Majesty' 'with respect' 'your highness'…

Now the offices of The Sunday Paper *burst into
activity.*

EDITOR'S OFFICE

HARVEY WINTERS, the Editor, dictating to secretary.

HARVEY: '...And so, you ask, "Where do the best minds go?
Not into politics or the civil service", you say "there's
no role for this country to perform – instead they
go into journalism and the mass media". Journalism
as an act of creating selfawareness in society! The
best minds don't want to legislate or exercise power
so, they comment! Good! And for that very reason
I believe it matters intensely the way newspapers,
radio and television report and comment on race
relations. In Britain, Television News has been an
offender – no, a gross offender; the interviewer asks
people in the street what they think and the weirdest
notions of reality are listened to with -the respect
accorded to truth, as if the electronic marvel of it all
sanctified the instant communication of ignorance!'
(*Phone rings.*) Bloody hell! I'll never finish those
letters. No calls after this. Hello, Winters.

*It's ANTHONY SHARPLES, editor of Business News
Section.*

ANTHONY: You rang?

HARVEY: Tony, yes. I want you to do something on women in
the Stock Exchange.

ANTHONY: Love to.

HARVEY: I was thinking of a light-hearted leader, not an
occasion for solemnity.

ANTHONY: Indeed not, no, indeed. Something about 'can the
dirty joke still be told on the floor?' How many
words?

HARVEY: About 450?

ANTHONY: Done.

IN DEPTH

Two journalists: CHRIS MACKINTOSH, JULIAN GALLAGHER.

CHRIS: (*Tearing sheet from pad.*) Falling bloody bridges! This subject must have priority over something though God knows what.

JULIAN: (*Banging on phone receiver.*) Hello? Hello? Blast! Going through to someone else. (*To CHRIS.*) Here's that couple of quid I owe you.

BUSINESS NEWS

This is a large section, only part of which we see, the rest tails off stage. Three journalists: ANTHONY SHARPLES, MORTY COHEN, DOMINIC FLETCHER.

DOMINIC: (*Who's been listening on a phone, shouts, off-stage.*) There's a stringer here says that the Transport and General Workers' Union in the north have an eccentric official who's bored with head office contracts. He insists that every new contract he draws up has to have an original clause in it and this time he's insisted that every man get a day off on his birthday. Anybody interested?

VOICE: (*Off stage.*) Try Features.

DOMINIC: (*Into phone.*) An incredibly stupid suggestion from one of my colleagues to try Features.

EDITOR'S OFFICE

MARY knocks and enters.

SECRETARY: Good God! How triumphant she looks.

MARY: They're going to work.

HARVEY: What was he like?

MARY: Shrewd, evasive and charmingly civilized.

SECRETARY: She's obviously enjoying herself.

MARY: Loving it.

SECRETARY: Why, Mary Mortimer, you're even radiant.

MARY: Don't I deserve to be? l worked bloody hard to set up those interviews and they're all going to happen.

HARVEY: We all worked hard –

SECRETARY: – had to pull strings you know. The notorious side of your brilliance isn't the most helpful key for opening the doors of power.

MARY: He's got the best journalist on Fleet Street working for him, stop complaining.

SECRETARY: You'll not expect me to do that.

IN DEPTH

CHRIS: I don't know why the bloody bridges fall down. I don't even know why they keep up.

JULIAN: (*Pointing to pile of documents while hanging on to a phone.*) By the time we read through this lot we'll be able to build them ourselves. Hello hello HELLO!

CHRIS: Have you got hold of anyone yet?

JULIAN: Going through to someone else now. Hello? Press office? At last. It took five people to get to you. Julian Gallagher, *The Sunday Paper* here. These bridges that keep falling down. Is your ministry making a statement yet?

EDITOR'S OFFICE

HARVEY: You getting your ministers to talk on the science versus politics issue?

MARY: I'm free ranging over everything.

HARVEY: Because I want us to build up a body of comment on that issue and your profiles will be central.

MARY: It's not easy. Not everyone sees the future as you do in terms of science versus politics.

HARVEY: We'll help them then.

MARY: And I trust you're planning to plaster the Saturday screen with the maximum spots?

HARVEY: Don't teach your granny to suck eggs.

MARY: Even granny's male pride is a little punctured, isn't it?

HARVEY: And don't draw me into your emancipation wars, love.

MARY: Confess. Liberated though you may be, Harvey Winters, women do not a paper make. Confess.

HARVEY: I'm not biting. Now be a good girl and go. Look! Letters!

MARY: I'm going. Got me laundry spinning round the corner.

ARTS PAGES / WOMEN'S PAGES

An office with two journalists from Arts Pages, SEBASTIAN HERBERT, editor, and ANGELA GOURNEY; shared with editor of Women's Pages, JANE MERRYWEATHER:

JANE: (*Just entering with mocked-up sheets.*) Not a very inspiring week's work, is it? An article about women's bums, one about two awful designers who make men's suits for £150 each and another about wild tea-drinking parties.

ANGELA: Women are only supposed to be able to write about boys and knickers. Stop complaining or cross the frontiers to us on the Arts Pages.

SEBASTIAN: Where she still might find the literature to be about women's bums and knickers.

IN DEPTH

CHRIS: Do I want a cigarette? Yes I do want a cigarette. (*Reaching for packet.*) No I don't want a cigarette. Bridges! Christ! What a come down for In Depth.

POLITICAL AND FEATURES

Two journalists: NORMAN HARDCASTLE, CYNTHIA TREVELYAN.

CYNTHIA: Look at these photographs. We've created a monster.

NORMAN: Aargh! The maimed, the dead, the diseased –

CYNTHIA: – and the starving. Look at them.

NORMAN: Someone must do them but I don't want to look at them.

CYNTHIA: And I can't get him to snap anything else now. 'Where the violence is, send me there,' he says.

NORMAN: You've encouraged a morbid squint in his eye.

EDITOR'S OFFICE

HARVEY: What's on today?

SECRETARY: You mustn't forget to speak to Chris Mackintosh about the collapse of Atlantis Insurance.

HARVEY: After the eleven o'clock.

SECRETARY: After the eleven o'clock. Then lunch with Morgan King MP.

HARVEY: The new fiery socialist superstar.

SECRETARY: The very same. Then the boss wants you at five.

HARVEY: Can't see myself in a fit state for him after three hours of wine and fiery socialism.

POLITICAL AND FEATURES

CYNTHIA: When he first came here he could hardly talk. Just threw his photographs on the desk and asked could we use them. In those days I pretended ugliness had poetry. Look at them. Not even pity, is there? 'This is how it is!' And every time he comes in with a new batch of evidence about cruelty it shows in his own features. Bloody hell, they make me feel so wretched!

NEWS ROOM

SECRETARY, who spends most of her time answering the phone, taking down messages and handing themm to the News Editor, PAUL MANNERING. A reporter, MARTIN CRUIKSHANK.

MARTIN: (*Waving newspaper.*) Another cutting to give to the honourable Miss Mary Mortimer for her Morgan King MP file.

SECRETARY: Where's he been speaking this time?

MARTIN: Humbermouth. Quote: 'Opening the town hall in the latest new town of Humbermouth, Mr Morgan King, the socialist M P for New Lanark, upset councillors by attacking what he called "the dead spirit of the place". In a speech which can't have endeared him to the town's architect he said: "But where is your town's spirit? This town hall? A building where functionaries meet to organize your rates and drainage problems? Surely," the fiery MP for New Lanark continued, "a town's heart is its concert hall, its swimming pool, libraries, meeting places, its gardens; where are they?"'

PAUL: Splendid. I've no doubt the bitch'll go to town on that one.

POLITICAL AND FEATURES

NORMAN: Jesus! I've got a lump in my throat.

CYNTHIA: Give up smoking.

NORMAN: It's all right for you to be flippant.

CYNTHIA: Who's flippant? You got a lump in your throat so stop smoking.

NORMAN: You also think it might be cancer?

CYNTHIA: Norman, for God's sake.

BUSINESS NEWS

DOMINIC: So I charms into me lap the lovely tennis player, who's also rich, privileged and American, and says to her, 'Ho hum, you think that now you're in my arms I'll not put out, that story?' 'But,' she says, 'I thought you were a business journalist not a sports reporter.' 'I am I am,' says I, 'but,' I pretend to her, 'the lesbian love affair of a famous Wimbledon player is too good for any kind of journalist to let slip.' With which she jumps out from the comfort of my ample thighs and cries, 'It's a terrible profession, terrible! Have you no standards?' 'Standards?' I say. 'Profession?' I say. 'I don't believe journalists have a profession. I don't know what that profession is anyway. And certainly they don't have any standards. It's the law of the jungle!' I cry, 'and not a very colourful one at that!' But, soft Irish nit that I am, I relent and in the end swop my silence for a night in the net – in a manner of speaking.

EDITOR'S OFFICE

NORMAN visiting.

NORMAN: How about letting me take a look at the guerrillas in the Middle East?

HARVEY: Climate's rotten. You know you catch whatever disease is in the air.

NORMAN: I'm serious, Harvey.

HARVEY: So am I.

NORMAN: You haven't got a better person in this paper to do it.

HARVEY: Bloody hell! The egos in this building.

ARTS PAGES / WOMEN'S PAGES

JANE: I'm not used enough. I ought to be more provocative instead of practical. 'Down with children' not 'Cheap canvas chairs from Chelsea'. 'Down with children'.

'Must mothers of handicapped children be martyrs?'
That sort of thing. Dammit! I'm paid well enough.
I want to be stretched. (*With its double entendre.*) I
luuuuve being stretched.

EDITOR'S OFFICE

HARVEY: (*On the phone to CYNTHIA.*) Cynthia, is Norman
nearby?

CYNTHIA: No.

HARVEY: He having problems with his wife?

CYNTHIA: Afraid so. Why?

HARVEY: He's pressing me about going abroad again.

CYNTHIA: Guerrillas in the Middle East?

HARVEY: The same. What's his illness this week?

CYNTHIA: Cancer of the throat.

HARVEY: Bloody hell! I'll talk to Gordon.

SPORTS PAGES

*RONNIE SHAPIRO, Sports Editor. MARVIN MCKEVIN, his
assistant.*

RONNIE: Fascist! That's what it is. All sport is fascist activity.
I've just realized.

MARVIN: Only just?

RONNIE: Governed by rules against which there's no appeal.

MARVIN: You've been talking to too many referees.

RONNIE: I mean apply them to a democratic society and they
wouldn't hold up for ten seconds.

MARVIN: How about taking over the Arts Pages for six
months?

RONNIE: And what's more fascist than all that crap. about
healthy body healthy mind?

MARVIN: And character being built on the playing fields of
Eton?

RONNIE: All balls. What character, that's the point. The Arts
Pages? I'd love to.

ARTS PAGES/WOMEN'S PAGES

SEBASTIAN: It's 9000. Last year we received 9000 books to
review of which we succeeded in covering roughly
one fifth – nearly two thousand in fact.

JANE: Is that good or bad?

SEBASTIAN: Very good, my girl. What, 1900 books in 52 weeks?
Work it out.

JANE: You work it out.

SEBASTIAN: I will, I will. That's let's see, 52 into 340, six – that's
roughly 36 books a week which, although many are
reviews in brief, is pretty good going. Yes, very good
I'd say.

EDITOR'S OFFICE

GORDON FAIRCHILD of Foreign Department visiting.

HARVEY: I'd like the research to begin now, Gordon. Go right
back to the thirteenth century, who was Islamized,
which minorities remained, the role of Imperial
England in protecting them, why did they survive,
how many guerrilla groups can be identified, and
what part did the Secret Services play?

GORDON: What about the power of the priests?

HARVEY: Right! You can give a breakdown on the sects as
well.

GORDON: I'm thinking of something more on the lines
of 'linking the massacres to the religious
rabble-rousers.'

HARVEY: Too big. It's a separate piece.

GORDON: But central, don't you think?

HARVEY: I know that priests everywhere have a lot to
answer for and one day we'll write it – something

for Tamara perhaps – but not now. This massacre's
enough. O.K.?

GORDON: As you say.

> *We watch* GORDON *move to Foreign Department
> and for the first time pause in dialogue to absorb
> the scene.*

FOREIGN DEPARTMENT

*TAMARA DRAZIN, foreign correspondent. GORDON, just
entering.*

GORDON: Harvey wants us to keep going at our Middle East
war.

TAMARA: (*With irony.*) He's not afraid of 'boring' our readers?

GORDON: Even if it does.

TAMARA: Small blessings.

GORDON: And I agree with him.

TAMARA: And I'm sick. Look at *it*. (*Indicating telex reports.*)
For what? What in this world is worth such savage
slaughter?

GORDON: Keep cuts to a minimum then.

TAMARA: Cut it? I want to weep on it.

ARTS PAGES / WOMEN'S PAGES

JANE: Do you know what Mary said to me when I first
came to work here? 'If you're young and in charge,'
she said, 'and you want to deflate an old journalist,
my advice to you is this: when she – or he – brings
his piece to you, you flip through it and then throw it
on the desk and say – well, honestly, I didn't expect
you to show me something like this.'

ANGELA: That sounds like our Mary. What made you think of
that?

JANE: Don't know. Remember the time I invited the
politicos to our ideas luncheon and we ended up

giving *them* ideas? Well, I gave the idea for those
in-depth interviews of cabinet ministers to Norman
and – well – oh, I don't know. Credit grabbing is one
of the sicknesses of this profession. Takes it out, of
you.

FOREIGN DEPARTMENT

*TAMARA is cutting out her clippings and pasting them in
her book.*

TAMARA: Look how full my scrap-book's getting.

GORDON: I've an idea which I put to Harvey and he likes.

TAMARA: Do you know why we all keep scrap-books of our
little bits and pieces?

GORDON: It's a serious long term project for you, listen to me.

TAMARA: So that in twenty years time we can say 'Look! I was
right. Here it is. In print!'

GORDON: An in-depth probe into, the power of the priests.
Something on the lines of linking massacres to the
religious rabble-rousers. The priests have a lot to
answer for, you know.

TAMARA: What priests? There are priests and priests.

GORDON: All dogma begins with the priesthood. And where
there's dogma there's massacre.

TAMARA: I'm not fit, Gordon, believe me, I'm not fit.

NEWS ROOM

PAT STERLING, a freelance, talking to PAUL.

PAUL: I don't think it's our story, Pat, not really. Aren't girls
of twelve having abortions all the time?

PAT: But this one had been refused by a National Health
Service gynaecologist. Some shrivelled-up old hag.

PAUL: We can't help being shrivelled-up old hags, you
know, and isn't it all over anyhow?

PAT: That's why you can print the story.

PAUL: And the poor child's had her abortion privately?

PAT: If you play adult games says this gynaecologist, 'you must expect adult consequences'.

PAUL: Awful, yes, I know, terrible story. Have you tried the *News of the World?*

PAT: Don't you just *know* what they'd do with it?

SECRETARY: The eleven o'clock in five minutes, Paul.

PAUL: (*Assembling papers.*) I'm sorry. (*Leaves.*)

PAT: (*To SECRETARY.*) Your paper will, print this story. I'll find the right door. Sooner or later.

FOREIGN DEPARTMENT

GORDON: Perhaps you should see a psychiatrist.

TAMARA: Uch! They're so immodest. They imagine every distress is curable, everything can be explained!

GORDON: Did you know I was under one for three years?

TAMARA: 'The fault of the past!' Such awful presumptions. They're too arrogant to acknowledge there's such a thing as *endemic* despair and you can't *pay* to have *that* cut out. It's something you're born with.

GORDON: Or something you have if you can afford it.

TAMARA: That's a crude observation.

NORMAN: Really now? Crude to observe that the starving child can't afford to reflect on life's hopelessness?

TAMARA: Ah ha! The starving child. He had to be brought in.

GORDON: Don't sneer at the starving child, my dear. Without him you'd have no endemic despair to enjoy.

TAMARA: Demagogue!

GORDON: Scorn not the man who doth attempt alleviation of man's ills.

TAMARA: Scorn such a man I do not. But man's relentless and ugly stupidities are mine to despair of. You want to do good deeds? Do them. I will give you my cheque and God bless you. But do them silently and not heartily and give me leave to lament what I will.

GORDON: I'm even more convinced you need help.

TAMARA: And don't insult me.

> *She leaves. MARTIN passes her, extending a greeting she ignores.*

MARTIN: She's getting worse.

GORDON: She worries me. She's speaking louder, faster and, with her deep-throated Slavic accent, she's becoming like a Noel Coward caricature.

MARTIN: A man just rang in, American, freelance. Says he's got a trunk load of documents that reveals the 'truth about Ethiopia'. (*Imitating.*) 'Oh boy, man, is this big. Wait till you get a load of this. This is really big.'

GORDON: They're all big.

SPORTS PAGES

> *MARVIN entering.*

MARTIN: Bloody hell!

RONNIE: I'm not interested.

MARVIN: Those phoney sports stories in the *Daily Sun* I've been blasting?

RONNIE: What of them?

MARVIN: Harvey stopped me this morning and said lay off.

RONNIE: *That* he should've said to me.

MARVIN: 'Lay off,' he said, 'my opposite number is squealing.'

RONNIE: Are we trying to change sports reporting or are we not trying to change sports reporting?

> *Phone rings. It's HARVEY from the Editor's office.*

HARVEY: Ronnie?

RONNIE: Yes, Harvey.

HARVEY: Yesterday's *Financial Times*. Page 12. Second column, three up from the bottom. Got it?

RONNIE: (*Who's been turning pages of the F.T.*) Got it.

HARVEY: Aston Vale Football club is offering you, me and others shareholdings in the club. Might make a good

story for 'Bullseye'. Who's selling them, how many, why, and who's buying. O.K.?

RONNIE: O.K. Thanks. (*Phone down.*)

EDITOR'S OFFICE

It has been slowly filling up with people for the 'eleven o'clock' editorial meeting.

Present are ANTHONY SHARPLES, CHRIS MACKINTOSH, GORDON FAIRCHILD.

HARVEY: (*To ANTHONY and having just put down the phone.*) You going to stop reading that paper and listen to us?

ANTHONY: When *you've* stopped phoning.

HARVEY: Right, gentlemen. And what are we going to do about our beloved leader and his government this week?

GORDON: I think it's about time we tried a touch of irony in our political commentaries. 'Today poverty is your own fault, today you can stand on your own two feet. Anyone can become Prime Minister.'

CHRIS: 'Our beloved leader has proved it.'

GORDON: 'And our nasty chancellor has proved it. All of them self made and nasty men saying you too can also be self made and nasty men...'

CHRIS: Think they'll get the point?, (*To GORDON.*) Here's that couple of quid I owe you.

POLITICAL AND FEATURES

TAMARA visiting.

CYNTHIA: 'Why so pale and wan, fond lover?'

TAMARA: I think what I'd like is a good, old-fashioned nervous breakdown.

CYNTHIA: That's a shocking thing to say, Tamara.

TAMARA: There's such honesty about going to pieces.

CYNTHIA: You mustn't be frivolous about such things.

TAMARA: Mornings. Wake up. A disc-jockey's forced jocularity.

CYNTHIA: Well, thank God for a little jocularity, I say.

TAMARA: These offices. Sour jealousies. Battles for space. Defeated journalists.

NORMAN: *Not* first day of the week, pleeease.

TAMARA: (*Picking up newspaper and turning pages.*) Then all this. The smug weariness of experienced politicians. The intimidations of bigoted minorities. The tortuous self-defence of money makers. The pomposity of knowledge-glutted academics. Genocide in the Middle East. And us, with our five or six hundred words, I feel so guilty being able to cope with it all.

CYNTHIA: Guilts! Guilts! Those sombre, Jewish guilts.

NORMAN: The price we pay for the pleasure of your company is the depressing effects of your conversation.

ARTS PAGES / WOMEN'S PAGES

ANGELA: (*Who is checking proofs.*) Sebastian, is it your idea of a joke, a correction, or an improvement to change the words of my review from 'to put it mildly' to 'to put it wildly'?

SEBASTIAN: Oh, here's a much better printer's error. (*Reading from a proof.*) 'They become incredibly wound up; yet these is method in their madness for the unwinding is ceremonies and without a bitch.'

POLITICAL AND FEATURES.

CYNTHIA: As a matter of fact I'm about to embark on a long eulogy of disc-jockeys.

TAMARA: Really.

CYNTHIA: All about the joy they bring to drab lives.

TAMARA: And how their constant stream of gaiety denies the existence of unhappiness and how there's nothing more gloomy than laughter at all costs?

CYNTHIA: It's not laughter at all costs, it's music at all costs.

TAMARA: Music? A spurious urgency, perhaps, to cover up for poverty of talent.

CYNTHIA: You're growing old and square.

TAMARA: What an easy. vocabulary of insults we have these days. 'Square' presumably is the state you need to think others are in so that you can feel young? (*She leaves.*)

CYNTHIA: How complicated these central. European ladies are.

EDITOR'S OFFICE

Editorial continuing. PAUL from News Desk entering.

HARVEY: Hello, Paul. Our problem is that we're all in agreement that government's wrong and we're right.

ANTHONY: Oh, I don't know. I'm more inflationary than you.

HARVEY: Are you? Well, you're wrong then. I think we're entitled to be absolutely critical of *all* aspects by now and it would be absolutely consistent with our policy to criticize the government's economic strategy.

ANTHONY: There is no economic strategy.

GORDON: But there is a philosophy. I mean 'let lame ducks go to the wall and stand on your own two feet' is a philosophy.

ANTHONY: Yes, but it's not a strategy.

HARVEY: Anyway, they're changing doctrines. State subsidy, for industries suffering from 'non-culpable decline'.

ANTHONY: From what?

HARVEY: 'Intervention in industry,' says the minister in today's *Times*, 'is respectable in areas of non-culpable decline.' What do we say to that?

GORDON: Sounds like a very sad apology for dying. 'Please, everyone, forgive my non-culpable decline.'

BUSINESS NEWS

MORTY: The great thing about Arnold Weinstock is – the man's so sane.

DOMINIC: What is there about shop keepers, d'you think, that mesmerizes the intelligent journalists of Business News?

MORTY: If he has to sack 5000 men because of waste he'll do it… And he'll justify it by saying it's better for the sacked ones because men get depressed hanging around doing nothing, lose self-respect.

DOMINIC: Compassionate man, Weinstock.

MORTY: And those that stay know that they're good because Weinstock has kept them and so they're men of confidence.

DOMINIC: A Solomon, no less!

MORTY: His prime task? To weed out a waste. He appeals to men's greed but, paradoxically –

DOMINIC: – paradoxically –

MORTY: – paradoxically he must elicit from them a high degree of *co-operation* in order to satisfy that greed.

DOMINIC: Paradoxically.

MORTY: His approach is precisely that of a good business journalist – determined to cut through half truths and vague generalizations.

DOMINIC: Really?

MORTY: 'Never believe anything,' he says, 'all information is suspect.'

DOMINIC: Arnold Wainscot's attitude is rather like that of the baron of whom it was asked: 'Why do you build your walls so high and strong?' To which the baron replied: 'In order to give the peasants' hovels something to lean upon.'

EDITOR'S OFFICE

Editorial continuing.

HARVEY: Where are we on the spaceship deaths?

PAUL: No further than any other newspaper.

GORDON: Anyone know why the monkey died last time?

ANTHONY: Boredom, I think.

POLITICAL AND FEATURES

MARY rushes in with her bag of laundry.

MARY: I'm late for the 'eleven o'clock'.

NORMAN: We've got another Morgan King quote for you. Cynthia?

CYNTHIA: (*Reading from a cutting.*) 'Addressing the annual Durham Miners' gala over the weekend, Mr Morgan King, the new fiery socialist superstar member for New Lanark, said: "I believe that before any legislation can be passed in parliament there must exist the machinery to communicate an understanding of that legislation."'

MARY: What the bloody hell does he think, newspapers and television are for?

CYNTHIA: '"It is not enough to print our complex white papers which few understand, nor to leave their interpretation to the not always adequately briefed and random intelligence of busy, information drunk journalists who interpret according to bias or the quality of their minds."'

MARY: The impertinence! The incredible impertinence of the man. How dare he? 'The quality of their minds'. Who the bloody hell does he think he is. A jumped-up miner's son with exaggerated notions about the value of self-education!

NORMAN: Uh-uh-uh-uh!

MARY: Well *I'm* not intimidated by working-class haloes – the pain of poverty has never blinded me to its

product of ignorance, and underprivilege was never a guarantee against charlatinism, and that's the function of journalism – to protect, society from shabby. little charlatans like him.

NORMAN: (*Leaving.*) And *who* will protect society from shabby little journalists?

MARY: (*Calling after him.*) I'll take you on some other time.

IN DEPTH

NORMAN visiting.

NORMAN: Where's your master?

JULIAN: Don't have masters or deputies in our department. Some of us just get paid more.

NORMAN: Worthy, Worthy.

JULIAN: Being someone's deputy is an invitation to assassination. He knows it, I know it, so we drop titles. Lovely life. Easy, civilized; just what I was born to. Scurrying across Europe to investigate this and 'that, pause for a love affair, a ballet, a bit of skiing. You ever go skiing, Norman?

NORMAN: Are you mad? Skiing? You can break legs and die of exposure and things.

JULIAN: Glad to see you can laugh at your fears.

NORMAN: I'm not laughing. That's the mistake everyone makes. I ceased laughing after Moliere. Humour for me is an internal haemorrhage, otherwise it's contrived giggles.

EDITOR'S OFFICE

Editorial continuing. MARY entering.

HARVEY: Hello, Mary. I think we ought to have someone in the Middle East in case war breaks out.

ANTHONY: In *case* war breaks out? With *six* million refugees and every major power full of pious platitudes? War? *And* revolution, *and*. famine, *and* cholera.

HARVEY: Any volunteers to go?

GORDON: Me please.

HARVEY: You'll bloody stay here and co-ordinate.

ANTHONY: No free trips this time, my lad.

HARVEY: I'm thinking of sending Norman to take a look at those Middle East guerrillas.

GORDON: You thinking or is he asking?

SPORTS PAGES

MAC SMITH, a trade union official, visiting.

RONNIE: So it's settled then?

MAC: I can't be sure, Ronnie.

RONNIE: There's very little any of us can be sure of in this life, we know, but, Mac, we met six times last week. Management say they're not yet closing down the garage. Your men are safe, for the moment.

MAC: Ah, but are they? And has management said they're not closing down the garage? They've changed the *date* for closure,but *we* asked them to withdraw it.

RONNIE: And haven't they agreed on that?

MAC: The position's very ambiguous.

RONNIE: Industrial disputes usually are, old son.

MAC: Don't be frivolous, brother, the strike threat's not passed yet.

EDITOR'S OFFICE

Editorial continuing.

HARVEY: Right, now, science and politics.

ANTHONY: Morty's getting a good picture of investments in technology. Should have it by the end of the month.

CHRIS: Norman's pursuing the backbone: 'Has technology rearranged the genes of political issues?' or some such thing to do with futurology.

GORDON: That'll bring them in.

HARVEY: You remain sceptical?

GORDON: I remain sceptical.

MARY: We doing something more about this racist new. book on race by the way?

CHRIS: What do you suggest?

MARY: Oh – something suggesting he's erring according to Hudson's law of selective attention to data?

PAUL: That might boomerang. Since the journalist's profession is given to just that: the selective attention to data:

BUSINESS NEWS

DOMINIC: They want to take over the shipyards? Workers' control? Right, here's what I'll want to discover: One: Can they produce workers who can manage and administer, can they overcome demarcation issues, can they double production? Two: If they can, will it be allowed to work? Three: If it's not allowed to work will this produce a chain reaction of protest from workers in other industries? Four: If it is allowed to work will the example be followed in other industries? Five: Most important – will it not produce a hierarchy creating its own disenchantments. As a good barrister by training my questions are already succinctly formulated.

MORTY: And as a good reporter the answers already written, I trust.

EDITOR'S OFFICE

Editorial continuing.

ANTHONY: And how's Mary's profiles? Coming along are they?

MARY: Four down three to go.

ANTHONY: Committing themselves on science versus politics?

MARY: Here and there. George Carron will, of course.

PAUL: I should hope so, being the Minister for Science and Technology.

GORDON: Do they actually let you come into their houses, fondle their dogs, tickle their grandchildren, pour wine for you and all that?

MARY: All that and more.

ANTHONY: More. Ah ha!

MARY: Harvey, I'd like, while we're talking about profiles, to pursue someone else I think we all should be keeping an eye on.

PAUL: Morgan King MP no doubt.

HARVEY: Oh, the superstar. I'm lunching with him today.

GORDON: You planning to rubbish him? Poor man. He's only just started his political career. I'd've thought small fry for you, Mary.

PAUL: She's actually been having a go at him for some time.

ANTHONY: Under cover of that 'witty, cool and deathly column' of hers.

HARVEY: They're heathens, Mary, ignore them. Tell us.

MARY: I don't know. He smells phoney. I'm just saying he needs to be kept an eye on and I'd like to know you'd be interested if I came up with anything.

HARVEY: Providing we don't get snarled up in any more litigations. Our libel insurance is running low.

GORDON: I actually get prickles on my skin every time I see Mary prepare to lunge for a kill. Thrilling. That's my word for it – thrilling.

MARY: Harvey, would you excuse me. I don't think you need me. (*She leaves.*)

HARVEY: You must stop getting at her or I'll begin to think it's professional jealousy, and you wouldn't want me to think that.

PAUL: I think she's lethal.

CHRIS: But a brilliant journalist.

PAUL: You all think so, I know.

POLITICAL AND FEATURES

CYNTHIA: Don't you ever feel uneasy, sometimes, as a
 journalist? We inundate people with depressing
 information and they become concerned. Then we
 offer more information and they become confused.
 And then we pile on more and more until they feel
 impotent but we offer them no help. No way out
 of their feelings of impotence. Don't you ever feel
 guilty?

NORMAN: Constantly.

Part Two

THE CENTRE SPACE

*Part of the lounge in the home of the RT HON. GEORGE
CARRON, Minister for Science and Technology. He's playing
chess with MARY.*

CARRON: I'm a bachelor, Miss Mortimer. If I'd been married
 – nice cultured woman and all that – I might be
 more interested in literature, films, plays: But I'm
 not.

MARY: You don't mind me asking, Mr Carron?

CARRON: After three gruelling sessions with this, old man?
 Ask away. I'll tell you what I mind and don't mind.
 But art? Can't help you there. You'll have to- put me
 down as uncultured. Science and politics, those are
 my passions.

MARY: And chess.

CARRON: Ah, chess. My only addiction.

MARY: So, it doesn't worry you that all those upstart writers
 are required reading in the schools?

CARRON: Worry me?

MARY: After all, their values point to one kind of society while you're legislating to shape another kind of society.

CARRON: Worry me? Strange question. Check. Look, I'm, an old man and, I'll confess, not a very happy one. I began my career as a labour politician from a farm labourer's background, and half way changed my politics to Tory – a man's driven by the profit motive, plain and simple, I soon found that out. But, it makes for a lonely life. To be despised. Not nice. You live with it but you never get used to it. Still, that's not the point. What I'm saying is that experience shaped me, not art. I didn't change roads because of what I read in books, but because of what I read in man. I'm tone-deaf, colour-blind and get very impatient with the convenient concoctions literary men make into novels. I saw a play once and I thought to myself, yes, well, them people can behave like that 'cos they got good scripts written for them. I prefer men who write their own scripts. They do it in 'The House' and they do it in the cabinet and they do it at international conferences and that's real. Art shaping society? I doubt it. Science, yes, not books. Still, I've got to believe that haven't I? Minister for Science and Technology and all that.

MARY: Can we talk about science then?

CARRON: You haven't moved out of check yet.

MARY: Sorry. (*She moves.*)

CARRON: Ah! You know what you're about, don't you?

MARY: I've got three children who kept calling me bourgeois for playing bridge so I pacified them by learning chess.

CARRON: My one regret – no children. Watch out for your queen.

MARY: The editor wants to focus – on the science versus politics debate.

CARRON: Facile divisions. Journalese. Look, the argument goes like this, I know it: there develops, it is said,

unnoticed by most of us, a whole range of scientific discovery which creeps up behind societies and suddenly – is there! And each time it happens, the argument goes, the political deliberations of decades are rendered useless and we have to begin to formulate our opinions all over again. Right? It's an attractive picture and I can see why newspapers choose it as a popular controversy, it's ripe for oversimplification! But how accurate is it? Look at the period between 1900 and 1913, 'La Belle Époque' we call it. Worldwide economic growth, prosperity, scientific and technological advances. The lot!

MARY: Science made possible by politics, not in *conflict* with it.

CARRON: Exactly! But look what happened after 1913 – something neither science nor political philosophy could account for: an idiotic, soul-destroying world war!

MARY: Then who *should* account for it?

CARRON: Ah! Now you're asking a question which needs the kind of complex answers newspapers can't give and presumably didn't give in those early 1900s. Instead they oversimplified, as you're trying to do. Books! History! The interaction of ideas – that's where you'll find your answers and where 1 think you ought to guide your readers for their answers.

MARY: But, Minister, that's a contradiction. You said *experience* changed men, not ideas from books. Now you're saying certain *ideas* formed the basis for 'La Belle Époque'!

CARRON: Contradictions? Well, you've got to live with them also. A Jewish MP once told me a story about an old rabbi who was asked to settle a dispute between two men. The first man tells his version and the rabbi listens, thinks, and says: 'You know, you're right.' Then the second man presents his side of the argument and the rabbi listens, thinks and says: 'You

know, you're right,' At which the rabbi's pupil who
was standing by waiting for wisdom says: 'But rabbi,
first you said this man was right, then you said that
man was right. How can that be?' And the rabbi
listened and thought and said: 'You know what?
You're also right.'

IN DEPTH

JULIAN: We were at this party and this Tory bag came up to
me and she asked me what I did, so I said, despite
my extremely youthful looks, I said: 'I edit *The
Sunday Paper,* ma'am.' And she, ignoring my youthful
looks, believed me and whispered: 'Ah ha! Wanted
to meet you. I think you've got three fully paid up
members of the Communist Party on your In Depth
team.' And quick as a flash I said: 'Oh no, ma'am,
they're not as right-wing as all that!'"

ARTS PAGES / WOMEN'S PAGES

ANGELA: (*Reading copy.*) Good God! What a negative piece!
Ever thought of asking a critic 'not to bother this
week'?

SEBASTIAN: What, him give up his precious space? My dear girl,
people opening their Sunday paper look forward
to reading a critic's piece. Wouldn't miss it for the
world. Even if it is only a bumbling on.

ANGELA: Funny creatures, critics.

JANE: Are they any good at taking criticism of their
criticism?

SEBASTIAN: Most accommodating. The better they are the less
they mind what you say. It's only, the minor critics
who go into tantrums.

EDITOR'S OFFICE

PAUL visiting.

PAUL: I'm not happy about our attitude to the government, Harvey. I know you feel we should be more vigorous in our comments but we do stand for something, you know.

HARVEY: Not uncritically, Paul. You can't say we're irresponsible in our condemnations of government policy. We've got a first-class team, Oxbridge firsts, good, hard analytical brains who understand the problems and –

PAUL: – and nothing, Harvey. They understand nothing. You know and I know and anyone who's an old hand knows that newspapers can't deal in truths but only in facts, and sometimes judgements. Not this lot though. They still believe in the sanctity of print!

HARVEY: I don't think that's fair, Paul. They're aware of limitations and careful of judgements. We'd do the same if the left were in power.

PAUL: I know that, Harvey. But not everyone else on the staff knows it. They're a bit cynical these youngsters you've gathered round you. They see *The Sunday Paper,* being an old conservative family newspaper and therefore commanding more credibility, as being the best journal through which to infiltrate radical views. True! The very words they use. 'In filtrate radical views.'

HARVEY: Come now, Paul, don't let's get too portentous.

BUSINESS NEWS

ANTHONY: (*Reading and laughing at a newspaper report.*) We're being told here by the illustrious *Telegraph* that – and I quote: 'The Business News section of *The Sunday Paper* is like the TV power game programmes, tending to see all business as a jungle and all

business men as nasty, wrangling, grinning, smooth handshaking, back-stabbing villains...' –

DOMINIC: Except Arnold Weinstock, of course.

NEWS ROOM

MARTIN: (*On the phone.*) Let's get this straight. They put a bomb in the boutique, gave them ten minutes to clear out and sent this note to *The Times?* O.K. let's have it. (*Writing down.*) 'If you are not busy being born you are busy buying.' Yes. 'In fashion as in everything else capitalists can only look backwards...' Jesus! This is school kid's stuff. O.K. go on. 'The future is ours.' *What?* Spend our wages on *what?* 'Nothing to do except spend our wages on the latest skirt or shirt.' They call this political analysis? Yes, all right, go on. (*PAUL enters. MARTIN explains.*) The Anarchists Brigade have struck again, a boutique. (*Into phone.*) 'Brothers, sisters, what are your real desires?' Yes. 'Sit in the drug store, look distant, empty, bored...' Yes, I've got it. Or *what?* 'Or blow it up or burn it down.' Yes. 'You cannot reform profit, capitalism and inhumanity, just kick it till it breaks.' What? Revolution? It just ends like that? Revolution? 're-vol-u-tion.' Got it. No, I don't write shorthand. I find most people so boring in what they say that my slow long-hand is fast enough to catch what's worthwhile. Thanks. (*Replaces receiver.*)

PAUL: A bomb in a boutique? My own particular problem is to distinguish between their outrage and their envy.

FOREIGN DEPARTMENT

Urgent sound of 'tick-tack'. MARY and TAMARA are reading what is coming through the telex machine.

MARY: Where the hell is our fiery socialist speaking from now?

TAMARA: Hamburg.

MARY: He's every bloody where.

Phone rings. It's HARVEY.

HARVEY: Mary? I want you to look after Peter's affairs for the month he's away.

MARY: And who'll look after mine?

HARVEY: Come on, love, you know you've always wanted to be special features editor and you've got the biggest shoulders of any of us.

MARY: Very flattering.

HARVEY: And the sharpest intellect. There! That better?

MARY: Isn't it about time Paul was pensioned off?

HARVEY: That question discredits you. I'll forget you asked it.

MARY: He's tired, sentimental and a third-rate mind.

HARVEY: He's efficient, dependable and knows the job from top to bottom. I don't like sacking old men.

MARY: If I'm to fill in for Pete he'll get in my way.

HARVEY: You're relentless, Mary.

MARY: A quality you not infrequently rely upon. Are you free?

HARVEY: No.

MARY: I want to hear your impressions of Morgan King.

HARVEY: Ten minutes. (*Phones down.*)

TAMARA: There's something unhealthy about your dislike of Morgan King.

MARY: I can't stand do-gooders…

TAMARA: Oh come now. Every politician is a do-gooder.

MARY: Please, read it, Tamara.

TAMARA: (*Reading from long, white telex sheet.*) 'I tell you of these incidents in my private life because, if we're talking about the need for society to produce the whole man then let us be seen as whole men, imperfections and all, since it is an imperfect man for whom we must build a compassionate society.'

MARY: Really! Who does he think he is? Protesting his imperfections as though we wouldn't believe he had any in the first place. Don't you find something irritating about a good person?

TAMARA: Not just 'something'. It's perfectly easy to identify: their goodness, by comparison, reveals our shabbiness. Simple!

MARY exasperated, leaves.

SPORTS PAGES

MARVIN: I've got eight brothers and they've all, all of them got funny names. Like Jack the Corporation, James the Jumper, Willie the Woodman: And why? Because my parents were publicans and each of us was born in a different pub. Solly the Dun Cow, Chris the Mortar and Pestle, Horace the Mulberry Bush. It was Jonah The Pig and Whistle who used to object most.

RONNIE: And you, Marvin. What were you called?

MARVIN: Don't laugh? Marvin the Mermaid.

NEWS ROOM

MARTIN: And yet, you know, I've a sneaking sympathy for The Anarchists Brigade. There's something about ostentation makes you want to blow it up.

PAUL: It's their cosy world of small sabotage that irritates me, their weakness for simplified political platitudes.

SECRETARY: I mean they're just spit-and-run boys, aren't they?

MARTIN: Do you know I saw a Rolls Royce with a TV aerial on it today? Why should anyone want to watch TV while being driven through interesting streets? Pale blue it was. And I was confused between admiration for its mechanics and disgust for its opulence. Got this great urge to crash into it. Irrational really. Not an urge I was proud of. Bit mean.

PAUL: Their passion for destruction is inherited from the enemy they loathe.

SECRETARY: Relieves them of tiny angers.

MARTIN: I did so want to knock it down.

PAUL: And their little bombs are not the most persuasive argument for nuclear disarmament.

MARTIN: Still, they .have tried everything else without much effect. Marches, sit-downs, teach-ins, civil disobedience.

ART PAGES / WOMEN'S PAGES

SEBASTIAN: I read your piece on Hughie Green, Jane. You actually think he's a genius?

JANE: Yes, I do – and I chose the word carefully.

SEBASTIAN: What an extraordinary misuse of the epithet!

JANE: His television parlour games have the highest ratings.

SEBASTIAN: Oh, I see. Impressed by numbers are you?

JANE: And he's a man of the people.

SEBASTIAN: Is that his claim or your conclusion?

ANGELA: Old ladies love him, it's true, but his gags are terrible.

JANE: Which is precisely what puts him on a level with 25 million viewers who are desperately relieved to hear a famous man only able to make jokes as awful as they would themselves.

SEBASTIAN: And that's genius?

JANE: 'The people count,' he says, 'and I am the people's servant.' And then he makes a brilliant volte face and defends the establishment. 'I sincerely believe,' he says, 'that there are certain of us who are better equipped to know what is good for us than others.' And double-thinking like that is real genius.

SEBASTIAN: Not in my dictionary it isn't.

SPORTS PAGE

RONNIE: We used to have a woman on the travel page who
regularly, for two years, used to hand in stuff saying
such and such a place was a lovely sunny beach
until the Jews got there! Didn't care that it was never
printed, she never seemed to get the message. And
it took two years before management could bring
themselves to sack her. She was a widow, you see.
Lived alone. Cruelly abandoned by kith and kin.
Acid personality – but a loner. You can't fling people
on the dole just 'cos they're, anti semitic, can you?

MARVIN: No sense of revenge, that's what irritates me
about you Jews. Understanding of everything and
everyone. Not healthy, Ronnie boy. Bite! Gotta bite
back.

RONNIE: That's our trouble. We're beginning to.

BUSINESS NEWS

CHRIS visiting.

DOMINIC: (*To MORTY.*) And who's your Arnold Weinstock for
this month?

MORTY: Oh, he'll last, my son. Good for a reference every
two months or so – at least.

ANTHONY: (*To CHRIS.*) And what are our In-depth colleagues
in-depthing this week?

CHRIS: The crash of boring old bridges I'm afraid.

ANTHONY: And what help can we offer you on that?

CHRIS: Not crashing bridges, old son, but crashing insurance
companies.

ANTHONY: Ah! The ill-fated Atlantis company.

CHRIS: I've got a lead from a high-up on the Board of Trade.

DOMINIC: (*Mocking.*) 'At 08.00 hours the shrewd and enigmatic
Mr Cruikshank –'

MORTY: (*Taking up the mockery.*) – a clean-shaven, handsome
man, greying attractively at the temples –'

DOMINIC: '– was seen by his cleaner to arrive an hour earlier than usual at the head office of Atlantis Insurance –'

MORTY: '– Meanwhile, back at the Board of Trade, Mr X–'

DOMINIC: '– who shall remain nameless –'

MORTY: '– was heard cracking his hard-boiled, mid-morning egg –'

DOMINIC: '–four minutes, of course –'

MORTY: '– with greater anxiety than, usual –'

DOMINIC: '– At that moment, 800 miles away in the Bahamas, the beautiful wife of the Swiss ambassador was sun-bathing with the even more beautiful wife of the junior partner of Atlantis Insurance and discussing the latest wines of the little known but highly sought after Chateau de Montage –'

MORTY: '– At first sight all these far. flung incidents have no connection –'

CHRIS: Care to take over the column, boys?

ANTHONY: Oh, we're much too flippant for your serious investigations, Chris. Now –

CHRIS: Now. What's the percentage an insurance: company must set aside to cover claims?

ANTHONY: Well, let's see. The big boys arrange that sort of thing amongst themselves, you know.

CHRIS: Good God!

ANTHONY: Yes, God is good: But, it would appear, only to them what already have. Now, at one time it was 9 per cent and then…

FOREIGN DEPARTMENT

GORDON: Of course you're growing old. We're all growing old. Especially in this profession. At 32 one's old.

TAMARA: Gordon, can you lend me a couple of pounds please?

GORDON: (*Dipping into his pocket.*) I remember when Kruschev died, there was this reporter, one of our top men,

tried to phone through to the Kremlin. Didn't stop
to think that neither of them would be able to speak
the other's language, just automatically reached
for the phone. The spark goes. Last night on TV I
was watching an awful tragedy and I was thinking
– yes, now how can we handle that? This way? Yes,
maybe. That way? Yes, well – I'll sleep on it. Years
ago I'd have immediately rung up people and started
generating ideas.

TAMARA: *(Referring to newspaper.)* And the slaughter goes on.
'Tanks fire on university students asleep in their
dormitories.' We're not reporting foreign news, we're
reporting madness.'

POLITICAL AND FEATURES

NORMAN exercising with chest expanders.

CYNTHIA: I find your piece on futurology spine-chilling.

NORMAN: Brilliantly written though.

CYNTHIA: What's so depressing about the futurologists is their
way of wrapping up the future. Nothing to look
forward to or be spontaneous about.

NORMAN: *(Puffing.)* You miss the point. They don't define what
will happen – only what could happen. Know the
dangers – prevent them.

RONNIE enters.

RONNIE: What the hell good do you think you're doing?

NORMAN: Healthy body, healthy mind.

RONNIE: What great writer do- *you* know who ran a couple
of miles before picking up a pen? If you're an idiot,
mate, not even an Olympic medal can change that.
A lovely bit of private distress, that'll sharpen your
wits, not a handful of jerks.

NORMAN: *(Stopping.)* I'm not suggesting a healthy body *makes*
a healthy mind, but given a lively mind to begin
with –

CYNTHIA: – such as you've got –

NORMAN: – such as I've got, then it's enhanced by a fit body. Oh my God! I've strained a shoulder muscle.

IN DEPTH

JULIAN: What are the layabouts in our business section up to?

CHRIS: Oh, trying to find a new Arnold Weinstock to write up.

JULIAN: In order to knock down –

CHRIS: – to make room for another Arnold Weinstock to build up –

JULIAN: – in order to knock down –

CHRIS: – to make room for another –

BUSINESS NEWS

MORTY: Have you seen the poster of Chairman Mao hanging up in the In Depth offices?

ANTHONY: It's rather like the photographs of nudes which boys hang in their rooms at public school to assert their independence while temporarily trapped by the enemy.

IN DEPTH

CHRIS: I do want a cigarette. I don't want a cigarette. (*Reaching for phone and cigarettes.*) I do want a cigarette. (*Reaching for a bottle of beer.*) And a drink. Bloody bridges!

ARTS PAGES / WOMEN'S PAGES

ANGELA: Yes, I do! I do think writing novels is more difficult than writing plays. A play is just dialogue confined to a physical space. Its canvas can't be large. A novel demands more attention to detail, greater

psychological exploration, a richer grasp of plot. Its space and movement is unlimited and you've only yourself to rely on. No actors to fill out thinly-drawn characters, no director to give rhythms which the material doesn't contain, and no lighting man playing tricks in order to create moods which the plot can't substantiate.

SEBASTIAN: Are you suggesting D. H. Lawrence is greater than Shakespeare?

ANGELA: No, but I am suggesting Shakespeare's not as great as Tolstoy.

JANE: Check!

IN DEPTH

CHRIS: (*On phone.*) Professor Cobblestone? Good morning. Chris Mackintosh of *The Sunday Paper* here – yes, you've guessed it, those fallen bridges. No – all right, not now. But in fact I didn't want to go into it *now*, only check you're the right man. You are? Splendid. To be frank I don't know how to start thinking on this subject at all and – good! I'll ring you again when I've read through all this material and got a basic shape to the piece and ask you if it makes engineering sense. O.K.? Thanks. Bye. (*Replaces receiver. Closes his eyes.*) Do I want a cigarette? No! I don't want a cigarette. (*Picks up phone to dial again.*)

SPORTS PAGES

Phone ringing.

RONNIE: Ron Shapiro here.

It's from the Editor's office. HARVEY has with him MAC SMITH, the trade union official.

HARVEY: Ron? Look I've got Mac with me. They're querying – the agreement we all thought we came to last week and if it's not ironed out now we'll all be in the shit again. Can you come down?

RONNIE: Coming. (*Replaces receiver.*) Who'd be bloody father
of a newspaper chapel!

MARVIN: That stoppage again?

RONNIE: They may freeze the messengers. Ring round, get
copy telephoned straight through to here and by-
pass copy takers. I shouldn't – as a union official,
but fuck it! I want' the paper to come out and I don't
care. You agree?

MARVIN: Agreed.

RONNIE makes his way to Editor's Office.

IN DEPTH

JULIAN: (*On phone.*) Look, I'm a layman and so if I could
explain in layman's language why those bridges
fell, rather than in your expertise – yes? Good. As
I understand it it goes something like this: I build
shelves for 15lb jam jars, test the – Shelves by
putting 20lb jam jars on, use 15lb jam jars for 20
years and *then* return to 20lb jam jars...what? Oh, I
see. Jam jars are hardly applicable. Of course. Well,
let's start again...

POLITICAL AND FEATURES

CYNTHIA: (*On phone.*) Yes, well I think it's a very interesting
story, Workers *should* get a day off on their birthday,
but it's hardly for us. Try the News Room.

IN DEPTH

CHRIS: As far as I can make out it's a perfectly decent feat of
engineering but no one seems to have taken account
of the fact that the things are built by incompetent,
lumpen Irish labourers who don't care a damn...

ARTS PAGES / WOMEN'S PAGES

ANGELA: And shall I tell you why I *don't* go to the theatre? It's pampered. There's more paraphernalia attached to a first night than the appearance of a novel.

SEBASTIAN: Ah ha! Now we have it.

ANGELA: Isn't it true? And there's *no* fuss at all about the appearance of a play on television and *that's* a medium enjoyed by millions!

SEBASTIAN: Demagogue!

EDITOR'S OFFICE

MAC: You see, Harvey, it says there that we've asked for withdrawal of the decision to close down the garage. Now you know that's not true. *We've* never ever said that. Management shouldn't go around sending notes like this to the staff misrepresenting our case. We've only asked that the *date* of closure be withdrawn to give *us* a chance to negotiate the men's future. That's not unreasonable, is it?

RONNIE: Hasn't that happened already, Mac?

MAC: Now, Ronnie, you *know* it hasn't. They've changed the date. But not actually withdrawn it.

HARVEY: Why do you want it withdrawn?

MAC: Now, Harvey, you. shouldn't be asking questions like that. Supposing we agree to a date for closing down the garages and when that date comes we're not in agreement on redundancy compensation, eh? Come now, Harvey. *You're* an old enough hand.

HARVEY: But for Christ's sake, Mac –

MAC: Now then, Harvey, Harvey. Let's not raise our voices

HARVEY: (*Softer.*) For Christ's sake, Mac, we're grown up, intelligent human beings. We've had problems like this before. Why shouldn't we come to an agreement on redundancy claims in good time?

MAC: Grown up, intelligent human beings – true. But 'the best laid schemes of mice and men' – you know what I mean? Besides, Ronnie, I'll tell you the truth. Because this document has falsified our position it's become a matter of principle for us. And for them? For management? Well, they've decided on a date and they've made it a matter of pride not to shift from it. So there's your problem. Principle versus pride. I'm taking it to my head office now and if nothing happens by the end of the week: I'm asking them to make the stoppage -official and I hope your men's give us your support. Good day lads.

Leaves.

RONNIE: Doesn't look like we're going to have a paper this weekend.

HARVEY: I'll bring the fucking thing out, even if it means working the machines on my own and delivering the sheets myself. But I may need a little help from you, Ronnie.

RONNIE: When not?

IN DEPTH

CHRIS: What I can't understand is how they test bridges?

JULIAN: They used to get battalions of guards to walk over them, then if the foundations trembled –

CHRIS: Our army isn't big enough, is it?

EDITOR'S OFFICE

MARY visiting.

MARY: And what was your lunch like with comrade King?

HARVEY: I can see why you're interested in him. He's a bit too good to be true, isn't he?

MARY: So you agree with me? He should be watched?

HARVEY: Oh, come on, Mary. He's not a spy for God's sake.

MARY: But he's sinister.

HARVEY: He's complex.

MARY: And sinister.

HARVEY: You underestimate him. He's got a good mind and a generous one. He sees the scale of problems in the perspective of history – which always impresses me. Only one very odd thing he said – not odd in its meaning but the words he used. He said: 'One thing I disagree with emphatically is the left's concept of the new man. Misleading,' he said. 'It's not the "new man" we must *create*,' he said, 'but the original man we must *reveal*.'

MARY: Sophistry.

HARVEY: 'Clear away the ignorance and the fear that's gathered around him over the centuries,' he said, 'and when the dust from that job settles then,' and these are his odd words, 'when the dust from that job settles then you'll see all the patterns men can make for the pleasure of their living.'

MARY: 'The patterns men can make for the pleasure of their living.' Jesus! Harvey! Come on! They say that certain poets are bullied by a bad conscience – well this is a conscience bullied by bad poetry.

FOREIGN DEPARTMENT

GORDON: Why don't you take a year off? Write a book? Everyone's doing it.

TAMARA: Write a book? Ha! I can hardly assemble words for these little bits of so-called foreign commentary. Conveyorbelt work, harsh, destructive, written in a hurry. I'm sick of first-class travel and first-class hotels and the quick friendships with people about whom one has finally to write something unsympathetic. Sometimes I think I'm in journalism because I'm unfit for anything else. A book! I'd like to resign.

NEWS ROOM

SECRETARY: (*On the phone.*) *A* union official who's *what?* Got a clause in about birthdays? No, it's hardly for the news room. Try our industrial correspondent. You'll find him in Business News.

> *MARTIN rushes in.*

MARTIN: Paul? That hold-up of the supermarket in Bolton?

PAUL: Yes?

MARTIN: There's been a new development.

PAUL: What are you doing with a crime story?

MARTIN: It may not be a crime story.

PAUL: Not.?

MARTIN: Not! Three days later 97 old people living in a new development for old-age pensioners woke up and found boxes of groceries on their front door step.

PAUL: And there's a connection?.

MARTIN: The police aren't certain. But I've got another hunch I want to follow: Remember that factory manager kidnapped two months ago, the one that had a strike on his hands for being a bully?

PAUL: So?

MARTIN: When he was released the strike was over and the men reinstated but none of us, no paper, was able to get a statement from him.

PAUL: Go on.

MARTIN: Well,: there's. another strike in South Wales, place called Llantrisant, and this time it's unofficial and not the manager but the boss himself has been kidnapped.

PAUL: Are you suggesting the unions have become militant urban guerrillas?

MARTIN: Not the unions, but someone! Now there's something else and here's the real break. Since the kidnapping there's been a large bank robbery and though there's no strike pay the men have been given money.

PAUL: A local strike fund.

MARTIN: No! Their full wages.

PAUL: HOW?

MARTIN: Cash, in the post.

PAUL: Well that's The Anarchists Brigade.

MARTIN: No again! The Anarchists Brigade are bomb-throwers not soup kitchens. Besides, they'd announce themselves.

PAUL: Sounds to me as though you'd better consult the brilliant Miss Mortimer. She's got Peter's job for the month.

ARTS PAGES / WOMEN'S PAGES

ANGELA: Why do you think. the devastating Mary Mortimer has it in for the King of New Lanark?

JANE: Because she can't bear idealism anywhere but in her own column, where she calls it 'responsibility', while in anyone else it's called 'charlatanism'.

SEBASTIAN: No, no, no! You mustn't talk to her so glibly. We – and Mary Mortimer – are much more complex than that. She suffers from the schizophrenia we all suffer from. She can't bear people who make judgements and, since in attacking them, *she* has to judge, therefore she's torn all ends up.

JANE: But we all make judgements, surely.

ANGELA: Only we fear to be seen doing so.

SEBASTIAN: Precisely! It's like a dirty act, to be done in secrecy. If you make *a* judgement you seem, by your choice, to be indicating those who've not chosen as you've done. And to make it worse Morgan King makes outrageous demands such *as* that old-age pensioners should get what the national minimum wage is. Capital fellow! But *frightfully* difficult to tolerate. Doomed of course. I don't personally have much sympathy for the giant-killing Miss Mortimers of this

world nor that 'witty, cool and deathly column' of
hers.

POLITICAL AND FEATURES

MARTIN visiting.

MARY: You've done no investigating yourself?

MARTIN: No, just assembled cuttings and kept an eye on it.

MARY: And the sequence is: a supermarket hold-up,
distribution of food to old age pensioners, strike in
Wales and a bank robbery?

MARTIN: And then full strike pay.

MARY: And *then* full strike pay. Um. And we know it's not
The Anarchists Brigade?

MARTIN: Certain.

MARY: What's your hunch?

MARTIN: It's only a hunch.

MARY: Let's hear it.

MARTIN: And it's way out.

MARY: Stop covering your retreats, out with it.

MARTIN: An opposition secret society.

MARY: That's not way out. There must be people in this
green and pleasant land simply livid that they're not
South American guerrillas.

MARTIN: Exactly! They-must be intellectuals.

NORMAN: Carefull! Some of my best friends are intellectuals.

MARTIN: They're highly organized, sophisticated, a sense of
humour and, probably, opposed to violence.

MARY: And what do you propose?

MARTIN: This: I've made contact with The Anarchists
Brigade. They're amateurs, clumsy and highly
emotional. Now, if such a secret society does exist
they're bound sooner or later, to want to make
contact with the Anarchists to tell them to lay off the
bombings.

MARY: Not. sure I accept the logic -of that. Still –

MARTIN: I just want one week free from other assignments.

MARY: I think we can spare him.

 MARTIN leaves.

ARTS PAGES / WOMEN'S PAGES

JANE: What do you think of a series on people's obsessions?

ANGELA: Do you have obsessions?

JANE: Me? I don't know.

ANGELA: And would you confess them?

JANE: Depends what I discovered I was obsessed with.

ANGELA: Why: don't you do a series on 'my best friend'. Find out what human qualities the famed and renowned look for in their closest.

 Pause.

JANE: People sitting around in offices, that's all a newspaper is, sitting around waiting for ideas to come, wondering what the hell to do next.

THE CENTRE SPACE

MARY MORTIMER's Lounge. Her three children – AGNES, JONATHAN and DESMOND – have come for a monthly 'family dinner'. MARY is in the kitchen preparing the meal. JONATHAN is reading from a sheet of copy. It's a proof of MARY's current column.

JONATHAN: She's attacking him again.

DESMOND: Read it.

AGNES: But please, let's not quarrel this time?

JONATHAN: (*Reading.*) 'Mr Morgan-fiery-socilaist-MP-King is with us once more. Oh what a dear, human, compassionate philosopher we have in our midst. And how thankful we must be, as he constantly reminds us, to have such a learned member of

parliament guiding us through the confusions of such awful times.'

DESMOND: *Does* he 'constantly remind us?'

AGNES: It's mother's poetic licence to lie.

JONATHAN: 'We quote: "I believe," says the self-styled sage, "that the first great myth of all time was the: story of the creation of order out of chaos, and all men's greatest endeavours since then have been the re-enactment of that one first *myth*. And because the chaos is endless so man's task will be endless. And if there is a purpose in life *that* is it." Unquote.'

AGNES: I can remember when he first said that.

JONATHAN: 'We may not know what he means,' says our oh *so* witty mother, 'but it's certainly reassuring to have such serious sounding pontifications as this to pin by our bedside and read each night before pulling sleep over our troubled eyes in this troubled world.'

> *JONATHAN has beside him a portable tape-recorder the button of which he now presses to produce the sound of an audience whistling and applauding loudly. He throws his arms open as though presenting this extract to 'an audience' for their acclaim. The recorder is his latest 'toy' – and he'll do this every so often throughout the scene.*

DESMOND: They all write so badly, that's what's so depressing:

JONATHAN: Their biggest mistake is to quote the people they want to demolish. Always boomerangs. Much better than their own little fifth-form farts. How about that? 'You've had the *Barretts of Wimpole Street* and now we bring to your screens – da-dum – *The Little Farts of Fleet Street.'* (*Presses tape for 'applause'.*)

AGNES: (*Unwrapping a package.*) But no quarrels, Jonathan.

JONATHAN: Yes, elder sister.

AGNES: We only have dinner with her once a month so no more dreary taunts about her being bourgeois. Des?

DESMOND: (*Deep in newspaper.*) Yes, elder sister.

AGNES: We don't think much of her column but we love her. Understood?

TOGETHER: Yes, elder sister.

AGNES: (*Revealing a Hogarth print in frame.*) Think she'll like it?

JONATHAN presses tape to applaud print.

DESMOND: Is that genuine?

AGNES: Not your first edition of course: From a later edition, possibly the fourth, 1838.

MARY enters in apron with a tray containing pot, of 'stew', plates and cutlery. She plonks it on the table, lifts lid triumphantly, and awaits for response. JONATHAN Switches on tape of applause.

MARY: My God! It's going to be one of those evenings.

They all begin to help themselves. Then –

Well, talk to me, my children. I know we always end up quarrelling over politics but that's no reason to be terrified of telling me your professional gossip. (*All three start at once.*)

Whoa! Jonathan, 'the youngest'. You start.

JONATHAN: Directed my first concert.

MARY: Great mistake to televise concerts.

JONATHAN: Agree.

MARY: Good God! We've started with agreements.

JONATHAN: Have you noticed how, at concerts, there are always one or two who leap to applaud almost before the last note has been struck? And you never know whether they do it from enthusiasm or from a wish to get it in that they know the piece so well.

Silence. There seems nothing to add – or go on to from there. JONATHAN presses recorder for his own applause.

MARY: We'll try the scientist then.

DESMOND: Three Soviet scientists – G. I. Beridze, G. R. Macharashvili and L. M. Mosulishvili have discovered gold in wine.

MARY: I beg your pardon?

DESMOND: Flowers and plants, you see, contain in their tissues residues of the metals contained in the soil where they grow. Hence bio-chemistry can trace deposits of nickel, silver, copper, cobalt, uranium, lead and other metals by pursuing, picking and analysing flowers and fruit.

AGNES: And?

DESMOND: And so three Soviet scientists called . G. I. Beridze, G. R. Macharashvili and L. M. Mosulishvili have discovered gold in wine. (*Pause.*) Which comes from grapes. (*Pause.*) Which grows in soils. (*Silence.*)

Well don't I get a round of applause for that?

JONATHAN belatedly switches on tape.

MARY: Do you children rehearse your pieces before coming to dine with me?

AGNES: This is a very fine stew, mother.

MARY: There speaks the diplomat of the family. How's the foreign office?

JONATHAN: Mother, don't be so damned bourgeois. We don't *have* to make conversation.

AGNES: (*Forestalling friction.*) I might be posted to the embassy in Lagos.

MARY: If he calls me bourgeois again I'll –

AGNES: I'll know in a month's time. (*Silence.*)

MARY: Bloody hell! You're not the most comfortable family to sit down to eat a meal with. Why must you always make me feel I've done something to feel guilty for?

JONATHAN: It's a change from you making others feel guilty in your columns.

MARY: That's my job. Investigation! Democratic scrutiny! (*JONATHAN presses tape for applause.*) And turn that bloody machine off! (*Pause.*) Oh, go home. I swear, I always swear I'll never make these dinners again and each time I relent, each time I think – no! They won't get at me this time, it'll be a happy family

event. And each time it happens again. What do I
need it for?

AGNES: We're sorry.

MARY: Don't I have enough bloody headaches in that
bloody newspaper office and those stupid, vain,
self-opinionated people I have to interview?

JONATHAN: You can't exactly deride those you interview as
'self-opinionated' when those interviews appear in a
column called 'opinions'.

MARY: Oh can't I just?

DESMOND: Mary, why have you got your teeth into Morgan
King?

MARY: Morgan King? What the hell do you care about
Morgan King?

AGNES: Desmond, you promised.

MARY: Why Morgan King and none of the others?

DESMOND: It's just that a special kind of savagery comes out
with him and it shows.

MARY: I'm a savage columnist, didn't you know?

DESMOND: We're embarrassed that's all.

MARY: Oh no you're not. There's a reason. Why Morgan
King?

AGNES: He conducted a series of seminars on local
authorities at Jonathan's college in Oxford and we all
got to know him rather well, that's all.

MARY: Well, why didn't I get to hear about him? I knew all
your other friends from university.

DESMOND: Other students, yes; but we kept the visiting lecturers
to ourselves.

MARY: I don't believe you.

AGNES: This is silly. Of course it's not only Morgan King, it's
your column in general. We feel it's getting –

DESMOND: – bitchy –

AGNES: – no –

JONATHAN: – strident. That's the word. (*Presses tape for applause.*)

MARY:　Please, please, PLEASE don't push that fucking button again.

JONATHAN:　Now don't cry, mother. Tough Journalists don't cry.

MARY:　You're rather cruel children, aren't you?

DESMOND:　(*Shamefaced.*) Yes, we are, you're right. I'm sorry.

AGNES:　We're all sorry. Look, the stew's getting cold.

MARY:　Well fuck the stew! You don't get off as easily as that.

JONATHAN:　Always dangerous to apologize. The sting resides in the 'tail of a bourgeoise's tears'. Mao?

MARY:　I AM NOT BOURGEOIS! Bourgeois is a state of mind, not of wealth.

JONATHAN:　Not in the classic sense it's not.

MARY:　To hell with the classic sense. Words acquire new meanings. Think! you have to *think* about them. Your lot are so bloody mindless. (*With forced calm and mounting distress.*) I loved and cared for my children, was that bourgeois? That was natural, an old, old cycle tested long before men began exploiting men. I gave you a home to grow strong in, not to seclude you but to help you face an insecure world, was that bourgeois? Did I force you into professions you were miserable with? Look at yourselves. Are you enfeebled, pathetic creatures? Should I be ashamed of you? What's my crime? I'm not bourgeois if I respect the past – people have been fighting and. dying for rights since Adam. I'm not bourgeois if I enjoy comfort – only if comfort defuses my angers against injustice. I'm not bourgeois if I fear the evil in men – that's human. If I enjoyed being helpless about. evil, you might call that bourgeois. If I indulged in *welt-shmertz,* – you might call that bourgeois. If I pretended order existed when it didn't, you might call that bourgeois. But if I try to create order out of chaos, that's human. If I have loves and hates and failures and regrets and nostalgias, if I'm weak and frail and confused and I try to make order out of the chaos of my miserable

life, then that's human, bloody human, bloody
bloody human!

*AGNES picks up the proofs of MARY's column and
gently offers it to her.*

AGNES: You see, mother, he also talks about order out of
chaos. That's just what we mean. It's as though
you're fighting yourself and it shows. In your column
it shows. (*Pause.*) Mary, we're our mother's children.
(*Small laugh.*) No escaping.

*MARY is stung but it only serves to deepen her
distress.*

Look. A Hogarth print. We've bought you a present.

Act Two

Part Three

THE CENTRE SPACE

An arbour in the grounds of the home of the Chancellor of the Exchequer, SIR REGINALD MACINTYRE. He is strolling up and down with MARY.

MARY: And the final question, Sir Reginald.

MACINTYRE: You won't be offended if I say, thank God!

MARY: Three days is a long time I know. You've been very patient. It's a personal question – I've asked each minister this and told them they can answer or tell me to go to hell.

MACINTYRE: I'm not very good at saying such things to ladies but I hope your question doesn't tempt me too much.

MARY: It's this. How do you reconcile the needs of your own private standards of living with the needs of those working people whose standards of living you, as Chancellor, are in office to regulate? (*Long pause.*) Please, if you think it too impertinent.

MACINTYRE: Impertinent? Yes, I suppose I do find it that. (*Pause.*) Do you mind if I answer in an oblique way, without, I trust, being evasive? (*Pause.*) It's a terrible problem, democracy. You see, if we could turn round and say all the men who are dustmen are dustmen because of their inequality of opportunity then it would be easy. No problem. We would simply create the right opportunity. But it's not so, is it? Make *opportunity* equal and the inequality of their qualities soon becomes apparent. It's a cruel statement to make but, men are dustmen or lavatory attendants or machine minders or policemen because of intellectual limitations. There! Does that offend

you? It used to offend me. Most unpalatable view
of human beings. But all my encounters with them
point to that fact. Even if we automate sewage,
automate everything, we're still confronted with the
awful fact that some men *are* born with intellectual
limitations. Now, what do we do? We can't talk of
these things, it's taboo. We can't say in public 'some
men are less intelligent than others' – though it's part
of any discussion on democracy: So what *should* we
do? Compensate their inadequacies with large pay
packets? But what of the dustman? Because when
he strikes for more pay he may not be asking to be
paid for his ability or responsibilities but he is asking
to be paid for, doing *what other men don't want to do.*
For what I think should be named 'the desirability
factor'. Isn't *that* a distinction? And a very
intimidating distinction I may add. In democracies
those who do our dirty work have us these days by,
as they say, the short and curlies. Now, government
must, you'll agree, remain in civilized hands. So,
whose 'short and curlies' should civilized man hold
on to?

MARY: Perhaps its the mark of the civilized man is that he
disdains from holding on to anyone's 'short and
curlies'.

MACINTYRE: No. Only that he *appears* not to be doing so. Does
that also shock you? But you make a man feel simple
by confronting him with problems beyond his
intellect. Wouldn't it be civil, human *not* to discuss
with a simple man what was beyond his *intellect,* or
ask him to perform duties beyond his power? Surely
you'd want me to *appear* to be his equal which I
could only do by not frustrating or humiliating him
in that way.

MARY: But supposing your judgements are wrong?
Supposing the man is capable of more than you give
him credit for?

MACINTYRE: Supposing all our judgements are wrong? Yours of
me, mine of you – so? Do we cease making them?

We are appointed because our judgements are more
often right than wrong. That too is one of the risks
of democracy, unless you can find me a man who
can create a system – or a system which can create a
man – whose judgement is right, all the time, *about*
everything. Do you find an answer shaping in all
that? Am I making myself clear?

MARY: Perfectly.

MACINTYRE: You will, of course, 'let me see – the – typescript
before going into print?

BUSINESS NEWS

DOMINIC: Well, people who fuck up the system appeal to me.

*Phone rings. He picks it up. It's PAUL from the News
Room.*

PAUL: Dom? I've just had an earbending fink on the phone
who says he's got damaging documents implicating
Leonard Crafton.

DOMINIC: Head of Onyx Foods? Oh, a charming man, a con
but charming. Everyone wants to rubbish him.

PAUL: Will you see him?

DOMINIC: If we must.

PAUL: He sounds interesting if erroneous.

DOMINIC: Interesting if erroneous. I'll remember that.

EDITOR'S OFFICE

An editorial conference.

GORDON: Well, do we have a newspaper this week or not?

ANTHONY: The problem, old friend, lies in the difference
between the production side and the creative side.
We're prepared to work at all hours in order to get a
newspaper out and production doesn't care a damn
about the kind of journalism we think we produce.
And why should they? They don't read it.

GORDON: *There's* your technology versus politics problem,
Harvey. Right in your own back yard.

ANTHONY: And a back yard it is – *that's* the problem. We've got
Victorian machinery. Thousands to man it. Millions
to buy it. Six years to install it. And all you really
need is half a, million for a Web off-set machine and
a handful of typists to run it instead of expensive,
obsolete printing men. Of *course* you'll always have
stoppages.

HARVEY: Anyway gentlemen, it's in the hands of their head
office and our management boys – let them fight
it out and may the best man win. Now our little
Middle East war; what about *that* bloody mess?

IN DEPTH

PAT: Well someone on your sodding paper ought to be
interested.

CHRIS: I've tried, love, honest I have.

PAT: I mean it's more than just another abortion story;
it's a story, about your knotty medical problems and
your callous authority.

CHRIS: That's what I said: 'Knotty medical problems and
callous authority,' I said. Try it on Mary. She's got
Pete's job for this month.

EDITOR'S OFFICE

Editorial continuing.

HARVEY: And as far as I can see we're going to be the only
ones to give the cholera epidemic a big spread. The
dailies have hardly touched it. Map with arrows
showing its route, three nine-inch columns – front
page.

ANTHONY: Don't believe in epidemic scares personally.

GORDON: You don't believe in the pollution scare either, so
you're no judge.

ANTHONY: Pollution's different.

HARVEY: Which nicely brings me to my next point. I want to cover the Mersey, long diagram; showing who's pouring what into its waters and from where. Every firm named, questioned, challenged.

SPORTS PAGES

DOMINIC visiting.

DOMINIC: If you want me to cover your tennis championships it'll cost you high in expenses. I'll spice it with the obligatory champagne-and-strawberries atmosphere, you pay for it.

RONNIE: You'll get what my budget will allow.

MARVIN: You're not the most brilliant tennis reporter we have.

DOMINIC: Oh I am, I am. And you know that I am.

MARVIN: Besides, your expenses come from Business News.

DOMINIC: It's true. I can't lie. My expenses are the highest on *The Sunday Paper* on account of the terrible terrible amount of bribing I have to do among the trade union officials.

RONNIE: You're a cynical man, Dominic.

DOMINIC: Cynical I am not. Spoilt, perhaps. But then we can't all have interesting, backgrounds like you, Ronnie. Russian Jewish immigrants. from the East End of London? Were you really born in the East End? God! How I resent my father for being so rich. All the best people were born in a ghetto. If only my father had bought us a ghetto, one we could go to for weekends. Now that would have been something.

ARTS PAGES / WOMEN'S PAGES

JANE: (*Reading a women's magazine.*) Ooh! Look! Moira Hartnel's entered the battle for women's liberation.

ANGELA: A top model gone politicking?

JANE: Think she's worth pursuing?

ANGELA: Any staying power?

JANE: I only have to do her once. She's not *star* quality.

ANGELA: Thank God for the woman's magazine. Jane can always rely on them to fill a hole in her column.

JANE: How about 'from women's waists to wasted women'?

ANGELA: Or 'model mauls men'?

JANE: Or 'from liberated fashions to fashionable liberations'?

SEBASTIAN: Meeow!

SPORTS PAGES

MARVIN: So there I was, in Northern Ireland, soldiers shot at, civilians murdered, bombs going off everywhere, reporting on a game of golf. Jesus! I, thought, what the hell am I doing covering a game of golf?

BUSINESS NEWS

THE FINK is introducing himself to MORTY.

MORTY: (*Shaking hands.*) And you're the gentleman with information on Onyx Foods?

FINK: (*Patting his briefcase.*) Minute research. It's all here. I take it I can speak openly? Good. The basis of my information is this: that Leonard Crafton – Crafty Crafton I call him – has stated a share price since 1967 based on a false market, and that he's been able to achieve this through a complicated system of interlocking holdings which work roughly in this way: the English company takes over a French company which then buys shares in a subsidiary of the French company and so on. Clever? Ah, very clever is our crafty Crafton. Now look at these graphs of share price rises and rising profits…

ARTS PAGES / WOMEN'S PAGES

SEBASTIAN: Oh my God! Another poem. We always get them
after disasters or Prince Philip's birthday. Says a
great deal for the soul of the British public I suppose
but doesn't contribute much to British poetry.

BUSINESS NEWS

THE FINK's Story, continuing.

FINK: Now, I'd been following him so closely that I
understood the pattern of crafty Crafton's behaviour,
his psychology as it. were, and of course, when his
shares were at 71 I bought them because I knew,
from watching his dealings, that they'd soon go up
to 93 or thereabouts, which they did, and at which
point I sold. And who's the Mafia, as it were, in all
this? Snuff! Oh don't laugh. (*Dips into his briefcase
for large foreign magazines.*) Snuff is the new narcotic.
You can put your LSD into it. Kids in Germany and
Sweden are doing it all the time. And so Mr Crafty
Crafton and his Jewish backers are putting their
money into snuff. Large profits, you see. Now, that's
not all…

ARTS PAGES / WOMEN'S PAGES

ANGELA: Oh yes, I agree, the elegant sneer is always admired.
And if it's like Pope it's very good indeed.

JANE: Problem is, it's rarely like Pope.

BUSINESS NEWS

THE FINK's story, continuing.

FINK: So, you're asking, where is all this leading? His saga
seems endless and many-vaulted, you're thinking
to yourself. Nearly there. I've told you about
Crafton's dealings on the continent and at home.

I've told you his motives and about the habit of his
Jewish brethren in helping poorer members of their
community. So, we know, they stick together, now
why?

EDITOR'S OFFICE

Editorial continuing.

HARVEY: What's your centre-piece this week?

GORDON: A finely argued- piece of demolition on the myth
of the silent majority, which makes the very simple
but devastating point that the convenience of such a
concept as silence is – the silence.

HARVEY: Quite right! If you say nothing anybody can claim
to speak for you.

BUSINESS NEWS

*THE FINK, who has gradually become excited by his own story,
allows his enthusiasm to take over his judgement.*

FINK: I'll be honest, lay my cards on the table. I'm
obsessed by the European Jewish Mafia. Been
reading about them as far back as the time Napoleon
freed the Jews. And here's my point, think about
it. There's the tightly-knit Jewish families of
Rothschilds, Mannheimers, and Herzens on the
continent, and Messrs Morgenstein, Rosenthal and
Crafton in this country. And now (*Clasps his fingers
together.*) with the European Common Market – click!
The opportunity they've been waiting for – a highly
closed plot in the traditional Jewish manner trying
to dominate the important areas of food and leisure.
(*Pause.*) You must not, however, think I'm anti-
semitic.

POLITICAL AND FEATURES

MARY: Shall I tell you what's wrong with your article on futurology?

NORMAN: I'd prefer you not to.

MARY: You believe the futurologists!

NORMAN: That's not true.

MARY: You ask a very reasonable question: Has technology rearranged the genes of political issues? and then you give *their* answer: yes it has!

NORMAN: I happen to agree with them.

MARY: Have you ever asked yourself why their books are so thick?

NORMAN: Scholarship.

MARY: Balls! It's because men aren't robots, they're human, unpredictable, millions of individual wills, all different – hence, a large book of hedged bets.

MARTIN enter.

Any luck?

MARTIN: To be honest I changed tactics.

MARY: Meaning?

MARTIN: I went to Llantrisant, where the strike was. Thought I'd get more of a lead there.

MARY: So, if your secret society did plan to contact the anarchists you've missed them. And we don't even know if they exist.

MARTIN: (*Handing her a sheet.*) I think I've got evidence to prove that. I picked up this stencilled document which was in the latest strike pay packet. A sort of manifesto. Very flowery stuff. Not like the anarchists at all. Correct grammar and statements with some degree of lucidity, except the end, which –

MARY: (*Who's been reading it.*) Eureka! Martin, keep on to that anarchists cell. It may lead to something fantastic. Fan-tastic! 'Souse me. (*She rushes out.*)

ARTS PAGES / WOMEN'S PAGES

JANE: It's a terrible confession – but my colleagues depress me. They play this great game at work and then they shuffle home on the commuter-train to suburbia.

ANGELA: Got to have something to compensate for lilliputian lives.

JANE: *That's* what we are. Lilliputians! Always wanting to bring down giants.

ANGELA: I seem to spend my time building them up.

JANE: *They* are paper giants. But the real ones – we never celebrate the real ones.

SEBASTIAN: Oh, I don't know. Business News celebrate Arnold Weinstock. Women's Pages celebrate Hughie Green.

JANE: Fashions! Novelty! We celebrate fashions and novelties.

ANGELA: Well, do something about it.

EDITOR'S OFFICE

MARY visiting.

HARVEY: (*Who's been reading MARTIN's document.*) It's slim, Mary.

MARY: The *exact* words, though. 'The patterns men can make for the pleasure of their living.' The same awful words: Morgan King! The man himself. Behind all those boyish Robin Hood antics.

HARVEY: Maybe they're not his words. Maybe I made a mistake and he was quoting from a poem or a Haziltt essay or something, and he and this group – whoever they are – were using the same source, coincidentally. Have a look, Gordon.

MARY: Coincidentally? Bloody strange coincidence. Harvey, Morgan King has formed a secret society of political Robin Hoods. I *know* it. 1t all fits in with his shifty passions. One of my sons attended a series of seminars he gave at Oxford and from the way he

describes him he sounds quite capable of seducing a small band of over heated romantic imaginations into playing urban guerillas.

GORDON: Not good enough, Mary. I'd say you needed more evidence.

MARY: I think you're all frightened.

HARVEY: No, cautious.

MARY: So am I. I'm not asking us to print anything, but it's worth following up for God's sake.

HARVEY: You're relentless.

MARY: So you keep saying. Hell! I can see I won't get much joy here. (*She leaves.*)

FOREIGN DEPARTMENT

MORTY visiting.

MORTY: And suddenly I realize. This Fink's spinning me the old yarn about the Jewish conspiracy to take over the world. Poor bloody Jews. Can't do anything right, can we? Jesus, Marx, Freud, Trotsky, you, me all part of some conspiracy or other.

EDITOR'S OFFICE

JANE visiting.

JANE: Well, we're staking pretty big claims as the most serious paper in the country.

HARVEY: And it's true.

JANE: Then let me bring the Women's Pages into the science versus politics issue.

HARVEY: What are you thinking of?

JANE: Oh, I don't know. Are women more attracted to science than politics and is there a reason? That sort of thing.

GORDON: You think women aspire to the practical rather than the empirical?

JANE: Could be. I just want the go ahead in principle.

HARVEY: You've got it, you've got it.

JANE: Hallelujah!

POLITICAL AND FEATURES

TAMARA visiting. NORMAN has been reading the proofs of her latest piece.

NORMAN: (*Handing it back.*) It's reasonable, Tamara, reasonable.

TAMARA: That's a good word, Norman. Succinct and diminishing. Thank you.

NORMAN: Now don't sulk.

TAMARA: Oh, how I'd just like to slide around, with no purpose, having little conversations.

NORMAN: Only you can't quite give up the glamour of catching a plane and having access to important people.

TAMARA: Can't I?

CYNTHIA: None of us can.

TAMARA: Important people? My contempt for the Western European politicians I've had to meet is gradually extending to the whole spectrum of human beings important or not.

NEWS ROOM

MARY visiting, with PAT at her heels.

MARY: (*To PAUL.*) Paul, who the hell turned this away?

PAUL: It's only another abortion story.

MARY: Another abortion story? Another *abortion* story?

PAUL: I can turn you up a dozen stories about girls of thirteen, twelve, eleven, even ten having abortions.

MARY: That's why I have to go through everything myself.

PAUL: Look, Mary, as news editor I judge the kind of news story we should be printing.

MARY: (*Storming off.*) I want this woman hung, drawn and quartered. She's a National Health Service gynaecologist and she's not paid with my money to offer moral judgement to twelve-year-old girls in need of help.

PAT: Thanks!

POLITICAL AND FEATURES

NORMAN: Well, I'm sorry – it is just a reasonable article because it is rather difficult to generate excitement about obscure Indian tribes in Latin America. I mean it may look good in print when you read a D H Lawrence novel, but Quetzalcoatl *does* sound funny when you actually have to say it.

TAMARA: Oh your bloody English upper-class wit! You still go on making pale jokes about the funny names of aliens. Haven't you heard that no one finds you funny any longer except your pudding-faced working class? They can always be relied upon to find the sound of Vladivostok good for a giggle.

IN DEPTH

MARY rushes in followed by a bemused PAT.

MARY: Right! Drop your bridges:

CHRIS: Did she say 'drop your breeches'?

MARY: I want this gynaecologist investigated.

JULIAN: Hell, Mary, it's a news story not an In Depth expose.

PAT: It's more important than a news story. The mother herself has asked us to investigate.

MARY: Problem is the doctor's clammed up. Refuses to speak to the press.

JULIAN: I don't blame her.

MARY: What we want is the story of a guilty gynaecologist. Was she married? Did she have an unhappy love affair, broken marriage? Are there any children?

CHRIS: That's Harold Robbins, not journalism.

MARY: And get a photograph, even if it's of her peering reluctantly round a door.

JULIAN: A classic newsroom story.

MARY: Pat, get this photostated.

PAT: How many?

MARY: About ten. Julian, you can get up there in two and a half hours on the M 1.

JULIAN: Three.

CHRIS: Four.

JULIAN: And basically what you want is all the dirt I can get on her?

MARY: Yes. And get photographs of the girl and her mother. Doorstep them if necessary.

JULIAN: How can you take a moral position about the gynae-cologist if you start invading people's privacy?

MARY: I'll worry about that.

She leaves.

ARTS PAGES / WOMEN'S PAGES

JANE: (*Entering.*) I'm in business.

ANGELA: He's agreed?

JANE: Of course he agrees. I don't know why I didn't push earlier. Do you think the story of Lysistrata comes under the heading of science versus politics?

ANGELA: That's sex versus politics.

JANE: But the Greek girls didn't have contraception – and that's science.

ANGELA: So?

JANE: Well, the general's ladies could last out longer today by safely taking their favours elsewhere.

SEBASTIAN: Bit of a strain on the imagination, that.

EDITOR'S OFFICE

Editorial continuing.

ANTHONY: Has the Chancellor read the typescript of his interview with Mary?

HARVEY: Not yet. Why?

ANTHONY: I hardly think he's going to approve of all her witty little interjections. '"It is a cruel statement to make,"' the Chancellor continued, "but men are dustmen or lavatory attendants or machine minders or policemen because of intellectual limitations." I resisted the temptation to ask if he had statistics on how many intellectually limited sons of the upper classes became dustmen.'

HARVEY: Heavy-handed but he does need knocking.

ANTHONY: Well why didn't she simply make the point to him and get his reply?

HARVEY: Nor is the Commissioner of Police going to be happy to have his force labelled 'intellectually limited'.

POLITICAL AND FEATURES

MARY: I think I'm tired.

CYNTHIA: You *think* so? You're not sure?

MARY: And I've got my mother for dinner tonight. She's never tired.

CYNTHIA: Don't you ever think of peppering evenings with mum?

MARY: Oh, Jason'll be there.

CYNTHIA: Your ex-husband seems to be the only man you ever see these days.

MARY: Only really intelligent man I know. God knows why I agreed to divorce him.

CYNTHIA: Why did you?

MARY: Used each other up. Why else? Some couples accept it, others don't. Simple.

CYNTHIA: Oh, Very.

FOREIGN DEPARTMENT

GORDON: Now, this is what I mean about religious dogma leading to massacres. (*Reading from* The Times.) 'My dear countrymen, peace be with you,' he said in his speech announcing war. "Our enemy has again challenged us. His dislike and enmity of us is well-known the world over. We have shown great forbearance but the time has now come when we must give the enemy a most effective answer. One hundred and twenty million crusaders, you have the support and blessings of Allah."'

TAMARA: Uch! Vain! Pompous! Demagogues! How I despise them.

BUSINESS NEWS

MORTY: (*To someone off-stage.*) Yes, well I believe in the Capitalist system so I have no conflicts. Conflicts? Hah! I've been looking for them for years. Always wanted to be able to resign on a matter of principle.

FOREIGN DEPARTMENT

GORDON: (*Still reading from* The Times.) '"Your land is filled with the love of the Holy Prophet."'

TAMARA: I just don't believe it.

GORDON: '"Rise as one for your honour and stand like an impregnable wall of steel in the face of your enemy."'?

TAMARA: And on and on and on…

BUSINESS NEWS

MORTY: (*To someone off-stage.*) And what's more, Arnold Weinstock is one of the most intelligent men we've met who's more intelligent than us, and we don't meet many of them!

FOREIGN DEPARTMENT

GORDON: (*Still reading from* The Times.) '"You have right and justice on your side"'.

TAMARA: Always!

GORDON: '"Pounce on the enemy in a spirit of confidence."'

TAMARA: No one ever learns.

GORDON: '"Let the enemy know that every one of us is determined to stand up for the defence of the dear motherland."'

TAMARA: As though history never happened for them.

ARTS PAGES / WOMEN'S PAGES

SEBASTIAN: ...It was Beethoven's violin concerto and Carl Orff's 'Carmina Burana' and our music critic overheard one of the musicians saying, in a very loud voice: 'now that we've buggered up Beethoven we'd better fuck Orff...'

FOREIGN DEPARTMENT

GORDON: (*Still reading from* The Times.) '"The enemy knows that victory in war does not go to those who have, numerical strength and large quantities of military hardware. It goes- to those who have faith in their mission and in the ideals of Islam and who believe. God helps the righteous."'

TAMARA: And who will help us? Dear God, who will help the rest of us?

Part Four

THE CENTRE SPACE

A table in a restaurant. MARY is dining with OLIVER MASINGHAM, Under Secretary of State. for Foreign Affairs. They are friends. She is slightly drunk.

MASSINGHAM: I hope you're not disappointed, Mary. Lumbered with a mere under secretary rather than the Foreign Minister himself?

MARY: You think I'm drunk far that reason, Oliver?

MASSINGHAM: He hates interviews. All that personality cultifying.

MARY: Who does he think – no! I mustn't.

MASSINGHAM: Mustn't what.?

MARY: I've been told by my children that my only contribution to British journalism is to have elevated the gutter question 'who does he think he is?' to a respected art form.

MASSINGHAM: And that hurt of course.

MARY: It *should* have hurt. Everything should hurt. But nothing does. Oliver – this is off the record, but here's a question I've been dying to ask one of you only I didn't dare. It goes like this: you're a minister. I've watched the House in action; fights, battles of wit, of personality, intellect – but, that's not all is it? There's personality conflicts also – in the cabinet, in ministerial departments with cantankerous old civil servants.

And then – tact! Diplomacy! Different kinds, in different ways, to different people: The public face on the one hand and the private reassurance to industry, the unions, the foreign ambassadors on the other. A great juggling act, wits alert all the time. And on top of all this, on *top* – of all *this*, there's the problems of being a husband, a lover, a father, a friend, uncle, brother – God wot! (*Pause.*) How-do-you-do-it-for-God's-sake? How? How don't you

become overwhelmed by it all? Do certain arteries harden? Is part of you callous? Like the doctor, or the writer? Tell me.

MASSINGHAM: Mary, I think you're very drunk.

MARY: But still functioning, eh? My lovely brain still ticking -tick-tick-tick-tick.

MASSINGHAM: Perhaps I should take advantage of your lovely,drunk brain and get you to talk about yourself for a change.

MARY: Me? Oh, I had a famous father, didn't you know? Famous for what they called in his day 'thought-provoking' novels. Only his thoughts provoked very few, very shallowly, and his day didn't last long. I used to taunt him in front of my university friends-about having nothing to say to my generation and he used to take notice and rush to read my required reading. I had to grow up in his growing darkness and watch his lively pleasure at being recognized in the streets, change into a grey anonymity. He was a gentle man, made for the comforts fame brings and which the Gods gave him only a taste of. And I, with innocent devastation, went into competition with him. I won, of course. Because good fathers never let their children lose. He stepped back, graciously, for the sake of a healthy family, following the false principle, which many indifferent artists follow, that, if he couldn't create a healthy, happy family he couldn't create a worthy work of literature: He created nothing from that moment on. Defeated! And I understood none of that.

NEWS ROOM

It's a Saturday.

The still slide of the printing presses now becomes a film of men preparing: the machines ready for use.

The paper is being laid out. Mainly the front page. Movement is reaching towards a height.

This area can now be filled with actors who've played other parts. HARVEY is standing beside a man who's sitting drawing possible layouts on a blank sheet.

HARVEY: Right, we'll have our Middle East war on the left, conductor and his baby centre space, cholera here and map over the top, here, and that leaves this area for the gynaecologist story, if there is one. Mary? Where's Mary?

ANTHONY: (*Taking NORMAN aside.*) Will someone tell me why we're featuring a photograph on the front page of a fifty-oneyear-old opera conductor with his eighteen-month-old baby-in his arms?

NORMAN: Well, we've got a story about an outbreak of another little bloody war, one about the spread of cholera, a morbid piece about a mother urging her daughter to death, and so, with a gruesome front page like that, don't you think we need a drop of human warmth? To make our millions of readers like the world just a little better on their Sunday off work?

ANTHONY: May I remind you, Harvey, that our messengers are still on strike and copy's not moving?

HARVEY: Ronnie's with Mac now.

SPORTS PAGES

MAC: Pensions are rotten in this place, Ronnie, and you know it.

RONNIE: I know it, but –

MAC: And I'm not advising my men back until management agree to postpone the date for cancelling closure of the garage so we have time to discuss them.

RONNIE: Mac! Sometimes you boys cut your nose to spite your face.

MAC: That's not friendly, Ronnie.

RONNIE: Friendly? Do you know that your boys stopped the Securicor van from bringing in the cash the other

day? Now who do you think that affects? Not us, or management. We all get paid monthly by cheque, straight into our banks. No! The office girls. The poor, bloody office girls. We had to whip round in this office and pay the secretary.

MAC: All wars have their innocent casualties.

RONNIE: Cant! Don't give me cant, Mac. Look, time's pressing. Release your messengers, get copy flowing again so's we can get the paper out and I promise you I'll persuade our chapel to give two weeks notice of strike if no agreement is reached on redundancies. Agreed?

MAC: Can you guarantee it?

RONNIE: Come on, Mac. You know I can't *guarantee a* thing like that. Agreed?

MAC: If it doesn't work, Ronnie, I promise you, we'll get the – whole of Fleet Street out and no one, anywhere, will have a paper.

MAC leaves. RONNIE has been dialling meanwhile.

RONNIE: (*Into phone.*) We've got a newspaper!

NEWS ROOM

SECRETARY: (*Yelling to HARVEY.*) We've got a newspaper!

HARVEY: Great! Mary, where's Mary? (*MARY appears with copy.*)

MARY: All right I agree, it is a news story. As long as she goes on the front page I don't mind.

HARVEY: And the bridges story'll go into In Depth where it belongs. Good. Got a photograph?

MARY: Messengers should've brought one from the dark room.

HARVEY: The first interviews read splendidly, by the way.

MARY: Thanks, but don't patronize me, Harvey.

HARVEY: Cheer up, Mary. We nearly didn't have a paper this week.

MESSENGER arrives with photo.

My God! She looks so hounded.

MARY: It'll be a lesson to other moralizing gynaecologists. She hounded that poor child.

She leaves.

SPORTS PAGES

RONNIE: I mean all strikes are like a marriage conflict, aren't they? Just one minor incident is needed and out comes all the bitterness of past abuse, magnified by the years. Do you think that when a union leader sits facing an employer he's merely confronting a man who wants to pay him less than he's asking? Never! Have you ever seen the conference rooms, in trade union offices? Replicas of city board rooms. And when he wins his five pound a week extra he's not only getting more money for his men he's also telling the other class what they can do with their elegant culture. I understand it, I can even defend it historically, but frankly, between thou and I, I loathe its spirit, its mean, I'll knock-you-down-spirit.

NEWS ROOM

The following snatches of conversation fly back and forth among the miscellaneous characters who flood this area.

PAUL'S SECRETARY: (*Clutching phone.*) Our copy taker is in chaos and Ian is sitting in his hotel waiting to dictate – can anyone do something about it?

HARVEY'S SECRETARY: Right! We're going to that wedding after all. It's royalty and the chief feels a little responsible *to* them or *for* them or *something…*

HARVEY: (*To his SECRETARY.*) Ring him up, tell him copy is O.K., but ask him what he means by the top of page 7 where it says 'the secret transcripts have been released'! *What* transcripts have been released by whom, to whom and about what…

HARVEY'S SECRETARY: It *was* a good story until the subs got at it – inky-fingered bloody maniacs…

PAUL: (*To HARVEY.*) Harvey, first edition of the *People* look. They've got an exclusive on the Prime Minister's private earnings.

HARVEY: Damn! We got anybody on to it?

PAUL: No one free.

HARVEY: I'll do it myself.

LAYOUT: Where you thinking of putting it, Harvey?

HARVEY: That's the problem.

ANTHONY: Do you really think it's that important?

HARVEY: What, after we published his diary extracts? We'd be laughed at to miss this. Right! We'll take the cholera map out and cut the last quarter column.

LAYOUT: And put the money story where?

HARVEY: Bit at the top here, across five columns, over the Middle East headline.

ANTHONY: Then we won't be the 'only one going to town on the cholera epidemic'.

HARVEY: Not the moment to be facetious, Anthony.

POLITICAL AND FEATURES

MESSENGER: Letter for Miss Mortimer.

SPORTS PAGES

MARVIN: (*On phone.*) But, Ned, we haven't got the space. We've already had to cut down on the swimming championships – it's a small paper this week. Wait, that's not a decision I can make, I'll ask Ronnie. Ronnie, Ned reporting the Arsenal West Ham match, he says the Hammers' new player is the greatest genius in the history of football.

RONNIE: That's because Net's a university graduate who wants to write about football as poetry. How much does he want?

MARVIN: Another three hundred words.

RONNIE: Tell him 150!

MARVIN: (*Into phone.*) 150!

POLITICAL AND FEATURES

MARY: Jesus Christ! (*She moves quickly to the door to call the MESSENGER back.*) What did he look like?

MESSENGER: Who, miss?

MARY: The man who gave you this letter, describe him, quick.

MESSENGER: Well, I don't know, do I? Reception give it to me and I just give it to you, didn't I?

> *He leaves. MARY whips up phone, dials. It's picked up in the NEWSROOM.*

MARY: Harvey, please.

SECRETARY: For you, Harvey.

MARY: Harvey. Can I see you? Alone?

HARVEY: I'm just about to start on the P.M.'s earnings. What is it?

MARY: Something on Morgan King. I've got to see you.

HARVEY: Well, briefly then, in my office.

> *MARY is about to rush out.*

CYNTHIA: What's all that, then?

MARY: Morgan King and kidnappings.

> *She leaves.*

BUSINESS NEWS

DOMINIC: (*He's slightly drunk.*) Women! Ah, women! I love them! Their touch, their look, their smells. I *love* a woman who smells of action. When she works in a

garage there's a smell of oil lingering around her.
If she's a doctor – it's medicinal. A painter – the
smell of paints. I love the smell of alcohol on her
breath when she drinks; of her body after she runs.
Anything that tells me she moves, is alive with
decisions, agitated. Fuck your art! Fuck your politics!
Fuck your conversation! Even your wine. Women! I
can't bear to be without them.

NEWS ROOM

JULIAN visiting.

SECRETARY: (*On phone.*) Time Life? Paul Mannering's secretary
here. Yes, the same one. We can't afford two. It's
about that article he promised you. I forgot it! Will
tomorrow do? Thanks. 'Bye. Holy Mother of God
forgive me for my sins.

JULIAN: How much are they paying you for all that, Kathy?

SECRETARY: Well they get a separate bill for every lie I tell – if
that's what you mean.

ARTS PAGES / WOMEN'S PAGES

ANGELA: I can't review this book.

JANE: You write novels. I don't think you should review
them.

ANGELA: I find his writing so awful and I gave his last one
such a knocking that I'm beginning to feel it's unfair.
Gives me guilts. No reviewer should have to feel
guilts.

JANE: Especially if she's also a novelist!

SEBASTIAN: Meeeow!

EDITOR'S OFFICE

HARVEY has just finished reading the letter MARY's handed him.

MARY: What do you think?

HARVEY: It's Suspect.

MARY: Not to me it isn't.

HARVEY: And we'll end up with the biggest libel suit in the history of Fleet Street.

MARY: Here's what I suggest. We've got three hours till the last edition. Can the bridges hold over till next week?

HARVEY: Till eternity I should think.

MARY: This man's waiting for me across the road in the pub. I'll take Chris and see what he's got to say. If the documents look authentic then we'll reproduce them and just ask questions. No comment.

HARVEY: They'll have to be bloody authentic.

MARY: We'll spend an hour with the fink, an hour to write it and it can be on the stone in good time for the last press as an In Depth story.

HARVEY: You're rushing, Mary.

MARY: I know, I just know – in my bones – these documents will be conclusive. I've pursued this man for a year now, Harvey, and I've warned – he's a phoney of the most t offensive sort and it's our responsibility to –

HARVEY: Mary, have you thought, that if he's linked with the robbing of supermarkets for old-age pensioners, bank robberies to pay strikers, kidnapping managers to give them lessons in civility, then you'll do just what you don't want, you'll make him a martyr.

MARY: Nonsense! The English temperament can't stand martyrs.

HARVEY: And there's another thing. I've got a sneaking admiration for the enterprise. It appeals to me.

MARY: Well, it doesn't to me. It's the wrong tone of voice. Half-baked revolutionaries who've borrowed other people's tongues. Its sentimental nonsense which belongs neither to our nature, our history nor our situation and I despise it.

HARVEY: Mary, some advice.

MARY: Not now, Harvey.

HARVEY: Yes, *just* now. We're only engaged in handing on fragments of information. You can spice it with comment, but don't fall into the trap of exaggerated pronouncements.

MARY: Harvey, I don't think –

HARVEY: Well I *do* think. You can't reveal, you can only inform. Don't simplify what's complex and then imagine – you've clarified the truth. And it is complex. New states being born, new classes, races finding their voice, feeling their strengths. A time ripe for opportunists, ripe for platitudes about suffering, ripe for revenge. Anything can happen: a release of all that's noble in men or a murderous unleashing of spites and envies. And we have the power to tip it one way or the other; not simply by what we say but the *way we say it.* The habit of knocking-down, gods is very. seductive and contagious. I'm not all that proud of the history of journalism, Mary, but I don't want to see *The Sunday Paper* perpetuating it.

MARY: But why this – *now* – and to *me.*

HARVEY: Because each 'god' you topple chips away at your own self-respect. The damage you do to others can boomerang and destroy you. That's why.

MARY: The duty of this paper, since we're handing out advice, is to investigate secret and well protected: misbehaviour – of any kind.

HARVEY: And there's no institution more 'well protected' than a newspaper.

MARY: But that doesn't mean we can afford to limit democratic scrutiny of our society-and its politicians, for Christ's sake!

HARVEY: I'm simply warning you. You might want to deflate the egos of self-styled 'gods' but be careful you don't crack the confidence of good men. We haven't got that many. Think on it.

MARY: I don't really think I needed all that.

She leaves.

POLITICAL AND FEATURES

NORMAN: She's lucky, Mary. She can insult fools. Not me. 1 was born to suffer the fool for ever. And why? Because when the stupid man is being stupid *he* knows he's being stupid, and I know that he knows, but I can't offend him by letting him know that I know! I'm a gentle soul. People must be allowed to-be stupid like dogs going off into corners to lick their wounds.

IN DEPTH

MARY visiting.

MARY: Chris, take a break and come and have a drink with a fink.

CHRIS: A gentle fink or an evil fink?

MARY: A Morgan King fink.

JULIAN: Ah! A king-sized fink.

CHRIS: Gossip or documents?

MARY: You know I never listen to gossip. Hurry, if it looks good I want to catch .the, last edition.

CHRIS: St George moves in for the kill.

‘ MARY: All right, all right! He's misunderstood. I'm the dragon.

Shall we move?

CHRIS: I fly, I fly. Watch me how I fly.

They leave.

POLITICAL AND FEATURES

CYNTHIA: I once knew a beautiful young boy who was like that. Everyone wanted to embrace him, me for example. And he was so sensitive to the embarrassment of refusal that he let me. Men, women they all wanted to touch him. The more brazen seduced him outright some people have a nose for those things, they can smell out victims. That's what he was, a victim. And so gradually he began avoiding people, shunned all contacts, withdrew. At the age of thirty hewas consigned to a home, morose, confused. Born for abuse.

FOREIGN DEPARTMENT

The urgent sound of 'tick-tack'. GORDON and TAMARA standing by the telex.

GORDON: (*Reading.*) 'At least 250 doctors, professors, writers and teachers, the cream .of the intellectuals who could have helped create the state – were found murdered in a field outside the capital.'

TAMARA turns away.

'All had their hands tied behind their backs and had been bayoneted, garrotted or shot.' Tamara, get this down to Harvey. It's Reuters, everyone'll have it. Tamara!

TAMARA: I –

GORDON: For Christ's sake, you're a journalist. Is this any worse than your reports on the Eichmann trial?

TAMARA: Darkness, there's such darkness in that act.

GORDON: It's war.

TAMARA: War? It's Mary's 'who-does-he-think-he-is?' gone insane. The poisonous side of the sweet apple of

democracy. It's what your lovely ordinary Everyman would like to do in order to feel equal – massacre the thinkers.

GORDON: Don't be a bloody fool. Men have been slaughtering their thinkers for centuries.

TAMARA: How blithely you say it.

BUSINESS NEWS

JANE approaching DOMINIC with a bottle of whisky.

JANE: With the compliments of Women's Pages.

MORTY: And what's he done that we haven't?

DOMINIC: Gave the girls a little anecdote about the man who was refused sterilization on the National Health.

MORTY: You selling your life story again?

DOMINIC: Oh very funny. But I tell you the population explosion is serious. I can hardly park my car for people in the way.

FOREIGN DEPARTMENT

TAMARA: I don't think I can really cope much more, Gordon.

GORDON: Go home, I'll finish your story.

TAMARA: Between the oppressors and the fanatics there's the rest of us.

GORDON: Go to a cinema, or the opera.

TAMARA: Helpless. We're always so helpless.

GORDON: Spoil yourself. Buy yourself a present – what about those antique markets you love so much?

TAMARA: Uch! Depressing! Cracked plates, torn lace, thread bare shawls. Old ladies' homes bought for a few pence and sold at such a terrible profit. All fraudulent, cheating –. and insulting. Above all insulting, and offensive, and greedy, and insulting and greedy greedy, greedy.

SPORTS PAGES

MARVIN: (*Slamming down phone.*) Thank you very much! Another bloody adviser. Why do they always come through on a Saturday, the day when we're the only office working our balls off.

RONNIE: Occupational hazard, mate. Unlike the other departments in this autocratic establishment we have democracy forced on us: Everyone's an expert on sport and every Sunday morning spiteful little eyes race down our columns in the 'let's-catch-'em-out-game'.

BUSINESS NEWS

MORTY: Tell me, Jane. That feature on dressing fat ladies, your model, where did you find her?

DOMINIC: Thinking of modelling fat men's wear, are you?

JANE: The less we talk of that little fraud the better. I think.

MORTY: But she was beautiful. Fat, beautiful, happy and well dressed. Tremendous. morale booster for stout ladies.

JANE: She got hundreds of offers of marriage, but what those photographs didn't show, and we only discovered it afterwards, was that the clothes she was given to wear didn't meet at the back and had to be kept together with safety pins.

NEWS ROOM

HARVEY: Right! My copy's gone down. (*To layout.*) Sam, you laid out the new shape yet?

LAYOUT: It'll look like this. What's your headline?

HARVEY: Any ideas?

ANTHONY: How about 'Earnings I ain't got'?

HARVEY: He had earnings all right.

LAYOUT: How about 'Earnings: P.M. tells all'.

HARVEY: No. We'll keep it straight. 'P.M. I've still got an
 overdraft'. That's what he said. Will it go in?

LAYOUT: I think we can fit that in.

MESSENGER arrives with proof sheets.

HARVEY: Anthony, do me a favour and sub that for me,
 please.

ARTS PAGES / WOMEN'S PAGES

SEBASTIAN: (*On phone.*) No, no dear fellow, you know it's
 much better to cut an entire paragraph rather than
 rearrange it. The printers invariably make a balls of
 it.

IN DEPTH

ANGELA visiting.

JULIAN: And so our ex-prime minister, Hotspur Hoskins as
 he was fondly known to us all, said of her, in one
 of his more jovial and confiding moods: 'Political
 commentator? Huh! That bitch'd get a scoop wrong
 if you gave it to her at dictation speed.'

ANGELA: Did he actually use the word 'scoop'? Jesus!

NEWS ROOM

MORTY arrives on the scene.

HARVEY: Morty, your fink's story. Anything in it?

MORTY: The problem is, if a company like Onyx declares an
 overseas profit of £1 million they don't have to say
 where it comes from.

HARVEY: On the other hand don't you always do business
 with your friends?

MORTY: Right. That's what business is about, and Crafty
 Crafton was only going about his business.

HARVEY: Good. So we forget it.

MORTY: And a plague on all their houses.

HARVEY: Tony, that piece Chris did on Atlantis Insurance.

ANTHONY: All true, Harvey. Every word of it. But. no documents.

HARVEY: We'll print it but it weakens the story without names.

ANTHONY: The old problem, loyalty to sources of information.

HARVEY: My piece O.K.?

ANTHONY: O.K.

HARVEY: Good. We'll push out the first edition.

PAUL: (*Into phone.*) Let's go! Roll 'em!

Now the film on the backscreen becomes a film of the machines beginning to roll out the first edition. And with it comes the full blast of their noise which, though subsequently reduced for the remaining dialogue, continues till the end of the play.

IN DEPTH

JULIAN: (*On phone.*) Yes, the Atlantis story is going in, it's a big story – very eye-catching – pretty diagrams and all that – most impressive. No! Of course no names are mentioned.

ARTS PAGES / WOMEN'S PAGES

ANGELA: (*On phone.*) Yes, yes. Your air tickets are in. the post, now concentrate on the paragraph you're going to cut for me. How about the one comparing his playing to a 'flight of homeward flying fleas'? Yes, it may be accurate and funny but we do try to discourage our distinguished critics from being gratuitously offensive.

NEWS ROOM

MARTIN rushes in.

MARTIN: (*Calling HARVEY aside from main table.*) Harvey?

HARVEY: What is it, Martin?

MARTIN: I was right. There does exist a secret society.

HARVEY: Let's have it.

MARTIN: It's hot.

HARVEY: Well let's have it for God's sake.

MARTIN: I'm sitting on top of an Anarchists cell when in burst three youngsters, nylon stockings over their faces, one carrying a gun, and they tell the Anarchists to lay off the violence.

HARVEY: With one of them carrying a gun?

MARTIN: It turns out to be a water pistol.

HARVEY: Go on.

MARTIN: So I trail the three rivals –

HARVEY: Make it short.

MARTIN: And one of them turns out to be Mary's youngest son.

HARVEY: Oh no! Bloody hell! No.

ANTHONY: You're looking harassed, Harvey.

HARVEY: (*To MARTIN.*) Tell him.

BUSINESS NEWS

JANE: (*Reading a letter.*) 'And what's more,' she writes, 'I think you should not only be urging people not to have babies but you should encourage them to save our resources. Water for instance. I mean, soon the world will run out of water. Forgive the personal touch but I've stopped pulling the chain-on my urination.'

DOMINIC: I see. Save our water and start a dysentery. epidemic.

NEWS ROOM

ANTHONY: You can't tell her, Harvey.

HARVEY: Not in front of this lot, I can't. And it can't be *her* story either.

MARTIN: You bet it can't. I've stood in the cold for days on this one.

ANTHONY: Don't be a fool, Martin. Yours is only half the ditty.

MARTIN: Half?

ANTHONY: At this moment Saint Maria Mortimer is out gathering dirt which she believes will topple the dragon of Lanark.

MARTIN: I don't connect.

ANTHONY: You should, my boy, you should. 'Only connect,' says Forster.

MARTIN: I didn't go to university.

ANTHONY: I thought everyone went to university. She's in a pub across the road, talking to an evil fink, who's offered her documents proving a link between Morgan King and your socalled secret society.

MARTIN: Jesus!

ANTHONY: Well, Harvey?

HARVEY: I'm still thinking.

IN DEPTH

JULIAN: (*On phone.*) And so I walked into El Vino's for the first time in my life, 'cos everyone assured me I had to do my drinking there or I wouldn't know what was going on in the world, and I was thinking to myself: that perhaps I'd come into the wrong profession after all, when a bloke comes up to me, pissed out of his mind, and says, as though he'd read my thoughts, he says: 'Psst. A journalist is a man who possesses himself of a fantasy and lures the truth towards it – remember that and you'll go to the top.'

NEWS ROOM

HARVEY: Right! The bridges story comes back. (*Picks up the phone.*) Frank? Don't hold that last edition. Yes, *don't* hold it I said. The bridges story stays in. Yes, in! In, in, IN!

ANTHONY: Martin my boy, what you now do with your story is your own decision. Can you believe it?

FOREIGN DEPARTMENT

Urgent sound of 'tick-tack'. TAMARA is in the middle of reading a long telex.

TAMARA: The most: horrific episode carried out by the guerrillas was in the midst of celebratory prayers which turned into cries of revenge for the 250 murdered intellectuals. The rally ended with Islamic prayers in which five prisoners, whose crime was alleged to have been an attempt to abduct two women, joined their captors in offering praise to Allah. The crowd began to beat the trussed up men until a group of the guerrillas, wearing black uniforms, pushed them back, fixed bayonets and began to stab the prisoners through the neck, the chest, and stomach. The crowd watched with interest and the photographers snapped away. A small boy of ten; the son of one of the prisoners, cradled the head of his dying father, which act infuriated the crowd who proceeded to trample on the child.' (*Breaks down.*)

GORDON: Go home!

NEWS ROOM

MARY and CHRIS rush in.

MARY: They're authentic. I knew it. Look.

CHRIS: True, Harvey. Front page material.

HARVEY: It's too late.

MARY: Too late. You've held the last edition, haven't you?

HARVEY: It was too late I tell you.

MARY: Too late? Too late? Whose nonsense is this? We agreed.

HARVEY: It came from the top. The bridges story had to stay.

MARY: Bloody hell! Didn't you tell them we had an important story coming up?

HARVEY: They wanted to see the evidence first. Too risky.

MARY: What cock and bull story is that, Harvey? You're the editor aren't you?

HARVEY: And that's my decision.

MARY: But I promised I'd bring him down.

BUSINESS NEWS

JANE: Do you know, I never ever see any of you working. You're always standing around reading magazines with incomprehensible graphs and tables.

DOMINIC: Not work? My dear lady. First of all it's Saturday and our work's all done. Secondly I'm reading the opposition, and that's work.

NEWS ROOM

MARY: I demand a better explanation, Harvey. That man's a politician and in the running to be on the party's executive. That makes him dangerous, a national risk.

BUSINESS NEWS

DOMINIC: Ah! Now, what we *should* do is one thing, what we're *able* to do is another. I tell you, the cigarette packets carry a notice saying: 'Warning! Smoking can damage your health!' But what about all newspapers carrying a notice on the -front page, just below their names, saying: 'Warning! The selective

attention to data herein contained may warp your view of the world!' What about that, eh?

NEWS ROOM

MARY: But I could have brought him down. I promised you I'd bring that man DOWN!

HARVEY: (*To someone.*) The bloody idiots have cut the wrong story.

MARY: He doesn't even listen to me now.

SPORTS PAGES

RONNIE: (*On phone.*) *I* can't help it. It'll have to wait over till next week. It's a small paper this week and fishing's a small sport – NO! I don't care if it does feed multitudes…

BUSINESS NEWS

JANE: I like it. 'Warp your view of the world.'

DOMINIC: just below the name. Imagine it. '*The Sunday Paper* – Warning! The selective attention to data herein contained may warp your view of the world.' Po-pom!

NEWS ROOM

MARY: Harvey, answer me!

BUSINESS NEWS

JANE: *Daily Mirror* – warning –

DOMIMIC: *The Times* – warning

JANE: *Private Eye* – warning –

TOGETHER: 'May warp your view of the world!'

NEWS ROOM

MARY: HARVEY!

ANTHONY: Mary, my dear, look, I've got a problem... (*He takes her, consolingly, from the scene.*)

MARY: But why isn't he listening? He's not even listening.

Now, as they move off, everyone in all departments talks at once, a babble, a crescendo of voices melting into the full blast of the machines. The sound continues but – the stage darkens – except for the bright image on the screen of the presses turning – turning.

BADENHEIM 1939

a play in five parts
no interval
with music needing to be composed

adapted by Arnold Wesker

from the novel by
Aharon Appelfeld

Characters

IN ORDER OF APPEARANCE

21 Characters, 9 musicians, and as many others for crowd scenes as can be afforded. Much doubling is of course possible.

SIX SANITATION INSPECTORS

MARTIN, THE CHEMIST

TRUDE, HIS WIFE

HEADWAITER

WAITRESS

PASTRY SHOP OWNER

SALLY, A LOCAL EX-WHORE

GERTIE, THE SAME

KARL

LOTTE, HIS GIRLFRIEND

GUESTS, AS MANY AS AFFORDABLE

PORTERS

Six-man Band including: SAMITZKY
 CONDUCTOR

DR. SHUTZ

SCHOOLGIRL

DR. PAPPENHEIM

FRAU ZAUBERBLIT

PROFESSOR FUSSHOLDT

FRAU MITZI FUSSHOLDT, HIS WIFE

PRINCESS MILBAUM

THE TWINS, HER PROTÉGÉS

DR. LANGMAN

OLD MAN

TELEGRAPH ASSISTANT

YANUKA, WUNDERKINDT

A TOWNSWOMAN

THE MANDELBAUM TRIO

STRANGERS:

> Parents and children
>
> Middle-aged and Well Dressed

THE MAJOR

FRAU ZAUBERBLIT'S DAUGHTER

HOTEL OWNER

CHEF, FROM PASTRY SHOP

SALO

TWO SANATORIUM MEN

HELENA, TRUDE'S DAUGHTER

OLD RABBI IN WHEELCHAIR

NOTES

Badenheim is an Austrian spa.

The guests are mostly middle-class, bohemian Jews.

Settings and action centre round the town square.

As a general principle dialogue and movement are concurrent. That is to say exchanges take place while there is movement elsewhere.

Occasionally certain areas will need to come into focus. Then all else freezes.

This is necessary not only to intrude, say, on The Trio or The Readers rehearsing, but to facilitate the technical effect of the settings deteriorating.

MUSIC

Original music is called for. Namely:

Five dances – Waltz, Polka, Tango, Chassidic Dance, Jazz Dance.

Band music.

A work for TRIO AND BRASS BAND.

Songs for the YANUKA.

Incidental music.

BREAK-DOWN

SCENES AND MUSIC

Part One

The town square – WALTZ!
The chemist's shop.
The cafe tables.
The chemist's shop – BAND MUSIC.
The town square.

Part Two

The municipal notice board.
The cafe tables.
A hotel room.
Telegraph office.
Hotel lobby.
Fussholdt's room.
The town square – POLKA!
The cafe tables – CHASSIDIC DANCE!

Part Three

The town square – CHAMBER MUSIC.
The chemist's shop.
A corner of the square.
Frau Zauberblit's room.
Telegraph office.
Sanitation Department.
Frau Zauberblit's room.
Sanitation Department.

Hotel lounge.

The Concert Hall – THE YANUKA'S SONGS.

Part Four

Hotel front door

The pastry shop.

Hotel bar – JAZZ DANCE!

Frau Zauberblit's room /

The chemist's shop / Silent scenes except for

Hotel lobby / WORK FOR TRIO AND BRASS
BAND

The town square /

The hotel cellar /

The cafe tables and town square – TANGO!

The chemists shop.

Hotel dining room.

Gertie's and Sally's front room – music from old horn
gramaphone.

Part Five

The hotel steps – A FIERCE VIOLIN CADENZA

Road to the station.

The station

Part One

THE TOWN SQUARE

Something impending. What?

We are uncertain if it is spring into summer, the town blossoming into holiday spa or –

– something else.

The first two events are ominous, dark, at variance with the setting's poised promise of gaiety.

But to begin –

– the stage is shrouded in spring's shadows.

Slowly they withdraw leaving the stage bathed in the cheerful light of an early summer sun.

Before this movement of light is completed two men arrive in the distinctive uniform of SANITATION INSPECTORS.

They prise open the heavy metal lid of first one sewer, then another, checking.

They are more than what they seem to be.

Before they leave, a woman peers out of the window over the chemist shop. TRUDE. A disturbed soul.

She watches them as they leave.

They register her.

A man passes them carrying packages from the station. MARTIN the chemist, TRUDE's husband.

The SANITATION INSPECTORS register him too.

MARTIN: (*To TRUDE indicating his packages.*) The train arrived on time.

TRUDE: And the mail?

MARTIN: A summer's supply of medication.

TRUDE: Where is the mail?

MARTIN: The holiday-makers can over-indulge. Food, drink, passion – I have a remedy.

TRUDE: No mail?

MARTIN: (*Patient and sad.*) No mail, Trude. It's Monday, the
mail only comes in the afternoon.

> *She withdraws. He enters.*
>
> *The shadows have been moving away all this time.
> The growing light is – tingling!*
>
> *Perhaps some of the town's inhabitants cross the
> square.*
>
> *The HEADWAITER to his hotel?*
>
> *The WAITRESS to her cafe?*
>
> *The PASTRY SHOP OWNER to open his shop?*
>
> *SALLY and GERTIE, the local ex-whores admiring
> each other's new summer frocks?*
>
> *One couple arrive, just off the train. GUESTS for the
> hotel: KARL pulls LOTTE, his reluctant partner for the
> holiday. They enter.*
>
> *Life slowly burgeons. Light grows. The air is full of
> church-bells and a sense of –*
>
> *– arrival!*
>
> *The spa bursts into life.*
>
> *GUESTS emerge from the hotel on their way to
> walks.*
>
> *OTHERS take their place in the cafe.*
>
> *PASTRY SHOP OWNER decorates his shop with
> flowers.*
>
> *PORTERS carry bags into the hotel.*
>
> *Activity around the souvenir shop.*
>
> *The SIX MAN BAND, dressed in blue, takes its place in
> the bandstand under its CONDUCTOR.*
>
> *When the different areas of life at the spa have been
> established there is a sudden hush. Something is about
> to happen. Gaiety held in check. Suppressed giggles.
> Stifled squeals of delight. The CONDUCTOR raises his
> baton. Anticipation!*

The BAND plays. A WALTZ! The square is alive with WALTZING COUPLES.

When it is over – applause, laughter.

A young man, DR. SHUTZ, emerges from the pastry shop with a tray of cream cakes. He seems anxious not to have been observed. They are for SALLY and GERTIE, who are delighted.

SALLY: Forbidden cakes!

GERTIE: Which *we* are forbidden!

DR. SHUTZ: He'll never know.

But the PASTRY OWNER has seen him.

PASTRY OWNER: No cakes for whores! No cakes for whores! They have disgraced the town. Never again, Dr. Shutz. You will not enter my shop ever again.

Mixed laughter, scandalised cries.

DR. SHUTZ: He'll forget and forgive. Eat and enjoy.

Suddenly – an apparition! A young woman arrives. She is stunningly beautiful but anxious, as though she should not be there and fears being caught. She is the SCHOOLGIRL.

DR. SHUTZ is struck. Cannot take his eyes off her. Hypnotised he moves to her, takes her cases and helps her into the hotel, out of which comes –

DR. PAPPENHEIM, a most important man, Artistic Director of Badenheim's central event: The Music Festival. There is even a little applause as he appears.

He approaches SALLY and GERTIE.

PAPPENHEIM: And how are the ladies?

GERTIE: Ah! Dr Pappenheim, if only everyone thought us ladies.

PAPPENHEIM: The past is the past. We must all be allowed to change our views, our styles, our friends, our husbands, our wives, our skins, our very lives!

GERTIE: A gentleman!

SALLY: A gentleman!

GERTIE: A real gentleman!

SALLY: And what has been happening out there in the big wide world?

GERTIE: The spa in winter is a very isolated place for women like us.

SALLY: For all the townspeople.

GERTIE: For all the townspeople.

PAPPENHEIM: Happening? Out there? Oh, nothing out of the ordinary.

GERTIE: But it was a strange winter.

SALLY: You must agree, a strange winter.

PAPPENHEIM: Not to worry! My festival's full of surprises this year.

SALLY: (*Delighted.*) Oh! Surprises!

PAPPENHEIM: A yanuka.

SALLY: (*To GERTIE, maternally.*) A yanuka.

PAPPENHEIM: A child prodigy.

GERTIE: (*To SALLY.*) A child prodigy.

PAPPENHEIM: With a voice to bring back paradise and all our lost innocence.

SALLY: All our lost innocence.

A WAITER brings a telegram for DR. PAPPENHEIM.

PAPPENHEIM: (*Opening it.*) Discovered him in Vienna. In the winter.

He reads telegram.

Catastrophe!

One of the bandsmen, SAMITZKY, strolls up.

SAMITZKY: Telegrams are always catastrophe.

PAPPENHEIM: Mandelbaum!

SAMITZKY: (*Impressed.*) Mandelbaum?

PAPPENHEIM: He's ill!

SAMITZKY: Mandelbaum here?

PAPPENHEIM: He's cancelled.

SAMITZKY: You managed to persuade the Mandelbaum trio to come here?

PAPPENHEIM: After years and years of begging.

SAMITZKY: The Mandelbaum trio!

PAPPENHEIM: The crowning glory!

SAMITZKY: Don't despair. At least you have us.

PAPPENHEIM, never having had real respect for the band, rushes off.

PAPPENHEIM: Telegrams! I must send telegrams. My festival is falling apart.

FRAU ZAUBERBLIT greets SAMITZKY.

FRAU Z: There is a faraway look in your eye, Mr Samitzky.

SAMITZKY: Strange thing. I feel homesick for Poland.

FRAU Z: And why is that?

SAMITZKY: Who knows? I was seven when I left but it seems only yesterday.

FRAU Z: Ah! Longings, longings. They come at you from nowhere. I was thinking about my grandfather's house. He was the rabbi of Kirchenhaus you know. A man of God. In the evenings he'd walk by the river. He loved nature.

A BANDSMAN calls to SAMITZKY.

BANDSMAN: Samitzky! Come and look at this pay cheque.

FRAU ZAUBERBLIT bows to him as he excuses himself.

SHE is deciding which way to go for her walk. Her gaze stops at a couple.

It is LOTTE and KARL.

LOTTE: All you know about me is that my husband was the head of a big firm and that he was killed in an avalanche. And all I know about you is that you're divorced and that your children live with their grandfather.

KARL: We'll learn more as the weeks go by. You'll see. Badenheim gives one such a feeling of vitality. You'll be so happy you've decided to stay.

LOTTE: I *haven't* decided to stay.

TRUDE, sad at her window.

TRUDE: (*To MARTIN below.*) Why is everyone walking so slowly?

MARTIN: Because they're on vacation, silly woman, that's why.

TRUDE: They all look very pale to me.

MARTIN: They've just come from the city.

TRUDE: Isn't that man standing beside Frau Zauberblit her brother?

MARTIN: No, Trude. Her brother's been dead for years.

TRUDE: Has the mail come yet?

MARTIN: Yes, but there's nothing for us.

No one was standing beside FRAU ZAUBERBLIT.

The SCHOOLGIRL joins her and they go off followed by a besotted DR. SHUTZ.

FRAU Z: There's nothing like a holiday in Badenheim.

At the Bandstand.

BANDSMAN: (*To SAMITZKY.*) Is this what was agreed?

SAMITZKY: (*Impatiently.*) It was agreed, it was agreed!

BANDSMAN: Because Pappenheim is not to be trusted, you know.

SAMITZKY: Are your rooms satisfactory?

BANDSMAN: For a change!

SAMITZKY: Clean sheets, clean linen?

BANDSMAN: Because we nagged all these years.

SAMITZKY: And who keeps you supplied with sweets and beer?

BANDSMAN: No more than our due.

SAMITZKY: Our due! Our due! We're a third-rate band, we never rehearse, and we keep on and on and on

about our due! Me? I don't care. We'll soon be
going to Poland.

BANDSMAN: Poland?

SAMITZKY: (*Uncertain why he's said it.*) So you'd better brush up
on your Yiddish.

LOTTE approaches.

LOTTE: Excuse me, is it possible to post a letter from here?

SAMITZKY: Of course.

LOTTE: That's strange. I thought the place was completely
isolated.

SHE wanders off as though lost.

BANDSMAN: *She's* not a regular.

SAMITZKY: She's not the only one.

*THE CONDUCTOR raps his baton. Time to continue
playing.*

As they play it becomes evening.

Against the music all else freezes.

THE CHEMIST'S SHOP

TRUDE upstairs lying on the bed.

*Downstairs MARTIN is being questioned by a SANITARY
INSPECTOR who writes down the answers.*

INSPECTOR: The business is yours?

MARTIN: Yes, sir.

INSPECTOR: Under your name only?

MARTIN: Martin Kesselman, yes, sir.

INSPECTOR: Did you inherit it?

MARTIN: Inherit? (*Laughs.*) My parents were penniless.

INSPECTOR: Then how could you acquire such a prosperous
concern?

MARTIN: When I bought this shop it was not prosperous.
The natural beauty of Badenheim hadn't been
discovered yet.

INSPECTOR: It is worth how much now would you say?

MARTIN: Such strange questions. You're the Sanitation Department. Why aren't you asking when I last spring-cleaned and disinfected?

INSPECTOR: When *was* that?

MARTIN: Funny people! A month ago.

SANITARY INSPECTOR puts away his papers. Takes out a measure and measures the room.

While he's doing that TRUDE calls.

TRUDE: Martin? Martin?

HE cannot go to her until the INSPECTOR has finished measuring and leaves, which he does, without a word.

MARTIN: Funny people.

MARTIN runs upstairs to his wife.

TRUDE: Helena doesn't write because Leopold won't let her. He beats her and he's afraid she'll complain to us.

MARTIN: These are delusions, Trude. Your daughter's well and your son-in-law is a good man.

TRUDE: I wish we had kept contact with my brothers.

MARTIN: That's your problem! Your heart is still with the old world, with those peasant Jews up in the mountains. Finish with this nostalgia and melancholy. It's beginning to affect me.

THE CAFE TABLES

PEOPLE strolling.

PAPPENHEIM and FRAU ZAUBERBLIT and MITZI FUSSHOLDT take a place at the cafe table. PAPPENHEIM is distressed.

MITZI: (*Of PAPPENHEIM.*) He's inconsolable.

FRAU Z: I'll buy him his favourite French wine.

PAPPENHEIM: Who will save me from artists!

FRAU Z: Don't worry. If the Mandelbaum Trio doesn't answer your telegrams I'll get the Kraus Chamber Ensemble for you. No unhappiness! I won't have it. I left the sanatorium to holiday in Badenheim with old friends. I feel young and happy –

MITZI: – and in love –

FRAU Z: – and in love. Isn't it absurd? At my age. And with a drummer in a band who still speaks German with a Polish accent.

At a nearby table LOTTE and KARL. A strained relationship.

LOTTE: What am I doing here? Why did you bring me?

KARL: Relax. Please.

LOTTE: What's so wonderful about this place?

KARL: A festival.

LOTTE: A festival?

KARL: A music festival.

LOTTE: You didn't say.

KARL: Everybody comes to Badenheim for the air and the festival.

LOTTE: (*Momentarily interested.*) Where does it take place?

KARL: In the big hall.

LOTTE: (*Her interest evaporates.*) I must go.

Stands, moves away, restless.

KARL: You can't imagine how wonderful it is.

LOTTE: I've been trying to go for days.

KARL: The great artists –

LOTTE: Why won't you let me go?

KARL: – the atmosphere –

LOTTE: Just point me in the direction of the station.

KARL: It's night. There are no trains.

He reaches for her hand. She is unhappy, which –

– contrasts to the happy laughter we hear from the SCHOOLGIRL being chased by a wild DR. SHUTZ.

FRAU Z: (*Calling.*) Dr. Shutz! Join us! Intelligent company and intelligent conversation.

DR. SHUTZ: (*In flight.*) For to everything there is a season!

PAPPENHEIM: Wasted! The man has a great musical talent.

FRAU Z: The man also has a rich old mother who pays his debts.

MITZI: Everyone spoils him. The darling of Badenheim. Besotted by him.

FRAU Z: Though now I rather think he's besotted *by...*

MITZI: Who *is* she?

FRAU Z: A wild young thing! A runaway! From her boarding school.

PAPPENHEIM: Spring drives the young mad. Me – it makes gloomy.

FRAU Z: No gloom! I've promised to cover your losses. No gloom!

LOTTE still stands, wanting to go, somewhere, anywhere.

LOTTE: Why, *why* did you bring me here?

KARL: The festival! Believe me! No evil intentions! An artistic experience.

LOTTE: I don't need an artistic experience!

KARL: Stay for one event.

LOTTE: I want to go back to the city.

KARL: Just one event. You can go back after that.

LOTTE: (*Unconvinced.*) I do not know what I am doing here.

KARL: Because it would be a loss. To miss such an impressive experience would be a loss.

Suddenly a scream rends the air.

Everyone freezes.

THE CHEMIST'S SHOP

TRUDE. Her bedroom. She cannot stop screaming.

MARTIN on his knees, his arms round her waist, his head clasped to her belly.

MARTIN: Trude, please, Trude! Calm yourself. There's no forest here. There's no wolves here. There's only me. Martin. Your husband. Trude, please.

Music from the BAND takes over from her screams.

The music is – strange.

THE TOWN SQUARE

The atmosphere is equally strange.

The square is full of uncertain people, uncertain shadows.

As the light falls DR. SHUTZ is drawing a shy SCHOOLGIRL back up the hotel steps and through its doors.

BLACKOUT.

Part Two

THE MUNICIPAL NOTICE BOARD

Days later.

GUESTS cluster round it. A buzz of concern rises from them, grows, and finally bursts as though from a pressure they had been enclosing.

What 'bursts' out of them, are FIVE SANITATION INSPECTORS.

TWO busy themselves measuring places – the cafe, the souvenir shop, the pastry shop, writing in a book.

THREE engage THREE SEPARATE PERSONS or COUPLES in questions, the answers to which are also written in a book.

The questioning is quiet, even friendly.

1ST S. MAN: (*To MITZI and her HUSBAND.*) Name?

PROF. F: Professor Rainer and Frau Mitzi Fussholdt.

1ST S. MAN: Ages?

PROF. F: Forty-five and thirty-five. My wife that is, thirty-five. I'm forty-five.

1ST S. MAN: Profession?

PROF. F: University lecturer.

1ST S. MAN: In what?

PROF. F: Jewish history.

1ST S. MAN: Purpose of visit?

PROF. F: Holiday ostensibly, but in fact it will be my wife who enjoys the holiday. I'm here to work on the proofs of my last book. Five years work. My best. The jewel in my crown.

1ST S. MAN: It is about?

PROF. F: I've lectured on Theodore Herzl, a hack writer with messianic pretentions. It could be about that. I've lectured on Martin Buber who couldn't make up his mind if he was a prophet or a professor. It

could be about that. I've lectured about Karl Kraus, now *there* was a great Jew – though he didn't like Jews if the truth be known but – he revived satire! Very important! How can a society be healthy without satire? It could be a book about that. Hack journalists, Jewish art, opportunism – it could be about any of those things.

1ST S. MAN: And which of those things *is* it about?

PROF. F: Ha! Look at him! He writes everything down!

SECOND SANITATION INSPECTOR questions the WAITRESS.

2ND S. MAN: Married or single?

WAITRESS: Single.

2ND S. MAN: Do you live here?

WAITRESS: Oh no, only for the season.

2ND S. MAN: Permanent address?

WAITRESS: 29 Kaiser Strasse, Vienna.

2ND S. MAN: Father's name?

WAITRESS: Same as mine. Rosenbaum. Theodore Rosenbaum.

2ND S. MAN: Mother's maiden name?

WAITRESS: Schmidt. Eva Schmidt.

2ND S. MAN: Father – Rosenbaum, mother – Schmidt? A curious mixture.

WAITRESS: And I'm the curious result!

She laughs gaily. Not so the SANITARY INSPECTOR.

THIRD SANITARY INSPECTOR questions newly-arrived guests, PRINCESS MILBAUM and the TWINS.

3RD S. MAN: And you are their patroness, Duchess?

PRINCESS M: I have that honour.

3RD S. MAN: Is this their first appearance at the festival?

PRINCESS M: Good heavens, no! They have been coming every year for seven years.

3RD S. MAN: And they have come to do what precisely?

PRINCESS M: To give readings precisely.

3RD S. MAN: And what do they read?

PRINCESS M: Poetry, young man, poetry! Do you have many more of these questions?

3RD S. MAN: (*With quiet contempt.*) Poetry. The poetry of whom?

PRINCESS M: The poetry of Rainer Maria Rilke.

3RD S. MAN: (*Writing.*) Rainer Maria Rilke.

> *A SIXTH SANITATION INSPECTOR has appeared during these interrogations and has been sticking up posters on the various municipal boards.*
>
> *We become aware of them. They read:*
>
> *LABOUR IS OUR LIFE.*
>
> *THE AIR IN POLAND IS FRESH.*
>
> *SAIL ON THE VISTULA.*
>
> *THE DEVELOPMENT AREAS NEED YOU.*
>
> *GET TO KNOW THE SLAVIC CULTURE.*
>
> *GROUPS gather to look at them.*
>
> *Sounds of knocking.*
>
> *Renewed activity.*
>
> *SANITATION INSPECTORS walk through carrying rolls of barbed wire and cement pillars suggestive of prisoner compounds.*
>
> *The knocking stops.*
>
> *Sounds of orders, instructions, barked.*
>
> *In the distance we see poles rising and strange, unpleasant flags being hoisted.*

SAMITZKY: If you ask me, the Sanitation Department is going to all this trouble because the festival's going to be a big affair this year.

FRAU Z: Our dear Dr. Pappenheim is making a name for himself at last.

SAMITZKY: There'll be more fun and games this year than ever.

MITZI: How can you be so sure?

> *A new guest emerges, DR. LANGMAN.*

DR. LANGMAN: It could be that a health hazard has cropped up.

SAMITZKY: A health hazard? With such preparations?

DR. LANGMAN: Or they could be Income Tax Inspectors.
Disguised!

SAMITZKY: Income Tax Inspectors go looking for bigger fish,
and the barriers are for a public celebration.

MITZI: I'm going for a swim in the pool, public celebration
or no public celebration.

SAMITZKY: A really, really big affair.

MITZI leaves.

*We see her later, on the verandah overlooking the
pool, in a swimsuit in which she stays for most of
the season.*

*SAMITZKY and FRAU ZAUBERBLIT take a seat in
the cafe.*

THE CAFE TABLES

SAMITZKY: (*To FRAU ZAUBERBLIT, shyly.*) I like your straw hat.

FRAU Z: One day, it was in the afternoon, after the doctors
had taken my temperature, measured the amount
of blood in my phlegm, written their little signs and
notes on those utterly incomprehensible charts, I
saw him. Death. Plain, undisguised. In the corridor,
next to the basin. Like an old lover. Herr Death.
And I decided. There and then. I dressed, made up
this old, ravaged face you see before you, packed
a bag, put on my straw hat and went to the railway
station. Badenheim! I had to return to Badenheim.

I used to come here with my daughter and my
husband, you know. General Von Schmidt. She
inherited his blond hair and pink cheeks. Attends
a girl's Lycee now. And the moment I arrived and
saw familiar carriages, the faces of old friends,
the pastry shop, the hotel, dear Dr. Pappenheim
– death left me. I feel no pain, I have appetite, I'm

filled with an urge to go on long walks, and I want to laugh all the time.

(*Reverie.*) When I was young. When they were young. When the world was young.

(*Re-awakening.*) But best of all, I've found my prince!

SAMITZKY: A prince who still speaks German with a Polish accent...?

FRAU Z: But who speaks a wonderful musical Yiddish.

SAMITZKY: ...who has these yearnings to go back to his little village in Poland?

FRAU Z: Poland is the most beautiful country in the world.

SAMITZKY: Most of the time I don't understand what you're saying, Frau Zauberblit. But I like you. I like you very much indeed. All these years I've played in the band, it's blunted me. I drink, sleep, beat my drum. That's my life. But now, you touch me. I don't understand what I can do for you but if I make you laugh – good! It's important to laugh.

An OLD MAN has been sitting eating a pastry in the cafe. Immaculately dressed.

Suddenly he rises, half eaten pastry in hand, clutches his heart, drops dead.

Commotion. He's carried off.

TWO more SANITATION INSPECTORS cross carrying another roll of barbed wire.

The CONDUCTOR plays patience at a table.

The WAITRESS flirts with him.

WAITRESS: And last night someone dropped dead in the Casino, and three weeks ago an old couple were found dead sitting in their armchairs. It's worrying. None of us stays young. Not even for a minute. So every death is a worry. Here, poppy-seed cake.

CONDUCTOR: Look, I can put a red queen on a black king and a black jack on the red queen. Now, what am I?

A black king with a red queen laying on me or a
black jack laying on a red queen?

He puts a hand up her skirt.

WAITRESS: (*Skipping away, pleased.*) Eat your poppy-seed cake.
It's the last piece. There's no telling when the chef
can make some more.

A HOTEL ROOM

The TWINS, the readers, rehearsing.

PRINCESS MILBAUM, enraptured, watches them.

One is agitated in his delivery, the other is subdued.

We see but do not hear them, as in a mime.

*Their rehearsal is interrupted by the appearance of the
HEADWAITER bringing a tray of pastries.*

*PRINCESS MILBAUM offers them to the TWINS who turn
away. She pleads. No! She eats them herself.*

The rehearsal continues.

TELEGRAPH OFFICE

*DR. SHUTZ has written a telegraph which the ASSISTANT is
checking by reading aloud. As he reads he eats a pastry.*

TEL. ASST: 'Dearest, dearest mother'. It's cheaper to put one
'dearest'.

Contemptuous snort from DR. SHUTZ.

'Dearest, dearest mother'.

DR. SHUTZ: You don't have to make a public performance out
of it.

TEL. ASST: (*Too softly.*) 'Dearest, dearest mother stop cost of
everything in Badenheim up this year stop don't
know where money is going stop your favourite
son embarrassed with debts stop generous loan
would help and be repaid on return stop the sweet
air is doing me good stop will come back healthy
and renewed stop your adoring son Rudolph.

HOTEL LOBBY

A dark area in which a fish aquarium is illuminated.

KARL, LOTTE and HEADWAITER are looking at the fish.

HEADWAITER: Last year a nature-lover persuaded the hotel owner to let him put some new fish into the tank. Blue Cambium they were called. First few days, perfect. They swam gaily back and forth. A very boring sort of life I've always thought, but no problem. Great harmony. Then, one morning, slaughtered! All the other fish. A massacre.

KARL: And are these the descendants of the murderers?

HEADWAITER: No, the hotel owner sentenced the murderers to death. These are new fish.

LOTTE: I see green ones and red ones.

HEADWAITER: I'm very fond of the red ones. There's something magnificent about them, don't you think?

KARL: Do they live in peace among themselves?

HEADWAITER: I think so. The green ones are very modest and retiring, not at all belligerent.

KARL: Don't you think they should be separated?

HEADWAITER: Perhaps. (*Beat.*) Come, I have some special pastries for you.

FUSSHOLDT'S ROOM

PROF. FUSSHOLDT absorbed in proof-reading. The room filled with smoke from his pipe.

His wife, MITZI, enters with a plate of pastries.

He takes one unheadingly.

She eats one. Lasciviously.

She is bored. He pays her no attention. She will try to attract his attention.

She reaches for a pot of cream, eases the strap of her swim suit off her shoulder. Rubs cream into her skin.

Her HUSBAND continues with his work.

She takes cream in both hands, reaches into her swim suit, rubs cream on her breasts.

In the distance – music. The BAND.

The suggestive action is lost on PROF. FUSSHOLDT.

MITZI gives up, irritated.

The music explodes!

THE TOWN SQUARE

A polka! Dancing in the square.

Everybody who is not dancing, eats pastries which the WAITRESS and HEADWAITER are serving relentlessly.

When the dancing is over there are cries of:

ASSORTED: Pastry! Pastry! I'm dying for a pastry! Cream! Strawberries! Chocolate! Marzipan!

> *Out of hubbub appears a baby-faced young man, almost a child, with a case in each hand.*
>
> *The YANUKA. He wears a suit too big for him. He seems lost and out of place.*
>
> *His arrival brings the activity to a halt.*
>
> *DR. PAPPENHEIM appears.*

PAPPENHEIM: He's arrives! The Yanuka has arrived! Now you will hear a voice. *Now* will you hear a voice. I feel confident about my festival again and you will all feel proud and privileged to have been in Badenheim in 1939.

> *DR. PAPPENHEIM embraces the young man.*
>
> *The familiar circle gather round him, pull him to a cafe table, ply him with huge pastries.*
>
> *Most return to their activities.*
>
> *TWO SANITATION INSPECTORS cross with another roll of barbed wire.*
>
> *A THIRD SANITATION INSPECTOR follows behind with two massive Doberman dogs on heavy chains.*

THE CAFE TABLES

PAPPENHEIM: No more pastries. He needs a substantial meal first.

SALLY: One pastry won't harm.

GERTIE: Not one, surely.

PAPPENHEIM: Badenheim's gone mad. Everyone's eating pastries. They can't stop eating pastries. It's an illness.

SALLY: He's so young.

GERTIE: So sweet.

PAPPENHEIM: Everyone will love him.

FRAU Z: What's your name?

PAPPENHEIM: His name is Nahum Slotzker. Speak slowly. He doesn't understand German.

FRAU Z: Then what language will he sing in?

PAPPENHEIM: Yiddish of course! What a question. Yiddish! He'll sing in Yiddish.

SAMITZKY: (*In Yiddish.*) Where are you from? Lodz?

YANUKA: (*In Yiddish.*) I'm from Kalashin.

They continue in Yiddish.

SAMITZKY: What does your father do?

YANUKA: He mends shoes.

SAMITZKY: And I'm sure your mother runs a vegetable store.

YANUKA: How did you know?

FRAU Z: Don't you love the way he speaks Yiddish?

GERTIE: But what does he say?

SALLY: We can't all speak Yiddish you know.

SAMITZKY: He was born in Kalashin, his father's a cobbler and I guessed his mother ran a vegetable store.

FRAU Z: (*With pride.*) He guessed.

SAMITZKY: I look at him and my youth comes back to me. We came from different villages in Poland but I know everybody he knows.

PAPPENHEIM: Enough! He must rest. I'm making a banquet for him. You'll be able to ask him all the questions you want.

> *DR. PAPPENHEIM departs with the YANUKA.*
>
> *A buzz of whispers grows.[1]*
>
> *It seems to be coming from a small group who are around one of the notice boards.*
>
> *As each person leaves it they seem to be handing on its message to someone else.*
>
> *OTHERS replace them by the board. The message spreads.*
>
> *The words 'MUST'... 'JEWS'... 'ALL'... 'REGISTER'... are heard disjointedly until gradually the full sentence is heard loud and clear and finally uttered by one very distressed person.*

DR. LANGMAN: All Jews must register?

SAMITZKY: That means me.

> *The refrain is picked up by OTHERS:*

ASSORTED: And me...and me...and me...

> *But not picked up by all. Some are confused. Some are angry, stern, aloof, silent.*

SALLY: Where?

DR. LANGMAN: With the Sanitation Department.

GERTIE: When?

DR. LANGMAN: By the end of the month.

SALLY AND GERTIE: (*Together.*) Why?

> *A TOWNSWOMAN steps into view.*

TOWNSWOMAN: I know why. Because of *him.*

> *She points to DR. PAPPENHEIM who is just emerging on the steps of the hotel.*

Him and his festival and his singers and his readers and his Musicians! Artists! They draw attention to themselves! The authorities don't like it. There's

1 This is a theatrical device first used by Arianne Mnouchkine in her production: *1789*

too much excitement, too much laughing and
singing and late-night parties. Too much –

She is at a loss for words.

DR. LANGMAN: – decadence!

KARL: What is he talking about?

DR. LANGMAN: You don't know what I'm talking about?

KARL: Explain!

DR. LANGMAN: You can't see how this, this, this Bohemian second-
rater has re-awakened all the old ghosts from their
slumbers?

KARL: Perhaps Dr. Langman would like us to send our
children to military academies.

DR. LANGMAN: What's wrong with young boys engaging in sports?
Why must it always be violins?

KARL: Because violins please me and physical exercise
revolts me.

DR. LANGMAN: Then *you* go to Poland. *You* join the Ost Juden.
Sport revolts them, too, the little Eastern European
Jews busy in their busy little busy shops.

KARL: Far better the busy little shopkeepers than busy
little steel-hearted army cadets.

SAMITZKY: Why is everyone talking about little Eastern
European Jews? I'm a little Eastern European Jew.

PAPPENHEIM: Please, no quarrels because of me.

DR. LANGMAN: Your festival awakens ghosts!

SAMITZKY: You mean me? I'm a ghost? Because I'm a little
Eastern European Jew I'm a ghost?

*In anger he goes to the bandstand and begins to beat
out a rhythm on his drum.*

*The other BANDSMEN pick up his rhythm which is
the beat of a lively CHASSIDIC DANCE.*

*The square becomes alive with this dance, seething
with a kind of defiant anger.*

When it ends –

BLACKOUT.

Part Three

THE TOWN SQUARE

Out of the darkness come sounds:

the barking of the Doberman dogs; hammering; lorries arriving; harsh orders; motor-bikes...merging into...

...chamber music and the flashing on and off of lights in different parts of the stage revealing couples telling each other:

VOICES: Mandelbaum's arrived! Mandelbaum's arrived! Mandelbaum's arrived!

> *The music grows fierce. THE MANDELBAUM TRIO are rehearsing.*
>
> *Lights build.*
>
> *A CROWD has gathered round a stern and haughty man – MANDELBAUM.*
>
> *He is obviously of much greater renown and importance than those surrounding him. He should not be there. He's out of place.*
>
> *Music stops.*
>
> *Lights full on.*

PAPPENHEIM: I thought you'd never make it. It's wonderful. My festival is complete.

> *A new occurrence is taking place.*
>
> *STRANGERS are appearing in town. They are haggard and dishevelled as they wonder through with their belongings.*
>
> *The first to appear – A MOTHER, FATHER and TWO CHILDREN, silently peering, frightened.*
>
> *MANDELBAUM regards them with distrust. How is it that he shares his arrival with such as these?*

MANDELBAUM: They caught up with us in Reizenbach. At first the whole thing seemed like a joke but no sir!

The Austrians turned out to be as efficient as
the Germans. No beating about the bush! The
locals were sent home and the Jews were put into
quarantine! Yes sir! Plain and simple!

FRAU Z: What did you do?

MANDELBAUM: What did I do? What did I *do*? What I always do in
such a case, send letters to my Academy.

PAPPENHEIM: Who acted at once of course.

MANDELBAUM laughs sardonically.

MANDELBAUM: Acted? Nothing! No action, no answers. Nothing.
Can you believe that? The Academy ignored its
President! Denied its Founder! Isn't that food for
thought, eh? It fed *my* thoughts I can assure you.
I'm bloated with thought. Ha!

GERTIE: They'll be sorry one day.

SALLY: Won't they just! Sorry indeed.

DR. LANGMAN: Forgive me asking, maestro, but how then did you
get here to Badenheim?

MANDELBAUM: A young officer. In charge of events in Reizenbach.
An honourable young Prussian. We asked to be
transferred to Badenheim. We explained to him,
there's a festival there, we've been invited, we
simply had to get to Badenheim.

DR. LANGMAN: Forgive me again, maestro. But what did the young
officer say?

MANDELBAUM: Say? Say? He laughed and gave his permission.
What else was there to say to such madness?
Laughed, gave his permission, snap! Like that! No
nonsense!

PAPPENHEIM: And now the maestro is here, and if the maestro
agrees to appear, ah!

FRAU Z: It will be the experience of our lives.

SALLY: The guests are extremely pleasant here.

GERTIE: They couldn't be more pleasant.

PAPPENHEIM: And this year, due to the restrictions, the
atmosphere is intimate.

MANDELBAUM: Me? Appear? I'm just a Jew, a number, a file. I'm not a rabbi, I'm not a cantor. What do you need me for?

PAPPENHEIM: You are our maestro, our one and only maestro and the only one we want.

MANDELBAUM's haughtiness has crumbled. Suddenly he is – one of them!

MANDELBAUM: Are we all Jews here?

PAPPENHEIM: The servants have run away –

HEADWAITER: – but I'm a Jew born and bred –

WAITRESS: – and I'm half Jewish –

SALLY: Everyone you see.

GERTIE: But not everyone in the town.

HEADWAITER: Here in Badenheim the maestro has many admirers.

MANDELBAUM: Badenheim is far more beautiful then Reizenbach, let me tell you. Had I known it was so beautiful I would have accepted your invitation years ago, Pappenheim. A man never knows where true beauty lies hidden or where his true admirers are.

The PRINCESS MILBAUM arrives and stands to one side waiting for MANDELBAUM to see her and approach. They are obviously from the same high-flown milieu.

HE sees her. Rises.

The OTHERS make way to allow these two naturally 'superior' beings to meet in private.

He kisses her hand.

PRINCESS M: So, Professor Mandelbaum too is amongst us.

MANDELBAUM: With you here, Princess, my disgrace becomes public.

PRINCESS M: And what does the Royal Academy have to say?

MANDELBAUM: They ignore my letters.

PRINCESS M: Sever your connections with them!

MANDELBAUM: Ha! That will I certainly do.

PRINCESS M: Teach them a lesson. Some manners.

MANDELBAUM: (*Conspiratorially.*) And here?

PRINCESS M: (*Arrogantly.*) Rotten to the core!

> *More STRANGERS pass through.*
>
> *MANDELBAUM's ferocity returns. He strides into the hotel.*
>
> *The music of the TRIO is heard again, furiously, till it reaches a certain musical passage which it keeps repeating.*
>
> *MANDELBAUM is rehearsing them mercilessly.*
>
> *We hear his voice raging at the MUSICIANS.*
>
> *The repetition of the music is nerve-racking. No one can think clearly, speak coherently, walk straight.*

SCHOOLGIRL: Someone should go upstairs and rescue them. Mandelbaum's torturing them. He's a sadist!

> *No one responds.*

This company makes me sick. As though nothing was happening. I'm going.

> *She leaves them.*
>
> *SHUTZ follows her like a dog.*
>
> *The music stops abruptly.*

THE CHEMIST'S SHOP

TRUDE: You registered us?

MARTIN: We're registered.

TRUDE: So quick? You've only just left.

MARTIN: It was a simple process. The clerk asked 'Jew?' 'Jew' I replied. 'Wife, Jewess?' 'Wife, Jewess' I replied.

TRUDE: And Helena?

MARTIN: I told him, my daughter is no longer a Jewess.

TRUDE: What did he say?

MARTIN: He asked a lot of questions about her.

TRUDE gazes out of the window, remembers odd Polish words. With each one she remembers, she smiles, as with a sense of achievement.

TRUDE: Suknia slubna. Pilka. Jarzyny. Góra. Czy może pan mi powiedzieć gdzie jest dworzec Kolejowy? (*Wedding dress. Ball. Vegetables. Mountain. Can you tell me the way to the railway station, please?*)

MARTIN: You are still living in the mountains.

TRUDE: If God wills it, a person returns to the land of her birth.

A CORNER OF THE SQUARE

WAITRESS: Will they let me come with you?

CONDUCTOR: What a question! Who'll wait on us if not you?

WAITRESS: But I'm not fully Jewish.

CONDUCTOR: And me, am I fully Jewish?

WAITRESS: Both your parents were Jewish, weren't they?

CONDUCTOR: Yes, my dear, they were *born* Jewish but – can you believe it – they converted to Christianity.

WAITRESS: Converted?

CONDUCTOR: You can't believe it can you?

WAITRESS: Did you tell them that when you registered?

CONDUCTOR: I told them.

WAITRESS: What did they say?

CONDUCTOR: They wrote it down. Everything you tell them they write down.

FRAU ZAUBERBLIT'S ROOM

SAMITZKY sits with her. HE is drunk. She is writing.

SAMITZKY: Writing! Writing! Everybody's writing something down. What something down are you writing?

FRAU Z: I'm writing my will.

SAMITZKY: That's morbid.

FRAU Z: My daughter will arrive any day now.

SAMITZKY: She's come to be with you on your journey, what does she need your will for?

FRAU Z: I think I will leave some jewellery for the Yanuka for his musical education.

SAMITZKY: Lucky Yanuka!

FRAU Z: Some cash for the twins.

SAMITZKY: Lucky twins.

FRAU Z: Some clothes for Sally and Gertie.

SAMITZKY: Lucky Sally, lucky Gertie.

FRAU Z: I want Dr. Pappenheim to say Kaddish for me and I do *not* want to be cremated.

> *SHE coughs violently into her handkerchief. Looks at it.*

> *SAMITZKY cradles, rocks her.*

FRAU Z: You are the only man I have ever loved to see drunk.

TELEGRAPH OFFICE

Full of people in a state of panic.

Collage of voices sending out telegrams.

The SANITATION INSPECTORS appear and whisper something to each person who then walks away.

When the last person has gone they shut up the office.

Only DR. PAPPENHEIM is left, crestfallen.

The MAJOR approaches.

PAPPENHEIM: I have not learned to do without letters and newspapers. I will *never* learn to do without telegrams.

MAJOR: I don't understand. Is there an epidemic?

PAPPENHEIM: A Jewish epidemic.

MAJOR: Is that supposed to be a joke?

PAPPENHEIM: Try to leave the town and see.

SANITATION DEPARTMENT

MAJOR: I demand to know when the telegraph office will re-open?

1ST S. MAN: Are you registered with us yet?

MAJOR: I'm an Austrian major of the last war and a registered citizen of Badenheim and I demand you re-open the telegraph office, the Post Office and the town gates; I demand that you take down the barbed-wire fences and those flags which are nothing whatsoever to do with Austria; I demand you restore order here.

1ST S. MAN: Your name, please?

MAJOR: Do you realise no food supplies are getting through?

1ST S. MAN: Your name, please?

MAJOR: My name is Major Kurt Hoffmansthal and I demand courtesy, respect and answers to my questions.

1ST S. MAN: Jew?

MAJOR: Damn your Jews and damn your bureaucracy. What has any of it to do with closing down the Post Office and holding up supplies? We have lost contact with the outside world. Don't you understand that?

1ST S. MAN: Sign here please, that way you can be registered.

MAJOR signs and leaves in a great distress.

FRAU ZAUBERBLIT'S ROOM

FRAU ZAUBERBLIT, her DAUGHTER, and SAMITZKY.

SAMITZKY: She doesn't look like you.

FRAU Z: She has never looked like me.

DAUGHTER: Please. I'm in a hurry.

SAMITZKY: (*Perplexed.*) They will let you out now you're in?

FRAU Z: When I sign this form they'll let her out.

SAMITZKY: More forms. Everyone's giving everyone forms to sign. What form can a daughter give her mother?

FRAU Z: A form renouncing maternal rights.

SAMITZKY: Renouncing maternal rights? How can you renounce maternal rights? They come with the blood!

FRAU Z: With forms you can renounce anything.

DAUGHTER: Please. I am in a hurry.

FRAU Z: Is this what *you* want?

DAUGHTER: What I want and what my father wants.

FRAU ZAUBERBLIT signs.

SANITATION DEPARTMENT

PRINCESS MILBAUM storms in.

PRINCESS M: (*Showing a form.*) What is the meaning of this?

1ST S. MAN: Is it signed?

PRINCESS M: How can I sign a form that's not accurate?

1ST S. MAN: It's not signed yet. Please sign.

PRINCESS M: Do you hear me young man? I sent word of my titles. My first husband – a Duke. My second husband – royal blood.

1ST S. MAN: Your father's name was Milbaum. It's on the form. Sign please, that way you can be registered.

PRINCESS M: (*Signing.*) I know who's to blame for this.

HOTEL LOUNGE

CONDUCTOR: When I went to register they showed me a book written by my father. About arithmetic. In Hebrew!

PAPPENHEIM: You didn't know?

CONDUCTOR: I didn't know. But in the Sanitation Department they knew. They know everything. It's very interesting what they've got there. And you know what? It's no trouble to them to show a man his past. They're happy to do it.

PAPPENHEIM: Parents baptised. I'd never have believed it.

CONDUCTOR: It doesn't make me proud. What my parents did it doesn't make me proud.

PAPPENHEIM: You could join the Order Of Jews if you want. One of the best orders around.

CONDUCTOR: I don't believe in religion.

PAPPENHEIM: Who talks of religion? You could be a Jew without religion.

CONDUCTOR: With whose permission? The Sanitation Department's?

1ST MUSICIAN: We're visitors here, do *we* have to register?

PAPPENHEIM: Of course you must register. What kind of a question is that? Don't you know the Sanitation Department wants to boast of its important guests? Our names are going down in a Golden Notebook. Honoured we are.

1ST MUSICIAN: Perhaps it's because we're Ost Juden!

2ND MUSICIAN: In the souvenir shop they're selling maps of Poland.

1ST MUSICIAN: Why Poland?

2ND MUSICIAN: Historical necessity.

PAPPENHEIM: What does it matter, here, there? Perhaps our true place is really there.

1ST MUSICIAN: What will they do with us there?

2ND MUSICIAN: You'll be a musician like you've always been a musician.

1ST MUSICIAN: Do you remember anything from there?

2ND MUSICIAN: Nothing.

CONDUCTOR: My parents converted, damn it!

2ND MUSICIAN: So you can leave. Pack your things and return to Vienna.

CONDUCTOR: My dear friend, my name has a place of honour on their list. My father's book. On arithmetic. In Hebrew!

1ST MUSICIAN: If it is to be Poland we'll have to start studying.

CONDUCTOR: At our age? My dear –

1ST MUSICIAN: Polish. It'll have to be Polish.

2ND MUSICIAN: And Yiddish!

DR. LANGMAN bursts in.

DR. LANGMAN: This country is finished.

1ST MUSICIAN: Which is why we'll have to learn Polish.

2ND MUSICIAN: And Yiddish!

DR. LANGMAN: I went to the department, saw the director, demanded a re-examination.

DR. SHUTZ: Of what?

DR. LANGMAN: Of my case. Of my specific case. I am an Austrian born and bred, and the laws of Austria apply to me as long as I live.

DR. SHUTZ: But you also happen to be a Jew, if I'm not mistaken.

DR. LANGMAN: Jew! Jew! What does it mean? Perhaps you would be so kind as to tell me what it means?

DR. SHUTZ: As far as we're concerned you can renounce the connection any time you like.

DR. LANGMAN: That's what I told them.

DR. SHUTZ: And what did they say?

DR. LANGMAN: They have their orders.

DR. SHUTZ: So why are you getting angry with us?

DR. LANGMAN: Because of what Pappenheim keeps saying. Don't you hear him? All the time? Calling us the order of Jewish nobility?

DR. SHUTZ: I heard him. I didn't know he had such a sardonic sense of humour.

DR. LANGMAN: You can't say such things with honour!

SCHOOLGIRL: Take me away from here. Can't you see I can't stand it any longer?

PAPPENHEIM: The child is unwell. Bring her some brandy.

DR. LANGMAN: *(To himself.)* My God but the Jews are an ugly people. No use to anyone.

Sound of gunshot.
Sound of singing.

THE CONCERT HALL

The YANUKA is singing.
The AUDIENCE gathers.
A dead MAJOR is carried through.
STRANGERS appear. Bewildered. Frightened.
BLACKOUT.

Part Four

HOTEL FRONT DOOR

Late evening.

A commotion. One of the STRANGERS, well-dressed, middle-aged, has the HOTEL OWNER by the scruff of the neck, screaming at him.

STRANGER: Ost Juden! Ost Juden! You're to blame!

HOTEL OWNER: Me? Why me?

STRANGER: I'll murder you all.

HOTEL OWNER: I'm to blame for nothing.

> *OTHERS are trying to pull them apart.*

STRANGER: You and your dirty little bohemian guests.

HOTEL OWNER: Take this madman off me.

STRANGER: You open your doors, you lower the tone, you anger authority!

HOTEL OWNER: Madman! I run a first-class house. Madman!

STRANGER: You!

HOTEL OWNER: Madman!

STRANGER: Your fault!

HOTEL OWNER: My fault – nothing!

> *The STRANGER is prised off still screaming –*

STRANGER: There was peace in the land, there was quiet in the land, there was dignity, there was order. And then came the festival, the artists and the whores!

> *– till he is pacified.*

1ST MUSICIAN: Why scream? It's not the end of the world.

SALLY: Nothing is ever as bad as it looks.

GERTIE: It may *look* bad but it never is.

PAPPENHEIM: If you think there's been a mistake the Board of Appeals will exempt you.

STRANGER: There's a Board of Appeals?

PAPPENHEIM: Every committee has a Board of Appeals. That's a well-known fact.

GERTIE: As everyone knows.

PAPPENHEIM: No committee can *ever* do as it pleases.

SALLY: Ever!

1ST MUSICIAN: There's a question of procedure.

PAPPENHEIM: And if the lower courts have made a mistake there's always a higher court to remedy it.

GERTIE: So you see there's no need to get upset.

SALLY: Ever!

STRANGER: Where does the Board of Appeal sit?

PAPPENHEIM: They'll probably make an announcement soon.

STRANGER: I mean am I a criminal to be thrown out of my own house? Tell me please, am I?

PAPPENHEIM: It's not a question of crime but of misunderstanding. We too, to a certain extent, in a certain sense, are the victims of misunderstanding.

HOTEL OWNER: Procedure and Appeal. Remember. Now. Rest a little. I have a spare room. Tomorrow we'll probably know more.

STRANGER: I'm sorry. Forgive me. Suddenly everything was taken away from me. They drove me here on the grounds that I'm a Jew. They must have meant Ost Juden. Not me. Me, I'm Austrian.

HOTEL OWNER: (*Taking him in.*) Come. You've been through a hard time. I'll find you pyjamas, a towel, you'll have a good night's sleep and in the morning, you'll see – the world will begin all over again.

STRANGER: My apologies, forgive me, you don't know –

THEY enter hotel.

SHUTZ and SCHOOLGIRL emerge.

She is in control. She is pregnant. She wants everyone to know.

They walk off.

PAPPENHEIM: Ladies, I think it's time for us to take a stroll, too.

GERTIE and SALLY each take an arm.

SALLY: Now we know why she was moody.

GERTIE: I thought it was because the swimming pool closed.

SALLY: She belonged to the water.

GERTIE: It was her element.

SALLY: Such a pity they cut off the water supply.

GERTIE: Just when we'd learned to swim.

SALLY: And closed the tennis courts.

GERTIE: Just when we'd learned to play tennis.

THE PASTRY SHOP

GERTIE, SALLY and DR. PAPPENHEIM stop outside the pastry shop which has closed down and over which creepers have grown.

GERTIE: And now the pastries are finished, too.

SALLY: Another shop closed down.

GERTIE: What will we eat on the train journey?

PAPPENHEIM: Oh they'll be selling chocolates at the station for sure.

PASTRY CHEF appears in his suit.

PAPPENHEIM: Getting ready are we?

CHEF: *I'm* ready, at least.

PAPPENHEIM: No hurry, there's still time.

CHEF: I wanted to ask you, Herr Doktor, how will the transfer take place?

PAPPENHEIM: By train. Won't that be nice, ladies? Don't you just enjoy long journeys?

GERTIE: It's been so long since we've taken one.

PAPPENHEIM: Then you have a treat in store for you.

CHEF: May I be permitted to ask a personal question,, Herr Doktor?

PAPPENHEIM: Anything, anything!

CHEF: I've been working here for 30 years. Will my pension be recognised there too?

PAPPENHEIM: Everything will be transferred. Have no fears. No one will be deprived.

SALLY: And what will we do there?

GERTIE: What would you suggest, Dr. Pappenheim?

SALLY: I imagine that in the evenings we might be able to attend a course of lectures.

GERTIE: All large cities have lecture courses in the evenings.

PAPPENHEIM: Of course. You will be able to attend lectures but I – I think I would like to go back to research.

Silence.

They are held between what they hope for and what they vaguely and inexplicably fear.

Then –

SALLY: I feel sad.

GERTIE: Me too.

SALLY: Doktor! Mr. Bloomfeld! A drink in the bar! How is that for a good idea?

CHEF: They still have drinks in the hotel bar?

PAPPENHEIM: I'm ready for anything!

HOTEL BAR

Levity.

The BANDSMEN have become a jazz band.

MITZI dances with a new STRANGER, SALO the salesman.

The WAITRESS dances with the CONDUCTOR. She's showing a lot of leg.

SALLY and GERTIE dance with each other and a clumsy DR. PAPPENHEIM.

Most are there – the YANUKA, the TWINS, KARL and LOTTE, DR. LANGMAN.

The dance ends. Applause.

PAPPENHEIM: (*Breathless.*) Oh! It will be a brilliant season.

SALLY: And if we *have* to emigrate –

PAPPENHEIM: – we'll emigrate! There are wonderful places in Poland. In a few days' time everything will be different. We are on the threshold of a radical change.

The WAITRESS takes the stage. She drinks continuously.

WAITRESS: Who am I?

She imitates MANDELBAUM playing a violin. We hear it. Applause.

WAITRESS: Who am I?

She imitates the YANUKA singing. We hear it. Applause.

WAITRESS: Who am I?

She imitates the TWINS reciting.

The Years go by…and yet, as in a train
we're going, years stay like landscape which we pass
and look at through our rattling window glass
which frost bedims and sunshine clears again.

Applause.

Thank you, thank you, thank you! Quiet now, please, quiet. (*She tells a joke.*)

Laughter. Applause.

(*Raising her glass.*) Down with Austrian cabbage!

Laughter. Applause.

Ladies and gentlemen, I give you a toast. (*Turns to PAPPENHEIM.*) To Doktor Pappenheim's Jewish Order!

DR. LANGMAN: That's not funny!

WAITRESS: To which I swear an oath of loyalty!

DR. LANGMAN: Don't say such things!

He's boo-ed down, storms off.

SALO and MITZI. She's flirting with him desperately. They're high and panting.

MITZI: You're a lucky fellow to have landed up here on
 your business travels.

SALO: But Poland? Return to Poland? I ran away from
 Poland.

MITZI: We all did once. Now we're going back.

SALO: So long as the firm's prepared to foot the bill for
 such a long journey I don't mind. It'll be a rest. A
 rest at the firm's expense is worth its weight in gold.

 MITZI cries. Maudlin tears.

 What's to cry about?

MITZI: I had a postcard from an old lover.

SALO: And that makes you cry?

MITZI: My husband works and works and works. His
 stupid book which no one will read.

SALO: Your husband's a brilliant man. With a mind like
 that what else can he do?

MITZI: You haven't been here long. Wait till you hear the
 Mandelbaum Trio rehearsing. They'll drive you
 crazy.

SALO: Don't you like music?

MITZI: No! I don't like music. And I don't like travel. The
 idea of a long journey frightens me very much.

PAPPENHEIM: What's to be afraid of? There are many Jews living
 in Poland. A man has to return to his origins.

 MITZI weeps and sinks into SALO's arms.

 He pulls her up and away with him.

 She follows feigning a coy reluctance.

SALO: In Poland it'll all be different. You'll see.

 *WAITRESS takes the stage again. She is now very
 drunk.*

WAITRESS: Samitzky! A drum roll, please.

 SAMITZKY obliges.

 *The WAITRESS provocatively raises her skirt, unhitches
 a suspender, and peels down a black stocking.*

 She slaps her ample thigh.

Austrian flesh! The Sanitation Department didn't register that.

Laughter. Applause. Another drum roll. Another stocking.

Approaches PAPPENHEIM. Offers her thigh.

WAITRESS: Isn't my meat tasty?

PAPPENHEIM: It's certainly tasty.

WAITRESS: So why don't you take this knife and help yourself to a slice?

PAPPENHEIM: Do I look like a butcher?

WAITRESS: You don't need to be a butcher to taste a slice of me.

SALLY: Leave the poor Doktor alone. You know he's incapable of cutting a fly let alone your flesh.

WAITRESS: In that case, I'll cut it myself.

She saws her thigh.

Blood.

Screams.

MARTIN rips a tablecloth to bind her.

WAITRESS: You won't leave me here. I'm coming too.

PAPPENHEIM: Silly woman! What did you imagine? Wherever we go you will go too.

MARTIN and CONDUCTOR take her away.

WAITRESS: (*Desperate. Insistent.*) I'm coming too. You won't leave me here. I must come too.

The atmosphere in the bar has changed.

People move off.

Gloom.

PAPPENHEIM: Oh, this is no good. No good at all. What have we been thinking of? This is madness. We should be rehearsing. The services have been cut off, supplies of food in the hotel are down to nothing, it can only mean one thing. We'll soon be on our way! Rehearse, children, rehearse! Artistic standards in Poland are high!

Music.

A work for TRIO AND BRASS BAND?

The MUSICIANS are working hard, and together.

The next scenes happen wordlessly as the music plays.

FRAU ZAUBERBLIT'S ROOM

TWO SANATORIUM MEN, not unlike the SANITATION INSPECTORS, are standing waiting for FRAU ZAUBERBLIT to finish packing.

One takes her case, another offers his arm.

THE CHEMIST'S SHOP

TRUDE opens her arms to greet her daughter, HELENA.

She stands by her side triumphantly facing MARTIN as though saying – I told you she'd return.

MARTIN falls on his knees and kisses his daughter's hands.

HOTEL LOBBY

LOTTE and KARL stare at the illuminated aquarium.

Fascinated. Anxious.

THE TOWN SQUARE

FRAU ZAUBERBLIT is leaving with the TWO SANATORIUM MEN.

She see's the YANUKA staring after her. Kisses him goodbye.

Pauses to listen to the music.

At that moment it is drums.

SAMITZKY unknowingly is saying goodbye.

She smiles, happy.

Leaves, coughing.

THE HOTEL CELLAR

The HOTEL OWNER is opening a door to his hidden cellar, revealing it to the HEADWAITER.

Inside it glows like an Aladdin's cave.

It is full of food and wine.

The HEADWAITER is amazed.

He picks up one tin after another. One box after another. Uttering the names in awed whispers.

HEADWAITER: Liqueurs. Swiss chocolates. Pecans. Peach preserves. Caviar. (*Beat.*) French champagne!

 On 'champagne' the music changes abruptly to a TANGO.

THE CAFE TABLES AND TOWN SQUARE

Lights up on a now seedy town square.

Neglect. Dilapidation.

Couples dance the tango.

The last of the food is being served.

PAPPENHEIM: A farewell feast to remember forever!

 DR. LANGMAN and PRINCESS MILBAUM sit aside, scowling on the proceedings.

 MITZI and SALO tango round them, tantalisingly, till – exhausted they flop beside them while the tango continues.

SALO: (*Breathlessly to DR. LANGMAN.*) There's no help for it. Everyone has to go.

PRINCESS M: (*To LANGMAN.*) Riff-raff!

SALO: There's nothing to be afraid of. In Poland there are lots of Jews. They help each other.

PRINCESS M: Leave us alone.

SALO: I know because I spent my childhood in Poland. A year or two among them and you'll forget everything. You'll get up in the morning and go to synagogue. Is that bad? You'll pray. Is that bad?

And if you're lucky you'll find a shop in the centre of town and you'll earn a living. Is that bad? Even the pedlars make a living. My father was a peddlar and my mother had a stall in the market place. We were a lot of children at home. I was the seventh. You listening?

DR. LANGMAN: No!

SALO: Don't put on airs. My advice to you – leave your arrogance behind. In Poland people treat each other with respect.

PAPPENHEIM: He's right! What do you say? Dr. Langman? Duchess? Pace pactus? East and West will be as one?

PRINCESS M: I will have none of it!

DR. LANGMAN: Cheap romanticism!

PAPPENHEIM: Come now. We have drunk the last of the wine, eaten the last of the tinned preserves and –

THE CHEMIST'S SHOP

TRUDE, MARTIN, HELENA.

TRUDE: (*To HELENA.*) – and soon we'll go to Poland and all will be well.

MARTIN: Your mother kept saying: 'Helena's on her way! Helena's on her way!'

TRUDE: Your father's excited.

MARTIN: And I never believed her.

TRUDE: Look at him how excited he is.

MARTIN: Was it bad. *Did* he beat you?

TRUDE: A goy is a goy. You mustn't blame him. What does he know better? I'm not sorry.

MARTIN: We were a little worried.

TRUDE: I was never worried.

HOTEL DINING ROOM

The food queue.

HEADWAITER and WAITRESS behind a huge pot of soup on a trestle table.

EVERYONE is there.

MITZI: (*To SALO.*) What do you say to a strawberry tart and a cup of coffee?

SALO: I'd give the world for them.

1ST MUSICIAN: Look at him.

> *Eyes turn to SAMITZKY who is sullen and withdrawn.*

Have *you* been able to get a word out of him?

2ND MUSICIAN: They told her: 'Our sanatorium is emigrating, too.' So she tells them: 'But I'm registered here, you know?' 'Never mind' they said, 'why not go with all your old friends from the sanatorium?'

1ST MUSICIAN: He hasn't spoken since. Just smashes things up and quarrels.

PAPPENHEIM: They say the air in Poland is purer. The purer air will do her good.

> *MARTIN runs up. Frantic.*

MARTIN: They've looted my shop. Someone's taken all the drugs. And I know who it is. Don't think I don't know who it is.

> *He turns to KARL and LOTTE.*
>
> *They are strange.*
>
> *KARL stares all the time at DR. LANGMAN.*

DR. LANGMAN: Stop staring at me! He stares! All the time he stares like a madman. Are you a madman or something? Stop staring at me!

KARL: Sport! He preaches sport.

DR. LANGMAN: Finish with this sports thing! I haven't spoken about sport for weeks.

KARL: He'd like us all to be in military academies hunting and shooting and being healthy.

PRINCESS MILBAUM pulls DR. LANGMAN away.

PRINCESS M: Ignore him. We'll eat later.

DR. LANGMAN: He's mad. I warn you all. This man is dangerous.

PRINCESS M: It's a mistake to be here. I should never have allowed my twins to perform at this festival.

KARL imitates a 'healthy soldier'.

PRINCESS M: There are civilised Jews and uncivilised Jews, Dr. Pappenheim, and you have gathered around your festival the uncivilised ones.

PAPPENHEIM: But who, gracious lady? Mandelbaum and his trio? The band? The Yanuka? Your twins, the readers?

PRINCESS M: You know perfectly well who I mean.

KARL taunts DR. LANGMAN with his 'healthy soldier' act.

DR. LANGMAN: (*Leaving.*) Go stare at your fish you crazy man, you. That's where you belong – in an aquarium!

HE and PRINCESS MILBAUM leave.

KARL: I want no one to use the word 'sport'.

LOTTE: Please, Karl.

KARL: 'Sport' is a word that's taboo.

LOTTE: Karl, stop this, please.

KARL: Do you all understand? 'Sport' – taboo!

LOTTE: Let's go for a walk. We'll eat later.

KARL: (*He's very high.*) And what about the fish? Do we abandon them to their fate?

LOTTE: (*Pacifying him.*) God forbid.

KARL: We're not Junkers and we're not Prussians. We feel sorry for the little fish in the aquarium. As long as we live we'll feel sorry for the little fish in the aquarium.

LOTTE: Of course we will.

KARL: It's food for *them* we must find. Us – we can always eat. But for them?

HE picks up dry bread from the table.

Leaves with LOTTE.

PAPPENHEIM: (*To a forlorn MARTIN.*) Do you know what I heard? That the musicians have looted the cutlery and silver from the hotel. To take with them!

At which he laughs. Uncontrollably.

The laughter stops when a new crowd of STRANGERS appear.

Among them a RABBI in a wheelchair.

1ST MUSICIAN: Is that our old rabbi?

2ND MUSICIAN: I thought he had a stroke and died years ago.

A silence. They look at the RABBI.

The RABBI looks at them.

RABBI: Jews?

HOTEL OWNER: Jews!

RABBI: And who's your rabbi?

HOTEL OWNER: You! You are our rabbi.

The RABBI is hard of hearing.

(*Repeating.*) You! You are our rabbi.

RABBI: Are you making fun of me?

HOTEL OWNER: (*Shouting.*) Have you forgotten? Years ago.

1ST MUSICIAN: (*Shouting.*) We thought you were dead.

HOTEL OWNER: Can we offer you some soup?

RABBI: Kosher?

Embarrassed silence.

He declines.

And what are you all doing here?

SAMITZKY: We're getting ready to return to Poland.

RABBI: What?

SAMITZKY: To return to Poland.

RABBI: Are you all from Poland?

SAMITZKY: What does it matter? It's where we're all going.

PAPPENHEIM: For my part I've had a letter from the Sanitation Department demanding that all my artists be registered with them. It can only mean one thing. A comprehensive concert tour awaits us!

GERTIE'S AND SALLY'S FRONT ROOM

It is GERTIE's 40th birthday party.

The music comes from their old horn gramophone.

GUESTS are coming in one by one or in couples.

PAPPENHEIM first.

He kisses GERTIE's cheeks.

PAPPENHEIM: It's been a long time since I was last here.

GERTIE: It's been a long time since any of you were here.

SALLY: Counts, industrialists –

GERTIE: – salesmen, tired intellectuals –

SALLY: – a long time.

PAPPENHEIM: But I'm the bearer of good news today. The emigration procedures have already been posted on the notice-boards.

GERTIE: Well how about that!

DR. SHUTZ and the SCHOOLGIRL.

She has a quiet authority. After greeting SALLY and GERTIE she backs away.

This party is full of silences.

GERTIE: Have you heard? The emigration procedures have been posted on the notice-boards.

DR. LANGMAN brings a bottle of liqueur. Kisses GERTIE's hand.

DR. LANGMAN: I found this. Don't ask where.

GERTIE: Oh! *Something* to drink.

Each is given a small glass.

DR. LANGMAN: How nice it is here.

Silence.

Karl refuses to budge from the aquarium. What
does he expect from fish?

SCHOOLGIRL: He changes the water and feeds them bread
crumbs.

Silence.

PAPPENHEIM: I tried to persuade Mandelbaum to come.
Hopeless. Rehearse, rehearse, rehearse.

*The TWINS and the YANUKA arrive. Shy and
awkward. They just sit.*

SALO and MITZI arrive next.

SALO: (*To GERTIE.*) So, you're forty!

GERTIE: And only yesterday I was thirty.

SALLY: Only yesterday… Counts, industrialists…

GERTIE: …salesmen, tired intellectuals…

Silence.

SALO: Karl's determined to take the fish with him.

Silence.

SALLY: (*To the TWINS and YANUKA.*) What can we do to
gladden the hearts of the artists?

MITZI laughs.

SALLY: Why are you laughing?

MITZI: No reason. People make me laugh. That's all.

Silence.

PAPPENHEIM: I must say, the emigration procedures seem very
efficient. Very efficient indeed.

DR. SHUTZ: (*To SCHOOLGIRL.*) In that case there's much we can
look forward to.

She ignores him.

PAPPENHEIM: You'll be able to teach in the mathematics
department. Poland is a very cultured country you
know.

DR. SHUTZ: Are they connected to the university of Vienna?

PAPPENHEIM: They must be. All centres of culture are connected
to Vienna or Berlin.

Silence.

GERTIE: I feel so ashamed that we have nothing to offer you.

PAPPENHEIM: Never mind. You'll give us a party in Warsaw. A lavish party.

GERTIE: That's a promise.

PAPPENHEIM: Ah, what a wealth of folklore there is in Poland. Authentic folklore. In Poland we'll be able to diversify our festival.

SALO: I remember now. I once saw a wonderful Yiddish play in Warsaw. I think it was called something like 'Bontze The Silent'. My father took me.

Silence.

DR. PAPPENHEIM stands.

PAPPENHEIM: Goodbye, house. Au-revoir, house. You're staying here and we're setting off on our travels.

Two shots ring out.

SALLY: I think the headwaiter has shot his dogs.

GERTIE: They refused to eat.

SALLY: Kept running away into the bushes.

GERTIE: Seemed very confused.

PAPPENHEIM: And au-revoir, maidens, until tomorrow morning at seven o'clock sharp on the hotel steps where the dawn and a new life will await us.

Slow, slow BLACKOUT.

Part Five

THE HOTEL STEPS

A clear, cold frosty morning.

MANDELBAUM and his MUSICIANS arrive first, dressed in white suits.

MANDELBAUM: Where's the carriage?

> *PAPPENHEIM appears, anxious about his artists.*

PAPPENHEIM: The emigration arrangements are evidently not yet complete.

MANDELBAUM: In that case we'll have to waste our time here doing nothing. And the pastry shop? What's happened to the pastry shop?

PAPPENHEIM: Everything's been closed down in readiness for the emigration.

MANDELBAUM: In that case we'll have to wait for coffee until we get to Warsaw.

PAPPENHEIM: Has the maestro already appeared in Warsaw?

MANDELBAUM: A couple of times. An enthusiastic and sensitive audience, more so than the Austrians I should say.

PAPPENHEIM: I'm happy to hear it.

> *DR. SHUTZ and SCHOOLGIRL arrive next.*
>
> *He is now weak and feeble and stooped. A wicker basket rests with pathetic domesticity on his arm.*
>
> *SHE is upright and proud.*

PAPPENHEIM: Allow me to introduce Dr. Shutz.

MANDELBAUM: Honoured.

> *SHUTZ fumbles.*

DR. SHUTZ: And this is my wife.

> *SHE turns away in anger.*
>
> *MARTIN, TRUDE and HELENA followed by KARL and LOTTE.*

KARL cradles a huge glass jar with fish in it.

They take their place in silence. His, the silence of madness; her's of patience.

MANDELBAUM: So, we're late as usual, Dr. Pappenheim!

MITZI, very made up, her husband, weighed down by boxes of proofs and papers.

PAPPENHEIM: May I introduce Frau and Professor Fussholdt. Dr. Mandelbaum.

MANDELBAUM: So, Fussholdt is with us, too?

FUSSHOLDT: Honoured.

MANDELBAUM: What a shame I didn't know.

The HOTEL OWNER next. Sad.

Followed by the MUSICIANS carrying heavy bags of loot and their instruments.

The CONDUCTOR stands aside from them with the WAITRESS.

1ST MUSICIAN: (*To CONDUCTOR.*) Stop glaring at us. If we come back we'll return them.

HEADWAITER arrives. Depressed.

MITZI: I'm sorry about the dogs. What were their names?

HEADWAITER: Lutzi and Grizelda.

MITZI: I could never tell them apart.

HEADWAITER: Lutzi was quiet. A dog with a lot of complexes.

MITZI: Such a pity!

SALO next in his salesman's uniform with his battered old case.

He stands with the MUSICIANS.

SALLY, GERTIE and the YANUKA. He's very changed. More a man, in a suit that fits him. He speaks with a heavy accent.

YANUKA: Hey, Salo. My new clothes. What do you think? Sally and Gertie say: 'You like a fairy prince!'

SALO: And right they are.

YANUKA: So – the 'prince' commands you – that box of sweets – in your pocket.

SALO: Not sweets, my dear. A pair of women's stockings. I'm the agent for a well-known firm.

A voice from inside.

RABBI'S VOICE: Are you leaving me here?

DR. PAPPENHEIM and MUSICIANS go to help bring him and wheelchair down steps.

PAPPENHEIM: We're all still here, but it was cold outside.

KARL to HEADWAITER, showing him the bottle.

KARL: What do you think?

HEADWAITER: If it's not too long a journey you might be able to save your fish.

KARL: I've got an extra bottle of water.

HEADWAITER: That's good, then. Thoughtful.

DR. LANGMAN, PRINCESS MILBAUM and TWINS appear at the hotel door but refuse to join the OTHERS at the foot of the steps.

PASTRY CHEF appears.

HOTEL OWNER: Where's your employer?

CHEF: Refuses to come.

HOTEL OWNER walks over to the dilapidated Pastry Shop.

HOTEL OWNER: Peter? Peter! You're contravening a municipal ordinance.

PASTRY OWNER: I'm not coming. Not with Pappenheim, anyway.

PAPPENHEIM: Why me? What harm have I ever done him?

HOTEL OWNER: You're an intelligent man. How can you be so irresponsible?

PASTRY OWNER: I'm staying.

HOTEL OWNER: Take my advice. Join us. For your own good. We have a rabbi with us.

PASTRY OWNER: I'm not religious.

ONE of the TRIO, to keep himself warm, takes out his fiddle to play a fierce cadenza.

The PASTRY OWNER comes out and takes his place.

STRANGERS join them.

SANITATION INSPECTORS, like policemen, unarmed, encircle them.

A whistle is blown.

THEY move off. Everyone is relieved. Happy.

SAMITZKY is the last to come out, his anger still clinging to him.

ROAD TO THE STATION

The motley crew 'walk'.

Badenheim passes them.

The countryside passes them.

MANDELBAUM and his MUSICIANS at the head.

SALLY, GERTIE, YANUKA between the TWINS.

DR. LANGMAN and PRINCESS MILBAUM.

The BANDSMEN.

CONDUCTOR and WAITRESS with her heavy cane stick.

HOTEL OWNER pushing the RABBI.

FUSSHOLDT, MITZI and SALO.

The HEADWAITER, KARL and LOTTE.

MARTIN, TRUDE and HELENA.

SHUTZ and SCHOOLGIRL.

PASTRY OWNER and his CHEF.

SAMITZKY.

STRANGERS.

PAPPENHEIM moves here and there checking.

The SANITATION INSPECTORS linger behind, guarding, silent.

CONDUCTOR: (*To WAITRESS.*) What I've never told you about
is my inheritance and my savings. My Christian

parents left me a little money, you know. Not a fortune, but enough! *And* I saved.

WAITRESS: So you're a rich man? My parents left me nothing. An Austrian father who was a pig. And if he hadn't been a pig he still wouldn't have left me anything.

Walk in silence.

1ST MUSICIAN: I tell you, I need the change. Perhaps we'll work fewer hours.

SALO: You can be sure of it.

1ST MUSICIAN: In fact, I wouldn't mind a couple of years' leave. The sound of brass is driving me out of my mind.

SALO: But be careful. The years on the threshold of retirement are critical. I've already collected twenty years of seniority without missing a day. I've got a month's annual leave coming to me. I promised my wife a holiday in Majorca.

1ST MUSICIAN: Majorca? I've never heard of it.

SALO: A warm, wonderful island. I owe it to her. She brought the children up. Wonderful children.

1ST MUSICIAN: Do you think we'll be able to save something in Poland?

SALO: You can be sure of it. Prices there are much lower, and if we continue getting our salaries in Austrian currency we'll be able to save a lot.

Walk in silence.

The WAITRESS weeps.

CONDUCTOR: What's this? Tears? For what? We'll reach the station soon. Soon we'll be in Poland! New sights, new people! A man must broaden his horizon.

Walk in silence.

MITZI approaches DR. LANGMAN.

MITZI: I had this dream last night. I was a little girl of six. My father took me to Vienna, to the Prater. It was a wonderful autumn day, and we walked and walked and I realised, he was only trying to tire me out so that I wouldn't resist having my tonsils

out. And then I was in the hospital and I saw all
the nurses and doctors running towards me and
they performed the operation. I dreamt all that last
night. It was such a vivid dream, I can't tell you. I
saw everything.

Walk in silence.

*Suddenly the RABBI, who has been sleeping,
wakes up.*

RABBI: What do they expect? All these years they haven't
paid any attention to the Torah. Me they locked
away in an old-age home. They didn't want to
have anything to do with me. Now they want to go
to Poland. There is no atonement without asking
forgiveness first.

MITZI: (*Excitedly.*) Look! The station! The station! We've
arrived!

THE STATION

PEOPLE scatter to do various things.

*SALLY and GERTIE to buy sweets for YANUKA, cigarettes for
themselves, vodka for SAMITZKY.*

DR. LANGMAN buys a financial paper. Reads. Laughs.

*Suddenly a strange, glorious light breaks over them. It is a
light which tells of the earth's beauty and abundance.*

Everyone looks up, their spirits risen.

PAPPENHEIM: (*Almost in tears of joy.*) What did I tell you! What did
I tell you!

The sound of an engine shunting into the platform.

Not carriages. Freight waggons.

Everyone is stunned.

Do we see the freight waggons?

Are they projected on huge screens?

*Do we guess what is there from their faces peering
out at us?*

Does someone say something to inform us?

The last image is of crestfallen humanity.

Silence.

PAPPENHEIM: Well! If the coaches are so dirty is must mean that we have not far to go.

No sounds.

No orders.

No weeping.

No sentimentality.

Just a cold dying of the light.

END.

Blaendigeddi
30 September 1987

from page ??
The VOICE OF THE TWINS reciting Rilke

The Years go by…and yet, as in a train
we're going, years stay like landscape which we pass
and look at through our rattling window glass
which frost bedims and sunshine clears again.

First stanza from a poem 'For Frau Johanna Von Kunesch'
translated by J.B. Leishman
from 'Rainer Maria RILKE – poems 1906 to 1926'
published 1957 The Hogarth Press.

PHOENIX, PHOENIX BURNING BRIGHT

a play in

two acts and seventeen scenes

CHARACTERS

RAPHAEL Professor, history of art, 45.

MADEAU His wife, 41. A housewife.

KARL-OLAF Historian, doing research, 35, Danish.

JANIKA His wife, social worker, 36.

LARS Their son, 11.

GABBY Their daughter, 8.

A WOMAN Housewife, 35ish.

TIME AND SETTING

Cambridgeshire, Whitsun, 1974

A rambling Victorian house set in a vast garden, rented by the Danes.

Weather, time of day, the light – all very important.

AUTHOR'S NOTE

This is a play in which the *drama* resides in the gradual unfolding of a friendship between two couples, and the *action* resides in the minutiae of a holiday they share.

We delight in the details of food, landscape, domesticity, and bodies giving themselves up to holiday and sun.

One couple is Danish the other British.

Two areas of conflict exist: one, domestic, between the Danish husband and his wife; the second, spiritual, within the English husband slowly discovering a deep urge to change his life, which worries his wife who fears where it may lead.

At the end of a long and lyrical weekend of rich friendship they realise they are not the people they once were when they first met many years ago when the older English professor was tutor to the two Danes when young.

Act One

SCENE 1

Friday afternoon – arrival.

Large kitchen/dining room leading to conservatory leading to large garden.

In the kitchen an Aga cooker, long deal table, Windsor chairs, pots and pans and old plates hanging on white walls.

Evidence in garden of children and long, hot summer evenings.

Sound of a car approaching.

JANIKA and KARL-OLAF are waiting for someone to appear. Their backs are to us. One stands, one sits – apart. A tension between them will hover throughout.

The car stops. Doors slam.

A couple appear: RAPHAEL and MADEAU. They carry a holdall between them, a carrier bag in each of their other hands.

They try to kiss at the same time. Fail. Walk at an angle of forty-five degrees forming a V with their arms.

Their gaiety is in contrast with the jadedness of their waiting hosts.

RAPHAEL embraces JANIKA. He's effusive, she's slightly resistant.

MADEAU and KARL-OLAF are less cautious, hold a long, full-mouthed kiss, and rock with pleasure.

RAPHAEL: I hope that you're pleased to see us and that you've laid in lots of food and drink and that you've got some new records and tapes and…

MADEAU: …and that you've got enough bikes for us all because I want to do some cycling.

They plonk their carrier bags on the table, unpack, banging with a flourish on the wooden table each contribution to their stay.

RAPHAEL: Eggs and many cheeses...

MADEAU: ...white wine red wine...

RAPHAEL: ...some freshly baked-today-chola[1] which must be eaten at once with cheese AND A LOVELY CUP OF TEA FOR WHICH WE ARE GASPING!

KARL-OLAF takes the hint, moves to put on kettle.

MADEAU: For which *he* is gasping, not me.

KARL-OLAF: (*Correcting her.*) Not 'I'.

MADEAU: (*Defiantly.*) Not 'me'. I'm gasping for *tea.*

KARL-OLAF: You mean '*me* is gasping for tea'?

RAPHAEL: (*Continuing list – in one breath.*) Farmhouse butter which we couldn't resist from that little shop which survives God-knows-how 'cos they can't be seen from the road and which must be spread on the Grodzinski fresh 'chola' and then put immediately into the fridge or it'll go rancid which is what farmhouse butter smells like to begin with but one must not be mislead by such things in life!

MADEAU drops cellophane packets on table.

MADEAU: Sweets and chocolates...

Drops assorted bars on table.

...and sweets and chocolates...

Lays various Easter eggs around.

...and sweets and chocolates. Where *are* the children?

JANIKA flops into chair, exhausted by them.

JANIKA: Oh, fishing, I think. Or probably drowning by now.

MADEAU: JANIKA! Don't make jokes like that.

Their energy is boundless and will be, finally, infectious.

1 Jewish plaited egg-bread

RAPHAEL: Next, tins of sardines which we knew you'd have none of and for which I've rediscovered an old childhood taste soaked in vinegar and smashed with chopped onions spread on thin toast and constantly kept in supply for odd snacks. Good cheap working-class standby. That and tinned salmon. The pink type not the red. The red was always more expensive and you needed more coupons for that. Did you ever have rationing in Denmark? Ration books! Ha! Food coupons, clothing coupons, sweet coupons…

MADEAU: Now, an assortment of Jewish things to go with the 'chola' and which Raphael tiresomely feels every gentile family should be introduced to…

RAPHAEL: …to globalise their tastes…

MADEAU: …such as pickled herrings, gefülte fish which I've had to learn how to cook and must carry around in jars as offerings to people we visit, God help them! Chopped egg and onion, chopped liver, and packets of matzos which have (*Accusatively at RAPHAEL.*) I point out to you, gotten smaller and smaller and fewer and fewer per box, and more expensive over the years…

RAPHAEL: Tea?

> *He pours tea to stem his wife's complaints.*

MADEAU: I wouldn't mind, but all these years I've imagined I was cooking Jewish food and now I discover there's no such thing as a Jewish kitchen really. They pinched it from wherever it was they were allowed to settle.

> *Meanwhile RAPHAEL with expertise and relish cuts and butters the spongy-fresh 'chola'.*
>
> *KARL-OLAF is about to put a slice to his lips.*

RAPHAEL: Wait! Pickled cucumbers!

> *He rummages in a carrier, finds the acid-soaked bag, slices them, and lays them over cheese.*

How could I forget the pickled cucumbers?

> *Each can now take a slice in their mouth. Crunch!*
> *'Mmm'.*
>
> *KARL-OLAF raises his mug of tea.*

KARL-OLAF: Welcome! It's nice to have you come and look after us again. We Danes are a people crippled with guilts. We feel guilty for having what the Third World hasn't, our men feel guilty for not being women, our professors feel guilty for not being workers, our actors feel guilty for not being the characters they portray, in fact we all feel guilty for not being each other! The English, on the other hand, who've been around for so long without interruption feel guilty for nothing. So, it's good to have you with us. Welcome!

> *ALL drink. They are old friends. Happy to be with one another.*
>
> *FADE*

SCENE 2

Friday evening – spring cleaning.

Meal over.

Warm, relaxed atmosphere.

RAPHAEL in rocking chair. MADEAU in his lap. Drinks in hand.

KARL-OLAF by the sink drying up.

JANIKA putting crockery away, hanging pots and pans on hooks.

The voice of GABBY calling.

GABBY'S VOICE: M-a-a-deau-eau-eau-eau…

> *GABBY swings on the name with no real expectation of response, as though the sound is pleasing enough.*

M-a-a-deau-eau-eau-eau…

> *We will hear this call every now and then throughout, like a plaintive punctuation.*

M-a-a-deau-eau-eau-eau…

JANIKA: She doesn't really want anything. She just likes calling out names.

Sometimes it's my name sometimes Karl-Olaf's.

> *MADEAU rises. Slowly moves around the kitchen. Wipes a finger along a shelf – dust!*

MADEAU: *I* think we've come at just the right time. Spring-cleaning time.

> *MADEAU wipes another finger inside a hanging plate, harder this time – grimey.*

JANIKA: But its Whitsun. Spring has gone.

MADEAU: Not in *my* heart it hasn't. I can always see lots of lovely little jobs to do.

> *She turns a leaning brass tray to view front and back.*

Nice old brass to polish up…

> *Draws a heart shape in the grime of a window-pane.*

…windows to make sparkle…

> *Surveys everywhere.*

Mmm! Yes! We're going to have a lovely time.

> *Her eye catches an object, candle-grease covered.*

MADEAU: What's under this?

JANIKA: A candlestick I think.

MADEAU: Do you want to keep it this way? I mean does it represent nights of toil for you? An accumulation of romantic memories?

> *JANIKA snorts. Huh! The very thought.*

Right, then I think here's where I start.

> *She finds a newspaper and knife and begins chipping.*

KARL-OLAF: I suppose as you helped us to clean up when we moved in you'd better do a yearly once-over.

RAPHAEL: Good God! A year gone already? A whole year gone by already? Time passing – sly! Don't like it.

JANIKA moves behind him to affectionately massage his shoulders.

JANIKA: Time never seems to pass for you. You're as young now as when you were lecturing us ten years ago.

RAPHAEL: There! You see! Ten years ago! Ten years since you were my students. And soon a day will come, the end of the week, just as we're leaving, and Janika will say: (*Ghost-like.*) 'You remember that Whitsun you spent with us, ten years ago?' And I'll say: 'But that's impossible. We arrived only six days ago' and she'll kiss me tenderly and stroke my hand and say 'no, no, Raphael, you're mistaken. We were doing our fellowship studies in Cambridge ten years ago, and you're as young now as you were then.'

MADEAU: That sends cold shivers through me.

Pause.

KARL-OLAF: Right! Dinner done! The blonde lady's making me restless.

He stands on a chair to remove wall plates from wall. Hands them to RAPHAEL.

JANIKA: I don't suppose I can sit around – which I would very much like to do – if you all work.

She turns on hot water tap. Squeezes washing up liquid into sink. Takes wall plates into hot water.

A house in activity.

RAPHAEL: How about some music?

JANIKA: What time is it?

RAPHAEL: Seven-thirty, why?

JANIKA: Each time of day has its mood…

She moves to visible part of lounge where is stacked hi-fi and records.

…and if it's seven-thirty on a hot, lazy evening –

KARL-OLAF: Lazy?

JANIKA: …you don't want the 'Dance of the Polovtsian Maidens' do you?

Everyone waits to hear what she'll choose.

Dionne Warwick. 'Do you know the way to San José?'

RAPHAEL: That's absolutely right.

JANIKA sways to the music, coy and pleased with herself.

RAPHAEL sways towards her. They dance.

And what would you have at nine in the morning?

JANIKA: Oh, let me see, how about Bach Concerto for Two Violins? Or the Schubert Trios? Or Duke Ellington?

RAPHAEL: And at eleven o'clock in the morning?

JANIKA: A little Bartok, perhaps? Say the Music for Strings, Percussion and Celesta? Or one of the pop concertos – Rachmaninov Piano No.2, or the Sibelius Violin – nothing difficult.

RAPHAEL: And at lunch time?

JANIKA: Beethoven, for sure, when the day is confidently in its stride.

KARL-OLAF: (*Intending to be playful.*) And what if the day is confidently *not* in its stride?

JANIKA: (*Hissing.*) Shut up, you!

RAPHAEL: (*Stepping in.*) How about six o'clock, before dinner.

JANIKA: (*Her enthusiasm lost.*) Wagner, a Brahms Symphony perhaps.

RAPHAEL: And do you have in-between choices? Like between the hour of three which is reserved for Mozart, and six which is put by for Wagner? Say, four-thirty?

JANIKA: Stravinsky!

RAPHAEL: Stravinsky? At half past four in the afternoon?

JANIKA: The Rite Of Spring. (*Directed at her husband.*) To waken you. Make you feel wild and barbaric when domesticity has reduced you to a washed-out cretinous lump!

They must let that moment settle.

RAPHAEL: (*Tenderly.*) Eleven at night?

Responds gratefully to his sympathetic tone.

JANIKA: The range is wide then. Richard Strauss, Four Last Songs. Bach Partitas. French Chansonners. Something sad.

> *She's holding back tears.*

> *KARL-OLAF has meanwhile returned some of the plates to the wall.*

RAPHAEL: Good God! Look how they shine.

MADEAU: Of course! A little soap, water and attention – we all shine, show our colours. Isn't that a beautiful blue? You don't see blues like that anymore.

RAPHAEL: Everything looks so dowdy now.

MADEAU: (*It being what she intended.*) That's right!

> *FADE*

SCENE 3

> *Later, Same evening.*

> *RAPHAEL by the sink washing more plates.*

> *KARL-OLAF wiping.*

> *LARS and GABBY have been quarrelling, confront MADEAU and JANIKA.*

LARS: You want to go out one evening, right? Well on that evening I want to have some friends for a little party and not one will be less than eleven and I don't want Gabby to stay up for it.

GABBY: Well I think that's silly because I won't be able to sleep will I? I'll be awake in my room and what's the difference where I'm awake?

LARS: We may have things we want to talk about and my friends will get embarrassed if you're around.

GABBY: Why? Eleven isn't very old you know, Lars, and I'm a very grown up eight.

MADEAU: (*Grabbing her.*) Mmm! I could eat you, you're so Danish-looking.

> *LARS storms off.*

JANIKA: Oh, dear.

GABBY: I'll be your Danish pastry, shall I?

JANIKA: Oh, dear dear.!

She goes after him.

GABBY: Is that a wooden candlestick?

MADEAU: Brass, we hope. I'll do another little bit tomorrow and then we'll start getting off those layers of blemish.

GABBY: What's 'blemish'.

KARL-OLAF sweeps down on her, picking her up in his arms.

KARL-OLAF: 'Blemish' my darling daughter is when there are marks on something very beautiful like this –

He bites her neck. She screams and laughs.

And this! And this!

JANIKA briefly appears to call KARL-OLAF to LARS.

Come on, daughter, let's get you to bed and leave these Englishmen –

GABBY: – and women –

KARL-OLAF: – and women, let's leave them to make our dirty house clean.

They're gone.

MADEAU: I think that's enough of candle-scratching. I'll bore myself if I go on. Tomorrow – the crevices. That's what I really enjoy, picking the crevices clean. I shall look forward to that.

She moves to behind her husband at the sink, creeps under his shirt in search of his nipples.

And tell you what else I'm looking forward to?

RAPHAEL: Don't do that.

She ignores him.

MADEAU: I'm looking forward to breakfast in the garden with my dressing-gown on –

RAPHAEL: Don't *do* that!

MADEAU: – a picnic somewhere –

RAPHAEL: *Don't!*

MADEAU: A barbecue one evening, a long bicycle ride, a little love in the afternoon perhaps...

RAPHAEL: DO-NOT-DO-THAT!

MADEAU: And although I've only been here a few hours I can see all the spring-cleaning that needs to be done.

RAPHAEL: If you don't stop doing that I'll –

MADEAU: Those doors for instance –

RAPHAEL: – I'll –

MADEAU: – stained with finger-marks and splashed soup –

RAPHAEL: – I'll –

MADEAU: – hot water and soap-suds for them.

> *RAPHAEL swivels in his wife's arms, a plate in each hand, feigns a tender response and then dips and bites into her neck forcing her to cry out, but she remains, enjoying it.*

KARL-OLAF: What is it with you two lovers?

MADEAU: New places. Taking your husband to a new place can be like meeting a stranger.

RAPHAEL: About which she knows a great deal, of course.

> *MADEAU is wandering around inspecting high and low.*

MADEAU: Cobwebs to brush away, wooden floors to scrape and polish, windows with a dozen storms on them, weeds in the garden, newspapers to burn...

KARL-OLAF: ...to recycle, please.

MADEAU: ...and I bet there are some lovely drawers to turn out, full of forgotten things. Mmm – how everything will shine!

RAPHAEL: You will be dazzled and amazed.

MADEAU: I can't wait!

JANIKA: (*Returning.*) I heard all that.

RAPHAEL: Don't worry, we won't get around to much of it.

JANIKA: It makes me tired just listening to her.

> *JANIKA slumps into an armchair, legs splayed, eyes cast down, fiddling with a button on her blouse.*
>
> *Pause.*

RAPHAEL: I loved that Pommes Lyonnaise.

KARL-OLAF: The secret is to grate in some nutmeg.

RAPHAEL: Who thought it up in the first place, I wonder?

KARL-OLAF: Who thought up *anything* in the first place?

> *Pause*

RAPHAEL: How's the research into – what? I've forgotten?

JANIKA: (*Wearily.*) Anglo-Danish trading in 19th century China.

RAPHAEL: Obscure – as research should be.

KARL-OLAF: You may laugh, old man, but it's in the details of trading-relations that one discovers the *real* history of nations.

RAPHAEL: You trying to tell me that the history of man resides in the pockets of traders rather than the pallets of artists?

JANIKA: (*Bitterly.*) It's only the history of woman that resides in the pallets of artists.

KARL-OLAF: Trading is a natural instinct.

RAPHAEL: Oh *you* just have this romantic idea of bearded old men bargaining in the desert over goblets of wine and being reasonable about the value of their artefacts.

KARL-OLAF: As natural as conversation, creativity, making love – all forms of intercourse.

RAPHAEL: Who says all things 'natural' are honourable? What's honourable about trading in consumer goods for millions?

KARL-OLAF: Millions can consume the goods!

RAPHAEL: What Ruskin called encouraging 'the habit of discontent'.

KARL-OLAF: (*Contemptuously.*) You and your John Ruskin!

RAPHAEL: Look!

All three turn to regard MADEAU who is outside
straining up to reach into the corners of the windows.
Her skirt has risen, revealing the bulbous 'V' of a full
(knickered) pelvis.

JANIKA rises angrily to quarrel with KARL-OLAF in
Danish. (To be translated and conveyed to us either as
VOICE OVER or projected 'over-titles.)

JANIKA: We can't do anything without being objects for you.

KARL-OLAF: Don't be absurd. A woman is a woman...

JANIKA: ...is a woman, is a woman, is a *woman*!

KARL-OLAF: It's rude to talk in Danish before our friends.

JANIKA: If they're our friends they'll understand.

KARL-OLAF: Janika, please, let's have a peace pact, just for this week?

JANIKA: You always have reasons not to face battles.

JANIKA rushes off.

KARL-OLAF: I suppose you understood all that you clever old man?

RAPHAEL: More or less.

MADEAU: I'm sorry. I'll wear jeans next time.

KARL-OLAF: No, I'm sorry, we're going through a very bad time.

RAPHAEL: And I'm sorry, we're going through a very good one.

The friends continue their work.

RAPHAEL: You know, I have a colleague – there *are* other art historians – and he's got a son called Mark. We read each other's once-a-year papers, and meet once-a-year at a party given by the magazine which prints our once-a-year papers articles. And every once-a-year when we meet he tells me: 'You know, Mark is going through a very difficult time.' When the child was seven, nine, eleven, at thirteen, at sixteen – we'd meet and he'd say: 'You know, Mark is going through a very difficult time.'

FADE

SCENE 4

Late Friday evening. End of a lovely summer day.

Music – Vaughan Williams 'Lark Ascending'.

FOUR ADULTS in the garden, sprawled around. Candles burning in the conservatory.

Sounds of summer – bees, sheep in the distance, birds calling.

Landscape, hot days, friendship – all pervade and colour this holiday in which nothing and yet everything is happening.

KARL-OLAF massages MADEAU's shoulders.

RAPHAEL is propped against a huge cushion, JANIKA cradled in his arm, his hand stroking her face.

THE FOUR have a trusting but sexually charged friendship.

GABBY'S VOICE: M-a-a-deau-eau-eau-eau... M-a-a-deau-eau-eau-eau...

 Pause.

RAPHAEL: If I ever committed suicide it would be at this hour. Sharing it with others – fine! A fine and beautiful hour. Alone – it's unbearable. The day's done, the light's dying – an end of things. Regret, longing, nothing will return. A sad, sad, country hour, full of loss.

JANIKA: For me it's the reverse. It's a time that is my own. Mine and mine alone.

 Long pause. She stops RAPHAEL's hand moving. Too dangerous.

KARL-OLAF: I had a letter last week. Bizarre. It's first sentence read: '*Dear Sir, The envelope in which this letter arrived could have contained a lethal explosive device.*' It was from a security firm offering for sale x-ray equipment. Some huge, some portable.

JANIKA: Oh Karl-Olaf. Please.

KARL-OLAF: And the letter went on to warn that '*the equipment and tactics of the modern terrorist make the security of the*

> *individual, the office building, and the general public a*
> *problem which becomes more difficult day by day.'*

JANIKA: You didn't think that perhaps this lovely moment
should have been left alone and your awful letter left
for some other time?

KARL-OLAF: *Is* it such an awful letter?

JANIKA: Yes, yes, yes!

KARL-OLAF: It was just another circular with drawings and
dimensions, like a fridge.

JANIKA: Only it wasn't a fridge. It was an instrument for
detecting guns and bombs, grenades and dynamite.
And we're lying in the sun in one another's arms and
looking forward to days of sweetness and light...

KARL-OLAF: I'm sorry, I didn't think.

JANIKA: You never do!

Distant voices.

GABBY'S VOICE:Ma-aaa-deau-eau-eau... Ma-aaa-deau-eau-eau...

FADE

SCENE 5

Saturday morning. Bright sunlight.

Music – Corelli's 'Christmas Concerto', full of lovely violins,
violas, double-basses and a harpsichord.

RAPHAEL in blue-leafed Japanese kimono, sitting, reading
a newspaper.

MADEAU, in a red-leafed kimono, sprawled in the morning
sun.

MADEAU: Breakfast in other people's homes. Nothing like it.

RAPHAEL: Brie cheese, garlic sausage, German pepper
sausage...

MADEAU: ...raw peppers, honied ham, scrambled eggs in
Philadelphia cheese...

RAPHAEL: ...hot croissant... We never eat like this at home.
Lots of tastes on one table. That's what greed is, not
quantity but taste upon taste upon taste.

After all, what does one *really* need to be sustained?
Bread, water, a little salted fish, some nuts and
raisins, perhaps.

*JANIKA enters with a pot of coffee in one hand and a
plate of Danish pastries in the other.*

JANIKA: Who wants more coffee?

RAPHAEL jumps up.

RAPHAEL: Me, me, me!

MADEAU: But not the Danish pastries.

*JANIKA wears a clinging night dress that reveals her
body outline.*

*RAPHAEL tweaks her nipples. She backs away but not
without betraying pleasure.*

RAPHAEL: Ah ha! There's life in you yet.

She puts down jug and plate.

JANIKA: What did you think!

MADEAU eyes the Danish. Mmm!

RAPHAEL: Well, I've not seen you embrace Karl-Olaf once
since we arrived.

JANIKA: I'm not in the embracing mood.

RAPHAEL: (*Croaking.*) Well I am.

*He gives chase. Hunched back, waving curled, arthritic
fingers.*

They exit.

MADEAU: Bloody kid!

GABBY and LARS enter.

LARS: Why is your husband chasing my mother?

MADEAU: Because he's a bloody kid.

GABBY: Kids aren't bloody.

MADEAU sweeps her up.

MADEAU: Of course they're not, my darling. But bloody grown
ups can be bloody kids.

Pause.

Okay. We've had enough of Corelli. Let's find something else.

She lowers GABBY and rummages through records.

No. No. No. No. Yes! This one.

Puts on record of Ewan McColl singing 'Paddy Works on the Railroad'.

She can't resist the rhythm, and dances to it. Her gaiety is infectious.

The children join in.

MADEAU becomes puffed after a minute or so, stops dancing, bends forward, and with a flick of her nightgown throws it up to reveal her bottom to the kids.

They laugh with delight.

SCENE 6

Saturday midday. The cycle ride.

Four (fixed) bikes.

The back wall becomes a moving panorama of the Cambridge countryside through which they are cycling.

The CHILDREN are always ahead, out of sight.

JANIKA and MADEAU are in front. RAPHAEL third. KARL-OLAF to the rear.

RAPHAEL: (*Pointing.*) Look! (*Quotes.*)

> '*Three centuries he grows*
> *And three he stays*
> *Supreme in state*
> *And in three more decays.*'

KARL-OLAF: What?

RAPHAEL: John Dryden!

KARL-OLAF: Who?

RAPHAEL: The oak!

KARL-OLAF: (*He's only heard the last.*) Ah, yes, I see it. Lovely. You've had no wars here recently.

They 'ride' on.

GABBY'S VOICE: M-a-a-deau-eau-eau-eau… M-a-a-deau-eau-eau-eau…

Suddenly.

MADEAU: Stop!

They do.

Look!

Sound of a gentle stream.

Watercress.

She dismounts. Bends to pull out a bunch of the green leaves.

She tastes some, then puts a little to each of their mouths.

There, take that. It'll purify your blood.

RAPHAEL: (*Teasing.*) And make you wittier.

MADEAU: Wittier?

RAPHAEL: Old proverb: eat cress attain wit. The Greeks swore by it.

MADEAU: And my father swore it kept his hair from falling out.

RAPHAEL: But your father was bald.

MADEAU: (*Touché.*) Uh huh!

They 'ride' on.

RAPHAEL: (*Calling to her.*) Are you certain you've got the right cress? I mean there's a poisonous one that resembles it, you know.

MADEAU: (*Calling back.*) You fall off your bike in agony we'll know, won't we!

Light change and landscape change to denote time has passed.

They stop, having reached a point where they're uncertain which way to go on.

JANIKA: (*Calling ahead.*) Gabby! Lars! Hold on a minute.

RAPHAEL: The sign says 'cycle track'.

KARL-OLAF: And we're moving roughly in the right direction.

The children appear.

MADEAU: Listen!

A tapping sound.

MADEAU: A woodpecker. Tapping for some poor old woodlouse.

GABBY: And what's that?

The sound changes to a drone.

MADEAU: There! See it? That golden green thing? A dragonfly. Now there's a macabre insect. Eats its own tail and carries on flying.

LARS & GABBY: (*Groaning.*) Yeach!

The KIDS move forward to return to their bikes.

For the first time we see GABBY calling out just for the pleasure of calling.

GABBY: M-a-a-deau-eau-eau-eau… M-a-a-deau-eau-eau-eau…

JANIKA: I hope she won't do that when you've gone.

They 'ride' on.

Light changes, landscape changes.

This time it's not a landscape but a brick wall. They are inside a tunnel. Stop.

RAPHAEL: What a lot of money to spend on a tunnel which surely can't be used by more than a dozen people in the year.

The children appear.

LARS: Why are we stopping?

RAPHAEL: (*Ominously.*) Perhaps it leads to an underground atomic shelter for important Cambridge scientists.

GABBY: (*Pretend shakes.*) Oooooooh!

Nevertheless the image has gripped them, each to their own nightmare –

JANIKA: I have this dread of something awful about to happen. It's not a fear of the bomb, I don't think it's that, but some kind of anarchy. A break-up of patterns of behaviour. I hoard things, like Christmas

wrapping which I fold away neatly in drawers. And string and brown paper from parcels, plastic bags – I've got three plastic bags full of plastic bags! And there's this cupboard full of imperishable goods – tins of soups, baked beans, stewed meat, packets of tea. Two week's supply.

But that's not the kind of hoarding I really want to do. What I really want to do, and I'm ashamed to admit it, is dig a huge square hole somewhere, line it with cement and plastic, and fill it up with tins of vegetables and broths, jars of pickles and Nescafe and honey and salt and spices and sugar and flour and packets of candles and batteries and vacuum flasks and soaps and medicines and bandages… For what? A siege perhaps, some unspeakable disaster. I fear – I don't know – a time of aberration, a great lapse of human kindness. They say it's the disinherited who will claim justice. Well…maybe… but I fear old scores will be paid off and new injustices made. There are such mad angers about and they frighten me and I want to lay low until they're spent, and protect my children.

JANIKA's picture has held and distressed them.

MADEAU rescues the moment.

MADEAU: I have an idea. We're in a tunnel, right? Can you hear how our voices have a nice, echoey tone to them? Now, kids, go back to your bikes and stand at the end of the tunnel and listen.

They go off.

MADEAU gives each of the adults a note to sing – they test it, it's a four part chord.

Now, when I say 'go', we ride and each sings their note as we go along the tunnel. Ready?

They each sound their note like a chamber ensemble warming up.

Ready, steady, GO!

*A gorgeous chord sounds which changes in timbre as
they proceed through the tunnel.*

Harmony replaces JANIKA's nightmare.

FADE

SCENE 7

Saturday late evening.

*RAPHAEL, MADEAU, JANIKA, KARL-OLAF in a car on the
way back from an evening meal in a restaurant. RAPHAEL
driving.*

KARL-OLAF: We should've known what sort of a restaurant
it would be from the menu. Did you notice,
Englishman, it had one pretentious dish in French
Truit à la Marguery

RAPHAEL: And the best wine on offer was an obscure drop of
nonsense called Chateau La Tour Ballet '67.

KARL-OLAF: I suggested the restaurant because a colleague
recommended it. It's run by a man who used to be a
TV personality.

RAPHAEL: Awful man! Loud mouthed, patronising, a kind of
hearty bully. I once saw him, after the News. There'd
been a competition and the prize was an opportunity
to run around a supermarket with a trolley and
pack as much into it as you could in three minutes.
The winners were a middle-aged couple, kindly-
looking, holidays in Southend, or Blackpool for a
treat – though God knows why we look at people
and presume to know them so well, but we do, and
there it is. And suddenly, on the word '*go*', this timid
pair from West Ham – I assume it was West Ham
because it was a Sainsbury's in West Ham, suddenly
this sweet, unassuming pair were immediately turned
into the greediest, graspiest, grabbingest couple on
earth. It was shocking everyone egging them on,
encouraging them to haul and snatch as fast as they
could.

'Only two minutes left! Only one minute left! Ten, nine, eight, seven, six…' They became so excited, their arms reaching up, reaching down, their faces showing panic if they hesitated and a second passed without them having thrown some 49p or 29p or 9p article into their racing trolley. And when they'd done, to applause mind you, this gross Cockney with his hateful bonhomie triumphantly announced to the millions of viewers that the reward for this obscene display of greed, this demeaning, self-abasing race, was £124 and 46 pence worth of groceries, or thereabouts. A month's supply of goods in return for entertaining the crowds with the spectacle of their humiliation. And do you think it was over? Not by half.

He had to have a go himself. To see if he could beat them. Which of course he did! But beside him the middle-aged couple appeared civilised. He, our huge huggable one didn't merely 'reach for' with honest hands, no! He flicked! This fat man ran and flicked at things which, because they weren't bodily lifted, more often than not knocked other things down. Eggs smashed, bottles crashed, boxes burst open, and he took his corners so swiftly that neatly piled 'special offers' came tumbling down in what for the crowd was hilarious disarray. Think of it! His pillaging drew applause from the onlookers. In this age of wide-spread poverty and anarchy he left behind him a trail of disorder and waste and, for me, despair. And those who watched, applauded. Imagine! Applauded!

> *Drive in silence.*

RAPHAEL: I've eaten too much.

MADEAU: You always eat too much and complain.

> *JANIKA, a little drunk, leans to whisper in RAPHAEL's ear.*

JANIKA: You should be grateful you're not a woman who also has to lose fat from having babies and…

She had not intended to score points but -

KARL-OLAF: Oh bleddy hell! Not *that* again. Jesus! I'm sorry
we're not women, I'm sorry we can't have babies,
I'm sorry God made us men but there it is – we
can't do anything about it. That's life! *You* have all
the pain and we have all the pleasure. Bleddy hell!
Bleddy, bleddy hell!

JANIKA holds back tears.

*RAPHAEL nudges her as though to say – take no notice,
he's drunk.*

Drive in silence.

Suddenly MADEAU cries out.

MADEAU: Stop, we just passed someone. It's a woman, she
doesn't look well.

Car reverses. The WOMEN get out.

KARL-OLAF: She been raped?

RAPHAEL: God knows! She *does* look poorly.

*MADEAU and JANIKA appear holding up a
WOMAN.*

*SHE is slight, looks older than her thirty-five years.
She and her clothes were once smart but now express
defeat.*

MADEAU: (*To RAPHAEL.*) You still got that flask of brandy in the
car?

WOMAN: No alcohol, thank you.

The way she declines tells us something.

MADEAU: You alright?

The WOMAN nods but looks down.

Nothing you want to tell us?

The WOMAN shakes her head.

Are you going home?

*The WOMAN jerks her face up in fear. Her face reveals
bruises.*

She's a battered wife.

JANIKA: Would you like us to take you home?

MADEAU: Or is there somewhere else you'd like to go?

No answer.

JANIKA: Would you like to come back to our house for a cup of tea?

Still no response.

JANIKA's next question tells the WOMAN they know what has happened.

JANIKA: Is your husband still at home or is he gone out?

WOMAN: Gone out I s'pect.

JANIKA: Do you live far.

WOMAN: No, just –

She points up the road.

JANIKA: There are people you can go to, you know, to talk about it.

MADEAU: Good people. With lots of experience and understanding. No one need know. I could give you an address.

Long pause out of which –

WOMAN: It would be alright, you know, if only he didn't want to kiss me on the lips. I don't mind what else he do, he can do what else he likes so long as he don't kiss me on the lips. I can't take that. Not that I can't. And that's what it's all about. Always has been and always will be. (*Pause.*) I'll go now. Thank you. You've been kind. I like kind people. G'night.

She moves.

MADEAU: I bet you're a kind person.

She stops. Regards them as though the thought had never occurred to her.

She smiles. The sweetest of smiles. And leaves.

MADEAU: Not her lips. Anything but her lips. Good God, I've never come across that before.

JANIKA: Self-respect! Protecting the most intimate part of her body.

MADEAU: Lips! What a revelation!

KARL-OLAF: (*Almost to himself.*) And like most women she married the wrong man!

SCENE 8

Early Sunday Morning, around 3 a.m.

Sound of whimpering.

KARL-OLAF is on the floor, leaning against a bookcase, legs straight out, arms limp, head rocking, weeping.

In one hand his glasses, in the other a faded copy of The Observer *which he has just been reading.*

RAPHAEL in his kimono dressing-gown comes looking.

RAPHAEL: Karl-Olaf, what is it? Stop crying. What on earth can it be?

KARL-OLAF: (*Holding up* The Observer.) This! This poor girl. What they did to her.

> *RAPHAEL waits for the sobbing man to collect himself.*

Couldn't sleep. Too much food. So – came to clear up. All these papers. Why do we hoard newspapers? And you know what it's like when you're throwing papers away, you read first, to check, make sure some 'valuable' piece of information isn't being discarded – dates, events… All nonsense, just nonsense. A historian's illness – hoarding facts.

And I came across this. This story. This grotesquery about a woman they'd captured in a village in South Vietnam. Thought she was a guerilla. Rape, torture, terror…this poor woman…forty eight hours…kept her…uncertain…for all that time…not knowing what they'd do. They had this power over her. Soldiers with no minds, no morality. Gangsters in uniform…capable of infinite cruelty…someone gave them the power. And this woman, at one moment she thinks they'll let her go, and she's happy, and then she can see – they won't, and she terrified, and then she's bewildered. And I can see it, you

know, I can feel it...her only life...and they don't
comprehend the meaning of that... Her Only
Life...they don't care...and she's helpless! And in
the end, after all that waiting and uncertainty and
hoping – they murder her. No pity. No justice. Only
cruelty...and I've just read it, one of the soldiers
who did it, confessed...and it makes me cry...for
her, for just her – a victim, a helpless victim. I mean
– she couldn't do anything. She was in their hands.
Bastard soldiers! Three-minute Emperors! It makes
me want to kill, to *kill.* Isn't that something? It makes
me understand revenge because I want to kill. Oh,
Englishman, look at me, I cry instead.

> *RAPHAEL takes the paper. Needs only to glance
> at it.*
>
> *Removes his friend's steamy glasses, wipes them on his
> kimono, replaces them.*
>
> *He clears a space for himself and sits alongside his
> friend in the same position.– keeping him company.*
>
> *They sit and sit and sit...*
>
> *Sounds of early morning...*
>
> *END OF ACT ONE*

Act Two

SCENE 1

Sunday morning.
music: Saint-Saens' Symphony No. 3.
MADEAU by the table, chipping away at her candle-stick.
LARS hovers.

MADEAU: Coming. Slowly, but coming.

LARS: Is it old?

MADEAU: Don't really know. I'm not good at guessing antiquity. About 100 years I suppose.

LARS: How do you know it's 100 years?

MADEAU: Alright, seventy then.

LARS: Oh, you're just guessing.

He's been nonchalantly turning over pages of a Woman's magazine. Nothing interests him there.

LARS: I suppose you're also on Gabby's side.

MADEAU senses this exchange could be important for the family she loves.

MADEAU: I don't really know enough about it, do I? But I do know everyone has quarrels and its not always because one's right and the other's wrong. Often they're both right to want what they want, but unfortunately the two 'wants' are in conflict. Crash!

She brings her two hands together in a collision.

LARS: That's not an answer.

MADEAU: Wait! I'm not finished. Anyway, If you think I'm coming down on one side rather than another you've got another think coming.

LARS: I *have* got another think coming.

He puts his fist to his head, pulls it back slowly.

It's coming, it's coming...

Opens his hand into a 'plane' which flies and then falls 'bang' on the table.

Oh dear, it came but it went.

MADEAU: Why do foreign children always seem more intelligent?

He curtails her admiration.

LARS: (*Business-like.*) Right and wrong – are you to continue?

MADEAU: Let me tell you something curious I learned the other day. You know of course that sheep are frightened of dogs – they use dogs to round them up. You must have seen it happening in the fields around. Sheepdogs they're called.

LARS: (*Disdainfully.*) Of course.

MADEAU: Well, when a sheep gives birth to its lamb she develops a strong maternal instinct…

LARS: A what?

MADEAU: Motherly feelings. She develops such strong motherly feelings that if a dog comes near her lamb she doesn't move but stamps her foot and sometimes even chases the dog!

He's captured.

In fact if there's an orphan lamb – the mother's died or hasn't any milk – it has to be given to another ewe to act as mother. And you know what the farmer does? He puts the strange lamb near the strange mother and sets the dog on them, and in this way the sheep becomes attached to the lamb because – she's been forced to protect it.

LARS: That's wonderful! I liked that story but what's it got to do with Gabby and me?

MADEAU: I suppose you're wondering what's this got to do with Gabby and you.

Both laugh.

MADEAU looks around, conspiratorially.

He joins in the game and leans towards her.

(*Loud whisper.*) Family! There's nothing like a family. Precious! I never had one. Nothing was done to keep *us* together. Very precious. Don't quarrel with sisters. Protect them! They'll love you.

When everyone else has let you down they'll stand by you. I promise. Sssssh!

> *LARS is touched. He strokes her face and, like a well brought-up young man says:*

LARS: Thank you.

MADEAU: (*Breaking the spell.*) Cor! What a stink! Where's it coming from?

> *RAPHAEL and KARL-OLAF appear with spade and fork which they lean against an outside wall where they remain to continue their exchange.*

LARS: Poooh! They've been turning over the compost heap.

> *Leaves.*

> *MADEAU continues scraping away at her candle-stick.*

KARL-OLAF: And I tell you that it's the Gadaffis who are the new dangers, not the old-fashioned Communists.

RAPHAEL: But Gadaffi's just an old-fashioned demagogue.

KARL-OLAF: Mistake! He's a new one with a new language – non-speak!

RAPHAEL: 'Non-speak'?

KARL-OLAF: He wants to create a democracy which is, and I more or less quote: 'the people's supervision of itself'. Now what does that mean? Sounds lovely, eh? 'The people's supervision of itself.' And how will they do this – the people supervise itself? Gadaffi proposes as follow: through a system of 'People's Congresses and Popular Committees'. And *that*, he declares, represents the people's supervision of itself. Non-speak!

RAPHAEL: 'Non-speak'. I like it.

KARL-OLAF: And no doubt will use it constantly!

MADEAU calls to them.

MADEAU: Go and change your clothes, you're polluting the summer.

They step out of dungarees.

Did you boys enjoying your shit-stirring?

KARL-OLAF: He's the best shit stirrer I've ever seen.

RAPHAEL: They don't know what a treasure they've got out here. The people you rented this house from must have been getting their shit together for decades. Ours is only four years old.

KARL-OLAF: I bet you just love putting smelly garbage on top of smelly garbage.

RAPHAEL: I do! I do! Especially from rain-gutters where they've lain all winter and gotten black and peaty and yeach!

KARL-OLAF: And where do you get your horse-shit from in the city, eh, Englishman? Eh? (*Prods him with fork.*) I bet you don't get real horse-shit, and no compost heap can be called a compost heap unless its got layers of real horse-shit on it, eh, Englishman? Eh? Eh?

MADEAU: Come on you two, there's fresh coffee to be drunk and doors to be scrubbed.

FADE

SCENE 2

Saturday mid morning.

Coffee break.

ADULTS sitting round the table, except MADEAU who stands scraping her candlestick.

RAPHAEL: And I wish you wouldn't keep calling me Englishman. I'm feeling very un-English these days.

JANIKA: And why are you feeling very 'un-English these days'?

RAPHAEL: Thin times, my dear. Thin, sour times. I quote you George Steiner who wrote that we live in '*A time of unmistakable thinness, corner-of-the-mouth sparsity, and*

they come with tight lips and deflation'. Mmmm! I love the smell of coffee.

KARL-OLAF: I was in Belgrade recently and there they call it minimalisation. '*We've got a plague of minimalisers*' they told me.

RAPHAEL: Janika fears 'mad angers', and my Jewish nose smells rot in the fabric. 'Corner-of-the-mouth sparsity!' Deflation camouflaged as 'a sense of perspective'. Urgency dismissed as 'earnestness'. Moral outrage defused as 'self-righteousness'. And 'they' prefer those words because *they* have no urgency, *they* have no moral outrage.

JANIKA: And who exactly are 'they', old man?

RAPHAEL: 'They'! The grey enemy out there. Those 'other people' Satre described as hell, always lurking with tight lips and cold smiles, ready to pounce and deflate. And less of the 'old'.

MADEAU: Do you know, he *buys* his horse-shit?

KARL-OLAF: *Buys* it?

MADEAU: From a nearby horse-riding school.

KARL-OLAF: *Buys* it? Huh! I bet he even likes the smell of it.

RAPHAEL: I do! I do! And what's more – I don't mind handling it, either, if it's old, and hard. I love the whole process. Gives me pleasure when I'm abroad to think everything in my compost is bacteriarating while I'm not there. The acid from the citrus peel eating into the clay, the horse-shit decomposing the food-swill, the leaves metamorphosing the peat. Everything mixing and mulching, and becoming rich. Like that soup boiling away there on the stove. Full of celery, tomatoes, onions, carrots, turnips, chicken…all those tastes mixing and mulching. Lovely! Compost and soup – what more does the world need?

FADE

SCENE 3

Saturday midday.

JANIKA and RAPHAEL washing down different sides of the same door.

RAPHAEL: Tell me what's been going wrong between you and the big Dane?

JANIKA: Oh, it's not interesting. Boring old blue-stocking stuff. We all have complaints.

RAPHAEL: Which is what friends are for – listening to monologues of complaint

JANIKA: Once, yes. Twice, perhaps. But endless long monologues of complaint become a habit. I deal with a woman in my social work who complains – endlessly. Every day brings a calamity. Her husband left her because she was full of long monologues of complaint. She'd recite them – like the Ancient Mariner – grabbing at whoever was passing by in her life, sometimes forgetting she was passing some people for the second time and telling them again. I have many clients like that – they're not with you. They don't look at you. They just look at this awful vision of their life – one long monologue of complaint.

Oh, the suffering is real enough for them but it's draining for everyone else. And insulting, really, because the monologues are saying '*you* don't suffer what I'm suffering, *you* don't understand what I understand'. As though it's happening only to them, they've been singled out. And they make people around them feel guilty for any little bit of happiness they've managed to snatch from life. And friends leave them; retreat to protect themselves. Who wants to be reproached all the time? So, no long monologues of complaint. I don't want to drive *my* friends away. I need them.

RAPHAEL: While you suffer quietly?

JANIKA: Better than suffering loudly.

RAPHAEL: I wonder…

> *JANIKA sees something in the garden.*

JANIKA: Good lor! Look at that! Extraordinary.

RAPHAEL: Lars is reading to Gabby, what's extraordinary about that?

JANIKA: How adoringly she's listening to him.

RAPHAEL: Why are you so surprised?

JANIKA: Because it's never happened before.

> *They're finishing the door.*

RAPHAEL: Isn't it lunch time?

JANIKA: Indeed it is.

RAPHAEL: You know, when I was young and hungry I used to say: 'I'm ravishing!'

JANIKA: (*Cooing.*) And you are, my darling, you are!

> *FADE*

SCENE 4

Saturday mid-afternoon.

Still, bleached sky.

The FOUR FRIENDS, in the briefest of briefs sprawl exposed to the sun on a lazy hot summer's day.

Only KARL-OLAF sits in a low slung deckchair with his back to the sun.

JANIKA sprawled at his feet.

Summer sounds, and –

GABBY'S VOICE:Ma-a-a-deau-eau-eau-eau…

LARS'S VOICE:J-a-a-a-nik-a-a-a…

> *KARL-OLAF nonchalantly moves his foot up and down inside JANIKA'S thigh. She doesn't resist.*
>
> *Soon his foot rests on her pelvis which he squeezes with his toes.*
>
> *She arches to him. Satisfied, he stands, stretches.*

KARL-OLAF: It's no good, my friends. My brain is melting away. Who's for a cold drink and cool music?

JANIKA: We all are.

He leaves them to put on a record.

We hear the lazy voice of Frank Sinatra.

KARL-OLAF: (*Calling, referring to the wine.*) Something special. From the cellars of St Anthony's College. And the cellar man made sure I *knew* it was something special.

He appears with a brown-coloured wine bottle and four tall glasses rattling on a tray.

(*Cockney accent.*) '1971, sir, a good year. Er, don't drink it with the food if you don't mind me telling you. More for after dinner, or a hot summer's day, if you'll pardon the advice.' Tactful, enlightened, Cockney accent. A Kreuznacher Kahlenberg Reisling. '*Better in ten years time, sir, but very good for immediate drinking.*' That's why people think socialism would work in England when it's failed everywhere else. You've got such a civilised working class.

Pours and offers each of them a glass. MADEAU first.

You've got a red face and freckles, Madam, do you know that?

MADEAU: (*Jerking up.*) I haven't! Damn.

JANIKA rolls over onto her stomach, finds her face near to RAPHAEL's.

JANIKA: You look so beautiful asleep. (*No response. To MADEAU.*) Do you think he heard?

MADEAU: He misses nothing.

RAPHAEL: (*Eyes still closed.*) You're wrong. I miss everything. You've always been wrong about me.

MADEAU: As you say, you miss everything!

JANIKA: Oh, everyone's so clever.

GABBY'S VOICE: Ma-a-a-deau-eau-eau…

LARS'S VOICE: J-a-a-a-nik-a-a-a…

JANIKA: One of the blessings about being here is that we hardly ever see the children, only at meal times.

MADEAU: Don't you ever miss their sounds?

JANIKA: Not the sounds those little buggers make.

Everyone is re-arranged.

They sip in silence, enjoying the wine and each other.

MADEAU: It's gone straight to my head. Drunk in the afternoon. What an indulgence.

JANIKA: Don't lie back in the sun then, lean up against the wall there, in the shade.

MADEAU does as she's told.

RAPHAEL: Do you find that beautiful settings emphasize loneliness?

Long pause.

JANIKA: S-o-o-o-o much sky-y-y-y-y.

RAPHAEL: Cambridgeshire. The Fens. Flat.

Long pause.

We miss the children. Ache for them, actually.

GABBY'S VOICE:Ma-a-a-deau-eau-eau-eau…

LARS' VOICE: J-a-a-nika-a-a-a-a…

RAPHAEL: Their quarrels, their awful music, their anxiety about sex, their coffee gatherings in the kitchen… I miss being greeted and hugged and kissed and helping them with their homework and answering their questions and giving them lectures. I miss revealing things to them. I can remember once telling Josh and Hannah that writers used language in three different ways – as prose, as dialogue, and as poetry. A simple fact but it was a revelation to them. '*What an idiot!*' Josh said, '*of course! Why didn't I realise that before!*'

MADEAU: Hannah used to switch off when you talked to *her*, though. Used to amuse me. As soon as Raphael began to explain something to her, her eyes would glaze over. She just wanted love and approval from him.

RAPHAEL: Driven crazy with puberty, that was her problem. But one day, she came home from school and told me about a debate they'd been involved in. '*And you know what, dad?*' she said to me, '*I didn't prepare anything, or plan what I was going to say, but suddenly I found myself talking and reaching into my brain and it was all there. Like a basket. I could dip into it and feel around and find things*'.

MADEAU: His tribe have a Yiddish word – '*kvell*'. It's a mixture of 'quake' and 'swell' – at least that's how I hear it. And it's what happens to your heart in moments of pleasure and pride – it '*kvell's*'.

JANIKA: And he '*kvelled*'?

MADEAU: We both did.

RAPHAEL: And now we measure time by their visits, grow old, and long for them.

GABBY'S VOICE: M-a-a-deau-eau-eau…

LARS' VOICE: J-a-a-a-nika-a-a-a…

FADE

SCENE 5

Saturday evening.

A country lane.

EVERYONE.

Laughter.

Someone has suggested they see who can walk the fastest. All are attempting to walk the comical walk of walkers in a race.

KARL-OLAF: Right, now see who can walk the slowest. Everyone start in a line, over here. And you've got to move. No one must stand completely still. Some part of the body must be moving. OK? Ready, steady, go –

> *Everybody moves very, very slowly, as in slow motion.*

RAPHAEL: Janika, you're not moving.

JANIKA: I was. I was moving my head from a down position to an up position and when that would have been finished I'd've started moving my arm...

KARL-OLAF: Come on, don't talk. Move.

It's slow and funny. Till –

LARS: Oh, I find that boring.

MADEAU: I think I agree.

They all give up.

KARL-OLAF: No patience! No patience!

RAPHAEL: Alright, I've got one. Something we used to do when I was young. Everybody form up in a line one behind the other. But close. Real tight.

They do so. RAPHAEL in front, then JANIKA, LARS, MADEAU, KARL-OLAF, GABBY.

RAPHAEL: Now, when I say 'by the left, quick march!' we all start off marching with our left foot forward and our left arm back.

GABBY: What do I do with my right arm and my right foot?

RAPHAEL: The right arm goes forward and the right foot follows the left as it does when walking. Get the first move right and the rest will follow. But be careful, because everyone's leg has to go underneath the person in front and if you get it wrong someone gets kicked. OK? By the left – quick march!

(Of course it isn't right first time and he has to show them again.)

Look, watch just me and Madeau.

They demonstrate.

Now, line up again.

They do so. Try again. Doesn't work.

Try again. Doesn't work.

Third time it works. They're off!

Until they trip over each other. Laughter.

Again – until they trip. Laughter.

Again – and so it continues as long as the moment will take it, finally marching off stage.

FADE

SCENE 6

Saturday late evening. Games.

They are playing PIT, a card game that involves a lot of shouting.

VOICES: Hay! Hay! Hay!... Rye! Rye! Rye!.... Oats! Oats! Oats!...Wheat! Wheat! Wheat!... Flax! Flax! Flax!... Barley! Barley! Barley!

MADEAU: (*Excitedly yelling.*) Hay corner! Hay corner! I've got it! I've got the Hay corner! Hay corner everyone!

KARL-OLAF: OK, children, enough for one day. Bed time!

Protests of 'one more, just one more'.

The day's over. Adult time! Off you go.

GABBY and LARS kiss everyone good-night and go off. LARS grumpy.

No sulking, Lars. Don't spoil a lovely day by sulking. There's always tomorrow.

They're gone.

RAPHAEL: Tomorrow, tomorrow! I once knew an Irish priest who told his congregation 'If you want to make God laugh tell him your plans for tomorrow.'

FADE

SCENE 7

Same time.

The FOUR ADULTS playing Scrabble.

Long, long silence.

MADEAU: Come on, Raphael. He always takes so long to make a word.

KARL-OLAF: Maybe we should put a time limit on each go.

Long silence.

RAPHAEL: (*Dead pan.*) Are you all familiar with the word 'Rozacks'?

MADEAU: (*Who knows him.*) There is no such word as 'Rozacks'. You!

KARL-OLAF: How would you spell it?

RAPHAEL: R-O-Z-A-C-K-S.

JANIKA: What would it be?

RAPHAEL: Well, I seem to remember it's a disease of the throat.

MADEAU: Take no notice of him.

RAPHAEL: What about 'Zoracks' – one of the Greek Gods?

JANIKA: Greek God of what?

MADEAU: Of diseased throats! I'll stop playing, soon. Are you going or not?

RAPHAEL: In which case 'scar' is all I can do.

He lays out his tiles and picks four replacements.

Would you believe it? Three 'e's and an 'i'. Still, now I can make 'Zeecki' which as you all know is a three-legged hopping bird from New Zealand.

Everyone is concentrating.

RAPHAEL leans back.

Tell you a story.

MADEAU: How do you expect us to concentrate?

RAPHAEL: You never know, my story might contain a word you can make.

Pause.

There was a young lecturer in my department, an intense, good-looking young man, happily married, with two children. Nineteenth century French literature. Not a huge demand for it but – well, he had this extraordinary capacity for using literary letters to illuminate their authors. '*He forgives everyone*' one of his students told me. '*He's full of desperate explanations for his authors' lives*' she said. So, he had one of the brightest, alert groups to whom he

communicated enthusiasm for what he termed 'The Epistolic Link'. And his students loved him.

KARL-OLAF: Good God! Epistle! I can use all my tiles. That's 50 plus!

MADEAU: I hate it when that happens. You can never catch up. (*To RAPHAEL.*) You and your stories!

RAPHAEL: Wait. I might give *you* a word, also. One day there was some confusion in the staff mail and one of the female lecturers opened a large brown envelope which she didn't look at since she assumed – as it was on her desk – that it was meant for her. Lecturers are always receiving large, brown envelopes – circulars, invitations to conferences, book lists, that sort of thing. And indeed, this *was* a book list.

> *Pause.*

A catalogue of books.

> *This time his pause is so long that they all look up and wait.*

Pornographic books! Very vividly illustrated. *Quel horreur!*

KARL-OLAF: Are you expecting us to be shocked?

RAPHAEL: Indeed not. In fact, if we're to judge by the times no one should have been, but – paradoxically, everyone was.

JANIKA: Except the young lecturer.

RAPHAEL: Wrong! He was mortified! He *shouldn't* have been, but few of us are bold about the things we want to keep private, and this poor young man magnified the 'sin' with unbelievable shame. I reminded him about the erotic preoccupations of the masters. No help! He couldn't reconcile a passion for belles-lettres with a passion for Pornography. I had to let him go.

> *Everyone has abandoned the game and is listening, waiting for RAPHAEL to continue.*
>
> *His pauses suggest reticence rather than drama.*

I saw the catalogue.

Pause.

There is…

Pause.

…a gutter side to us all.

KARL-OLAF: Ha! Your husband was turned on!

JANIKA: (*Pointedly.*) He wouldn't be the first.

RAPHAEL: I was. A little. But that's not the point. The incident set me thinking about other things.

JANIKA: Such as?

RAPHAEL: Oh…about what I *really* feel, *really* believe, really *care* about.

> *MADEAU tenses. She knows what this is about..*

I could see my*self* being ashamed to confront things – beliefs I no longer believed, values I no longer supported. Change…

MADEAU: Doesn't anyone want to continue with this game of Scrabble?

RAPHAEL: …politics, art, friends, sex, Madeau…

MADEAU: Are we going to finish this game or not?

RAPHAEL: My poor lecturer. What started him off?

> *MADEAU can't hide her irritation.*

You know what turns Madeau on? The area of flesh between the top of a man's sock and the bottom of his trouser leg.

MADEAU: Stop it now!

RAPHAEL: And for me? Just there – the crease behind a woman's knee.

> *He touches the spot behind JANIKA's knee.*

And one wonders: what would it be like to touch it? Curiosity! The quality we keep demanding from our children: '*Be curious!*' we urge, '*Ask questions! Have appetites to know!*' What if I reconsidered all the views I ever had? What would it be like if I hitch-hiked across Europe? What would it be like if I lived

on my own for a long time? What if I speak to that stranger, listen to that unfamiliar piece of music, kiss that woman, run my finger behind Janika's knee? It's a basic, even scholarly question: '*what if?*' Could lead to new perceptions. And yet – I fear change as though change was somehow a betrayal of who I once was, as though change would reveal I was someone I'd always feared to be. I think the reason why my poor lecturer needed to forgive his authors and find explanations for them was because he knew one day explanations would need to be found for *him*.

MADEAU: I'm going to my polishing.

> *Which she does, angrily, fearfully, as though in some way the conversation threatens her.*

> *Long pause.*

RAPHAEL: I'm thinking of giving up my university post.

> *Everyone is a little stunned.*

> *MADEAU's fears were founded. She persists desperately with her candlestick.*

KARL-OLAF: You never fail to incredulate me.

> *RAPHAEL smiles at the coined word.*

And do what instead? Be *who* instead?

RAPHAEL: Oh…I don't know. I want to re-read the nineteenth century. Carlyle, Pugin, Pater, Arnold, Eliot, Ruskin –

KARL-OLAF: (*Contemptuously.*) Ruskin? That empire tub-thumper? That denigrator of women, that impotent old lecher-after-young-girls who wanted to establish codes for perfection which men like your poor lecturer failed because they couldn't measure up to them?

RAPHAEL: Wrong! Codes for perfection? Never! Ruskin never asked for that. Listen – every month I carry a passage from something I've read or something some one has said. And what do you know, this month it's Ruskin, from 'The Nature of the Gothic'.

KARL-OLAF: Who was last month's?

RAPHAEL: George Steiner.

KARL-OLAF: And who will be next month's?

RAPHAEL: Isaiah Berlin.

> *Finds what he's looking for.*

KARL-OLAF: Incredulate me! You incredulate me!

RAPHAEL: Listen!

> *It's a dramatic quote, and he reads it dramatically.*

> '*You can teach a man to draw a straight line, and to cut one; to strike a curved line, and to carve it; and to copy and carve any number of given lines or forms with admirable speed and perfect precision; and you find his work perfect of its kind; but if you ask him to think about any of those forms, to consider if he cannot find any better in his own head, he stops; his execution becomes hesitating; he thinks, and ten to one he thinks wrong; ten to one he makes a mistake in the first touch he gives to his work as a thinking being. But – you have made a man of him for all that. He was only a machine before. Men are not intended to work with the accuracy of tools. Let him but begin to imagine, to think, to try to do anything worth doing, and the engine-turned precision is lost at once. Out come all his roughness, all his dullness, all his incapability; shame upon shame, failure upon failure, pause after pause; but out comes the whole majesty of him also.*'

There! Imperfect but – majestic!

> *RAPHAEL is jubilant.*

> *FADE*

SCENE 8

Sunday morning.
They've just had breakfast.
RAPHAEL and KARL-OLAF washing up/drying.
JANIKA putting things away.

MADEAU: I shall miss them. These days eating out in the garden – miss them!

Fry-ups for breakfast, barbecues for dinner, rare wines in between. Do you realise how long it is since we cooked such a fry-up as we had this morning?

RAPHAEL: Never!

MADEAU: In our youth, when the children were young and we were teaching them bad habits. Only problem with eating outside is the pesky flies and bees.

KARL-OLAF: Every lovely thing has its price.

JANIKA: You paid precious little for me.

KARL-OLAF: Please, Janika. It's the Lord's day, a day of rest, and it's our friend's last night.

MADEAU: Yes, I shall definitely miss them.

KARL-OLAF: Your candlestick is coming through, madam.

MADEAU: Wait, you've seen nothing.

Hot. End of day.

Again a tableau of a relaxed group.

RAPHAEL: I've suddenly realised why this country-hour is a sad hour for me. I was a slum evacuee! This was the hour when I'd have to go to bed, curtain drawn... full daylight outside...strange bed. In London I was allowed to stay up all hours, but in an alien countryside to be tucked away at this hour? – you really knew you were separated from home. I pined. Used to cry to myself.

MADEAU jumps up.

MADEAU: The last evening. Must finish the candlestick.

By the kitchen table she holds the candle-stick up to the light to locate the last thin slivers of candle-grease.

Long pause.

RAPHAEL: I can't bear this. Must have some music. You said you had another tape of Corelli?

KARL-OLAF: In there somewhere, rummage around, you'll find it.

RAPHAEL leaves to rummage.

EVERYONE settles to listen to the music.

But an extraordinary moment occurs. It is not music.
It is a voice. Of an old man – European and Jewish,
talking to them as though from the dead.

VOICE: *'…Almost every great school of thought, but a really*
great school of thought, that dominated the thinking of
generations, has gone through its ups and downs, its
periods of great intellectual expansion, awakening and
development, and its periods of decadence, decline…'

ALL except KARL-OLAF are a little stunned. It's
almost an eerie moment. As the VOICE continues they
speak over it.

KARL-OLAF: Isaac Deutscher. Lecturing the students at the
London School of Economics. I taped it ten years
ago at your house. You've forgotten.[1]

D'S VOICE: *'…Marx as a forecaster, as a prognosticator, never*
promised victories for the revolution and any definite dates
at the calendar. All that he forecast is that there is going to
be a struggle. A struggle that will go on for generations…'

The VOICE continues in the background.

RAPHAEL: What minds they had, those old Jewish fathers.
Exiled from everywhere, lecturing on everything
– Jewish identity, world literature, political theory
– slow, rational, smouldering with a passion for the
rights of man. Outrage! That's what they had. A
horror of one man's inhumanity to another. Biblical!

He imitates the stern, paternal, European accent.

'Leave him! That's God's creation! Made in his own
image – a sacred thing!'

KARL-OLAF: Is that why the Jew is a revolutionary in an
oppressive capitalist society, and a dissident in an
oppressive socialist one?

RAPHAEL: Correct, comrade! The Jew is the eternal outsider.
No respect for 'historical imperatives', only human
ones. (*Paternal voice.*) 'A human being is a sacred
thing, to be cherished. Hands off!'

1 This tape exists in the BBC archives.

D'S VOICE: *'... Now, there is one essential moment – only one! Only one essential element in the Marxist critique of capitalism, and it is this – it is very simple and very plain, but in this criticism is focused all the many-faceted analyses of the capitalist order: the contradiction between the increasingly* social *character of the entire process of production, and the* anti-social *character of capitalist property. That's all! In this one idea is focused the whole of Marxist critical thought. That was Marx's main idea... This contradiction between the anti-social character of property and the social character of production. This is the source of all anarchy in capitalism, is the source of the irrationality of the capitalist system. This contradiction cannot be reconciled any longer. The collision must come. That is what Marx said...'*

> *Tape ends. Click! It has left them silent, thrown back to a period in their lives when the degree of their political commitment was closely linked with the pleasure of being young.*

JANIKA: (*Quoting.*) 'The great contradiction of capitalism is between the *anti-social* character of property and the *social* character of production.' He makes it all sound so simple.

> *RAPHAEL is uncertain. So too KARL-OLAF.*

KARL-OLAF: Something wrong with that formulation isn't there, old man?

RAPHAEL: (*Thoughtfully.*) Yes, but not being a political theorist, I can't re-formulate it.

KARL-OLAF: (*Turning it over.*) 'The great contradiction of capitalism is between the *anti-social* character of property and the *social* character of production...'

RAPHAEL: Whereas... (*He finds it.*)...the great contradiction of socialism is between the social character of production and the anti-social character of *state-control.*

KARL-OLAF: (*Mock shock.*) That's heresy, comrade!

RAPHAEL: And like all heresy – magnificent! Ideology *is* anti-social!

KARL-OLAF: (*Gaily.*) Heresy! Heresy!

RAPHAEL: People don't betray the idealism of their youth, they don't lose faith in humanity, they just discover that all ideology is anti-social.

KARL-OLAF: But Marxism, old man, Marxism analyses the past to help understand what has happened.

RAPHAEL: Right! What *has* happened! But the moment people turned it into an ideology to tell us what *must* happen it became tyrannical. All ideology leads to tyranny, hence – is anti-social!

Long pause. The light is dying.

MADEAU: I read about this Ukrainian poet, Krasivsky, about 50, who after years of intolerable prison life was due to be transferred to a concentration camp. But the KGB was worried about his influence on the other camp inmates, so they brought a new accusation against him. They accused him of writing anti-Soviet poems, a cycle called 'Apocalypse', and they sent him for psychiatric examination. The Serbsky Institute For Forensic Psychiatry in Moscow, looking for symptoms of what they were convinced was his 'mental disease'.

But they could only find one. You won't believe what it was. They asked him: '*Why is it that you're so cheerful during the day time and yet you write such tragic poetry at night?*' How could he answer? It was true. As true for him as for most of us. So they diagnosed schizophrenia! And there he is, in a mental prison hospital being treated with debilitating drugs for this terrible disease of daytime gaiety and midnight melancholy…

MADEAU is in tears.

RAPHAEL is angry. He leaps up and hurls his words through cupped hands to the wide-open Cambridgeshire countryside.

RAPHAEL: ALL IDEOLOGY IS ANTI-SOCIAL!

*Walks further, out of sight, his voice still there but
fading as he moves further away.*

Attention, please, attention! This is a health warning.
All ideology, religious or political is anti-social! Are
you hearing me? Political or religious – all ideology
is anti-social…

FADE

SCENE 9

Monday morning.

Cases are around to tell us the guests are leaving.

*In the centre of the table is MADEAU's bright candlestick.
Beside it is a box of 'Staybright'.*

The OTHERS gather round, admiringly.

The last cup of coffee is to hand.

MADEAU: I have a problem. That took a lot of rubbing. In a
few days it will need a lot of rubbing again. And
then again in a few more days. Rubbing and rubbing
and rubbing. Forever. But you see this spray here? I
could spray a skin over it and it wouldn't ever need
rubbing again. I'll show you.

> *She sprays a part of the candlestick and holds it up
> to the light.*

What do you think, kids?

GABBY: The skin makes it so dull.

LARS: There's no hard shine.

MADEAU: That decides it. It'll have to be cleaned again and
again and again. By hand. Hard work I'm warning
you, but – it'll sparkle.

> *They finish their coffee.*

> *KARL-OLAF picks up a case, takes MADEAU's hand
> and leads her off with GABBY holding her other
> hand.*

> *RAPHAEL picks up the other case, puts his arm around
> JANIKA and they go off.*

LARS picks up a smaller case, and follows, with a last look back at the middle of the table on which sits –

– the candlestick.

Sparkling.

END

21 October 2006
Blaendigeddi: